INVENTING MASKS

Z. S. STROTHER

INVENTING

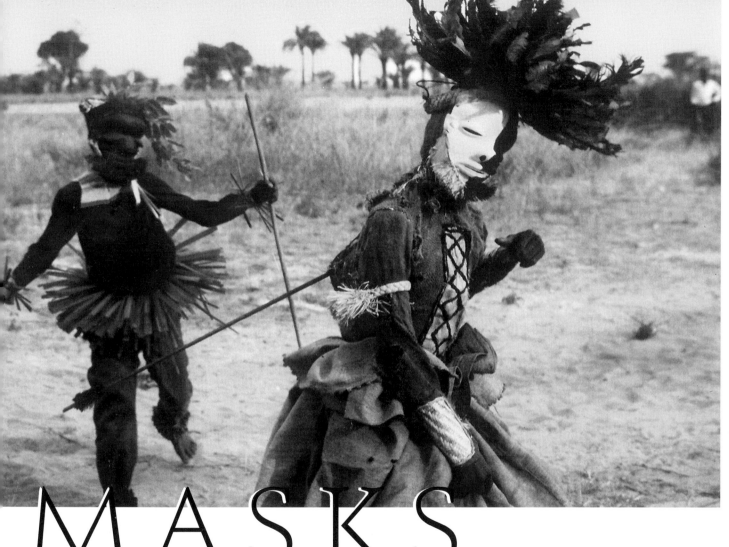

Agency and History in the Art of the Central Pende

MASKS

THE UNIVERSITY OF CHICAGO PRESS • CHICAGO AND LONDON

36739650

DLC

149-99

Z. S. Strother is assistant professor of art history at Columbia University.

The University of Chicago Press thanks the University Seminars at Columbia University for assistance in the preparation of the manuscript for publication. Material drawn from this work was presented to the University Seminar on the Art of Africa, Oceania, and the Americas.

The University of Chicago Press, Chicago 60637
The University of Chicago Press, Ltd., London
© 1998 by The University of Chicago
All rights reserved. Published 1998
Printed in the United States of America
07 06 05 04 03 02 01 00 99 98 5 4 3 2 1

ISBN (cloth): 0-226-77732-4

An earlier version of portions of the Conclusion appeared in "Invention and *Reinvention* in the Traditional Arts," *African Arts* 28 (Spring 1995): 24–33, 90, and is reproduced with the permission of the Regents of the University of California.

UNCREDITED PHOTOGRAPHS ARE BY THE AUTHOR.

Library of Congress Cataloging-in-Publication Data

Strother, Z. S.
 Inventing masks: agency and history in the art of the Central
Pende / Z.S. Strother.
 p. cm.
 Includes bibliographical references and index.
 1. Masks, Pende. 2. Pende (African people)—Rites and ceremonies.
 3. Masquerades—Zaïre—History. I. Title.
 DT650.P46S77 1998
 391.4'34'08996393—dc21 97-16344
 CIP

For Sylvia Ardyn Boone,

for Léon de Clerque-Wissocq de Sousberghe,

and for Khoshi Mahumbu
in celebration of masquerade

ILLUSTRATIONS

PREFACE

Coquery-Vidrovitch . . . said fifteen years ago that "no one doubts any longer that precolonial societies had a history." Still, it is one thing to recognize the undeniable, another to give account of it. Models of noncapitalist orders abound, yet few demonstrate their internal capacity for transformation. . . . [H]ow much have we *really* advanced on our old conception of "traditional" societies, "cold" cultures? Of local worlds trapped in repetitive cycles of structural time . . . [until] they suffer "historical accidents, usually due to contacts with foreign formations"?

—John Comaroff and Jean Comaroff, *Ethnography and the Historical Imagination*

This book explores the history and process of invention in the masquerades of the Central Pende people of Zaïre (now the Democratic Republic of the Congo). I came to the subject late, in the twenty-eighth of thirty-two months of field research on the visual arts, when I caught myself out in some peculiar assumptions.

In May 1989 I had arranged to rendezvous with three friends from the Eastern Pende at the Festival de Gungu. In the 1980s an entrepreneur, capitalizing on certain carrot-and-stick incentives provided by the state, organized annual festivals of "traditional" dance and masquerading at an administrative center within a day's drive of Kinshasa, the capital. The performers, mostly Pende, were organized into competitive teams based on their home counties. My friends came, partly to wish me farewell, and partly out of curiosity to see how other Pende masquerade.

Day after day, I grew tired of how these friends criticized the Pende performers for "dancing like white people," that is, for dancing with their heads, lolling from side to side, rather than from their hips on down. Finally, a troupe of *minganji* maskers (plate 1) took the floor in an explosion of acrobatics and synchronized dance. I turned in triumph to Chief Nzambi to ask, "How about that?!" thinking that he could not but admire the verve of their performance.

"Yes, it's very nice, but it's not a Pende dance."

"Not a Pende dance! What do you mean—not a Pende dance?! You just don't want to concede that the Central or Kwilu Pende have anything interesting at all. Those were the *minganji* dancers, the equivalent of the maskers from your men's fraternity; they go way back."

"The masks go way back," he replied, "but that dance was *not* a Pende dance. Pende people do not move their bodies in that way."

Piqued, I grabbed Khoshi Mahumbu, one of the most acclaimed Central Pende dancers, and related what Nzambi had said.

"Well, of course it's not a Pende dance," he said. "We borrowed that dance from the Kwese after the rebellion was over in '65. You've never seen the old dance. It's rare to see it these days, except at the funerals of circumcisers. It's just that no one has died lately."

Stunned, I was left wondering whence came my easy assumption (without careful verification) that the dance I saw in 1989 had the same form in 1960 and the same form in 1900. I also wondered why I had assumed that the masquerader's facepiece, costume, dance, song, and name were an indissoluble package rather than an assemblage in which one part might change, even drastically, while another part remained quite conservative.

Later, anxious to make up for lost time, I was grilling an older man on the origin of a certain mask. "Was it a *new* mask?" I wanted to know.

"Oh no," he replied, "it's a *mbuya ya mambuta.*" *Mbuta* (pl. *mambuta)* is a Kikongo word appropriated by the Central and Kwilu Pende. Literally, it means "older sibling." Commonly, it is used in the plural to refer to the (living) elders of the village. As Igor Kopytoff noted, the term is a comparative differentiating older from younger; it does not distinguish the living from the dead (1971: 131). Consequently, it can refer also to those elders who

are deceased. Without inquiring further, I *assumed* that he wanted to say that the mask was old, that it stemmed from the dim and dark time of the ancestors.

Later, I learned from careful cross-checking with other sources that the man's very own uncle had invented the mask in question. I went back to him to ask him why he had told me that it was a "mask of the ancestors" *(mbuya ya mambuta)* when it was his very own uncle who had originated it. Dumbfounded, he explained: "But my uncle *is* a *mbuta!"*

One wonders how often such comedies of mistranslation occur. The differences between cyclical African and linear Western conceptions of time are well documented. To some degree, the Pende collapse the near past and the middle past unless there is good reason to make a distinction. If necessary, they will identify something as truly ancient by saying that it came "out of Angola," that is, preceding the migration into what is now Zaïre in the seventeenth century.

If most Pende do not put the same priority on exact chronological age that we do, this does not mean that they are not interested in agency. Aficionados of one specialty or another will be careful to learn the names of practitioners who have made contributions to their field. No one likes their creative gifts to be forgotten. Even sorcerers will cite the originators of their recipes in prayers.

I eventually found that the question was not "Is this a

new or an old mask?" but *"Matangi a nanyi?"* (lit. "Whose ideas?"). "Whose ideas?" indeed. In fact, *who was responsible for the dazzling abundance of Central Pende masks? Who invents masks? And why?* To my surprise I realized that there was very little in the literature on this subject in Africanist art studies and began to wonder why.[1]

The problem of an overinsistence on the establishment of rules has been generally recognized in Africanist art studies. Patrick McNaughton has asked: "which is more important to know, the rules or the ways people live them?" (1993: 83). Simon Ottenberg has regretted the absence of the lived reality of "conflict, competition, chaos, and disorganization" in art studies, particularly of art forms associated with ritual (1993: 73). He notes: "We prefer to show the positive and cohesive view of African life in the face of so many negative stereotypes in the West. So we often depoliticize African tradition in our writing and our exhibitions" (73).

The problem of opposing a discrete, inert "tradition" to a contemporary reality is by no means reserved to Africanist art studies. Modernism has constructed itself in shadow play with its alter ego "tradition" as a history of disjunctive breaks, one after the other, with the past. In the popular imagination, it is still deeply satisfying to restrict the "modern" world to the "West" and to co-opt for that world the experience of both change and personal agency.

For example, in one of the most popular introductory texts to art history for decades, the Renaissance expert H. W. Janson writes that subtle changes introduced by Giotto into the genre of the Madonna Enthroned "must have seemed a near-miracle" to his contemporaries (1977: 325). On the other hand, in speculating on the source of differences in two reliquary figures from the Kota area of Gabon, Janson concludes: "Any gesture or shape that is endlessly repeated tends to lose its original character—it becomes ground down, simplified, more abstract" (43). Apparently, we are to assume that Giotto's contributions to Italian art spring from genius, whereas those of the Gabonese artists are the result of incompetent copying. Janson's conclusions are based on the unvoiced assumption that an African artist, as part of a "traditional" society, cannot possibly wish to do something *new.*

Janson's assumptions should and do seem naïve to most specialists twenty years later; however, the third edition of the textbook, revised and expanded by Anthony F. Janson in 1986, leaves his assessment intact, as does the fourth edition of 1991.[2] In contrast, anthropologist Roy Wagner has advocated an "open-ended experience of mutual creativity": "The crucial step—which is simultaneously ethical and theoretical—is that of remaining true to the implications of our assumption of culture. If our culture is creative, then the 'cultures' we study, as other examples of this phenomenon, must also be. . . . And if creativity and invention emerge as *the* salient qualities of culture, then it

is to these that our focus must now shift" (1981: 16). Wagner calls for study of the structures of creativity within other cultures. In his wake, a number of important books, such as *The Invention of Tradition* (Hobsbawm and Ranger 1983) and *The Invention of Africa* (Mudimbe 1988), have delineated how Western societies have been able to manufacture traditions out of whole-cloth both for themselves and for others. The impact of these studies has been profound. Kuper tells us quite simply: "The theory of primitive society is about something which does not and never has existed" (1988: 8).

What has been much more difficult, however, is to escape the hegemonic voice and to take up Wagner's challenge of studying the role of invention in *other* cultures. Anthropologists John Comaroff and Jean Comaroff underscore this continuing problem: "Models of noncapitalist orders abound, yet few demonstrate their internal capacity for transformation. . . . [H]ow much have we *really* advanced on our old conception of 'traditional' societies? . . . Of local worlds trapped in repetitive cycles of structural time . . . [until] they suffer 'historical accidents, usually due to contacts with foreign formations'?" (1992: 24). Dynamic popular-culture studies have focused on colonial and postcolonial forms in Africa, leaving the impression that change was introduced by contact with the West. They have also focused on urban forms, creating an artificial divide between rural and urban experience. Only a few authors, such as Mary Jo Arnoldi, have pub-

lished extended studies of the "internal capacity for transformation" within the so-called traditional arts (1995). It is the goal of this work to accept Wagner's challenge by writing, not on the invention of tradition, but on the *tradition of invention*.

In his analysis of the novel, Bakhtin has provided a possible model for writing the kind of ethnography that Wagner advocates: "The novel as a whole is a phenomenon multiform in style and variform in speech and voice. . . . The novel can be defined as a diversity of social speech types (sometimes even diversity of languages) and a diversity of individual voices, artistically organized" (1981: 261–62). Students of invention must come to terms with the role of the individual in culture and the role of competing voices. I have drawn my inspiration from Bakhtin to use extensive quotations in the text in order to convey a sense of the individual in the act of reinventing the cultural code. It is in hearing the sculptors' and dancers' voices that we are able finally to exorcise the figure of the anonymous African artist of legend, the slave to tradition.[3]

The book is split into two parts. The first examines the internal process by which masks come to be among the Central Pende and how they change over time. Chapter 1 provides a grounding in some basic cultural tenets relating to masquerade. Chapters 2–4 use the case study method to ask what exactly is a "mask" and who invents it. If I had to learn to ask the question "Whose ideas?" I

also had to learn to approach aesthetic criteria through the question "How do men differ from women?" Chapters 5–6 delineate the codes of gender and physiognomy discovered to be critical both to the invention of masks within and across genres and to personal expression. A coda to part I briefly considers evidence that gendered visual language may be central to a number of African societies.

Readers may be surprised by references to mask "genres" rather than "types." As a term, "type" has flourished through biological metaphor as "the sum of the characteristics of a large number of individuals, used in arriving at a classification and providing the norm against which variants are assessed and classified" *(New Webster's Dictionary and Thesaurus of the English Language)*. The effacement of difference in order to construct a "norm" is precisely the method this study wishes to eschew.

In Pende studies, it has been popular to compare Central Pende masquerading to the commedia dell'arte and to refer to the different masks by extension as "village types."[4] This analogy has been profoundly misleading because it implies that mimetic representation is central to the project of masquerading. In fact, the oldest masks resist any simplistic pigeonholing of this kind. Even MBANGU (the bewitched) and NGANGA NGOMBO (the diviner) turn out to be complex composites of multiple conditions and personalities. The masquerades represent few of the true professions (e.g., blacksmiths or traders). Instead, the dances of many older face masks are abstracted from work movements. For example, MUBOLODI integrates a lighthearted parody of the motions and possible mishaps of chopping down a tree with fast-paced footwork (plate 5). MUBOLODI, however, does *not* represent a "woodcutter"; there is no such profession. Every adult male will have to take on this chore at some point. Similarly, GALUSUMBA parodies the stiff, jerking feints of a man aiming his arrow at birds hopping this way and that in the treetops. This mask does not represent a type, "the bird hunter," but builds a highly stylized dance out of the staccato movements of a frustrated archer. GALUSUMBA will never succeed, although the occasional performer lets loose an arrow. The male clown TUNDU holds up outrageous *behavior* for mockery; yet there is no TUNDU in the village who enjoys equivalent license. Even the female mask acts out an abstraction of "woman" rather than presents a young girl whom one might meet in the village (fig. 10).

In the new critical literature, "genre" has moved beyond the sense of "scenes from daily life." It has become a vaguer term, which in current practice has been defined as "classes of texts that have been historically perceived as such" (Todorov 1990: 17). While "types" tend to be studied synchronistically, one in relation to another, most current criticism stresses the historicity of genre categories.

The emphasis on history has been important in providing a conceptual framework for simultaneous analysis of difference and similarity, of invention and repetition. Literary critic Hans Robert Jauss makes this clear. He argues

that "every work belongs to a genre—whereby I mean neither more or less than that for each work a preconstituted horizon of expectations must be ready at hand (this can also be understood as a relationship of 'rules of the game') to orient the reader's (public's) understanding and to enable a qualifying reception" (1982: 79). However, "genres are to be understood not as *genera* (classes) in the logical senses, but rather as *groups* or *historical families*" which exist in a "continuity in which each earlier event furthers and supplements itself through the later one" (79–80). Once "genre" was freed from the fixity of "types," scholars became fascinated by a work's interrelationships: with other works in the same genre; as a representative of one genre with another; with an audience. Jauss summarizes: "The historicity of a literary genre stands out against a process of the shaping of a structure, its variation, extension, and correction, which can lead to its ossification, or can also end with its suppression through a new genre" (89). Change becomes as central to the history of a genre as stasis.

Although Jauss is speaking of literary genres, his remarks resonate beyond literature to the formulation of categories more generally. Masks, too, belong to a "continuity" in which they meet or breach audience expectations, in whole or in part. They distinguish themselves against other works of the same class and against other classes. They are ignored, or championed. They can ossify in success and then outlive the audience that appreciated them. They can die. They can mutate into a new class altogether. The play of familiarity and difference in genre is precisely what needs to be recovered in order to understand the dialectic of continuity with change, of tradition with invention.

It is sometimes asked whether it is the critic or the artist who creates genre. Adena Rosmarin presents an extreme view: "Whereas . . . the critic presents himself as describing or representing what antecedes his text . . . the genre is actually conceptualized, textualized, and justified by the critic's present-tense act, by his writing of the genre's definition" (1985: 26).[5] In this case, the writing project itself textualizes and no doubt inadvertently hardens boundaries of genres that must remain fluid in the masquerade context. Nonetheless, there is ample evidence for the existence of genre categories in Kipende: *mbuya jia mukhetu* (the female mask, lit. "masks of the woman"); *mbuya jia mafuzo* (*mafuzo* masks); *mbuya jia mukanda* (men's fraternity masks); *mbuya jia kifutshi* (village masks); *mbuya jia ilelesa* (comedic masks); *mbuya jia miyelele* (masks that provoke ululations of joy); *mbuya jia gudiata* (striding masks); and so on. Moreover, although each mask bears a distinctive name, in descriptions Central Pende will assign masks to categories based on a certain number of headpieces. GABATSHI (G)A NYANGA is described as a POTA that performs in the bush like GIWOYO (fig. 98). TATA GAMBINGA is depicted as NGANGA NGOMBO in Ding dress. GAMBUYA GA MALELA is

a GIWOYO that runs across the dance floor. GATUA ULU is GANDUMBU gone fishing. As the critic, I have used these regular associations to trace genre boundaries and also to identify those masks that served as originating models. In the end, it is well to remember Derrida's warning: "every text participates in one or several genres, there is no genreless text; there is always a genre and genres, yet such participation never amounts to belonging" (1980: 65). "Participation" implies calculated decisions of association and distance. An emphasis on historical relationships is critical to perceive the role of individual agency, of choice, of refusal, in "participation" in a genre. It is the goal of this work, not to identify static genres, but rather to see how genre relationships facilitate the invention of masks.

Because of the importance of history to this study, I have had to introduce a certain level of detail in order to reveal how mask inventions and innovations were situated in time. While bald assertions, such as "x mask was invented in the 1920s," would be easier to read, they would also be less honest in not revealing the lines of the argument. I hope that the necessary names, age grades, villages, etc. will not prove too much of a hindrance to the general reader.

The second part of the book tackles the question of history directly by proposing a precolonial and colonial history of Central Pende masquerading. Writers usually move from the general to the specific. In this case, it was necessary to reverse the usual movement so that the read-er had heard the voices of the sculptors and was fully comfortable with the indigenous understanding of masquerading and invention.

Throughout the text—in discussions of change and finally in the case study of the mask GINDONGO (GI)TSHI? —the issue of reinvention emerges. Masquerades are performance art, and dialogue with the audience (including future performers) is paramount. A mask must elicit reinvention or it will disappear. The continuing interest and reformulations of future generations distinguish the great masks.

The issue of creativity has become a difficult one. Modernism constructed a world marked by obsessive concern with the questions of origin and originality (Krauss 1981: 170). The avant-garde held that "tradition" was for other people, for those left behind. They constantly opposed themselves to imaginary "primitives" caught in time. African art specialists responded to the interest of the period by emphasizing the social and communal.

Today, it is necessary to steer a course between the two extremes. On the one hand, we do not wish to paste onto Africa romantic eulogies of "the genius," who can create independently from all society. On the other, we must break out of the mold of primitivism to open up room for the creative participation of the individual *in* society. We must learn what "invention" is in other cultures and thereby begin to build the "open-ended experience of mutual creativity" that Wagner advocated.

ACKNOWLEDGMENTS

Africanists, often pursuing research on three continents, amass many debts and obligations. Because no one can acknowledge everyone who has made a contribution, many Pende end lists and prayers with the adage "To cite [is to show] favoritism" *(Kubulumuna luthondo).* This phrase functions both as "etc." and as a warning that for every person remembered, there will be someone else forgotten. With that caution in mind, I am happy to thank some of the individuals and institutions that have made this study possible.

The fieldwork in Zaïre on which this project rests was primarily funded by three Fulbright Predoctoral Grants, 1986–87, 1987, 1988–89, issued by the U.S. Information Agency. The Yale Center for International and Area Studies (1988–89) and the Department of the History of Art at Yale University (1988) contributed supplemental funds. The Belgian-American Educational Foundation provided six months of support for museum and archival work in Belgium (1986). The Carter G. Woodson Institute for Afro-American and African Studies at the University of Virginia financed the completion of the dissertation (1990–92), which serves as the core of part I. The Michigan Society of Fellows supported the revision of the thesis for publication (1992–93). The Metropolitan Museum of Art contributed crucial funds for travel and photography (1996).

THE CAST (IN GEOGRAPHICAL ORDER)

My greatest tribute must go to Sylvia Boone, who lured me from the dim and dusty archives of French art into the sunshine and laughter of African masquerades. It was the best decision of my life and I am very grateful. I also owe a great debt to Robert Farris Thompson, who has the won-

derful gift of "tuning" his students' ears to hear the nuances of African discourse on performance and aesthetics. His support has been phenomenal. Great thanks also must go to Eugenia Herbert, Patrick McNaughton, Jan Vansina, Christopher Miller, Henry Drewal, Costa Petridis, Jonathan Reynolds, and Ruth Herold for insightful readings. Remaining imperfections, of course, are attributable only to the author's own bullheadedness. Last but not least, I thank my mother for her patience with a wanderer "born to the sound of the outward bound."

In Belgium, Léon de Sousberghe, S. J. has been a gracious mentor, ever generous with his time and field materials. His monumental work *L'art pende* will never cease to serve as the touchstone for future scholarship. Annick Wouters will never know just how much she facilitated the mechanics of my work in Zaïre. Mme Huguette Van Geluwe, Gustaaf Verswijver, Viviane Baeke, Els De Palmenaer, and the staff of the Ethnography Section of the Musée Royal de l'Afrique Centrale (Africa-Museum) have tolerated my rummaging in their closets for long periods. Malutshi-Mudiji-Selenge gave me my first exciting lessons in Kipende (or "Giphende," as he would insist). Nestor Seeuws kindly made available his personal collection of photographs from his two collecting expeditions among the Pende. Paul Bamps helped identify many plant specimens.

In Frankfurt, Angelika Krüger, as Keeper of the Nega-

tives, showed them more care than I do and untangled many an enigmatic German construction.

In Kinshasa, Herman W. Henning, Jr., the Cultural Affairs Officer at the U.S. Embassy, showed heroism beyond the call of duty in battling red tape so that I could stay in the field. His vote of confidence truly made a difference. Susan Duncan Daniell and Doug Daniell, Keepers of the Notebooks, provided a safe haven both for me and for my precious field materials whenever I staggered into town for shots or visas. I thank Susan also for the gift of her enthusiasm. Mangunza-Aley-Biswa Anselme came to my rescue more than once. I thank him, Germaine, and the children for giving me a home away from home. Last but not least, I must acknowledge the sponsorship and support of Lema Gwete and his fine staff at the Institut des Musées Nationaux du Zaïre. They were ever helpful despite the turbulence around them.

I salute Gisagi Kidiongo for his help as my field assistant in 1989. We traversed Pendeland (west of the Loange) on foot from north to south and east to west. To my amazement, we got lost only once, briefly, on a moonless night in a labyrinth of millet fields. His patience, conscientiousness, intellectual curiosity, and fortitude make him an estimable colleague. I also thank Gisagi's father, Kidiongo Sh'a Kabeya, and his family for their warm hospitality in Mukedi.

At Nyoka-Munene, I acknowledge Chief Kapinga, who

first introduced my project to the village, and Malenge-Mundugu-Mukhokho, for becoming its most energetic advocate. I also thank Malenge, Kwanza Pumbu, and their children for providing a home of rejuvenating laughter after a hard day's work. (I still maintain that I won that footrace!) Masuwa, you are not only a great dancer but the very model of Pende hospitality.

Most of all, I must thank the premier sculptors of Nyoka-Munene, who made this project possible: Nguedia Gambembo, *le doyen*, Khoshi Mahumbu, Gitshiola Léon, Gisanuna Gakhusu, Zangela Matangua, and Mashini Gitshiola. They welcomed me with all good cheer, thoughtfully considering my daily round of obtuse questions as I wandered from atelier to atelier. In particular, Khoshi Mahumbu, you were my treasure. Without your extraordinary kinetic memory and without your critical intervention with other dancers, I never would have understood the decisive role dancers play in the invention of masks. I dedicate this work to you in honor of your great abiding love for the *mbuya jia Apende*.

Other individuals who contributed include Chief Ndunda Musenge, Chief Gamushi Togó of Ngondo, Gifembe a Pinda, and Chief Nzamba Gikhopo of Pidi-Samba. Gin'a Khoshi Ndemba of Nyoka-Munene and Kwanza Bendelo and Munjila Muteba, the oldest women of Ngunda, gave an invaluable historical perspective on women's rites.

I thank three friends from the Kasai, Fumu Nzambi (Kibunda a Kilonda), Nzomba Kakema Dugo, and Nyange Samba, who made an arduous trip to join me at the Festival de Gungu for a last goodbye. I greatly profited from their observations on that occasion. I hope my friends in the Kasai will understand that my acknowledgment of their help must await publication of that research.

Lois Braun supplied a welcome haven of laughter, chocolate desserts, and the best English-language library bar none in Zaïre. Not least among her contributions to this project stand the Dr. Scholl's moleskin pads that fortified the researcher for new feats of derring-do.

The Central Pende have raised hospitality to an art form and I can never hope to thank everyone. Their generous spirit is summed up in the actions of a young girl who took pity on a wayfarer flagging in the hot sun by running to share her lemon juice cocktail. It was the best drink that I have ever tasted. (Spiced with pili-pili, it was also quite revivifying!) *Kubalumuna, luthondo.*

Nzambi amibambe, Nzambi amikuatshise, Nzambi amikolese.

NOTE ON ORTHOGRAPHY

In the Pende language (Kipende), the meaning of some words changes on the basis of aspiration or nonaspiration of the consonants: for example, *mukanda* (men's fraternity) versus *mukhanda* (small rectangular building). Informal linguistic convention notes the aspiration with the addition of an *h* to the consonant. Because of the importance of aspiration to their language, many Pende are disturbed by the tendency of francophones to mispronounce the ethonym "Pende." French speakers, who lack an aspirated *p* in their language, naturally tend to pronounce "Pende" without aspiration. To ensure correct pronunciation, some Central Pende have proposed using the "phonetic" orthography of "Phende" (Mudiji 1981: 4 n. 1).

Unfortunately, neither French nor English uses a truly phonetic alphabet, and this proposal will engender more problems than it solves. Native speakers of both French and English are far more likely to read *ph* as *f*, reasoning on the models of "photograph," "phonology," "phosphate," and a host of other words. Because the difficulty does not exist for English speakers (who naturally voice the aspirated *p*) and because the orthography "Phende" will only lead *both* French and English speakers into the greater mispronunciation of "fende," I have chosen to retain the traditional spelling: "Pende." However, with the exception of the letter *p*, I have tried to follow the convention of adding *h* to mark aspiration of consonants in transcriptions.

Kipende is also a tonal language. Unfortunately, I do not have the linguistic training to mark tones consistently in the text without making errors.

As a language, Kipende is subdivided into many dialectical regions, signaled by the prefix *kikua-*. For instance, *kikuaNdjindji* refers to the dialect spoken around Ndji-

ndji. One of the most apparent regional differences in accent is the drift noted among the Central Pende of *k* to *g.* For example, Central Pende refer to their language as "Giphende." Because the shift from *k* to *g* is of comparatively recent origin and because the *ki-* marker in the language conforms to standard Bantu language practice, I have decided to retain "Kipende" in the orthography of the language. Apart from these exceptions, I do my best to conform to local pronunciation, although I may sometimes fall into error through a greater experience with Eastern Kipende.

Official Pende names are usually formed from a combination of the individual's personal name joined to his or her father's personal name. Thus, "Gifembe a Pinda" signifies that Gifembe is the son of Pinda. Sometimes individuals use "a" between the names to signify this relationship, sometimes not. "Nguedia Gambembo" is likewise Nguedia, son of Gambembo. *The formal mode of address entails use of the first name.* One may refer to "Gifembe a Pinda" as "Gifembe" but never as "Pinda," since the latter is his father's personal name. Gimasa Gabate's son is named "Gaseshi Gimasa," *not* "Gaseshi Gabate" as in the English system.

If a man has a nickname, he will often write this as his third name. For example, in the case of Malenge-Mundugu-Mukhokho, "Malenge" is the polite and normal form of address. Intimates have nicknamed him "Mukhokho," the name of a deceased uncle, because of a family resemblance. Only close friends and family will avail themselves of that privilege.

In daily discourse, most adults go by the name of their eldest child; thus, "Gin'a Khotshi" is the "mother of Khotshi" and politely addressed as such. If there is confusion about which "Gin'a Khotshi" is in question, she may be identified as "Gin'a Khotshi Gisanga." In this case, "Gisanga" is her given name. "Sh'a Ganzala" is the "father of Nzala." When asked which name they would prefer cited in the text, everyone opted for the official name. I cite the "Sh'a" or "Gin'a" forms occasionally to prevent confusion among similar namesakes or through ignorance of the official form.

While those are the basic rules, anyone is free to change or invent a new name. For example, one man who was going through a period of great difficulty decided one day: "From this point my name is 'Suffering'" (Lamba). And it was.

As a convenience to the reader, all mask names are capitalized. All foreign phrases and quotations are italicized. Personal names and the names of Pende age grades appear in normal typeface.

➤ ➤ ➤

In 1885, The Berlin West Africa Conference created the Congo Free State as a personal fiefdom of the Belgian king, Lepold II. This geographical unit has remained intact and has undergone several political transformations, reflected in the following name changes: Belgian Congo (1908–60); Republic of the Congo (1960–64); Democratic Republic of the Congo (1964–71); Republic of Zaïre (1971–97). While this book was in press, on 17 May 1997, Zaïre reverted to an earlier name, the Democratic Republic of the Congo.

THE PROCESS

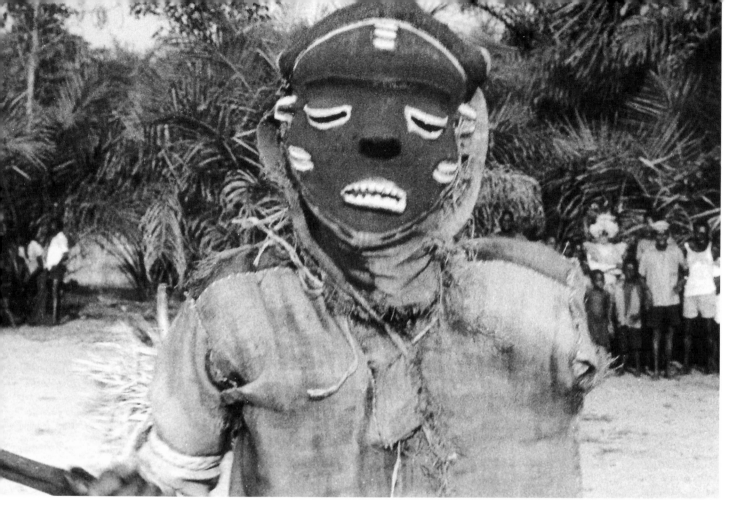

OF INVENTION

CHAPTER ONE

We came to warm ourselves in the sun's rays, [but]
our home is in *kalunga* [the otherworld].

—Common proverb

"Dancing the Masks"

Introduction to the World of Pende Masquerading

WHAT MAKES A "PENDE"?

From 1963 to 1965, a few Pende took part in a rebellion against the new regime in the Democratic Republic of the Congo (later, Zaïre). In reprisal, soldiers moved into Pendeland, burning and looting villages. Families fled into the forest. The mother of an acquaintance became separated from her family and was fleeing alone down a road with her young son strapped to her back. All of a sudden, she spied a soldier coming in her direction down the road. Fearing robbery or rape, she threw down her young son and fled off into the bush. Later, she was able to collect the boy and rejoin her family.

The young woman no doubt reasoned instantly (and correctly) that the child was in little danger from the soldier. Nevertheless, there were witnesses. Some time later, when order was restored, the woman was called before the chief and elders to account for her actions. With a self-possession unusual in Pende women, who are not accustomed to speaking in public, she stood. She is reported to have answered with disdain: "Would you have me, a fertile woman, risk my life to defend a boy? . . . A boy who will never add a person to this lineage?!"

What she said was irrefutable because the Pende are matrilineal, and descent travels strictly through the

female line. If a couple has just one child, it had better be a girl. If the sisters of a family have no female children, the family is considered "dead," mortgaged without a future. Although rarely invoked, not having a daughter provides grounds for a woman to divorce her husband. Whenever she had a beer too many at festivals, one of my hostesses used to reproach her husband for giving her six sons and no daughters. He would wail: "What can I do?!"

Nonetheless, there are truths that no society likes voiced. The woman's bald statement scandalized the crowd. Her behavior did not conform to the idealized love that a mother owes a child in Pende society. All the same, after hemming and hawing, the chief could only dismiss her, saying weakly: "Well, next time, try to take him with you."

The above anecdote illustrates the importance of matrilineal affiliation. Pende society has engaged in a remarkable experiment in communal organization based on an extended kinship system that collapses large groups of people to the same rubric. For example, "mother" in Kipende is a class that includes the biological mother, her sisters, and the daughters of the mother's mother's sisters.[1] What is critical to note is that these are not idle classifications; they are lived realities that touch on law, morality, and the emotions. All the women categorized as "mother," for example, have duties of nourishment and support toward the classificatory "child." In return, children are not supposed to make distinctions in either affection or gifts among their "mothers." A paternal uncle has identical responsibilities, both legally and morally, toward his brothers' children and his own.

This system provides a safety net for all involved. Not infrequently, children are raised by individuals other than their biological parents. Perhaps a grandmother has need of someone to care for her; perhaps a young married woman has need of a baby-sitter; perhaps a child is not getting enough to eat in a large family.

In light of current questions focusing on the colonial construction of ethnicity in Africa (Vail 1989), it is worthwhile to weigh briefly the value of a term like "Pende," considering the importance attached to membership in the extended family described above. While it is no doubt true that self-identification before the imposition of the colonial state centered most often on local lineage, clan, and chiefdom, the scattering of clans from one end of the territory to the other and exogamous marriage practice ensured some sense of collective identity. During certain important rituals, foreigners from other ethnic groups may plead ignorance of the rules in cases of infringement, but custom allows no such excuse for "Pende," no matter whence they come. In distinction from their neighbors (especially their northern neighbors), they see certain

important societal institutions uniting them, such as language, matrilineal social structure, cultivation of millet, circumcision and age grading based on initiation to a men's fraternity *(mukanda)*, and, once most important, the use of objects called *mahamba* as spiritual "transistors" facilitating contact with their ancestors in order to petition for the necessaries of life.

This culture has a vivid sense of itself as one composed of immigrants from Angola. The ultimate justification for a belief or custom is that it "came from Angola." Among the Eastern Pende, where the investiture of the chief remains a vital ritual, the candidate must demonstrate both his eligibility and his acceptability to the ancestors by reciting a history. This begins with the words *Ngudi Mupende* (I am Pende) and proves his assertion by detailing the migration route from Angola and by listing correctly the "grandmothers" from whom he is descended. Most believe that ultimately all "true" Pende (i.e., those descended from the female line and not allied through slave lineages in the male line) share descent from the same "mother."[2] Whether or not they share many customs and outlooks with their neighbors is immaterial; ultimately, they do not have the same grandmothers and may not call on the same ancestors for aid. It is not language but this sense of shared lineage and history that warrants the use of the term "Pende."[3]

HISTORY

The Pende live today in the bush savanna of south-central Zaïre. Their oral history states that when they fled north in small groups to escape the slave trade in Angola, a large segment of the population reunited for a time at Mashita Mbanza in present-day Zaïre. Archeologists recently calculated the earliest carbon 14 dates from the middens at Mashita Mbanza to be 1685–90 ± 55 C.E. (Pierot 1987: 196).[4] Carbon 14 dating can be unreliable, but these estimates coincide nicely with those made by scholars that the Pende left Angola in the seventeenth century (e.g., Kodi 1976: 177; Haveaux 1954: 19, 23). After Mashita, tradition has it that they dispersed peacefully eastward, some eventually going as far as the Kasai River.

In their flight, the Pende found a niche suited to their millet cultivation on the sandy savanna bordering the forest zone of Zaïre, about 400 kilometers northeast of their home in Angola. Here they were able to live peacefully with peoples who had moved down from the north with forest skills. In the late nineteenth century, the Chokwe in the south disrupted the balance of power as they pushed farther and farther north, searching for trade goods (such as elephant ivory and beeswax) and for women to expand the population of their lineages. Between the passage of Hans Mueller in 1884 and Leo Frobenius in 1905, the

Chokwe were able to drive the Eastern Pende into the northeast corner of Pende territory along the Kasai River (Wissmann et al. [1888] 1974: 85–119).

Many Central Pende retreated to the Mbuun frontier in the north. There they banded together with their neighbors to defeat the Chokwe. The consolidation of a Belgian presence in the early 1900s discouraged the Chokwe from continuing their aggression. Some of these Central Pende remained in the north, expanding the frontier (Kodi 1976: 378–79) and creating an active artistic center at the beginning of the twentieth century.

No one can know precisely when the first Pende crossed the Loange River, which today marks the border between two cultural zones (fig. 1). The considerable differences in language and social practices on either side of this frontier suggest a significant period of separation. The earliest collections of Pende art, made by Emil Torday in 1905 and 1909, by Leo Frobenius in 1905, and by Frederick Starr in 1905–6,[5] support this: they show the strikingly individual regional styles to be already fully developed.

Popular usage distinguishes between the "Eastern" and "Western" Pende, who are separated by the Loange River. Since 1932–33, the Loange has marked the border between two major administrative units, the "Kasai" and the "Bandundu." Hence, the Eastern Pende are sometimes referred to as the "Kasai Pende"; and the Western Pende, as the "Bandundu Pende." This administrative division has increased differences between the two regions by placing the language, Kipende, under the influence of two very different lingua francas (Tshiluba and Kikongo) and by exposing the people to two vastly different economic regimes (diamonds and palm oil).

The administrative division at the Loange River has tended to obfuscate internal regional relationships in Pendeland. In many ways, the Central Pende, situated between the Kwilu and Loange Rivers, are closer to their cousins in the Kasai than they are to the Pende west of the Kwilu River. Clans are scattered throughout the territory, but those situated in the center keep stronger ties with those in the east, occasionally even seeking candidates for the chieftainship from relatives on the other side of the Loange. Although the men's fraternity has evolved differently in the two areas, both organizations clearly spring from the same root, and there are striking parallels in investiture customs.

On the other hand, the Pende west of the Kwilu once had their own distinct artistic style and masquerading tradition (de Sousberghe 1959: 24, 31, 69 ff.; Kodi 1976: 327). They practiced certain customs considered bizarre by all other Pende, for example, the enforced chastity of chiefs (de Sousberghe 1954b). They also seem to have had much more interaction with the Aluund (Lunda), borrowing certain political terms and insignia from them.

The South-Central Pende, who are notably less inter-

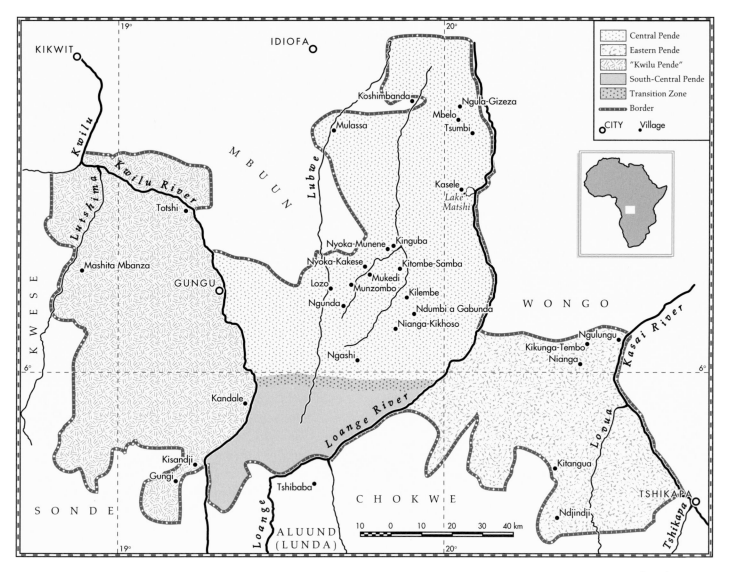

1. Map of Pende territory.

ested in masquerading and who also have had a long history of interaction with the Aluund on their frontier, compose another cultural zone. If anything, they are perhaps closer to the Pende west of the Kwilu than they are to their neighbors due north.

For these reasons, the administrative division of "Western" and "Eastern" Pende (separated at the Loange River) is misleading. The text will distinguish among *four* regions: the "Kwilu Pende" (west of the Kwilu River), the "Central Pende" (north of Ngashi, sandwiched between the Loange and Kasai Rivers), the "South-Central Pende," and the "Eastern Pende" (sandwiched between the Loange and Kasai Rivers) (fig. 1).[6] In the text, to the best of my ability, I will try to distinguish among these regions. "Pende" will refer to customs spanning the territory. This study focuses primarily on the masquerading of the Central Pende.

Between 1903 and 1913, foreign commerce among the Central Pende centered on rubber. When the rubber market crashed in 1913, the state began to exert more and more force to increase local production of palm oil. Colonial control greatly increased in the 1920s. In 1930, in response to the precipitous fall in world palm oil prices, the colonial administration raised its head tax in the Kwilu area and in south-central Pendeland. Without the means of raising such exorbitant sums, entire villages fled to the forests to hide. Hunted down, chiefs and village

elders were publicly whipped. Colonial administrators applied considerable coercion to "recruit" workers for the Lever palm plantations (known as Huileries du Congo Belge).

In 1931, a constellation of forces provoked rebellion among the Pende west of the Kwilu.[7] Due to the death of one Belgian administrator, they suffered brutal reprisals. In the wake of this incident, the administration deposed or threatened many chiefs in the territory of the Kwilu and the Central Pende in order to impose their own selections. The consequence of this action has been an extraordinary erosion of respect for and prestige of chiefs in these areas vis-à-vis the Eastern Pende.

Life eased a bit in the 1940s and 1950s, and young Central Pende men, deprived of traditional avenues of prestige in hunting and leadership, turned increasingly to the masquerades both as entertainment and as a form of indirect protest against the occupation force. Independence in 1960 brought short-lived euphoria. Some Kwilu and Central Pende joined Mbuun neighbors in a Maoist peasant rebellion against the new regime, which resulted in civil war and a reign of terror, 1963–65. Once again, whole villages fled, abandoning their fields, to live hand-to-mouth in the forest or to take refuge with kin in the south. The Mulele Rebellion, as it is called, marks a real watershed for the Kwilu and Central Pende.[8] Because of the flight and the consequent famine, there was high mortality among

the elderly. Many survivors returned to their burned or looted homes demoralized, intent on rethinking what elements of their heritage continued to hold relevance for the present. Many customs already on the wane were simply not renewed. For the Central Pende, masquerading marked the one great exception.

PROBLEMS OF DATING

For a study such as this, the relative placement of individuals and objects in time is critical. One major tool used is the dating system of the Pende themselves: men's age grades. Every ten to fifteen years, the Pende formerly initiated boys into the men's fraternity *(mukanda).*[9] The "generations" *(indongo)* that resulted were distinguished by names that described something topical at the time of the initiation. For example, the initiation camps that sprung up in 1972 chose the sobriquet "Zaïre" to commemorate President Mobutu's renaming of the country in October 1971. They were the first generation to graduate in the country Zaïre. Present practice among the Eastern Pende mixes boys who range from about eight years old to the early twenties. Among the Central Pende, an occasional initiate was already married and a father.

Villages make more or less autonomous decisions to launch initiation camps. However, once several villages start, boys clamor not to be left behind their peers, and an initiation fever lasting several years sweeps across the region. Dates and names do not always correlate *between* regions. The following is a list of the Central Pende generations relevant to the text.

Milenga (ca. 1885–90): The name of this generation helps to date its initiation. *Milenga* is derived from *sogo jia milenga,* the name for immature manioc carrots about an inch wide. When the war with the Chokwe began, many Central Pende fled north to seek refuge with kin on the border with the Mbuun and were obliged to abandon their fields. On their return, they precipitously launched the new age grade. The women had replanted the fields, but the manioc had not yet matured. De Sousberghe records that the last of this generation died in the 1950s (1955d: 82; 1961a: 68 n. 1). The first sculptor of Nyoka-Munene, Maluba, belonged to this age grade.

Mingelu (ca. 1901–3):[10] The name is derived from the verb *guneluga,* "to reflect" (used for both water and oil). At this period, palm oil was heated as part of the extraction process, which rendered it shiny and reflective *(maji a kingeluka).* The local factory, Bienge, forcibly recruited large numbers from this generation to carry small barrels and drums 195 kilometers to the main factory in Kikwit. The sculptor Gabama was a member of this generation.

Mapumbulu (sing. Pumbulu) or Mbunda (ca. 1916–19):[11] In the village of Lozo, Kilota Kayongo and Maluanya explained that this age grade was originally called Mbunda but later became known as

Mapumbulu (soldiers) when the Belgians forced some of the older boys to serve in World War I. Two other Mapumbulu at Lozo recounted that their age mate Gipuku was drafted from the camp to go fight. The sculptor Gitshiola was a member of this age grade. Only a few of the very youngest of this generation were alive in 1989.

Ndende (palm nuts) (ca. 1931): Many camps were in session at the time the rebellion occurred in 1931. The name probably refers to the large numbers of men from this age grade recruited for the palm plantations in the north. The sculptor Nguedia belongs to this group.

Pogo jia Mesa (table knives) (1938–40):[12] This was the first generation to arrive at the camps with many boys already circumcised as infants in state birthing centers. It is the age grade of Miteleji Mutundu (b. 1930), inventor of the mask GATOMBA.

Solomogo (1946 at Nyoka-Munene; 1949–50 in the Kinkasa [Mbuun] area): Its name translates as "burst out" and indicates that the boys spent little time in camp. This is the age grade of the dancers Khoshi Mahumbu (b. 1935) and Masuwa.

Yembele (1956 in Mukedi, Nyoka-Munene, Lozo, Ngondo): This is the last generation initiated in the bush across much of Central Pende territory. The sculptors Gitshiola Léon (b. 1940), Zangela Matangua (b. 1943), Gisanuna Gakhusu (b. 1943), and Mashini Gitshiola (b. 1949) belong to this group.

Zaïre or Tuzua Meya (1972): Some villages held a short, folkloric version of the old initiation rituals.

Dardar (slang for "quick") (ca. 1980): A few villages, especially in the north, held a short, folkloric version.

In addition to the age grades, local events may be tied to known documented dates of either national or local significance. Important watersheds in local history include the rebellion of 1931, independence in 1960, the disruptions of the Mulele Rebellion of 1963–65, investitures of important chiefs, and the dates on which the Belgians compelled certain villages to rebuild along the roads (for surveillance) and away from the water (for fear of sleeping sickness).

SOCIAL CONTEXT OF THE MASQUERADES

The historians Kodi and Sikitele have argued that resistance to authority is a perduring Pende cultural trait (Kodi 1976: 164–65; Sikitele 1986: 118). Despite government opposition, even today villages fracture easily and some Pende joke that they vote with their feet. The goal of many institutions is to preserve a relatively egalitarian social structure. Because they are matrilineal, the eternal conflict between individual autonomy and responsibility to the group is visualized on a personal level as the struggle between nephew and maternal uncle *(lemba).*

Although descent travels through the female line, the Pende are patriarchal and virilocal, so the most important

figures in a person's life are the "uncles." These men are the classificatory brothers of the mother and matrilineal grandmother. In a substantive sense, children belong to the "uncles," a concept that has certain repercussions for sorcery, as discussed below. Theoretically, the "uncles" are supposed to provide for the education and major expenses that an individual incurs. In the past, they kept a community chest for the needs of the lineage. Fines are billed to the "uncles." In return, they have rights to "nieces'" children and "nephews'" labor. As children usually grow up in their father's village and move back later, there is always a certain mobility and fluidity in the region.

Because the "uncles" hold so much power over their sisters' progeny, the maternal family relationship is usually a prickly one marked by undercurrents of fear. The older generation tends to feel neglected; and the younger, exploited. Because of their interest in building a communal society, evenhanded generosity is the virtue most admired in Pende ethics. Hoarding and bias provoke insults because they create a situation in which envy and hurt feelings may blossom into rancor and malice. The danger is that they may lead to sorcery *(wanga)*.

A masquerading anecdote will illustrate this point. At Kinguba, there is an energetic entrepreneur, Mungilo, who has been teaching himself how to sculpt. He is also a gifted dancer and one day went to his "uncle" Gifembe a Pinda to ask to borrow his elaborate costume for the mask MUYOMBO, which Mungilo wished to perform at an upcoming masquerade. Gifembe prides himself on his reputation as a renowned dancer for this premier Central Pende mask. He refused categorically. He also went so far as to forbid Mungilo from performing MUYOMBO at all. This is extraordinary behavior, and village scuttlebutt attributed his motives to a fear of being upstaged. MUYOMBO's dance requires great vigor and flexibility. Many think that the aging Gifembe has passed his peak and is relying on the beauty of his costume rather than his performance to please crowds (fig. 2).

At the masquerade, Mungilo became inspired after his uncle had performed and sought out a makeshift bodysuit and headpiece. Witnesses claim (perhaps for the sake of a good story) that, despite the ragged costume, they have never seen such an accomplished and moving portrayal. When the audience poured onto the floor to applaud Mungilo, his uncle left in a fury. That night Mungilo suffered a nervous breakdown and has remained a shadow of himself to the present.

The timing was damning and angry accusations flew that Gifembe had bewitched his nephew out of envy for his youthful grace. Fearing violence, Gifembe and the elders insisted that the state be brought in to try the case. These officials ruled that drug abuse had been responsible for Mungilo's breakdown, and many at Kinguba seem to accept this explanation. Abroad, most prefer to use the

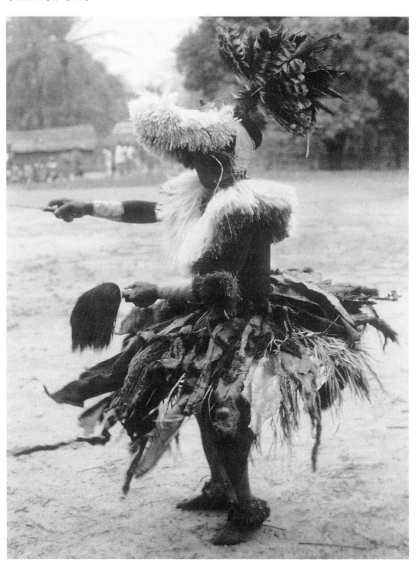

2. Gifembe a Pinda dances the mask MUYOMBO. Kinguba, Zaïre, August 1989.

story as an exemplar of uncle-nephew rivalry.

Crudely translated above as "sorcery," *wanga* is the ability to manipulate the material and spirit world for personal advantage: it is the "power-to-make-things-happen."[13] As power may be used for benign, as well as self-aggrandizing, motives, it is an ambivalent concept. Considered the cause of all illness (with the recent exception of malaria) and sudden death,[14] it is also associated with all talents and abilities, no matter how mundane, that surpass the ordinary. A public speaker famed for eloquence, a student who always gets the highest marks on exams, a hunter who never fails, even a woman who routinely produces hot, delicious meals in the blink of an eye: all will be suspected of having sought out a charm or some form of *wanga*. While the Pende admire talent as much as anyone, they fear that egocentric ambitions can undermine the communal base of society by provoking envy.

The emphasis on *personal* advantage is important. Performers and artists may

seek to distinguish themselves; nonetheless, they contribute something very real to society. It is the wealthy who pose the greatest threat to the communal ideal. People reason that since everyone works hard, for one person to amass significantly more than others calls for a helping hand on the "other" side.

Wanga stands as the linchpin of the ethical system. It is the spur that drives redistribution of goods in the communal society for fear of arousing the resentment and envy of others. The specialist in *wanga* (the *nganga*) will always emphasize that he cannot strike without ethical cause. Even with the worst intentions in the world, his recipes will not "take" unless the victim or the victim's family has made her or him vulnerable through selfishness, adultery, etc. Sorcerers will address a wheedling prayer to God, trying to transfer responsibility for their actions: "Maweze, *you* created the leaves and the objects that we use, so we are just using that which *you* have provided us." However, it is understood that their actions will not work unless there is cause *(kitela)*. Still, human nature being what it is, most people fear that it is all too easy for the malicious to find some excuse in an individual's comportment.

There is a great deal of critical debate about how Westerners may have exaggerated the negativity of African conceptions of sorcery. It is a thorny question because as Christianity takes root in Pendeland, its duality of good versus evil is definitely recasting the debate and shifting the conception of *wanga* toward the purely negative. It is also disassociating the system from God (Maweze), so that sorcery no longer plays a role in ethics. All sorcery *(wanga)* has become "criminal sorcery," to borrow a useful phrase from Achille Mbembe (1991: 120).

Nonetheless, even if *wanga* was never construed as "evil," the term has always been weighted toward the antisocial because of its emphasis on *personal* advantage. Suspicions can drive old men out of the village to live miserable and alone. Accusations at funerals can become volatile enough to provoke bloodshed. Periodic antisorcery movements in the past often culminated in the accused being forced to drink a poison *(kipomi)* to prove guilt or innocence. Unless one can counterdemonstrate one's use to the community in some way—for example, as chief, accomplished healer, or gifted hunter—a reputation as a specialist in *wanga* is not one to cultivate.

It is rare for serious accusations of sorcery to be made against women. As will be discussed in chapter 5, women are believed to be loath to hurt others. They have other, benign means of releasing their anger. The grandmother who wants something will send a gift of pineapple or spice to activate old affections. Refusing her may result in embarrassment, but no fear. Her displeasure or crankiness, unlike her husband's, will be cause only for tolerant amusement. Novelist Margaret Atwood has observed: "I don't think that it does women any favors to think they

are congenitally nice. Power is always potentially power to harm. Think of electricity, think of fire. It can be used for benign purposes, but unless it has that implied or implicit ability to harm, it's not power."[15] Because they hold little political or economic power, women are seldom accused of *wanga*. Significantly, in the two instances I witnessed where women were accused, both had used business acumen to help make their husbands wealthy.

In the context of the masquerades, it is the selfish use of metaphysical power that receives the most attention in representations of older men. These "uncles" may have turned to sorcery out of a love of power, out of envy for the abilities of youth, or out of resentment at the callous indifference of young relatives. While anyone (including the occasional woman) may turn to the exploitation of metaphysical power for personal ends, people fear most its consolidation in the segment of society that already holds the most power over others. The only prudent way to neutralize this fear is by scrupulous attention to the needs of the "uncles" so that they do not feel driven to seek external means of exacting care and respect.

THE VILLAGE THAT DANCES TOGETHER STAYS TOGETHER

In Kipende, one speaks of "dancing a mask" *(kukina mbuya)*, and a "masquerade" is literally a "dance of masks" *(ulumbu wa mbuya)*. In addition to the performers, the event requires a team of drummers and as many singers as possible. Its success also depends on the active participation of the audience, who will sing, clap, and dance along with the masks.

An entire lineage of musicology has stressed the important role of music and dance in socialization. In a seminal work, Alan Lomax observed:

> Teamwork of any sort demands that idiosyncracies and personal conflicts be subordinated to the requisites of a common goal. Most music-making and dancing are the outcome of teamwork; indeed, it might be argued that a principal function of music and dance is to augment the solidarity of a group. Singing the same melody, dancing to the same rhythm, even utilizing the same pitch . . . arise from and enhance a sense of communality. . . . Thus every performance demands and brings about group solidarity in some degree. (1968: 171)

Within African studies, however, while scholars have reaffirmed the role music plays in building communities, they have observed that structures such as multiple meter, call and response, and improvisation assure the individual of room for personal experimentation and recognition (e.g., Chernoff 1979: 125; Thompson 1966: 91).

Many Pende crave fame *(lutumbu)*. Masquerades provide a safe and socially sanctioned means for personal distinction while contributing to the health of the communi-

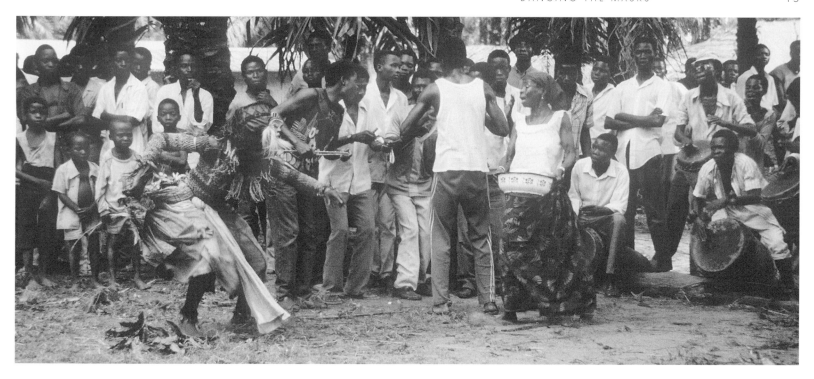

ty. Like a baseball game, it diffuses male rivalry into the realm of popular culture. Each batter has his moment when all eyes focus on him alone, but then he must fade back into the team. The serial nature of mask presentation provides dancer after dancer with his time in the limelight. While the masquerade lasts, singers, drummers, and sculptors get their chance to exhibit their accomplish-

ments. The occasion allows elders to show off their generosity in praise gifts and everyone can parade their good clothes. Because audience participation is the rule of success, a masquerade requires a huge number of people to flourish (fig. 3). In the past, the chief appointed someone to secure the dance floor from envious or ill-willed practitioners of sorcery.[16]

3. The Eastern Pende POTA in performance. Note the supportive singers and drummers, as well as the chief's wife, who is honoring the masquerader. Kingange, Zaïre, 29 February 1988.

Masquerades build and cement communities. Among the Eastern Pende, where the ritual context is alive, they reunite the maternal family across the divide of death. In traditional theology, Maweze created the world and placed humans in a cycle of reincarnation in which the dead act as caretakers over their junior relatives. Masquerades occur after the ritual renewal of the village to thank the ancestors for past beneficence and to petition for their continued goodwill. They tend to occur when the millet is to be sowed or harvested, when the chief is seriously ill, when there are calamitous epidemics, etc. In short, they take place when the community has pulled together to meet a challenge. Group solidarity is such a goal, in fact, that villagers who refuse to participate may be fined for asocial behavior. (If they are ill, all the more reason to come.) Masquerades celebrate the restored state of peace and security.

Older men and women insist that the dead dance among the living on these occasions in a true reunion of the extended family. The night before a masquerade begins, the talking drums boom out with the rhythms of the different masks. This rehearsal gives younger dancers a chance to show their mettle and alerts the countryside to the festivities. Most important, the drums invite the guests of honor, the village's deceased family members.[17]

The masks *do not* impersonate or incarnate the dead.

Exegetes insist that explanations of masks *(mbuya)* as the dead *(vumbi)* are for the noninitiated. As a church constitutes an agreed-upon site of contact for Christians between the physical and metaphysical realms, so the masks create a liminal space in which the worlds of the living and the dead may be superimposed. The masks' presence reminds the living of the invisible family members dancing alongside. The danced communion is followed on the last day with a sacrificial meal behind the chief's house for lineage heads to honor the dead, to assure them that they have not been forgotten. *Kubalumuna, luthondo.*

There is good evidence that masquerades among the Central and Kwilu Pende once fulfilled the same ritual function.[18] This function seemed to decline with belief in the efficacy of appeal to the ancestors after the disastrous rebellion of 1931. At that time, Pende west of the Kwilu received graphic demonstration of the inability of the ancestors to protect them from the bullets of the militia. Nonetheless, even in its secular form, the sense of community remains paramount in the masquerade. One should remember that many Americans who are agnostic or atheist celebrate Thanksgiving as a ritual of family and national incorporation. The Central Pende will dance only when there are no problems in the community, when there are no important disputes.[19] If they cannot seek the

help of the ancestors in building a community, they still use the masquerade to reinforce a sense of community and common purpose.

What is important to stress, however, is that this easy adaption of the masquerade to the secular world was possible precisely because individuals before the colonial period had greatly expanded the masquerade's entertainment function. From the point of first contact, outsiders were struck by the extensive corpus of Central Pende masks.

MASK CATEGORIZATION

The Jesuit anthropologist Léon de Sousberghe identified two categories of masks: the *minganji* and the *mbuya*. He attributed the difference between them to the materials of manufacture: the *minganji* are made of raffia, and the *mbuya* of wood (1959: 29). Although this is largely true, there are a number of exceptions, as de Sousberghe himself noted. The most famous of the *minganji*, GITENGA, is sometimes made of wood, and there are several *mbuya* made (or once made) of raffia (TUNDU, GANDUMBU, KOLOMBOLO, etc.). A truer translation of these two categories would be masks associated with the men's fraternity *(minganji)* and village masks *(mbuya)*. This point is made crystal clear among the Eastern Pende, who refer to

mbuya jia mukanda, "masks of the men's fraternity," and *mbuya jia kifutshi,* "masks of the village" (in the largest sense, including fields and forest). The distinction, therefore, is made by context and function rather than by materials. This study will address the village masks, although one could as easily focus on histories of invention for the fraternity masks.

The fraternity masks are associated with whips and the discipline of boot camp (plate 1). Among the Eastern Pende, they appear only during the initiation period and act both as protectors and as drill sergeants for initiates. West of the Loange River, they may appear singly and in groups at any time. For example, chiefs commonly send them to ambush cheaters attempting to harvest caterpillars before the legal season begins.

Village masks are reserved for members of the men's fraternity, but they do not perform during the initiation period, and they are never connected with violence or disruption of any kind.[20] On the contrary, as described above, their performance is conceived of as a service for the community at large, most definitely including women. However, in the past, it was believed that physical contact with any of the paraphernalia of the men's fraternity could render a child ill. It could also provoke a host of gynecological problems for women, including miscarriages. Some associates among the Eastern Pende feared this fate

for the writer and urged me to return for treatment if any symptoms developed.[21]

Villages once kept communal chests of masks and costumes, enabling those with the skills and desire to perform for the benefit of all. If a given mask's popularity waned, it sometimes happened that "nephews" of the inventor or last performer felt obliged to keep it alive for fear of alienating its deceased advocate. Pende reason that the dead, like the living, do not like to see their contributions passed over and forgotten.[22]

The Central Pende hunger for masks was such that it encouraged the development of itinerant dancers who would circulate with a lead drummer (and perhaps a good singer). As the communal chest was abandoned, dancers began collecting their own personal collections of costume and props necessary for performance.

NYOKA-MUNENE

I began to work in the Bandundu region after two years' work among the Eastern Pende, where I had witnessed fifteen days of village masquerading and over four months of daily initiation *(mukanda)* masking.[23] Circulating among the Kwilu and Central Pende in 1989, I was astonished at the differences from the Eastern Pende, among whom ritual life continues to flourish. The Kwilu Pende, who bore the brunt of repercussions for the rebellions in 1931 and 1963–65, have made the sharpest break with the past. In fact, many are more comfortable speaking the lingua franca Kikongo than Kipende. The oldest men, of the Ndende age grade, initiated around 1931, had never practiced as adults much of what they were describing. Consequently, their understanding, derived from childhood memories, lacked subtlety.

The Central Pende, in contrast, regard themselves as placed at the heart of Pende culture and language. Some were highly amused that I should try to speak Kipende with what they regard as a provincial accent and archaic vocabulary from across the river. They too have made a sharp break with the past. There seem to be only a few pockets downriver (i.e., north) where old, conservative chiefs maintain ritual houses and still make sacrifices to the ancestors.

Masquerades, however, continue to flourish among the Central Pende. Transformed from their original ritual role, they still galvanize young men. From my reconnaissance, one village stood out: Nyoka-Munene.[24] Other villages are better known for their performers, but certainly no other center is more obsessed with masquerading. This village of approximately 750 people[25] supports 7 professional (full-time) sculptors. I do not know of a greater concentration of Pende sculptors in one place. Even the local Pende nurse had caught the fever and hung twenty or so masks in the dispensary waiting room!

Exhausted by over three months of constant hiking in sand and heat, I approached Chief Kapinga with a project of studying the masks for which his village was renowned. He agreed, reasoning on the lines that it would be good public relations for the village. The sculptors also welcomed the free advertising and asked me to send as many clients their way as possible. As will be made clear by this study, there is no hermetic division between city and country, between "modernity" and "authenticity." The same sculptors who take pride in their work for Pende dancers pay their children's school fees with money paid by Zaïrian middlemen for masks destined for sale to foreigners in Kinshasa.[26]

Thus began a very agreeable *séjour* spent wandering from sculptor's atelier to atelier. Accustomed to friends and clients stopping by to watch them work, the sculptors are entirely at ease in discussing fine points of their profession while they handle the adze or knife. They are all men who love masquerading and enjoy reflecting on its nuances. As a spin-off from the mask trade, Nyoka also supports seven raffia weavers, a lost art in the diamond-rich Kasai.

One breakthrough came in the twenty-ninth month of fieldwork in a discussion with the sculptor Mashini Gitshiola. Benefiting from an agile mind, he started to make comparisons between the faces of masks and people as a means of reminding me of what he thought that I must surely know about the world and the roles of men and women in it. At that moment, I discovered that the question "How do men differ from women?" elicited an entire aesthetic discourse. This is a subject that interests a great many people, and even children have a lot to say. I had the impression that male field associates took a certain ironic satisfaction in telling a female researcher all about the perfidy of women. I often challenged them, and my refusal to see facts amused them greatly. Some of my own interests and habits that did not seem to conform to the rules were attributed to personal or national oddity and thus did not pose a challenge to the system. Among the Eastern Pende, women would sometimes ask why I got to do things that they could not. The standard reply, rather exasperated because it was embarrassed, was: "BECAUSE SHE'S NOT PENDE." Colonialism may have ended, but world power relationships extend to the remotest village. In 1987–89, Zaïrians realized that one had to be careful with Americans, that there were repercussions if they disappeared or got hurt. Sculptors resisted my experimenting with an adze, for example, out of fear that they would be held responsible if I wounded myself. In general, however, women and youthful researchers benefit from appearing less threatening. The Pende are very kind to "children."

As in the Kasai, a critical point in my education was reached when some Pende, interested in the project for

itself, decided to intervene. Malenge-Mundugu-Mukho-kho did so with his customary wit and whirlwind energy. He decided that I was not going about the project in the right way, as I was talking to sculptors but neglecting the performance of the masks. At that point Nyoka had not hosted a masquerade in over two years due to tensions between the new chief and the Mulamba quarter. In addition, converts to the Neo-Apostolic Church since 1988 have expressed some hostility about whether or not masks constituted "graven images."

Malenge started agitating in the village for masquerades. He also approached a friend of his at Kinguba, Gifembe a Pinda, a well-known dancer of the mask MU-YOMBO, to suggest that Kinguba should also get involved. In the end, Nyoka-Munene and Kinguba each sponsored two days of masquerading, at which I learned a great deal. As well as seeing the *minganji* (plate 1) a little bit everywhere, I also witnessed impromptu village masquerades at Mukedi, in delayed celebration of Ndunda Musenge's investiture as chief, and at Makulukulu. The 1989 Festival de Gungu was a photo event, but many of the dancers were coerced by state officials, and their performances lackluster.

Khoshi Mahumbu also radically reshaped the project by insisting that I interview performers like Gambetshi Kivule. Both professional dancer and sculptor, Khoshi is more committed to masquerades than any man that I

have ever met. They are his life, and the joy that they arouse in audiences allows him to recoup a reputation tarnished in the Mulele Rebellion. He has an extraordinary kinetic memory, including an acute sense of who introduced what when. It was he who found all of my best case studies. Popular with the other dancers, his entrée made a significant difference in my reception. In a real sense, this study emerges from Malenge's and Khoshi's reorientation of the project toward dancers.

CONCLUSION

The Central Pende have largely removed masquerading from its original ritual context. Yet field associates across central Pendeland and into the north insisted that masquerades "beautify the village" *(gubongesa dimbo)* or "rejoice the village" *(gusuanguluisa dimbo)*. One dances when the village is calm, at peace, most emphatically not when it is torn by dissension or rivalries.

Muhenge Mutala, a Pumbulu initiated late, ca. 1921, spoke eloquently of the power of dance. He explained that the masquerade was capable of "making rejoice the bodies that are shivering."[27] The cold and the ill assume many of the same postures. Malaria often begins with the chills, and nothing is colder than the grave. Traditionally, the Pende believed that the primary attraction for spirits of the dead in the world of the living was simple warmth. As

a familiar proverb has it: "We came to warm ourselves in the sun's rays, [but] our home is in *kalunga* [the other-world]."28

According to Muhenge, dance warms the body and the heart. It drives out the chill of incipient death. It stimulates the weak and ill so that they feel stronger and interested in others as well as themselves. By doing so, it strengthens and reinforces the village *(gukolesa dimbo)*. It speaks with bravado. Muhenge relates that one marks off the masquerade arena with palm fronds in order to boast, "We will dance until the fronds dry up" (one to two days); that is, we will not get tired. In short, dance puts death at a distance.

CHAPTER TWO

You can't just invent a mask . . . you need a dance!

—Gitshiola Léon

Who Invents Masks Anyway?

Very recently a few scholars have begun to explore the nature of the patron-client relationship that underlies the production of much of African art. Arnold Rubin wrote an eloquent appreciation of the "face-to-face interaction" possible in small-scale societies, noting: "The artist becomes the vehicle, the agent, the proximate cause—not the ultimate cause—of the work of art and the aesthetic experience" (1987: 8). Henry Drewal has provided a marvelous account of the role of one "patron" in the creation of a new Yoruba Egungun mask (1984: 96–98). He underlines this man's contribution to the "form, iconography, and meanings" of the mask produced (1984: 96).

The use of the term "patron" is perhaps misguided in this context. While it has the advantage of connecting with venerable Western institutions, it has the disadvantage of understating difference. Since the Renaissance, patrons have ceded more and more responsibility to individual artists for the final product. "Patron" is a bit tame as a term to describe a man who conceives of a mask, names it, designs its costume, selects its headdress out of a wide array, and eventually dances it (Drewal 1984: 97). This man has gone beyond the popular definition of "patron" as a "wealthy or influential supporter" of the artist *(Webster's Ninth New Collegiate Dictionary)* to

become an inventor in his own right or, in the context of Egungun masquerades, at least an innovator.[1]

While it has become axiomatic that one cannot separate African masks from their dance, few have cared to delve into the processes by which the "mask," consisting of headdress, costume, and dance, comes into being. What is the relationship between the parts? How are they coordinated? Who comes up with what? What are the agents' motivations? Is any part privileged over the others? Invention implies an act of imagination, and little could be deemed more imaginative than African masks, but who invents masks anyway?

In an article examining the jurisprudence of the Pende people, Léon de Sousberghe observed in a footnote that one can recover the names of masks fallen into disuse from songs used in court trials (1955a:346 n. 8). Lest the reader jump to the conclusion that Pende masquerading is in decline, he adds that it is, on the contrary, continually re-created afresh. The creative process that de Sousberghe observed among the Central Pende continues today and makes them an ideal subject for the study of processes of invention.

The method used in part I of this text will center on close analysis of case studies to abstract patterns of conduct, with a special emphasis on recovering Pende codes of criticism. Masks come, masks go, some endure for centuries. What contributes to the success of certain constel-lations? The advantage of the case study method, as Drewal argues, is that it "can illuminate art and its history as products of individual creativity and cultural dynamics" (1984: 96). It is the individual who has been far too absent from Africanist art studies.

TESTIMONY OF MITELEJI MUTUNDU ON THE MASK GATOMBA

GATOMBA is an example of the type of mask that has its day of popularity and then disappears from the scene. No one dances GATOMBA today, although certain sculptors still produce its facepiece in quantity for the foreign art market. For several decades, however, GATOMBA was a welcome addition to masquerades in the region and spread from Nyoka to outlying villages, such as Mukedi and Nianga-Kikhoso.

Its inventor, Miteleji Mutundu, was born the year that Chief Nzamba of Mukedi was invested in office—1930. Miteleji was initiated in the age grade Pogo jia Mesa around 1938–40. Today he lives at Kinguba, where he works, but his home village is Nyoka-Munene. The following testimony is paraphrased. Questions rounded out his original account by clarifying various points. The period that he is discussing is most reasonably dated in the mid-1940s.[2]

At that period, there were not many schools, and the few that existed were far away. There was not much work for many of us, so we stayed in the village and invented songs. Then we developed a dance to correspond to the song. One after another would try, add, criticize. Then we'd invent a name. Then we'd go to a sculptor and describe what we wanted.

[For Gatomba,] we were in a group of seven to eight. Maboyi was there and Sh'a Pasa and Gitamba. We were initiated but not yet married. I worked out the dance and came up with the name "Gatomba." At that time, there were many, many dances, practically every week. Our original idea was: All masks dance with two hands. What can we do for something new and different? A mask that dances with one hand alone! We wanted to be stars, we were searching for *lutumbu* [for fame]. Mungula Muhenge worked out the song; he was strong for songs. Then we consulted the drummers in order to develop the rhythm: Gishashi, Mabanji, and Ngulumingi.

When it was all worked out, we went to Gabama, who else? [Gabama was Nyoka's premier sculptor.] He was always happy to help. He liked the number of masks in the village to grow so that the honor and reputation of the village would grow. We told him, "Sunday, we want to dance," and showed him the song and dance. We told him we wanted a face mask with no projection at the chin [*mutumbi*]. Gabama gave it a headdress that had a bald spot on the crown of the head for leaves. This coiffure was called *lumbandu*.

For his costume, Gatomba wore a raffia wrapper, had rattles on his feet, and carried a sword *(pogo ya khusa)* in his right hand. His left arm was hidden in his shirt (fig. 4).

Gatomba is a mask composed in the spirit of "Doctor, heal thyself." The lyrics that Mungula Muhenge composed suggest the exegesis for the mask:

> *Gatomba e e, [i]za!*
> *Utombe akuenu ng'aye udi nganga.*
> *We Gatomba e e! [I]za!*
> *[U]tombe akuenu ng'aye udi nganga.*
>
> Gatomba, come!
> Find the others, if you are a sorcerer.

Like the contemporary dance "The Wife of the Sorcerer Has Died," the song mocks sorcerers who advertise their great powers, only to fall prey themselves to another's designs. Gatomba dances with his left arm inside his shirt, indicating that he has lost his arm. The Pende class such a catastrophic accident as the product of sorcery, possibly involving a failed attack on the victim's life.

In his field notes, de Sousberghe observed that the name "Gatomba" is derived from the verb *gutomba*, which means "to choose," "to find," "to recognize." It is a verb commonly used for tracking an animal. He also observed that "Gatomba" was a nickname that the Pende gave to a Belgian administrator, Monsieur Krott, as "the one who finds the truth in palavers."[3] Today the verb

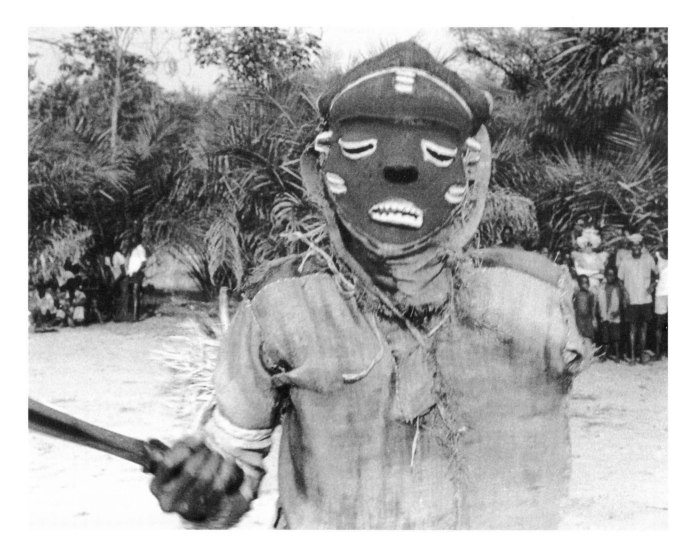

4. The mask GATOMBA.
Nyoka-Kakese, Zaïre,
1974. (Photograph by
Malutshi-Mudiji-Selenge.
M-5.416. Courtesy of the
Institut des Musées
Nationaux du Zaïre.)

refers most frequently to tracking the footprints of a thief back to his house. GATOMBA thus represents a man searching out what is hidden, a man trying to track the sorcerer who struck him before he strikes again. This is why Miteleji originally danced with a sword in hand; GATOMBA intends to find and execute his attacker. Nonetheless, GATOMBA remains a comic figure rather than a tragic one, because he himself claims to be a sorcerer. The *ga-* prefix in Kipende is reserved for diminutives. By attaching it to his name in the song, the audience belittles him and mocks his impotent boasts.

The story that Miteleji recounts of the invention of GATOMBA is typical. It is almost invariably young bachelors who invent masks, young men looking, as Miteleji says, for fame *(lutumbu)*. Dancers are the rock stars of the Central and Kwilu Pende. They naturally attract wine, women, and good company. They can get away with almost anything. Everyone knows very well who is dancing what. Although noninitiates are forbidden from speaking their knowledge, they are not forbidden from singing it. For example, when Khoshi Mahumbu performs the comedic mask MUKUA MAUDI, the women exchange his name for the mask's:

Khoshi a Mahumbu, [I]za ukuate kundu!

Khoshi Mahumbu, you'd better grab your stomach! [Or you'll fall down . . .]

In fact, singers commonly weave the names of the greatest performers into the refrains of the masks that they dance best.

It is even possible for the name of a great dancer to replace the name of the mask itself. One renowned dancer of the mask MUYOMBO, Muwawa from Ngombe a Giboza, traveled widely for years throughout Pende territory, following his initiation ca. 1921. He even crossed into the Kasai to perform among the Eastern Pende. Today in some regions his name has displaced the very name of the mask he danced, so that MUYOMBO has become MUWAWA.

Miteleji's cohorts were all of the most recently graduated age grade (Pogo jia Mesa) or very young representatives of the preceding age grade. Thus, inventing masks was also a means of exercising to the limit the liberty bestowed upon them by passing through the rigors of the initiation to the men's fraternity *(mukanda)*.

What is critical to note is that the invention of masks always begins with the dance. This point was underlined by the sculptor Gitshiola Léon, who, when asked about the invention of masks, protested: "You can't just invent a [face] mask . . . you need a dance!" Miteleji and his group brainstormed to find a gimmick that would make their masker stand out and attract an eager audience. Once they came up with the idea of a one-armed dancer, Miteleji worked out the steps, no doubt with critical comments from his friends. Part of working out the dance steps

involves deciding on what props will aid the performance. Probably Miteleji decided at this time to carry a sword. It fell to Mungula, as the conception evolved, to compose the lyrics.

It was only when the conception had gelled that the originators of GATOMBA sought out other professionals. One cannot stress enough that the characterization of the mask is set with the dance. All else follows from that. Once Miteleji and his friends had completely worked out the persona of GATOMBA as a failed sorcerer, who would move in a certain way because of his injury, they sought out the drummers.

THE ROLE OF THE DRUMMER

Many Pende men are competent drummers, especially on the smaller sizes. The Central Pende orchestra commonly includes five types of drums. At least three of these must be present for a performance; the largest is absolutely essential. In fact, the quality of the dance depends on the lead drummers, those who can handle the largest drum. Only a small, prized minority have the strength and skill necessary.

A touring dancer will always take his lead drummer with him. This is because the context of Pende dance is quite different from that of Western dance. Westerners are used to considering the dancer as an interpreter of a set (written) musical piece that should be more or less the same every time it is played. The orchestra at the ballet sinks out of sight. This is impossible in a Pende context because the relationship between dancer and lead drummer is one of active collaboration that produces each time a result at least somewhat new and different.

The dance terrain itself is oriented so that the drummers have an unobstructed view of the dancer. Although Mudiji has proposed a symbolist reading of why the dancers come out of the east (1979: 188–93), one pragmatic consideration that every performer stresses is that the drummer must not be blinded by looking toward the setting sun. Since dances are scheduled in the late afternoon to take advantage of cooling temperatures, the drummer always looks east, so that the sun sets behind his back. He usually sets up under a tree, and this point becomes the center to which the dancer gravitates. Since maskers tend to look down at the ground, to protect their bare feet and to keep their concentration, they are not bothered by the direction of the sun.

It is vital that the drummer be able to see because he must follow the feet of the dancer. Masquerade rhythms are composed of separate phrases that can be recombined in varying arrangements. The tempo and accentuation of these phrases are also completely open to the interpretation of either drummer or dancer. The drummer, there-

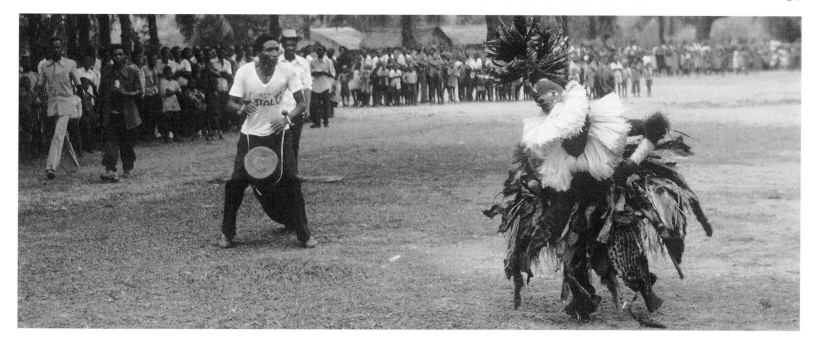

fore, must be able to follow the feet of the dancer, to see when he wishes to slow down or to speed up or to break to a new part of the dance.

If the dancer, for example, decides that he wishes to begin a new part of the dance, he will start to do so, and it is up to the drummer to follow him without a moment's hesitation. This is a real collaboration, however, and if the drummer feels that it is in their dramatic interest to switch, he will break to a new rhythm or tempo, and it is

up to the dancer to follow seamlessly and without pause. To help him pick out his own rhythm among the din of competing rhythms on the other drums, the lead drummer sends out pulsing cries that the dancer follows.

For important masks, when all is going well, the lead drummer will actually work his way out into the center of the floor to perform one-on-one with his dancer, eye to eye, as a means of complimenting him and of inciting him to new feats of excellence (fig. 5). This is the moment at

5. Drummer Muthamba encourages Gifembe a Pinda, dancer of MUYOMBO, at the climax of his performance. Kinguba, Zaïre, August 1989.

which the crowd inevitably goes wild; it marks the crescendo, a superlative moment in the dance.

Undoubtedly, in Miteleji's group of seven or eight, there were competent drummers. However, once they had worked out the general conception of the mask GATOMBA, they sought out Gishashi, Mabanji, and Ngulumingi, all lead drummers of the preceding generation (Ndende), then in their prime. This is the usual pattern unless one of the originating young men is a very talented drummer indeed. These three lead drummers worked out a rhythm that would fit the song and the general idea of the kind of dance that Miteleji wished to perform. GATOMBA now had a dancer and drummers and awaited only a face for public performance.

THE ROLE OF THE SCULPTOR

It is hard for Westerners to realize that the *sculptor is the last stop in the invention of a mask.* Miteleji and his group went to consult Gabama, the sculptor, only when everything else about the mask was already settled: its dance, its song, its rhythm, its costume. They went to Gabama only when they had both the dancer and the drummers and were ready to go on the stage. In Kipende, *mbuya* (or *mikanda*) refers not only to the face- or headpiece of a masquerader (as in English) but also to the the-atrical persona created through headpiece, costume, *and* dance. The sculptor is the last stop because the characteri-zation of the mask persona must be entirely articulate before the sculptor can produce a form in harmony with it. This text will follow Pende usage in conceptualizing the masker with his signature movements as a "mask."

It should also be noted that even with the plethora of sculptors then operating at Nyoka, Miteleji and his group chose to go to Gabama for the invention of a new genre. As with the drummers, they did not go to just anyone but to the recognized leader.

They described GATOMBA to Gabama and demonstrat-ed the song and dance. They told him that they wanted a "face mask." This was a further definition of the character, delineating the kind of mask that would engage in some comedy and that was inspired by village mores, rather than one of the more mysterious masks worn on the top of the head like a baseball cap or slanting down over the forehead. The fact that they gave him all of this informa-tion points to the seriousness with which they regarded the desired harmony between physiognomy and charac-ter, between face and dance.

The link between physiognomy and character can only function within a series of culture-based conventions. Miteleji, for example, specifies that after their discussion, Gabama chose to give the mask a *lumbandu* coiffure.

Under questioning, Miteleji and others revealed that during that epoch, there were distinct fashions in hairstyles for men based on age. Older men often wore leaves on the crowns of their heads. This was called *lumbandu*. Younger men absolutely eschewed this hairstyle, favoring rolled braids or sculpted styles fixed with palm oil and red clay.

In Pende thought, "old man" is almost synonymous with "sorcerer." The Central and Kwilu Pende have a proverb that reflects this belief: "White hair, sorcery" *(Jimvi, wanga).*[4] Gabama, therefore, learning from the song that GATOMBA was a sorcerer, chose to give him the hairstyle of an old man. The *lumbandu* is a sign that conveys laconically the outer age and inner state of its subject.

THE ISSUE OF CHANGE

Let no one assume that a mask's conception, once entirely achieved in dance, rhythm, and form, will remain static. Nothing better helps one understand this than Chinua Achebe's beautiful passage on the Igbo artistic sensibility:

> But once made, art emerges from privacy into the public domain. There are no private collections among the Igbo. . . . Collections by their very nature will impose rigid, artistic attitudes and conventions on creativity which the Igbo sensibility goes out of its way to avoid. . . . When the product is preserved or venerated, the impulse to repeat the process is compromised. Therefore the Igbo choose to eliminate the product and retain the process so that every occasion and every generation will receive its own impulse and experience of creation. (1984: ix)

Chinua Achebe neatly turns on its head the category of "traditional art." It is Westerners who turn out to be the object fetishists; it is they who must deal with "anxiety of influence" since they so tenaciously preserve former models. What we must understand is that societies like the Igbo and Pende, which historically have not kept collections, eschew the practice precisely in order to *free* themselves from the dictates of the copy. Art does not carry a copyright in their societies. As Achebe wrote, it belongs to the public domain.

In the case of GATOMBA, individuals absent when Miteleji and his friends were brainstorming may have good ideas for elaborating on the mask's persona after they see a performance. Such differences may be small or large. Some may be tried once; others may find a following. For example, when Khoshi Mahumbu decided to start dancing GATOMBA in 1947, shortly after it was invented, he did not like the idea of dancing with a sword. A great dancer, Khoshi felt that the twirling of a fly whisk in the good hand would better coordinate with the steps of the dance than the brandishing of a weighty sword. One won-

ders if he also felt that a sword would be inappropriate for GATOMBA, as a comedic figure, a failed sorcerer. Swords are usually carried only by the most frightening of masks. Although he danced GATOMBA with a fly whisk for years, this alteration did not find a following. At the last recorded performance at Nyoka-Kakese in 1974, commissioned by the Institut des Musées Nationaux du Zaïre, the researcher Malutshi-Mudiji-Selenge photographed a man dancing GATOMBA with machete in hand, following Miteleji's prototype (fig. 4).[5]

Today Gitshiola Léon is the biggest producer of the mask GATOMBA. His version is distinctive because he burns the forehead black and then uses his knife to fleck out a repeating pattern of reversed white triangles (fig. 28). Evidently, his father, Gitshiola Shimuna, originated the idea, but Léon has made it his own. The white flecks are universally described as *kaji-kaji*, a term referring to the alternating light and dark spots of a leopard. Léon explains that *kaji-kaji* is appropriate as a sign for the *ngunza*, "killer," as a sorcerer is understood to be. His brother, Mashini, noted that it also refers to the folk belief that when sorcerers gather "to eat" one of their victims, they rub ashes on their foreheads and then spot them with red and white as a sign of fellowship with their fellow *ngunza*, the leopard.

To the Pende, the spotted forehead is about as subtle as a sledgehammer. The spotted forehead is an updating of Gabama's *lumbandu* coiffure. No one wears leaves on the crown of the head any longer,[6] and only the oldest know what it signified. On the other hand, everyone, including children, can read the spotted forehead correctly. Talk about what sorcerers wear and how they behave at their nefarious reunions is very current. GATOMBA's characterization has shifted from the more lighthearted, mocking interpretations of Gabama and Khoshi toward a more threatening and dangerous portrayal.

INVENTION OF THE MASK GIKITSHIKITSHI

The Central Pende appetite for masks is voracious and it does not dictate that every mask be created fresh out of whole cloth. Men searching for a gimmick *(gadilo)* may be inspired by preexisting songs, old or new, not formerly associated with a masked character. Such is the story of the mask GIKITSHIKITSHI.

When the first Europeans arrived, the Pende observed them just as closely as the Europeans were watching the Pende. Local wits soon fell on the early priests with their extremely long beards as a source of parody. They were also bemused (as many still are) by the typical Western stride, which they regard as having the stiffness of a soldier's march. (Throughout my stay, little children would mimic my hiking style and then double up laughing.) This was the origin of a popular song:

Gikitshikitshi, [i]za ujime muevu e e!
[Ga]muevu tendele [or zagalala].

Gikitshikitshi, come extinguish [your] beard,
Your unkempt beard!

The joke here is that the beard was so long and wild that the European himself set it on fire with a cigarette or pipe. Kipende is a language rich in onomatopoeia. *Kiji-kiji* is the sound of heavy stamping; *gikitshikitshi* by extension refers to something that goes about stamping, that is, the European.

No one knows the origin of the song, but field associates in several villages testify that it was the drummer Kianza Lundanda of Nyoka-Kakese who worked out a dance to the song. He presented it as a mask to great acclaim. Muwawa a Bungu, present at the inception, records that he, Kianza, and a group of other men went out to the bush one day to cut straw for a roof. Kianza was amusing them by singing the song. It was especially topical because of the visits of the Catholic missionary Iber (Hubert?), whose beard was exceptional. Kianza was inspired on the spot with a dance to the song that his friends admired. Incited by their cheers, he worked out the drum rhythms and later taught them to his age-grade peer, the drummer Gatemo Pumbu. When they had finished gathering the straw, Kianza went straight off to commission a mask from a sculptor.

Kianza required that the mask have a long black beard extending all the way to the stomach. This the sculptor made of dyed corn silk. In honor of the subject, he also gave the mask a yellow face (from the clay *gindobo*) rather than use the redwood powder favored by the Pende themselves. Kianza danced it with a big straw hat and a European jacket, although he wore a wrapper underneath with rattles on his feet. The dance itself was quite stylized and featured much striding about the dance floor.

The drummer Gatemo places the invention about 1940–45.[7] He observes that GIKITSHIKITSHI was an immediate success and that many wanted to copy it but often found the rhythm too difficult for their drummers. Despite this, the mask did spread locally. At Nyoka-Kakese itself, Mukua Gabinda (Sh'a Pemba) picked up the dance and made it his own. His nephew Nzuji continues it today. At Nyoka-Munene, Khoshi Mahumbu, the master of all comic masks, started dancing it around 1950, a few years after he began performing publicly. At Nyoka-Munene, Mulela also distinguished himself as a gifted interpreter of GIKITSHIKITSHI. Today, however, the mask endures only in its home village.

In order to mimic Caucasian skin, Khoshi tried dancing it with *pemba,* or white clay, rubbed on the facepiece. He found this to be unworkable, as it is more friable than other types of clay and tends to blow into the dancer's eyes. Muyaga reports that others experimented with dif-

ferent materials and with the dance: some using a cane; some, fly whisks (1974: 81).

If Miteleji and his friends banked on the gimmick of a one-armed dancer to sell their mask, Kianza relied on the popularity of a current ditty. Obviously, borrowing a known melody is also a great laborsaving device. Although the rhythms still have to be worked out for the drums, the general direction is evident and one can count on having a good-sized chorus familiar with the song. Nonetheless, the invention of the mask will involve at least two other professionals: a lead drummer and a sculptor. Kianza, like Miteleji, went to his sculptor ready with the song and dance. He also went with some clear indications of what he wanted the mask to look like.

As with Gatomba, no one felt that Kianza's or the sculptor's conception was sacrosanct. Mukua Gabinda became a far more famous dancer of the mask than its originator, and others felt free to experiment with the form and dance, although they kept to the general outline.

Long beards are out of fashion for foreign priests these days so, to some extent, this mask has outlived its topicality. As happens with many localized masks, however, nephews in the lineage may continue to perform for several generations a mask associated with an uncle who achieved fame as a dancer. This is partly to show respect to the uncle, since one feels that anything deemed important by the dead should be continued. One may also fear repercussions, such as illness, if one exhibits willful neglect.

At the same time, the nephew profits by drawing a crowd curious to see a mask that has become rare and a bit mysterious. What once attracted through *topicality* now does so through *anachronism.* Among such masks number Mukua Maudi at Nyoka-Munene and Tshiopo in the Mulamba quarter of Nyoka-Munene.

INVENTION OF THE MASK GALUBONDE

If a mask is strictly topical and excels in neither dance nor form, it will soon disappear as a flash in the pan. Such is the case of the mask Galubonde at Nyoka-Kakese.

Three field associates at Nyoka-Kakese, Gimasa Gabate, Muwawa a Bungu, and Mushila a Bungu, report the following. One of their neighbors at Nyoka-Kakese, Mushila Mabega, served as a *musheshe* for a period. This is a type of police officer who delivers letters for the state, collects fines, and sometimes arrests malefactors. Mushila served under an officer named Galubonde, notorious for abusing his authority. If the state demanded a fine equivalent to 1,000Z, Galubonde would charge 2,500Z and pock-

et the difference. He was particularly disliked for extorting chickens as hush money from the innocent and guilty alike. In disgust, Mushila composed the following song:

> We yaye e e Galubonde, nzangi e e e!
> Musheshe wa pala Galubonde, nzangi!

> Galubonde [is a] thief!
> The senior officer Galubonde [is] a thief!

Although the song is devastatingly direct, the form of the mask had nothing to do with its subject. Mushila danced it with a headpiece that was perched on the forehead and had a short projection *(mutumbi)* and with the raffia bodysuit and wrapper worn by most of the masks.[8] He carried two fly whisks. Unlike Kianza, he made no effort to make costume, dance, or headpiece conform to the subject that he was mocking. He simply borrowed the headpiece from another mask. The pleasure for the audience came in publicly mocking a powerful bully and thief. The masquerade was merely a pretext that allowed Mushila to get away with it. He seems to have performed only once or twice, and no one ever took over the character.

Mushila was of the age grade Mapumbulu, initiated ca. 1916–19. The three field associates could only date his performance by saying that he definitely danced GALUBONDE after the Pende rebellion in 1931 but before World War II.

ADAPTING DANCES TO MASKS: GABIDI-MUAMBA

If pirating a popular song is a great laborsaving device for the aspiring masquerader, the greatest gimmick of all is to pirate an already established dance. This is perhaps the most common form of mask invention. The story of the mask GABIDI-MUAMBA[9] well illustrates what often happens.

At Nyoka-Kakese, Gibata Ngondo is accounted the inventor of the mask LUNGELO. Gibata says that he was born in 1930. He belongs to the Pogo jia Mesa age grade, initiated ca. 1938–40. Before he married, he spent two years among the neighboring Lele at Mapungu, where he worked in the great palm plantations. "I saw how they danced, and when I came back, I put it into a mask." The dance that appealed to him the most was "Gabidi-Muamba":

> Gabidi Muamba e e, Muamba Gabidi
> Gabidi Muamba we! Muamba Muluba

> Call: *Gabidi Muamba e e!* Response: *Muamba!*
> Call: *We! Muamba Muluba.* Response: *Muamba!*

Gibata and other Pende interpret the Tshiluba lyrics as asking for the dish *muamba* a second time *(gabidi)*. *Muamba* in Kipende is a preparation featuring palm nuts ground to release some of their oil.[10]

On his return from the plantations, Gibata sang and danced this piece for his brother, a drummer, who adapted the rhythm to the drums. This was still in the old village (pre-1949). He decided to give the mask a Pende name, LUNGELO.[11] Once they had synchronized the dance and rhythm, Gibata went to the village of Kamba to see Midiba, a professional sculptor, who had several masks ready for sale. He chose one with the fashionable *supi* coiffure, which features long hair combed forward over the forehead. It was a new and interesting dance and brought Gibata many gifts in praise. He only stopped dancing it a short while ago.

Gibata was not, however, the only Pende entranced by the catchy Lele rhythm of "Gabidi-Muamba." In these years, many Pende men were forced to work at the same palm plantations as Gibata or obliged to go to Luebo, the Lele-dominated city, for administrative reasons. And apparently, many different men independently decided to introduce the rhythm in their home villages under the guise of a mask.[12] It is found all over north-central Pendeland, which borders on Lele country.

The dance always remains the same but there is an important distinction between the interpretations of Gibata and of the northern dancers. Gibata picked out a mask with a *supi* coiffure, the chic hairstyle of a fashion-conscious young man at that period (figs. 21, 41). He would come out with a piece of paper attached to a pole, mimicking a flagpole. He stuck the pole in the ground and then began dancing with free hands. Clearly, he envisioned the young Lele dancers that he saw at the palm plantations dancing on the wide clear spaces around the flagpole. Like the hairstyle, the flagpole is a reference to modernity, to up-to-the-moment fashion.

In the north, however, GABIDI-MUAMBA was tied, not to a reference to modernity, but to the archetypal image of the shabby traveler. Lele and Luba cuisine is heavily based on palm oil, and entrepreneurs from these groups visited Pende villages during this period in great numbers seeking palm nuts for their famous *muamba* and related dishes. These merchants would purchase the nuts to make the oil and carry them in two baskets balanced on a pole that lay across the shoulders (fig. 6). Hard work and constant travel gave the itinerants a tired and dusty visage.

Northern dancers connected the ever-present "Luba" merchant to the "Luba" dance.[13] In this case, the dancer would come out carrying the baskets of nuts or, for lack of the proper baskets, raffia sacks stuffed to look like they were full of nuts. He would set down his charge and then start to dance with fly whisks. His dress would be dusty and dirty, and the mask commissioned would reflect an older man, often with the older man's hairstyle favored by GATOMBA. In the village of Pidi-Samba, sculptors even distorted his face a bit to look like the mask MBANGU (fig. 50).

This northern version was the one that the dancer

6. Three Pende harvesters of palm nuts with their equipment. (Nicolaï 1963: 342, photo 78.)

Gilembe brought to Nyoka-Munene. A member of the Yembele age grade, graduated in 1956, Gilembe grew up in his father's village, Ngashi, near Lake Matshi in the north. When he moved south to his uncles' village, he saw that he could gain some fame by introducing the mask that he had learned at Ngashi. Not having the proper baskets, he dances it with two sacks. Even in Nyoka-Kakese, Gibata's own village, this other version has made its appearance. Kamba Kingungu has danced it there with a sack and a mask with the old man's hairstyle. Gibata remains firm, nonetheless, that his goal was to perform the Lele dance, not to imitate a Luba merchant.

The itinerant merchants of palm nuts have passed from the scene but dancers continue to perform GABIDI-MUAMBA. As they do so, the sense of the performance has shifted. Today the mask no longer mocks the grimy visages of actual Luba visitors but refers abstractly to the travail of all travelers. There has been a movement from the topical to the archetypal.

THE ROLE OF GENRE IN INVENTION

In his survey, in trying to make sense of the multitude of masks in the Gatundo region, de Sousberghe sometimes collapses different characters into one. The obscene GIBANGO is merely a synonym for the clown TUNDU, who often engages in obscenities (1959: 40); GABIDI is another name for MWENYI (1959: 52); TATA GAMBINGA is only a variation on NGANGA NGOMBO, the Pende diviner (1959: 53). While the masks cited above have distinct dances, and therefore qualify according to Pende reckoning as distinct masks, de Sousberghe's associations are not without merit. Therein he implicitly recognizes categories of genre. It is precisely the lateral explosion of *variations* on a genre that makes possible the proliferation of masks so typical of Central Pende art history.

MWENYI (or MWENYI-MWENYI)[14] seems to be quite an old mask in the Central Pende region (de Sousberghe 1959: fig. 48). Although long defunct, its memory lingers among the Central and Kwilu Pende because of the dramatic theater in which it engaged. The dancer, dressed in dusty rags, carried a sack over his shoulder. He strode briskly back and forth across the dance floor until he reached the drummer. At that point, a man would shout out: "The stranger will flee! Catch him!" *(Mwenyi! Mwenyi! Ulenga! Mukuatshienu!).* Then a crowd of men would rush up to conceal him in their midst while the dancer undressed and the lead drummer stuffed his clothes up a drum. When the dancer was safely absorbed into the crowd, the men would then disperse, holding up in triumph to the noninitiates the dancer's sack and the little packets that it contained. In response, the women cried out that the men had killed a foreign traveler.

There are several variations on the mask's song:

Mwenyi! Mwenyi e e e!
Lusugu lua guzuga,
Mutshima kenene.

The stranger! The traveler!
The day of departure,
[His] heart [is] sad.

Mwenyi e e! Mwenyi!
Tumujiya jina.

The stranger! The traveler!
We do not know [his] name.

The songs refer significantly to the stranger's apprehension and anonymity. It is important that he should be anonymous. Folklore claims that in the past the investiture of a great chief entailed the death of an anonymous sojourner. Fears of such customs long made people reluctant to travel. The drama of MWENYI acts out the widespread rumor of the sacrifice of strangers to provide ghostly guardians for the chiefdom.

GABIDI's inspiration lay in a new formulation of the archetypal genre of the traveler. In its northern incarnation, it captured the new profusion of itinerant merchants during the colonial period and their "Luba" exoticism in its song and dance. In this sense, GABIDI updated MWENYI. With the disappearance of itinerant merchants of palm nuts, its form has become archaic. Nonetheless, dancers continue to perform GABIDI because of its infectious rhythm and because it still fills a recognizable archetypal genre.

TATA GAMBINGA: VARIATIONS ON A GENRE

There are myriad examples of dances, both foreign and domestic, introduced into the masquerading milieu to expand a genre. Like GABIDI-MUAMBA, these offer the dancer the novelty of a new rhythm and artistic formulation to attract an audience while appealing to the comfortable familiarity of a tried-and-true genre. This is a common strategy in popular culture the world over.

In American television, for example, police and detective shows have merely updated the epic, individual struggles between good and evil represented in the genre of the western. While radical updating and replacement happen only periodically, there are constant, small reformulations. The success of the television show *Dallas* spawned many clones, in which the same story of the struggle for power within a family empire received only window-dressing changes of locale, accent, and gender.

As de Sousberghe recognized, the mask TATA GAMBINGA, which he calls KHAKA KAMBINGA (1959: 53), is a variation on the familiar theme of the diviner important to Pende life.[15] Unlike GABIDI-MUAMBA, however, it is an example of a mask whose appeal has remained only topical.

Gibao a Gasanji relates that during the war with the

Chokwe, many from his village, Kimbunze, retreated to live at Kabuata in the north. Later, his ancestor Muyonzo a Mitumbi (Sh'a Ngambo) went to live there for a time following a family dispute. Muyonzo was of the generation Mapumbulu, graduated ca. 1916–19. While at Kabuata, Muyonzo admired a new mask developed by a villager there who had combined parts of the dance used by Ding diviners and the song "Tata Gambinga":

> *Yaya e e e. Yaye e e e.*
> *Tata Gambinga wahuena nene.*
> *Muhiga wangushiya, watele ikumba.*

> Tata Gambinga stays silent.
> The slave is killing me, [the one who] cost so much.

Probably the song lent itself to a mask representing a diviner because of its theme of illness and discord. According to Gibao, Ding diviners perform a dance in which they flourish a weapon before looking into a mortar filled with water (or a mirror) to see in the reflection the face of the sorcerer responsible for their client's illness. He understands the song as follows: someone of the same clan as Tata Gambinga laments that Tata Gambinga has not acted to discipline the ungrateful slave who is rendering the speaker ill. De Sousberghe reports that the song is used in trials to protest when someone with special knowledge remains obstinately silent (1955a: 346 n. 8).

On his return to Kimbunze, Muyonzo commissioned a facepiece from a sculptor. He told him that he wanted one with the calm physiognomy of a chief. As costume, he dressed in a voluminous wrapper, with tufts of raffia on the arms and with rattles covering his legs up to the knees. It was the addition of rattles from ankle to knee that rendered the mask unique and gave its dancer his "gimmick" *(gadilo)* to attract a crowd. Perhaps Muyonzo was also trading on the popularity of Ding diviners in the colonial period, as reported by de Sousberghe (1959: 53).

Muyonzo usually danced with a cane and with fly whisks, but sometimes he carried a horn that he sniffed. The horn was a borrowing from Pende diviners. He usually performed standing, but sometimes on his knees. Everything in the dance paraphernalia and gestures links the dance to the familiar rendition of the Pende diviner, Nganga Ngombo. Tata Gambinga, for example, did not dance with a mortar as a stage prop.

After Muyonzo retired, his nephew Tshiamo took up the mask but danced it with a hoop *(mukhela)* covered with many twisted raffia cords *(nyanga)*. At first, he used his uncle's facepiece, but eventually he bought another that had the distinctive hairstyle of Nganga Ngombo, the mask representing Pende diviners (fig. 7). Tshiamo was of the age grade Pogo jia Mesa, initiated in the late 1930s. It was his interpretation that spread to nearby villages. Mbote and Mashini, the son of Chief Nzamba at Mukedi, made it their own.

Gisaga of Kitombe-Samba saw Mashini a Nzamba perform TATA GAMBINGA on a visit to Mukedi and decided to introduce the mask to his own village. He started only a couple of years after graduating from the Pogo jia Mesa generation, so this would be the early 1940s. He commissioned a "very beautiful mask" (*mbuya yabonga sha*) from Gabama himself that fit like a dream. This was again in the form of NGANGA NGOMBO, the mask representing Pende diviners. Gisaga sold Gabama's work before the rebellion in the 1960s, and its replacement, made by Mulemo at Mukedi, has never fit very well.

Gisaga is the only surviving dancer of this mask.[16] He dances it with a cane somewhat in the fashion of TUNDU, the clown. After sticking it in the ground, he shakes his head from side to side so that the braids fly about. He wears a hoop with skins over it and rattles made from mango pits on the inside of his legs all the way up to his thighs. Gisaga reports that he has danced TATA GAMBINGA only once since the Mulele Rebellion of 1963–65. He knows of no followers. Seemingly, the variation on the genre has grown old and lost its power to attract new performers.

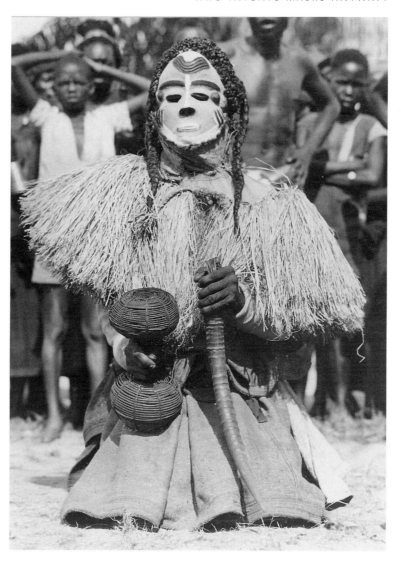

7. Mask identified as KHAKA KAMBINGA; however, its face and costume are identical with those of the mask NGANGA NGOMBO. Nyoka-Kakese, ca. 1950. (Photograph by J. Mulders, *Congo-presse*, Cl. 105013 [EPH 8248]. © Africa-Museum, Tervuren, Belgium.)

CONCLUSION

In review, these case studies reveal that the inspiration to shape a new "mask" (in its totality of dance, costume, and sculpture) most commonly originates in young, unmarried men seeking distinction and public acclaim. One cannot stress too heavily that the invention of a new mask centers on its dance. As Miteleji did for GATOMBA, the first performer may choreograph the steps himself and then seek out a song to accompany them. As Kianza did for GIKITSHIKITSHI, he may be inspired to work out a dance in response to a popular song. Or, as Gibata did for LUNGELO (better known as GABIDI-MUAMBA), he may adapt a preexisting dance to the masquerading milieu.

The last model is the most frequent since it has the advantage of requiring less work and fewer creative partners. One particularly notes the adaption of familiar dances in the masks representing young women. The form of the following nine masks is practically identical: GAMBANDA, GALUHENGE, GAGILEMBELEMBE, GABUGU, GAKHOLO, ÉLIZA SOLO, GAHUNGA A ISHISHI, ODOMA, GATAMBI A IMBUANDA. All represent a young woman; only small details of their costumes may differ. Nevertheless, each showcases a different dance and is therefore entitled to a distinct name and persona. Nothing testifies better to the primacy of the dance.

If the impetus of invention begins with a dancer, it inevitably involves two professionals: the drummer and the sculptor. The belief that the face should conform to the character of the mask and its dance points in directions hitherto unexplored. On what criteria do the Central Pende base such judgments? Future chapters will explore this question in relation to both the costume and the face.

These case studies also introduce inevitably the problem of change. While some masks pass generationally from uncle to nephew, others spread geographically as well when a visitor in the village admires a performance and determines to introduce it to his own village. The history of TATA GAMBINGA provides evidence of both models. The Pende firmly believe the adage that imitation is the sincerest form of flattery. If an invention spreads, it only adds to the fame *(lutumbu)* of its creators.[17]

There are myriad opportunities for the movement of masks. The evening before a masquerade, the talking drums sound, often for hours, inviting one and all to the festivity. Visitors come to perform their own masks as well as to admire those of their hosts. From time to time, itinerant dancers pass through with their drummer and singer to demonstrate their skill. Masks also move with the passage of men from their fathers' villages to their uncles' in this matrilineal culture. This is how GABIDI-MUAMBA, for example, spread south to Nyoka-Munene.

As the masks change hands, there are many opportunities for refinement or redefinition. The meaning of

GATOMBA has remained remarkably stable over time, but the symbolism of its original form (the *lumbandu* coiffure) has shifted from obvious to arcane. By giving it a speckled forehead, Gitshiola Léon has merely modernized this symbolism. On the other hand, it is the form of the northern version of GABIDI-MUAMBA that has been stable over time, with its baskets or bags of palm nuts. It is the meaning that has shifted from topical satire of omnipresent Luba merchants to archetypal treatment of the shabby traveler.

Finally, these case studies illustrate how the existence of genres provides the frame in which performers can freely introduce new dances and forms. TATA GAMBINGA provided a new dance and "gimmick" to jazz up an old genre, the diviner. GABIDI-MUAMBA, however, provided (in its northern version) a radically new formulation of the genre of the stranger *in addition to* an attractive new dance. The continuing ability of this mask to attract performers relates to its dual innovation.

The ability to shift from the purely topical to the more universal seems to be a key ingredient in a mask's success. Nonetheless, the masquerade always boils down to the dance. It must continue to interest generations of audiences. GATOMBA, the bewitcher bewitched, represents a fairly archetypal figure for the Pende, but his one-armed dance no longer excites the crowds. Miteleji put more thought into the gimmick *(gadilo)* of dancing with one arm than he put into the footwork.

CHAPTER THREE

Costuming for Change

The investigator discovering change for the first time may feel that it is chaotic and unpredictable. One performer dances the mask GABIDI-MUAMBA with a flag; another, with a basket of palm nuts. One dances TATA GAMBINGA wearing a wrapper; another insists on the addition of a hoop. In the invention stories recounted in the previous chapter, we noted that dancers felt free to change and refine both costume and dance. However, mask prototypes *do* stabilize over time as they achieve a form that their audience judges appropriate or becoming *(gutagana)*. The performer's experimentation is not haphazard but a process of dialogue with the audience based on their mutual understanding of the possibilities inherent in masquerade genres. For the costume, there are two aesthetic principles at work that allow the form to come to equilibrium: (1) the optimum acoustic and visual enhancement of movement and (2) the clear separation of parts.[1]

FOOT RATTLES

A great deal of the aesthetic of the mask's costume relates to the acoustic and visual enhancement of movement. As researchers delve into the subject, it is becoming clear that Africans ascribe considerable value to the acoustic proper-

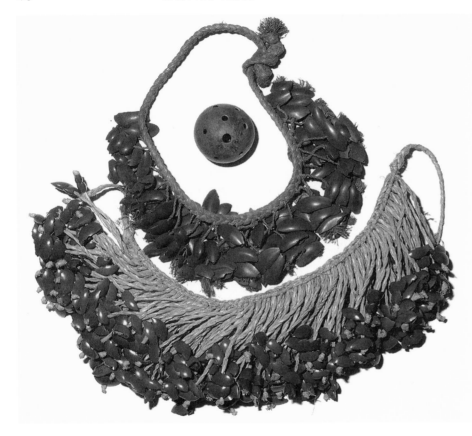

8. Central Pende foot rattles: *(top)* one *manjolo* fruit bored for use in a strand for the comedic masks; *(middle)* a strand of *sambu jia matshotsho* from the American Museum of Natural History, collected by Frederick Starr; *(bottom)* a strand of *sambu jia nzuela*, the rattles reserved for the beautiful masks. (Photograph by Z. S. Strother, 1996. Courtesy of the American Museum of Natural History.)

ties of materials. Eugenia Herbert noted a classic example of this connoisseurship in the precolonial African appreciation for copper, the "red ringing metal."[2] Copper and its alloy, brass, were prized as sounding metals over soft and silent gold (Herbert 1984: 277–82).

In Central Pende masquerading, the attention to acoustic properties is nowhere more evident than in the importance attributed to foot rattles. Any dancer or musician, blindfolded, is able to identify a mask by the sound of its foot rattles alone. In fact, it is difficult for a dancer to demonstrate the steps for a mask without foot rattles because he cannot *hear* whether or not he is doing it correctly. The analogy in American culture for this phenomenon would be tap dancing. In working out the persona for a mask, the dancers must give due thought to the appropriate acoustic aesthetic.

In the Gatundo region and in the north, dancers avail themselves of three different classes of foot rattles *(sambu)*. The most beautiful, the most expensive, the most desirable of these are the *sambu jia nzuela* (fig. 8). Their name derives from the verb "to speak" *(gunzuela)* because the Pende consider that they are pitched like the human voice. They give a gay, high-pitched, tinkling sound reminiscent to Westerners of sleigh bells.

Entrepreneurs make them to sell to dancers from the seeds of the edible fruit of the forest vine *dishui dia banvu*. Some plants give large fruits with large seeds that

are distinctly lower pitched. The true *nzuela* come only from the small fruits of this vine with their smaller seeds. The high cost is related, not only to the rarity of the vine, but also to the difficulty of boring holes into the small, hard seeds without splitting them and to the quantity required. For each foot, the artisan will sew together strands of 200 or more pairs onto thick raffia cords. A discriminating dancer will make considerable effort to get a pair pitched appropriately for the mask(s) that he wishes to perform. It may take him years to find the exact sound for which he has been searching.

The Pende prize *nzuela* for their cheerful sound and for their carrying power. On the feet of a good dancer, they sing out clearly across the largest of dance arenas. And it is not only the dancers who need to hear the rhythm of their foot rattles to know whether or not they are dancing well. The audience uses it as a gauge as well. One can literally measure the quality of a performance from the sound of the rattles before one sees anything. It is not enough to have a fine pair of *nzuela;* to make them sing it takes a superior performer who gives clear, separate, and powerful dance steps. This is why the most common criticism of a fledgling dancer is *"Ngolo!"* ([Do it] stronger!). The critic is indicating that the dancer must stamp the ground harder to bring out the music from the foot rattles. When a dancer has a particularly fine pair of *nzuela* and makes his audience recognize that fact, everyone present will remark upon their quality, even wondering what he has put "in" them (i.e., what medicine) to make him dance so well. The foot rattles are prized because they are capable of transforming the dancer's body into an instrument fusing sound and motion.

The division of the foot rattles highlights a preliminary but fundamental division in the masks. The *nzuela* are reserved for what the Central Pende call "the masks of beauty" *(mbuya jia ginango)* or "the masks of style" *(mbuya jia lulendo).* This category, in fact, includes the majority of masks, but it is exemplified by the mask MU-YOMBO (fig. 9), considered the ultimate "mask of beauty," and by those representing young women (fig. 10), deemed too delicate for other kinds of rattles. For either of these masks to appear with another kind of foot rattle would spoil the audience's appreciation fully as much as if the dancer fell down during the performance or if his headpiece split.

If the *nzuela* rattles are likened to the human voice, the designation of the next class of rattle, *sambu jia matshotsho,* compares it to the din of weaverbirds who nest at twilight in huge colonies in the village's highest treetops. The racket that these birds make is called *matshotsho;* the noise of the rattles is described as *wotsho-wotsho* in contrast to the higher-pitched *tshia-tshia-tshia* of the *nzuela.* Artisans make these rattles from the same seeds used for the *nzuela,* but they choose the largest seeds, about four

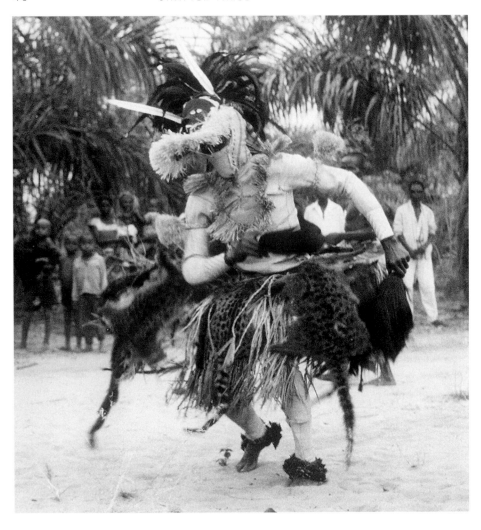

times larger than those for the *nzuela.* The *matshotsho* rattles are perhaps the rarest today (fig. 8).

The *matshotsho* rattles are used to mark a different style of dance for a small subcategory of masks, including PUMBU, MATALA, MBANGU, and GIWOYO. The lower tone of the rattles is judged appropriate for ominous masks, such as PUMBU (fig. 92), and for dances that show a strongly marked break in the rhythms. The continuous tinkling of MUYOMBO's dance, for example, contrasts forcibly with the energetic hopping from foot to foot of MATALA's. Whereas the *nzuela* sound best in continuous motion, the *matshotsho* work best to dramatize the contrast between silence (rest) and action. These works are still classed as beautiful masks *(mbuya jia ginango)* and may dance with *nzuela* if there is a shortage of *matshotsho.*

The third category of foot rattles, *sambu jia manjolo,* belong to the *mbuya jia ilelesa,* the comedic masks (TUNDU, GANDUMBU, MUBOLODI, TATA GAMBINGA, etc.). The rattles take their name from the forest fruit, *manjolo (Oncoba spinosa),* that dancers gather to make them. When the fruits dry, one bores several little holes into them and one big hole that will eventually be plugged with a raffia knot (fig. 8). Into the big hole, one inserts

9. Masuwa dances MUYOMBO. The way this mask approaches the dance floor is considered the ultimate in style and requires the foot rattles *sambu jia nzuela.* Nyoka-Munene, Zaïre, June 1989.

nzedi (Abrus precatorius) seeds. The *manjolo* seem to be getting rarer and rarer, so many dancers today use mango pits as a substitute (fig. 11).

The sound of *manjolo* carries only a fraction of the distance of that of the other foot rattles. The Pende find their noise cacophonous and consider their form ungainly and inelegant. In these regards, they suit the comedic masks like TUNDU and GANDUMBU (fig. 11), whose costumes in general caricature proper dress. Their low-pitched dissonance acts like an American comedian's drumroll to underscore the masks' abrupt and outrageous behavior.

One can see that the masquerade unites a symbolism of sound and action reminiscent of the relationship between a motion picture and its score. The soaring melodies of a love theme or the deep notes accompanying a danger sequence subliminally cue the viewer to the proper response to the action at hand. In a different medium, the Pende use the tones of the foot rattles to much the same effect. The fundamental division into beautiful and comedic also reveals a great deal about proper audience response. On the one hand, the rattles clue us that even an ominous mask like PUMBU (fig. 92) is admired primarily for its beauty. On the other hand, they indicate that even a well-dressed mask like MUBOLODI (plate 5) is primarily savored for its comedy.

If a dance incorporates gestures or steps unique to a given mask, sometimes other noisemakers will be used, in

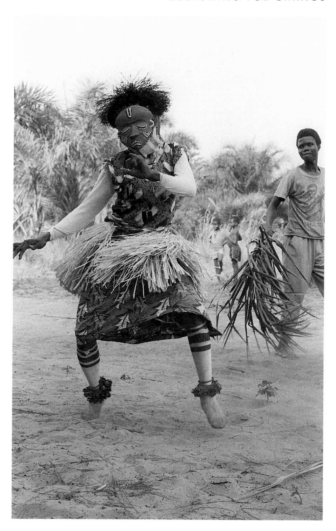

10. Gabuangu performs GATAMBI A IMBUANDA, a female mask. An audience member is about to praise the dancer's performance by hitting the ground with palm fronds. Nyoka-Munene, Zaïre, 1989.

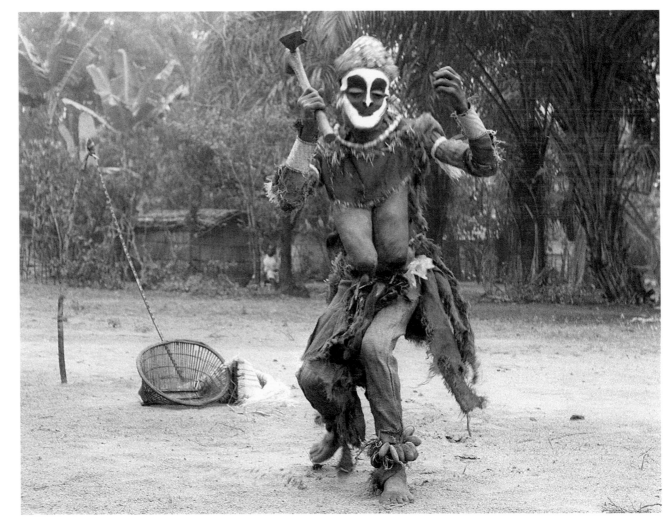

11. Mandala Gansanzo of Mubu dances GANDUMBU, a comedic mask representing an old widow. Note the mango pits substituting for the appropriate foot rattles, *sambu jia manjolo*. Kinguba, Zaïre, 1989.

addition to the foot rattles, to heighten the effect. For example, Giwoyo has a distinctive run-in-place step emphasized by the placement of a bell above the performer's buttocks, where it rings out the most clearly for this part of the dance (fig. 12). As with the foot rattles, there is usually a concordance of sound and symbolism. When the mask Mbangu, the bewitched, wears the wooden bells of a hunting dog, they act not only to accentuate the jerking feint of his dance but also to underline that he is on the hunt for the sorcerer who disabled him (plate 4).

ENHANCEMENT OF EVERY-DAY MOVEMENTS

Whereas foot rattles and bells draw attention to themselves, the intertwining of visual and acoustic accentuation of motion can also be subtle. In her book *Radiance from the Waters*, Sylvia Boone notes the

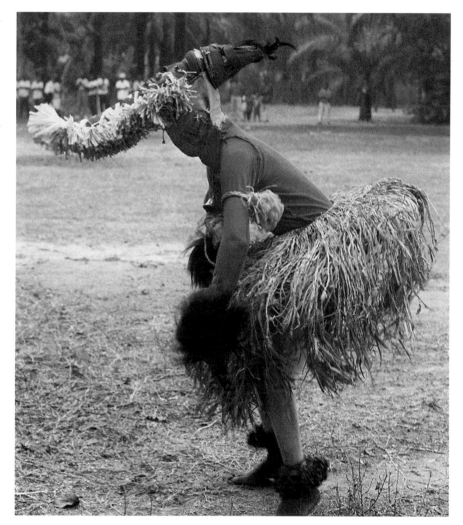

12. Mungelu Ngueze performs Giwoyo. The dancer has moved the mask's bell from its customary position above the buttocks to the chest. Audience members greatly criticized the change because in this position the bell no longer accentuates the mask's signature run-in-place step. Kinguba, Zaïre, 1989.

13. The beloved coiffure of the Central Pende: *guhota sanga*. ("La Mission de Mwilambongo (Kwango) . . ." 1933: 4524.)

Nous n'avons pas encore atteint ce degré de perfectionnement dans la coiffure féminine des Bapende.

priority given to the visual appreciation of the body in motion, whether the mouth, through its smile, or the buttocks, accentuating the style of the walk (1986: 99, 110). Motion to the Pende acts like perfume to the French, adding sensory enhancement to everyday encounters.

Consider hairstyles for a moment. When Westerners conceive of a hairstyle, they picture something sculpted and fixed outside time, hence the recurrent use of styling gels and hair sprays. Even when the disheveled becomes stylish, as it is today in the "windswept" look, women and

men paradoxically have recourse to these products to fix the hair permanently in place.

Although the Pende have at times experimented with such "sculpted" styles by applying clay and palm oil to the hair,[3] the Central Pende's most enduring admiration is for a hairstyle that itself enhances the motion of its wearer: *guhota sanga*. This style involved rolling hundreds of braids around the head, usually topped by either a long inverted raffia cone *(mukombe)* that curved down the back (fig. 13) or a small cone of clay (fig. 14). It was equally popular among men and women. This was one of the styles that the first European visitors found, and despite Belgian resistance, it survived for many decades. Today it is sometimes revived for state-sponsored dances, and there is a great deal of nostalgia about it. It is the ultimate hairstyle because the smallest movement makes it quiver and sway. Able to beautify *(gubongesa)* the least gesture with a rhetorical swoosh, it comes alive in the dance as the rolled braids bob and bounce to articulate visually the rhythm of the head's movements.

This is the hairstyle adapted to most of the masks fea-

14. The woman shown wears a *guhota sanga* hairstyle. This is one of the earliest photos of the Pende. It was taken at Mulassa in 1909 by Hilton-Simpson on the Torday expedition. (Courtesy of the Royal Anthropological Institute, Photographic Collection, London.)

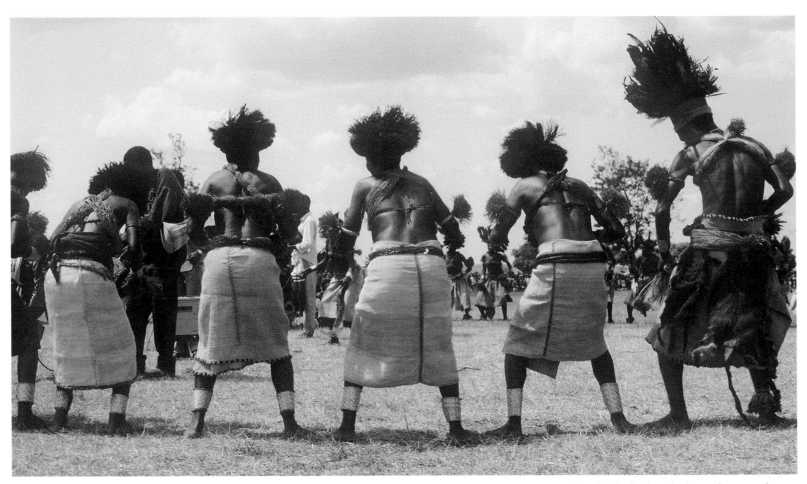

15. Women on the Lozo team at the 1989 Festival de Gungu adopt old-fashioned dress. They wear wigs in the *guhota sanga* style. Belts of raffia thread substitute for ropes of rubbery *jigita*. Also note how the women tie their wrappers as tightly as possible around their hips.

turing a young woman. Women also use wigs in this style for important state-sponsored dances (fig. 15). Oddly enough, it is the hairstyle's connection with the masks and with "tradition" that inhibits young people from adopting it today despite their admiration. For those dreaming of being "modern," it is too tied to the past. The current equivalent in Kinshasa is a multitude of long braids weighted at the tips with beads. While this hairstyle appeals to the same principles, it is much heavier than the soft rolled braids favored in the past by the Pende and does not respond so immediately to every small motion.

Moving down the body, one can find many other indications of an acoustic or visual enhancement of motion. Filed teeth, for example, are beautiful not so much in stasis as in conversation, when they sparkle and weave constantly changing patterns. Many commentators have noted the role of clinking bracelets and anklets in accentuating dance steps (Herbert 1984: 237). They also embellish the gestures of conversation and everyday walking. One notices this particularly today with Eastern Pende chiefs, who continue to wear a wealth of brass bracelets. The gentle clink that accompanies their gestures lends gravity and importance to their words as well as beauty. The weight of the bracelets also acts to shape the chief's gestures by discouraging jerky or frivolous movements.

The masks reflect these embellishments in their form and costume. Sculptors continue to give certain masks of beauty filed teeth—for example, GAMBANDA, the young woman (fig. 33), and MATALA (fig. 41), the young man. Dancers, who no longer wear bracelets themselves, tie small yellowish mats around their wrists to simulate the gleam of brass bracelets in the sun.

Many Pende pay as much attention below the waist as above it in respect to the accentuation of movement. The most beautiful way for men to tie their raffia wrappers, today as in the past, is with a small fold hanging over in front that bobs gently as they walk. On important occasions, the chief and others wear voluminous wrappers, which they pleat in the front or, more rarely, all the way around (fig. 16). Although sometimes uncomfortably warm, this style had the advantage of creating a swooshing sound and movement to embellish the man's walk.

Inevitably, many mask personae reflect the concern to embellish movement. If the dance requires much striding about *(gudiata)*, the masks will wear wrappers tied according to the men's fashions. MUBOLODI (plate 5), GATOMBA, and GINZENGI, for example, all wear the shorter, kilt-length variety. MAZALUZALU, who represents the chief, wears an extremely long and voluminous wrapper. His "dance" is composed of a stylized walk that swishes his pleats this way and that with dramatic flair, always in time to the beat. His name in fact derives from this enhanced walk. The verb *guzaluga* means "to float"; *mazaluzalu* is "someone who floats."

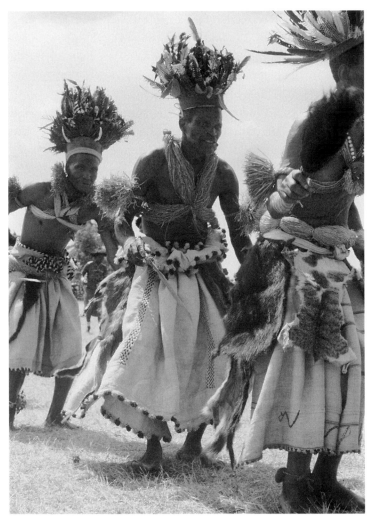

16. Men on the Lozo team at the 1989 Festival de Gungu wear pleated wrappers allowing full freedom of movement. The wrappers have been lengthened for artistic embellishment.

In the past, women wore knee-length raffia wrappers as well. Today, their clothes conform to the Zaïrian national model. The wrappers are long, brightly patterned, and made of cotton.[4] Whereas men tie wrappers so as to accentuate their walk, with pleats both to swish and to give them freedom of motion, women are encouraged to tie them straight, as tightly as possible over the buttocks, in order to inhibit their motion (fig. 15). Like high heels, this mode obliges women to take small steps and to exaggerate their hip action. The fashion for *jigita* also emphasized the motion of women's buttocks rather than their stride. *Jigita* were ropes of rubbery black disks made from the earliest plastics. Women wore them in great quantities around the seat. These would bob a bit when the owner walked but really came into their own in the dance (fig. 15). Much of the interest in traditional women's dance lay in the circling of their buttocks; the dancer's incorporation of the bouncing *jigita* into the dance was much admired.

Today, the female masks wear contemporary cotton wrappers (fig. 10). Since everyone knows that the dancers of these masks are men in drag, much of the interest in the performance lies in seeing whether the dancer captures the distinctly gendered mincing walk and dance style used by

women. The dancers of these masks tend to be light in build and gifted mimics. The tension between the gender of the performer and the gender of the mask and its body language makes the audience conscious of what defines the feminine in society. A successful performance does not challenge concepts of innate gender difference. Instead, it reinforces these conceptions by representing them as manifested in the body. By bridging the gap (temporarily) between the genders, the performer draws attention *to his skill,* not to the artifice of gender constructions.

ENHANCEMENT OF THE DANCE

When one understands how much thought the Pende give to the enhancement of everyday motions, one can hardly doubt that they give the same scrutiny to dance steps and gestures. Much of what seems, to an outsider, arbitrary or even eccentric in masquerading costumes relates to the very problem of how to render their dance as distinctive, as *legible,* as possible. Various performers and sculptors often reflect on what makes the dance of a particular mask special and individual. They will ponder what accoutrements, both acoustic and visual, accentuate these qualities. Alfons Dauer has noted that in African dance in general the parts of the body accentuated by a particular rhythm will be marked by "clustering of feathers, raffia fringing, bells, and other elements" (cited in

Thompson 1974: 9). In most cases, the accoutrements play a double role, serving as both visual and aural enhancement.

Pende critics identify five parts of the body that a dance may activate: the head, the shoulders, the arms and hands, the hips, and the feet. The movement of the head is not the focus of great interest. In those cases where it is of distinction, however, the mask's coiffure will often evolve to highlight the movement. For example, the male version of the mask NGANGA NGOMBO, the diviner, often appears today with hair shaped into four small balls *(matutu),* each topped by two to three small braids, called *mikotshi* (fig. 17). The use of braids in this fashion is not a naturalistic style. They were the invention of a sculptor at Nyoka-Munene, probably Gabama, to call attention to the distinctive head-shaking that characterized a Central Pende diviner's performance. Gabama was elaborating on the older style, which featured long braids (figs. 7, 76). Similarly, although both men and women once wore the light, rolled braids, they have lingered only in the female masks because they nicely accentuate the bobbing distinctive to many women's dances (fig. 10).

Although some Central and Kwilu Pende men's dances feature impressive shoulder rolls, these do not make it into the masquerading, probably because much of their interest lies in the rippling of muscles. In the masks, the body-suit would disguise this. There are two exceptions.

17. Zangela Matangua carved the facepiece for Nɢᴀɴɢᴀ Nɢᴏᴍʙᴏ (the diviner) with many small braids to accentuate the mask's head-shaking motions. Nyoka-Munene, Zaïre, 1989.

The first is the unique NYOGA (snake), represented by men wearing body-paint instead of body-suits (fig. 101).

In conventional masquerading, the other exception is the dance of the diviner, which showcases shoulder movements. It is not surprising that this is also the one mask to wear an enormous shoulder ruff *(dizanga)*, in both the male and female versions, made of raffia (fig. 7). Muyaga stresses the distinctive importance of the ruff: "[Nganga-Ngombo] has the same costume and head as other masks, but it has a large ruff that it wears at the neck. . . . Nganga-Ngombo does not dance lifting its feet so as to sound the foot rattles; all its dance is in the ruff at the neck, whether [the dancer performs] standing or on his knees on the ground."[5] The women's version of this voluminous ruff is called *gikhukha*, a term that points to the underlying aesthetic. The word derives from the gesture women use in grinding millet on a stone. They slide their arms forward and back; the swinging motion of the ruff as it flies up and down in response to the movements of the dance recalls this action. Much criticism of the dancer will focus on whether or not he has properly activated his ruff. Muyaga points out that at the climax of NGANGA NGOMBO's dance the ruff will fly up, even covering the performer's face at times (1974: 62). It is surprising how far the rustling of raffia carries. The ruff acts as an aural, as well as a visual, aid.

In contrast to Western ballet, with its outflung arms, Pende dance tends to keep the arms rather close to the body. The arms are usually flexed, with the hands in front. Almost all the masks tie a pom-pom of raffia *(masamba or masago)* to the upper arm (fig. 12, plates 2–3). These bob to the motion of the arms as they move in and away from the body in time to the rhythm. To add punctuation to the arm, most masks may also dance with one or two fly whisks in hand (made from the mane under the neck of a ram) or perhaps a rattle.

While the arms are the locus of a steady, supportive motion, and the head and shoulders may or may not be of interest, the hips and feet define the nature of the dance itself. Commentators divide much of masquerading into *gutshiatshiela* and *gudiata*. The former is best described as lifting the feet in fast succession on the toes in such a way as to make the most noise possible with the foot rattles. The name refers back to the *tshia-tshia-tshia* sound of the *nzuela* foot rattles. The dancer Khoshi Mahumbu explained that there are several different styles of *gutshiatshiela*. For example, MATALA hops lightly from foot to foot (fig. 22), whereas PUMBU picks up his knees more and puts more weight into it, making his *gutshiatshiela* more of a stamping *(wajimbila)* from foot to foot. MBANGU moves his feet in and out (plate 4), whereas MATALA hops up and down on the spot.

The distinctly Central Pende classification of *gudiata* (to stride) essentially involves stylized walking, as typical of MAZALUZALU, GINZENGI, MUKUA MAUDI, MUBOLODI

(plate 5), and others. Khoshi observed that aging dancers often prefer these masks because they require less energetic execution: "A mask of the old [for older dancers], its dance is cool [or calm or quiet], with style, like Mazaluzalu's."[6] As noted above, the striding type of mask always wears a pleated wrapper, as that best harmonizes with its long gait.

The majority of the *gutshiatshiela* masks, however, eschew the naturalistic wrapper. They wear a flat hoop *(mukhela)* made of concentric circles of pliant *itanda*, held together with zigzags of *khodi*. The dancer ties this hoop loosely to the waist with cords so that it floats at his hips. Over this, he places several to many strands of narrow raffia braids *(nyanga)*. These extend only to the knees for fear of their becoming debilitatingly heavy. As a professional dancer, Khoshi explained: "All my masquerading gestures are in the hoop. . . . The role of the hoop is to kick up the *nyanga*."[7] After the fast footwork of the *gutshiatshiela*, the dancer breaks by flipping up the hoop with its raffia cords. He may swing it to the right or left, he may lift up one knee *(gutupula kulu)* to make the *nyanga* fly up on that side, or he may hit the hoop downward in front to make it sweep up in back. As Khoshi pointed out, all of these gestures make the raffia braids swing up and around.

Most of the masks that wear a hoop also wear animal skins over it. Reportedly, dancers in the forested north around Lake Matshi once used skins exclusively over the hoop, without any raffia braids at all. Dancers at the village of Munzombo stressed the aesthetic considerations involved. While there are no skins prescribed or proscribed, they prefer furs from small- to medium-sized tailed animals because they hang nicely (plate 2) and fly up and out beautifully during the dance. One can see that they function exactly like the raffia braids to embellish the dancer's hip action. Common favorites include *shimba* (genet), *njinji* (serval or civet), *tshima* (a small, gray monkey), *mudiji* (two- spotted palm civet, *Nandinia binotata*), and *mukenge* (mongoose). While any hooped mask may display any skin, the masks judged especially fastidious and stylish (MUYOMBO, GIWOYO, MATALA) ideally should wear a great quantity. As with the foot rattles, serious dancers may spend years building up their stock.

Weight is also a factor; furs are lighter. People appreciate how a powerful dancer can make them twist around his hoop. Until recently, antelope skins were despised because of their weight: not only do they inhibit the performer's actions, but they also hang stiffly and do not fly out as they should. Today, because of the game shortage, dancers cannot always afford to be so choosy. Some Central Pende are experimenting with cutting antelope skins into narrow strips in order to gain something of the old visual effect. Among the Eastern Pende, dancers now borrow the colorful cotton wrappers worn by the women and fold them into narrow belts that they tie around the waist

(pondela). During the vigorous parts of the dance, these fly out in every direction, making quite a display. Dancers from every region commented on the charm of these effects. To get the best effect, the sculptor-dancer Mufufu from Makulukulu advised: "One must put the skins on top of a good quantity of raffia braids; when [the masks] come, it is extremely beautiful to see."[8] In the movement of the dance, the raffia braids below lift up the furs and make them fly higher.

As connoisseurs use the foot rattles acoustically, so they use the hoop visually, to judge the quality of a performance. Woe to the dancer who lets his hoop float unemployed. For example, the respected lead drummer Muthamba once delivered ringing criticism of a dancer of the mask GINJINGA for not having made "gestures with [his] hoop" *(ilembo jia mukhela).* He explained that GINJINGA should have turned it from side to side, spun it around, and swung it powerfully. All of this would have made his skins and cords fly out. As it was, he had not profited from the hoop at all. This is a damning dismissal when, as Khoshi voiced above, all of a dancer's gestures are based in the hoop.

DIVIDED AT THE HIPS

Alan Lomax noted that sub-Saharan African dance divides the trunk into two units, pelvis and thorax,

through vigorous twists at the waist (1968: 256).[9] Absolutely distinctive of African dancers is the capacity to treat these two units as "two totally independent entities, sometimes moving in different rhythms and giving rise to bodily polyrhythm" (1968: 237). The division of which Lomax writes is as crucial in understanding Pende dress and costume as it is in evaluating dance performance.

Fundamental to Pende aesthetics is the taste for a clear separation of parts. The Eastern Pende use the pile of raffia cords and skins around the hips of the masquerader as a means to divide the body visually into the same two parts described by Lomax: *thulo* (thorax) and *mbunda* (pelvis and legs). During the performance, this division becomes particularly enhanced as the furs fly out. The Central Pende have further articulated the separation of the two sections of the body through recourse to a hoop. The flat hoop is a distinctly Central Pende invention. It not only provides a framework for the cords and skins but also gives rhetorical flourish to the division into *thulo* and *mbunda*.

In the body, the division of *thulo* and *mbunda* is also a concern. Many Pende consider that babies are somewhat amorphous in form, born without wrists and without distinctive waists. Often this is a source of anxiety to mothers; what is amusing and cute in an infant would spell social disaster for an adult. Consequently, a mother may tie cords around the offending wrists or waist in order to

18. The sculptor Gabama's grandson Mungongo Mukishi impersonates Tundu the outrageous. Nyoka-Munene, Zaïre, 1989.

give the baby's body the visual articulation it lacks. When asked why his baby daughter wore such cords, Gisagi Kidiongo explained: "The string around the wrist of the child is put [there] in order to separate the hand and the arm. To make [it] smaller. The cord around the hips is to divide the waist and the buttocks so that [the latter] will be large."[10] Mothers hope that the cords, by gently pinching the flesh at the wrists and waist, will actually help form the desired articulations. Gisagi's wife, Milomba, feared that without such intervention, her daughter might grow up with "buttocks smooth and flat [like a wall]" *(matago shanana)*. This is an insult that children often shout at each other. Adults use it, too, most commonly for women.

The Pende also have a particular distaste for large stomachs, precisely because they blur the line between *thulo* and *mbunda*. When a child overeats and his belly swells, adults frequently tease the offender by crying: "Hold onto it or it's going to fall!" *(Kuata! Dibua! Dibua!)*. In the masquerades, one hears the same insult thrown at Tundu (fig. 18) and Mukua Maudi (fig. 19), comedic masks that cultivate the ugliest possible appearance, complete with sagging stomach.

Within the context of this aesthetic, the creation of the hoop by the Central Pende to sharply demarcate the thorax and the lower body becomes understandable. Pende taste does not run to tunics, which unify the body visually by disguising the waist and buttocks. Their clothing

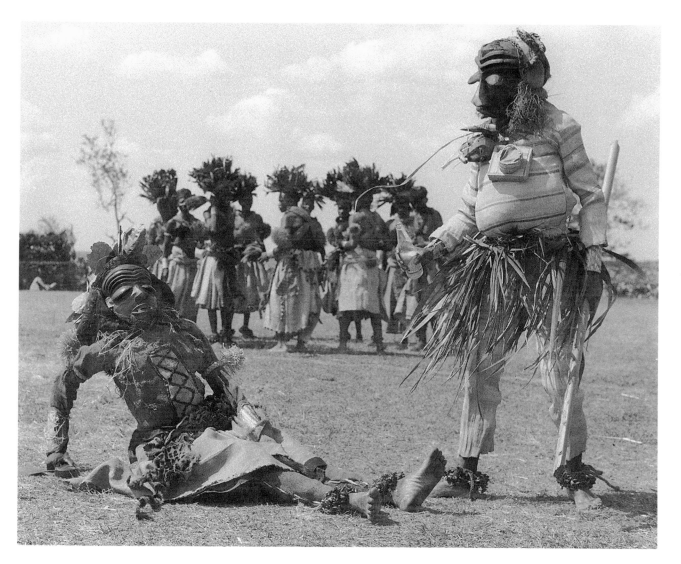

19. MUKUA MAUDI observed
by TUNDU in tourist garb.
Gungu, Zaïre, 1989.

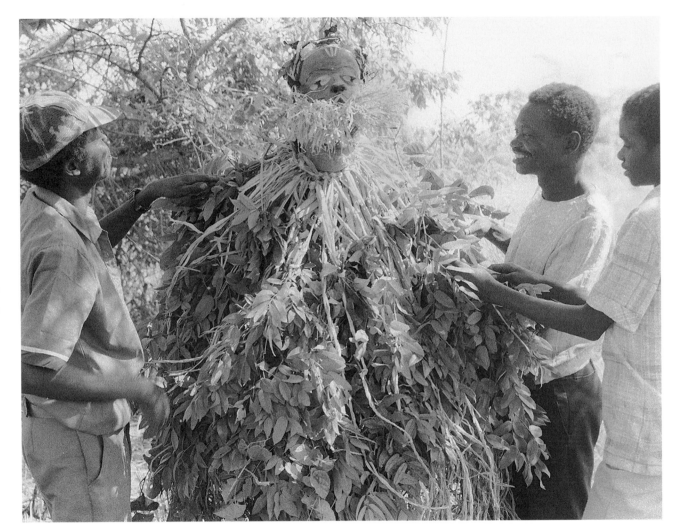

20. The sculptors Zangela and Gisanuna dress Khoshi Mahumbu for his role as the mask POTA. Nyoka-Munene, Zaïre, 1989.

conventions always stress this division, notably in the tying of wrappers; however, the flat hoop gives it dramatic extension. It is fitting that the hoop is reserved for those dances exhibiting the strongest hip action.

The principle of clear separation of parts informs every aspect of the body's, and the mask's, visual embellishment. Both men and women once wore the *mukebu*, a line drawn in redwood powder with oil to separate the hair from the face proper. On the masks, dancers trace it in kaolin for greater contrast and visibility (fig. 17). The phrase "to put a *mukebu" (gumba mukebu)* referred also to the shaping of the hairline with a razor by removing straggling hairs. Use of the razor today is still so omnipresent that the sight of a low or squarish forehead comes as a shock. Sculptors use kaolin to lend legibility to tattoos and scars on the masks. They take liberties with their shapes in order to reinforce volumes of the face.

The Pende express a dislike for goiters and "fat necks" on the same grounds as for big bellies and large wrists. Although rarer, these also negate the division between important body segments: the head *(mutho)* and thorax *(thulo)*. It is interesting that the one unfortunate aspect of the mask's appearance is judged to be its "fat neck." Because the dancer must cover all flesh, except for the hands and feet, a friend sews him into his mask, covering his neck with raffia cloth (fig. 70).

In one case, dancers turned this taste for articulation of parts against itself for dramatic effect in the proverbial exception that proves the rule. The mask POTA, as the Central Pende dance it, consists of a headpiece, worn at an angle on the forehead, and belt after belt of raffia cords hung from the neck and from the waist, over the hoop (fig. 20). The dressers stuff the twisted raffia cords with leaves of several varieties. The dancer appears at the beginning with a bolt of raffia over his head so that, from a distance, as Koshi Mahumbu described, one could almost mistake the shapeless, quivering mound for an animal or a moving pile of leaves. POTA's dance is called *gudigita*, or "shivering," and a strong dancer will indeed be able to make the leaves shiver and shake. Their rustling carries a considerable distance.

In describing POTA, Muyaga locates its most salient characteristic in the fact that its hips are *not* set off. He observes that the arms are invisible as well during the most active part of the dance (1974: 46). The mystery of this mask precisely plays off the viewer's expectations of artistic articulation. Its very shapelessness is what captures the viewer's attention.

INVENTION OF THE MASK MATALA

If we turn now to the analysis of costume changes in a given mask, we find that far from being arcane or arbitrary, dancers' experimentation revolves around the aes-

thetic principles of maximum articulation of form and movement. The story of the mask MATALA is typical in this respect.

Throughout the Gatundo region, men cite Gipangu Zangela (Sh'a Khumbi) of Mukedi as the inventor of this popular mask. Gipangu was a renowned dancer of the Mapumbulu generation, initiated ca. 1916–19. Like GABI-DI-MUAMBA and TATA GAMBINGA, MATALA is a mask inspired by a foreign dance.

As a young man, Gipangu was obliged to push goods back from Djoko Punda (Charlesville) with a handcart. The impetus for this may well have come from the American Mennonite missionaries who established a mission at Mukedi in 1923. Gipangu's age-mate Muhenge Mutala of Nzaji testifies that he was also obliged to push a handcart to Djoko Punda to pick up housing supplies from the riverboats for the missionaries and to haul the goods 150 kilometers back to Mukedi.

What everyone agrees is that at Djoko Punda, the gifted dancer Gipangu became enamored of a "Luba" dance and decided to introduce it back home with a mask.[11] Members of the subsequent age grade, the Ndende, remember that he did this when they were very young, before their own initiation in 1931. This suggests a date in the 1920s.

Gipangu performed the dance with a thumb-piano (gibinji) of palm bamboo that used a calabash as a resonator to increase its volume. The thumb-piano may or may not have been borrowed from the original dancers at Djoko Punda. He wore a male face mask, but instead of a more typical coiffure, he wrapped an animal skin around the back of the head and let it flop over the forehead. He wore a raffia body-suit and wrapper. His foot rattles were nzuela.

In the north, MATALA also enjoyed a period of popularity, probably due to independent borrowing, as in the case of GABIDI-MUAMBA. There, however, young men danced it with a calabash face, the poor man's mask, and it never took on the detailed persona that it has in the Gatundo region.

To Pende eyes, the "Luba" dance recalled the hovering flight of weaverbirds building their nests in the treetops, batting their wings back and forth in a quick blur to hold their position, and moving their heads from side to side. The masker arrives with the thumb-piano and does a quick hopping step (gutshiatshiela), with the elbows going in and out as he pretends to play the instrument. His head moves from side to side in rhythm, and his foot rattles sing out with the forceful impact of the alternating dance step. It is this part of the dance that recalls the hovering weaverbird and is echoed in the song "Matala e e! Nde nde nde." Matala is the Kipende word for weaverbird,

and *nde nde nde* is onomatopoeia for the sound of shivering from the cold, a movement reminiscent of wings sustaining hovering flight. It remains mysterious who associated this simple Pende song with the "Luba" dance rhythm, but it seems to have been used from the beginning both by Gipangu as well as by dancers in the north.

As soon as Gipangu introduced MATALA to the Gatundo region, it became a sensation. Although he himself continued to perform it in the same fashion for years, those who followed him made numerous changes in its form that helped it to carve a niche for itself in local masquerades. They changed the coiffure, the costume, his gestures, his foot rattles. They added the *mukhela* hoop, with consequent modifications of the dance. While these changes accentuated MATALA's distinctive movements, they also contributed to the development of a distinct persona and genre for the mask.

Probably because of its association with a new and "modern" dance and because of the use of the thumb-piano beloved by young men, the popular mind quickly interpreted MATALA as a representation of a fashionable young man. This filled a new niche in Pende masquerading. GAMBANDA and GABUGU represent stylish young women, but there was no previous parallel for a young man. In this case, the female genre provided the model for the male.

Because of the links to the persona of the young man, Gipangu's followers rejected from the beginning the inchoate conception of a masker with an animal skin coiffure. His followers instead sought out a more traditional face mask and hairstyle. After Independence, when the *supi* style of combing long hair forward caught the taste of Pende youth, it became the established coiffure of MATALA.

Gradually, MATALA became not only a stylish young man but a vain one as well. In character with his new persona, dancers elaborated MATALA's costume to include the most handsome of vests or shirts, preferably bright in hue, fine socks, watches, whatever would catch the eye of a young man concerned with his appearance. The Pende Beau Brummell tries to outdo everyone: his hair is the longest, the raffia tufts on his arms are the largest, etc. (fig. 21). In accordance with this conceit, dancers added comedic gestures of vainglory like sucking in the stomach to enlarge the chest *(gukeya vumo)*. MATALA now commonly strikes poses for his audience so that they may admire his elegant profile. Men now wear their hair close-cropped, but the *supi* has remained distinctly MATALA's hairstyle. Chosen first for its chic, dancers now value it because its exaggerated length nicely emphasizes the alternating head motions of the dance.

An energetic personality like MATALA could not be

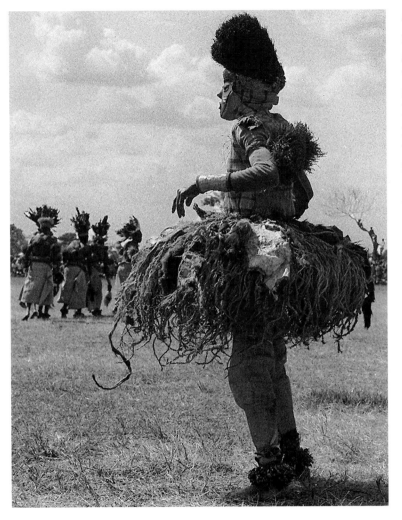

21. The mask MATALA at the 1989 Festival de Gungu. Note the hair combed forward in the *supi* coiffure.

content for long with the simple raffia wrapper favored by striding masks *(mbuya jia gudiata)*. A later dancer realized that a hoop would better emphasize the swinging hip movements of the dance. In character with MATALA's concern for style, most dancers prefer to pile the hoop high with animal furs, which fly out and accentuate the pulsing rhythm of the dance.

Gestures for the hoop had to evolve as well. Today, after a period of dancing, the performer stills his feet, allowing his foot rattles to fall silent, while he continues energetically to swing his hips back and forth, making a great swishing sound with the many braided raffia cords on the hoop (fig. 22). He holds the thumb-piano in place but makes no pretense of playing it. Suddenly, he hits the hoop in front to make it fly up in the back and whirls around to recommence the dance from another angle.

MATALA requires a dancer with both endurance and agility. When Khoshi Mahumbu, in his fifties, proposed to perform MATALA at an upcoming masquerade, his young wife sniffed derisively, *"Wanema"* (You are too heavy). By this she referred not

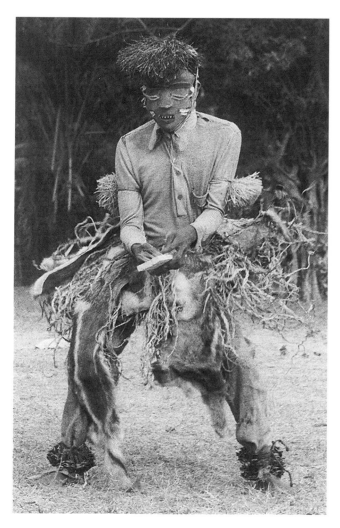

to his weight but to his ability to maintain the light-footed nimbleness required of MATALA. He proved her wrong, but the dance left him exhausted. At Gungu, Pende dancers criticized the performance of another MATALA for "showing his age." Apparently, he did not jump high enough or dance lightly enough. The fact that he had a lovely costume did not save the performer from censure (fig. 21); he betrayed the illusion of youth and strength through his lack of flexibility.

MATALA's foot rattles have also changed. Today, whenever possible, he wears *matshotsho*. These make a louder noise that better accentuates the strong beat of his dance. They also play on a linguistic pun since the noise that the weaverbirds *(matala)* make in the treetops around their nests is referred to as *matshotsho*. In fact, in metonymy, the birds are sometimes referred to by their noise: "*Matshotsho abanda mu mutshi ou*" (The weaverbirds live in this tree). Gipangu's followers have thus reunited the mask nicknamed "weaverbirds" with the din that they make.

Despite these touches of humor, MATALA most definitely belongs to the category of "masks of beauty" *(mbuya jia ginango)*. This grouping, like the weaverbirds, is also sometimes described through onomatopoeia, in this case by sounds the masks provoke: *mbuya jia miyelele. Miyelele* are the ululating cries made by women or men to show admiration and joy. When MATALA struts

22. Khoshi Mahumbu performs MATALA. In the second part of the dance, the masker stills his feet and swings the hoop forcefully with his hips. Kinguba, Zaïre, 1989.

onto the floor, the women launch ululations of delight that continue to burst forth whenever he swings his hips or ripples his shoulders. It is for this reason that the sculptor Mashini says that MATALA is a "mask that embellishes the dance floor" *(mbuya yana [gu]bongesa luwa)*.

CONCLUSION

The evolution of MATALA in the 1920s and 1930s marked the creation of a new genre, the young man, as well as the creation of a new mask. It modernized the older genre MUYOMBO, known for its style and flair, through the addition of a more naturalistic face mask, references to contemporaneity, and small touches of comedy. These changes were inspired by the mask genre spoofing contemporary young women. The audience and numerous performers made essential contributions to the conception and development of MATALA over the years. Its form has now stabilized.

Typically, the first years after the invention of a successful mask are a period of experimentation and flux as the mask's persona becomes more and more defined. This will be familiar to Westerners from watching television series. Changes may be made in the first episodes to modify characters and costumes to suit the audience's preferences. After a certain point, the audience resists any further alterations in now familiar characters. In the case of MATALA, his persona is now so firmly established that only changes noticeably expanding his delineation as an active young man could be accepted.

During the early years, dancers experimented and changed MATALA's costume in accordance with the two aesthetic principles outlined in the chapter: (1) the optimum acoustic and visual enhancement of movement and (2) the clear separation of parts. They added the long hair to accentuate visually the head movements of the dance. They added the *matshotsho* foot rattles to give clear aural definition to the mask's hopping from foot to foot. They added the hoop to divide the masker into thorax and pelvis in order to underscore visually the polyrhythmic division of the body in the dance.

As in daily dress, costumes must submit to the rule of shaping as much as embellishing bodily motion. The addition of the *matshotsho* rattles, for example, or the hoop makes the performer pay more attention to refining his steps and hip action, as these accoutrements will magnify, rather than disguise, any sloppiness in the performance.

A union of form and content is revealed in many choices relating to costume, as described in the section on foot rattles. The enormous pom-poms on MATALA's arms underscore the vigor of his gestures, but their size also

testifies to the mask's ardent desire for distinction (fig. 21). The thumb-piano that he plays reinforces the rhythm of the dance, but it also testifies that MATALA represents one of the young men who live for entertainment and gaiety. The hoop divides his body into two fastidiously separate parts, but it also clearly marks that he belongs to the category of *mbuya jia gutshiatshiela,* masks with fast, vigorous footwork.

In this chapter, we have investigated some of the principles contributing to the form of costumes. In the next two chapters, we shall consider some of the factors shaping the form of the masks' facepieces.

The problem of the expression of [the artist's] individuality is perceived in time.

—Robert Farris Thompson, "Àbátàn: A Master Potter of the Ègbádó Yorùbá"

Birth of an Atelier, Birth of a Style

In her deconstruction of the theory of "tribal style," Sidney Kasfir observes: "In Western art history, style is assumed to have both spatial and temporal dimensions" (1984: 169). From the beginning of the discipline, scholars have recognized the importance of fixing their studies in time. In a review of various methodological strategies, Meyer Schapiro notes: "Common to all these approaches are the assumptions that every style is peculiar to a *period* of a culture" (1953: 288; my emphasis). In Western art, style is never a cultural constant.

In African art, on the other hand, there has been a tendency to prioritize geography over chronology in the mapping of style zones. Given the mobility of people and objects, Susan Vogel warns that this emphasis can lead to error. She urges: "We must further ask whether a style we think of as regional might not be the style of a given moment in time. Are the differences we see in Dogon styles regional or chronological?" (1984: 37). The issue of historical placement is critical to any study of innovation since its very recognition is predicated upon a knowledge of what came first. Without knowing that the Model T Ford preceded the Model A Ford, it would be difficult to identify the innovations in the latter. One might speculate, given the vagaries of the archeological record, on a

geographical, rather than a historical, relationship. Perhaps southerners drove Model A's; and midwesterners, Model T's.

The problem of what came first is equally urgent in any study focusing on the role of personal agency in invention. As Robert Farris Thompson wrote in his study of the artistic evolution of a Yoruba potter: "The problem of the expression of her individuality is perceived in time" (1969: 121). This chapter will attempt to uncover as much as possible of the role of individual enterprise in the history of a particular style among the Central Pende.

In his important survey *L'art pende*, Léon de Sousberghe noted that previous commentators had described Pende art solely in regard to the seminaturalistic style of the central region (1959: 19). Even Hans Himmelheber, whose work did so much to undermine the reigning paradigm of "tribal style," restates it: "Seen in a museum, African art shows considerable variety. If however we travel to Africa and there study the art of *one* certain tribe we observe an astonishing uniformity. Each tribe has its own style. Characteristic of the Bapende style, for example, are slanted lines, fleeing backward from the observer" (1963: 105). What is curious is that Himmelheber traveled in Pende country and was personally aware of the variety of styles practiced. The vagueness of his formal analysis betrays his inability to deliver what he thinks should exist: a *single* Pende style.

De Sousberghe instead identified three major regional styles. Two great rivers, the Kwilu and the Loange, divide Pende territory neatly into three zones (fig. 1). De Sousberghe argued that these zones corresponded to major regional styles: the style of those living west of the Kwilu, that of those living east of the Loange, and that of those in the center, which he named after one of its most populous chiefdoms, "Katundu" (1959: 19).[1] Although he corrected the earlier reductive vision, de Sousberghe agreed that the "Gatundo style" was the most important and the most creative (1959: 22). "No Pende, no matter to which chiefdom he belongs, will contest the mastery of the Katundu in this domain."[2] He noted that when the style appears elsewhere, as at Luisa or Gungi, it turns out that Gatundo emigrants are responsible (1959: 23). Commentators consistently describe the characteristics of this style through the rendering of the face: heart-shaped, with vaulted forehead, pointed chin, continuous arching brows, and (for masks) carved eyelids (e.g., Lema 1982: 53).

Having localized a regional style, de Sousberghe then argued for its antiquity: "This formula of style is extremely old . . . it dates from former contacts with the Portuguese in Angola."[3] He based his judgment on the patina of certain ivory pendants and key-shaped whistles, which he linked to the "Gatundo style" and believed showed great age (1959: 22). De Sousberghe himself notes the mobility due to virilocal marriage in a matrilineal

society but assumes that this mobility does not foster the movement of styles because he believes that "traditions and artistic specializations stay attached locally to villages and clans."[4] He uses the example of Nyoka-Kitamba (i.e., Nyoka-Munene), where he states that the Kisenzele clan has been famous for making ivory pendants "for generations" (1959: 10). This chapter will challenge the accuracy of these assertions.

De Sousberghe's terminology has caused some confusion in the literature. By "Gatundo," he was referring to "the region of Kilembe, in particular, to the chiefdom Katundu, the most important chiefdom in the region."[5] His association of the style with the Gatundo region is misleading on two points: (1) very few sculptors so far have originated in this chiefdom and (2) the association with the large Gatundo chiefdom has led many to extrapolate to a false situation of political domination by that group.

The Pende themselves divide the center into three regions: the north (*gu mbongo*, lit. "downriver"), the center (*mu gatundo*, "in the Gatundo region"), and the south (*mu thunda*, lit. "upriver"). Pende use of "Gatundo" in this case refers to the densely populated heartland of the Central Pende (extending on the map approximately from Mukedi west to Lozo, south to Ngashi, and east to the Loange River; see fig. 1). The text will use "Gatundo" in the Pende sense as a purely regional designation that does not imply any position of political or cultural domination for the Gatundo chiefdom, located near Mukedi. While the north was populated relatively recently by emigrants from the Gatundo region, the south has some strikingly different traditions, and one could argue that it represents a distinct cultural zone.

Sculptors in the Gatundo region do not claim the antiquity for their style that de Sousberghe does. He is right that the style is reflected in the work of isolated sculptors throughout this region, but the center is indisputably the village of Nyoka-Munene and the clan Kisenzele. By carefully tracing the history of their sculptors, one can gain a clearer understanding of how styles move and change over time.[6] One also perceives the irreducible role of personal initiative and creativity.

MALUBA (CA. 1870/75 TO CA. 1935)

Nguedia Gambembo is the acknowledged dean of the sculptors at Nyoka and their historian. He relates that Maluba was the first of the great sculptors at Nyoka, and indeed in the region. There was no sculptor in the generation before him. The eldest villagers are agreed that Maluba was of the age grade Milenga, hence initiated ca. 1885–90. He died ca. 1935–38, before the initiation of the Pogo jia Mesa age grade. He was still working when Nguedia was initiated in 1931.

As a young man, one of Maluba's clan brothers, Gilumba, moved north to live in the region of Ngula-Gizeza. On a visit, Maluba saw for the first time the masks of a blacksmith named Gizeza from the village Kasele. Maluba was enchanted. He resolved that he would do his best to copy the man's style. This was also when Maluba saw for the first time the *mbuya jia mafuzo,* a new category of masks that he would help to introduce to the Gatundo region. Maluba did not care to spend the time and money for a formal apprenticeship to Gizeza, so he thought up every possible excuse to watch him work, intending to replicate his manner at home. This kind of pirating still goes on for those gifted enough to bypass a formal apprenticeship.

Field associates in the north corroborate Nguedia's account. Villagers at Kasele remember the fame of their sculptor-ancestor Gizeza, who, unfortunately, did not leave many artistic heirs at Kasele itself. In this northern region, his acknowledged protégé was Kidia Mavu of the village of Tsumbi. Kidia Mavu, in turn, trained sculptors from several villages. His best students, Kamuanga and Mufufu, old men today, both remember their master talking of the admirable Gizeza.

Both Kamuanga and Mufufu state that Gizeza died long before they were born. Kamuanga, who is usually fairly reliable, attributes his age grade to the Minzata generation. If true, this would mean that Gizeza was initiated

in the 1870s. Both agree that he had a son, Ndege a Gizeza, named after Gizeza's father. Ndege a Gizeza worked for a time at Kasele, but on his death, the villagers were obliged to go to Gizeza's protégé Kidia Mavu for their masks.

Kidia Mavu, who took for himself the name Maluba Gindunji (one who surpasses), was of the age grade Mayaga, the northern equivalent of Milenga, initiated ca. 1885–90. He would therefore have been of roughly the same age as Nyoka's Maluba. Kidia Mavu followed a formal apprenticeship with Gizeza in Kasele before moving back to his village, Tsumbi. In those days, most of the population in the north was centered around Lake Matshi, where Kasele is located. People only gradually moved out under the pressure of population growth.

Kamuanga was initiated as a very young boy in the Mapumbulu generation, ca. 1916–19. Significantly later, in the 1930s, as a mature adult and working blacksmith, he decided to apprentice himself to Kidia Mavu. He accompanied his friend Kikhau, of the Ndende generation, initiated in 1931. Mufufu, who also graduated in 1931, went to study with Kidia Mavu later.

Today, throughout the north, Kamuanga enjoys the reputation of being the best sculptor in the region. He still receives frequent commissions, but unfortunately arthritis makes carving painful, so I was unable to examine any examples of his work. Mufufu noted that Kidia Mavu was best known for the masks POTA and GAMBANDA and that

23. POTA mask carved by
Mufufu. The artist has not yet
applied the coloration.
H. 18 cm, w. 18 cm. Maku-
lukulu, Zaïre, 1989.

Kamuanga's style was very close to his teacher's. Fortu-
nately, Mufufu, although himself ailing, had an unfin-
ished POTA on hand (fig. 23). His own style is strikingly
similar to that of many of the older masks in European
collections (fig. 24) and shares a definite family resem-
blance to the work done in Nyoka-Munene.

Kamuanga, although admired as a sculptor, is widely
feared and disliked in the region as a sorcerer. Harassed by

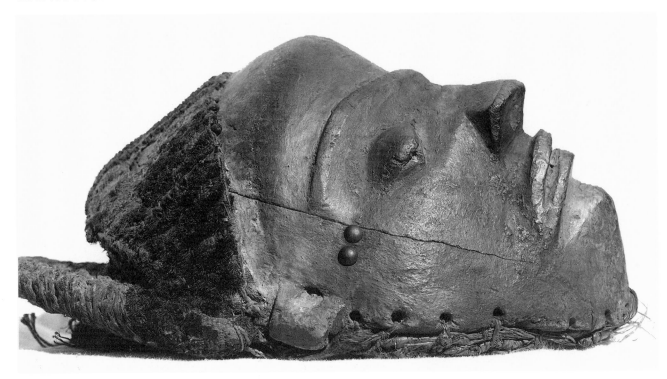

24. POTA mask originating
in the village of Luisa.
(Collection of R.P. Léon de
Sousberghe.)

constant allegations of malevolence from many of his rel-
atives, he has preferred to retreat from his village to live
on the fringe of the forest belonging to the Catholic Mis-
sion of Belo. There he lives alone with his wife and one
nephew. There he has constructed for himself a beautiful-
ly landscaped haven. Kamuanga was formerly one of the
premier circumcisers of the region, and these men,

strongly implicated in sorcery and in the aggression of
surgery, often find it difficult to enjoy a tranquil old age.
His colleague Mufufu was formerly a popular dancer of
an unusually wide range of masks, including MBANGU,
GANDUMBU, GALUSUMBA, and MATALA.

Nyoka's Maluba, like Kamuanga, was also a circumcis-
er *(nganga mukanda)*. In fact, he was the Kisenzele clan's

chief circumciser. As the holder of this office, he was oblig-ed to maintain a small ritual house *(nganda)*, where all the circumcisers slept on the eve of a circumcision. By extension, the house was also used formerly as a storage room for all the masks and dance equipment in the village. Since women and noninitiates were not allowed to approach the building, some old men might go there to grill meat that they did not wish to share. The house became a kind of men's clubhouse, and sculptors would work there on rainy days or when they did not care to carve in the bush.

Maluba also held the title of "chief of the dressing and sculpting area" *(fumu ya bwadi)*. After the masquerade, it was his duty to collect the praise gifts deposited in front of the drummers. He would use these to buy palm wine and meat in order to host the participants to a congratulatory dinner.

Gin'a Khoshi Ndemba testifies that the women in the village respected Maluba as much as the men did because he was always very gracious about making ritual para-phernalia for them for free. Maluba was definitely a major figure in the village.

Maluba was responsible for introducing professional sculpting to Nyoka-Munene and to the Kisenzele clan. As near as one can fix a date, this occurred in the early 1900s. After Maluba's return from the north, he taught many of his "brothers" in the lineage. After a clan dispute, some of

these joined with other discontents to move south to Luisa, where de Sousberghe commented on the presence of the so-called Gatundo style (1959: 23) (fig. 24). Malu-ba's most talented protégé, however, was his nephew Gabama, who remained at Nyoka and who secured the reputation of the village.

GABAMA A GINGUNGU (1890s? TO 1965)

The reputation of Nyoka-Munene rests primarily upon the work of one man, Gabama a Gingungu. Gabama was born in Lozo (30 kilometers west of Nyoka-Munene), the village of his father, Gingungu a Khumba. He grew up at Ngunda with his mother, Ngombe, and her second hus-band. He was mature when he was initiated at Ngunda in the Mingelu age grade in the early 1900s; he married shortly afterward. After his stepfather's death, it was time for Gabama to move back to his mother's uncles' village, Nyoka-Munene. His wife did not wish to leave her own village, so they divorced amicably. At this time, Gabama earned his living primarily as a fisherman and basket-maker. Gabama must have been in Nyoka at least by 1919 because he participated in the initiation there of the fol-lowing age grade, the Mapumbulu.

Gabama soon found his true vocation through his "uncle" Maluba's teaching and quickly surpassed him. Nguedia recounts how at the dressing area *(bwadi)*, the

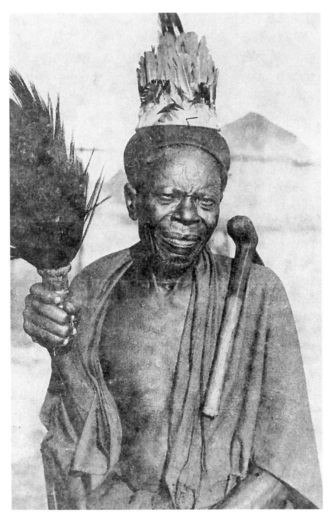

25. The great sculptor Gabama a Gingungu. (Kochnitzky 1953b: cover; photograph by J. Mulders.)

sculptors would lay out all the masks. The dancers would snatch up all of Gabama's before they started on Maluba's pile. Gabama's reputation attracted the attention of foreigners. Léon Kochnitzky, who visited in 1951, wrote that Gabama, bordering on sixty, "enjoyed a great fame in Pende territory."[7]

He received so many foreign clients in fact that his daughter Ngombe, who played hostess to them, became better known through the nickname "Matamu," a deformation of "Madame." J. Mulders, a Belgian photojournalist, photographed Gabama alone and with his family in 1952 (figs. 25–26).[8] The portrait shows his signature feather hat *(gilongo)* and the exceptionally thick fly whisk that he carried at dances (Kochnitzky 1953b: cover). Both Kochnitzky (1953b) and Jeanne Maquet-Tombu (1953) published small articles on him for the colonial press.

Gabama seems to have been quite a character, and just bringing up his name provokes fond smiles and head-shaking from those who knew him. Everyone has his or her own favorite story. What is clear is that he *passionately* loved the masks and everything to do with the men's fraternity. Like Maluba, he became a circumciser. He went on to earn the position of guardian of the surgical knives for the village. After Maluba's death, he succeeded to the title of "chief of the dressing and sculpting area." The small ritual house *(nganda)* was built next to his own.

An extremely serious sculptor, Gabama received com-

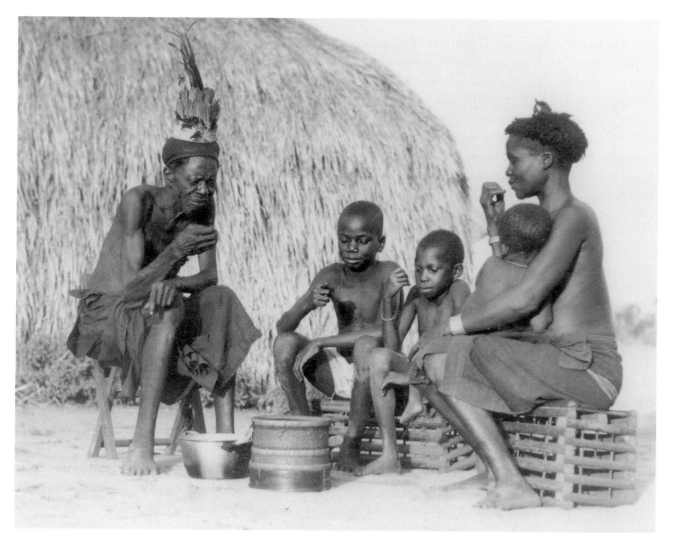

26. J. Mulders posed this photograph of "daily life" showing the sculptor Gaba-ma a Gingungu eating with his third wife and some of his children. (Pende etiquette dictates that men rarely eat with women and children; they dine alone or with other members of the men's fraternity.) (No. 21.170/2. Courtesy of the Photothèque, Voix du Zaïre, Kinshasa, Zaïre.)

missions from all over Pendeland west of the Loange, even far into the south in the Kisandji/Kombana area. Initiated boys who went to watch him work were given huge piles of raffia thread *(pusu)* to make. He told them that their *ukhakha* (joking relationship with classificatory grandparents) had to be left behind at the work site; he did not have time for that kind of horseplay.[9] In return, they would get some tasty dog meat as their salary. Since elders have the right to junior relatives' labor, his young workers considered this arrangement eminently fair.

Gabama loved sculpting and intended to make a living at it. He first realized the potential of working as a professional sculptor by hawking his wares as an itinerant to Pende clients. Serious dancers had long ago set the model for this, traveling with a drummer and a singer. After the Ndende age grade came out in 1931, Gabama took his nephew Nguedia with him north to Gabuata (Mulassa region), a good base to sell to the dance-crazy north.

They stayed for over two years, circulating in the region to the villages of Ubole Nenga, Mbombi, Kasembe, Muhenu, and others. The Mbuun people on the frontier were adopting the Pende men's fraternity *(mukanda)*, and Gabama also did a brisk trade at Bikwitshi and Madimbi. Previously, he had received numerous commissions from this region and knew its potential. He would sculpt a dance mask for any villager of Nyoka-Munene for free or for some palm wine and the raffia cloth necessary to make

the headdress (as the sculptors do today). He charged other Pende one chicken per mask. According to Nguedia, they came back with "baskets and baskets."

Business was so good, in fact, that Gabama only returned at all to deal with the serious illness of his daughter Matamu.[10] As her father, it was his responsibility to seek a healer to treat her. On their return, everyone was amazed at how tall Nguedia, his young apprentice, had grown on the road, apparently benefiting from all those chickens. Nguedia's job was to make the coiffures for the masks according to Gabama's exacting standards and to do the coloration, thereby freeing his uncle for the carving itself.

Later, Gabama realized the potential of the itinerant model for selling to foreign clients as well. He would go regularly with his nephew Gitshiola to Kilembe to sell masks to the Belgian priests. He found that he could sell more if one of them would beat the mask's dance rhythm on his chest while the other demonstrated the dance. In pursuit of a sale, they were sometimes liberal with the identification of a particular mask, believing strongly in giving the client what he wanted, whether they had it or not. A doctor working there became a particularly close friend. At one point, Gabama even moved to Kipita, near the Loange River, to better capitalize on the foreign trade.

At home, Gabama was scrupulous about the conventions of the men's fraternity and careful to prevent any

harm arising to women in the family from contact through him with the men's secrets. His daughter remembers, for example, that each time her mother was expecting and began to show, he would fasten an uncolored MUYOMBO mask over the door to the bedroom. He explained that this was by way of ritual inoculation to prevent the baby from being affected by proximity to the masks. Such a contagion might manifest itself through goiter or through an unattractively thick neck. The connection with the neck is by analogy to a masker's costume. Once sewn into his costume, the dancer unavoidably acquires an unappealingly sturdy neck. Also, a diviner might diagnose that "the men's fraternity trapped him or her" (mukanda wamukuata) if a baby refused to suck and suffered from a high fever. If all went well with the birth, Gabama would take down the mask, color it, and sell it.

As Maluba had taught him, Gabama knew that he needed to be particularly careful when he was working on MBUNGU, GINZENGI, PAGASA, KOLOMBOLO, KHOLOMA, and the other mbuya jia mafuzo (this mask category is discussed in chapter 8). He would sleep apart from his wives in another house from the time he began working on one until the time of the dance itself. Like the dancer, the maker of these masks could not eat a regular meal or drink water; only palm wine and "dessert" foods like peanuts, manioc carrots, and fried plantains were permitted. These precautions were geared to preventing jealous rivals from

engineering mishaps for the dancers, for example, falling from stilts or tearing costumes. His daughter recalls that although Gabama would never allow the uninitiated to see him working, he did recount to his family each day what he had made, even mafuzo like PAGASA and GINZENGI.

Gabama is so affectionately remembered because he was generous with his children and nephews. Matamu remembers that he bought the children clothes and meat even after they were married, a very great compliment from a Pende daughter. In a matrilineal society where most often maternal uncles are feared and disliked for their suspected role as sorcerers, it is striking how warmly Gabama's nephews guard his memory. He watched over their traditional education and equipped them all to earn a living. He fulfilled the ideal role of the maternal uncle.

Even Gabama, however, because of his age and role as a circumciser and sculptor, could not entirely escape allegations of sorcery. In 1958, he unaccountably but emphatically forbade his third wife from going to tend her peanut fields. She, not wishing to lose time, sneaked off anyway and died that day from lightning with fourteen other women when they sheltered under a tree during a rainstorm. Because he tried to prevent his wife from going, and because of his role in the men's fraternity, village scuttlebutt inevitably implicated him in the affair. Nevertheless, this incident did not diminish him in the eyes of

villagers at Nyoka, because they considered that he had given his wife fair warning.

Gabama worked until the end. As they age, Pende sculptors frequently become too frail to chop down trees and to transport the wood for masks. As Gabama began to feel his years, he switched more and more of his production to decorative ivory pendants. He could buy elephant or hippo ivory fairly easily from itinerant merchants and in this way economize his energy. Many visitors in the 1950s commented on the popularity of miniature masks worn as pendants (Strother 1995a). Many were carved in wood or from a hard nut; the most expensive were made from ivory. At this period, Kochnitzky described Gabama as primarily a "carver of amulets" (ciseleur d'amulettes) with a huge local clientele. Kochnitzky learned to recognize his hand in the pendants worn throughout the region (1953b: 13). Jeanne Maquet-Tombu noted the pattern of old sculptors mixing wood and ivory in their trade by comparing Gabama to another old sculptor at Musanga Lubue (1953: 16).

Several of Gabama's former students noted that he did not repeat the mistake of Gizeza in allowing unrestricted access to his working area. Although he did frequently work with his old friend Lumbale from Kimbunze, who was a blacksmith and competent sculptor, Gabama tended to restrict the bwadi to his maternal heirs and children. He was afraid of encouraging competition.

Gabama died in 1965 when the village was evacuated during the Mulele Rebellion against the government. His family regrets that they were unable to give him a proper wake and burial because they needed to flee the rebels. His surviving work was lost in the chaos, looting, and fires of that period.

Gabama dominated sculpting in this century among the Central and Kwilu Pende. When asked for the name of the best sculptor they have known, almost all connoisseurs cite his name.

THE SCULPTORS AT NYOKA-MUNENE TODAY

Two of Gabama's sons took up sculpting after him. His colleagues rate Gibundula, initiated around 1950, the more talented. He died at the hands of Mbuun revolutionaries at the time of the rebellion. His older brother, Khumba, was of Nguedia's generation. After Gabama died, Khumba sought out his maternal uncles, first at Mubu and then at Malundu. He died in 1986.

In this matrilineal culture, Gabama was blessed in that his most talented protégés were his maternal nephews (see fig. 27): Gitshiola Shimuna, of the Mapumbulu age grade, initiated ca. 1916–19; and Nguedia Gambembo, initiated in 1931. Gabama thus had the rare pleasure of founding a workshop where he, Gitshiola, Nguedia, Khumba, and Gibundula were all working simultaneously.

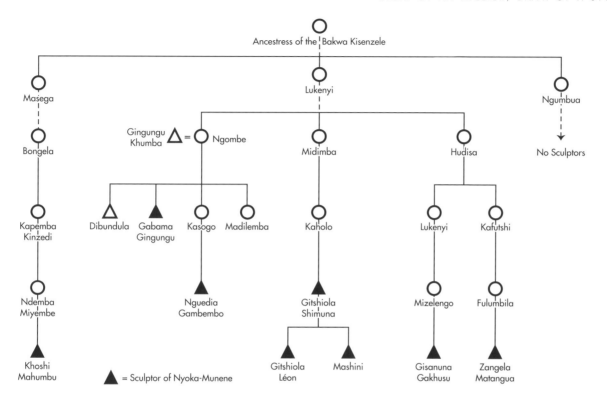

27. Kinship chart for the sculptors at Nyoka-Munene, Zaïre.

Ancestress of the Bakwa Kisenzele

Masega
Lukenyi
Ngumbua

Bongela
Gingungu Khumba △ = ○ Ngombe
Midimba
Hudisa
No Sculptors

Kapemba Kinzedi
Dibundula Gabama Gingungu Kasogo Madilemba
Kaholo
Lukenyi Kafutshi

Ndemba Miyembe
Nguedia Gambembo
Gitshiola Shimuna
Mizelengo Fulumbila

Khoshi Mahumbu
▲ = Sculptor of Nyoka-Munene
Gitshiola Léon Mashini
Gisanuna Gakhusu Zangela Matangua

After Gabama's death, Gitshiola picked up the leadership and became *fumu ya bwadi,* "chief of the dressing and sculpting area." When he died on 14 April 1974, that role descended in turn onto Nguedia.

Although Nguedia received the most rigorous appren-

ticeship possible at the hands of Gabama, he likes to stress his own initiative. Since the uninitiated were not allowed in the *bwadi,* where the sculptors worked, as a young man Nguedia would skulk and hide in order to observe whatever he could. Finally one day, he tried to hack out his own

mask in the village and created a cause célèbre. Who had taught him?! Suspicion inevitably descended on his "uncle," Gabama, who had to hustle to talk himself out of a fine of five to eight goats. Nguedia demonstrated that he had acted out of his own *ngolo,* "strength." Although he had to desist for the moment, he eventually got his wish when initiation fever swept the region in 1931. Nguedia lost no time in rolling out the talking drum into the bush. When he began to play, the other boys joined him and the Ndende age grade was launched.

When he graduated, Nguedia joined Gabama on his circuit north and received a closely supervised education. Gabama's training methods resembled those of Rubens in his atelier in Flanders. Gabama's apprentices started by grinding colors; at that time, red came from *musege (Pterocarpus)* and white from kaolin. He also assigned to them the time-consuming separation and dyeing of raffia threads necessary for the coiffure. Students quickly progressed to painting the many layers necessary on the masks. Gabama, a fastidious supervisor, usually reserved the last coat for himself. If the apprentices showed themselves to be neat and careful, they could progress to sewing the "hair" of raffia threads into place. Gabama by all accounts was extremely punctilious in this regard, and Nguedia inherits his pride in impeccable craftsmanship. After a certain point, Nguedia was allowed to hack out rough masks with the adze, which Gabama finished. As

Nguedia progressed, Gabama would put on fewer and fewer finishing touches. Even today, master sculptors often cannot resist correcting the work of others. With the flick of the knife, they can transform the eyes or the line of the cheekbones.

Nguedia is feeling his years. Like Gabama before him, he is switching over more and more of his production to pendants and other small goods. Hippo ivory is still available, but he is also experimenting in making pendants from ox bone. His uncle's insistence on carefully crafting coiffures has stood him in good stead, as he is the premier wigmaker for the Central Pende. Clients travel considerable distances to place commissions with him in this line for festivals. He continues to sculpt wooden masks when young entrepreneurs bring him the wood; he no longer ventures into the forest.

The Mulele Rebellion, Gabama's death, and the steady decline of the men's fraternity among the Central and Kwilu Pende have all contributed to changes in the handling of masks. After Gabama's death, the sculptors started to carve in shelters near their homes rather than working together in the bush. The dancers now own their own masks and costumes; the village no longer keeps a community chest.

Today, Nguedia in turn is blessed with two "nephews" and two "sons" who are gifted sculptors. The latter are the children of his "older brother," Gitshiola. Since their

mother comes from an attached conglomeration, they have continued to live at Nyoka even after the death of their father. Nguedia, remembering his own careful instruction at Gabama's hands, tries to pass this on to his charges, but they have long since developed their own mature styles.

When Maluba introduced Gizeza's style into the Gatundo region, he was moving it to the most densely populated part of Pende territory, indeed into one of the most densely populated areas of Zaïre. Availing themselves of plentiful clients, Maluba and Gabama became in a real sense professional sculptors.

Building on an earlier distinction made by Daniel Crowley between "professional" and "amateur" ([1973] 1989: 233), Dolores Richter has outlined the attributes of professionalism: "Professionals consider themselves, and are considered by others, primarily as being craftsmen who realize a large part, or all, of their livelihood from their craftsmanship. They are paid for their work and are often accustomed to working for a wide variety of customers, many of whom may not be members of the craftsman's own ethnic group and may not share a religious iconography or belief system" (1980: 2). The most original observation made by Richter lies in her emphasis on the change in self-definition on the part of the professional.

Gabama saw the possibility of earning most of his income from sculpting and acted to achieve this wish.

Unlike Gizeza, who earned most of his income from blacksmithing, and who sold sculptures primarily to the villages in his region, Gabama earned almost all of his income from sculpting, and his talent brought him commissions from every direction. He adapted the itinerant dancer model and sold to Pende customers in other regions, and even to the Mbuun, fascinated by Pende masks. He also shrewdly foresaw the advantages of expanding into the foreign art market.

Gabama used his entrepreneurial skills to create a wider market for his works, and today's sculptors at Nyoka reap the benefits. They no longer have to seek clients; most can sell all that they can produce to the Pende, Luba, and other middlemen who come to place commissions. While most of these sculptors still draw pride from their work for Pende dancers, they all earn their daily bread from the foreign trade to Kinshasa.

Today at Nyoka there are seven full-time sculptors (fig. 28). Because of the middlemen's voracious appetites for masks and because they try to establish a uniform buying price, no matter the quality, there is a certain tension among the sculptors. Obviously, it is in the best interest of the sculptors to produce the maximum number of pieces, but temperament plays a role. Gisanuna, popularly judged the best of Gabama's heirs, cannot bring himself to produce more than one or two masks a week. Courted by Pende dancers, he cannot live on the modest commissions

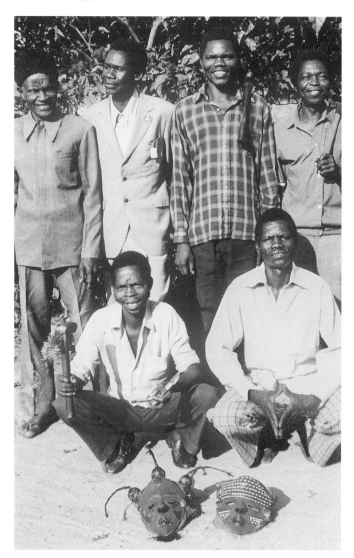

28. Six of the seven professional sculptors of Nyoka-Munene in 1989. *From left to right, back to front:* the dean Nguedia Gambembo, Khoshi Mahumbu (also a renowned masker), Mashini Gitshiola, Zangela Matangua, Mijiba Giboba, and Gitshiola Léon (with two examples of his work in front). Gisanuna Gakhusu is shown in fig. 20.

that he earns from them, and he is disgusted to earn the same price (approximately $0.25/mask in 1989) from the middlemen as the worst hacks. In disgust, he left for Tshikapa in 1989 in order to make dugout canoes for use in the diamond mining operations on the Kasai River.

On the other end of the scale, Gitshiola Shimuna's son, Gitshiola Léon, can turn out as many as twenty masks per week and earns a very nice income from the foreign trade. Ridiculed in the village with the nick-name "the factory" *(l'usine)*, or sometimes "the machine" *(la machine)*, Gitshiola Léon justifies him-self by pointing out that he has nine sons to support. Léon's work is rarely sought out by Pende dancers (unless they are in a hurry), and his "father" Nguedia often shakes his head over how he is lowering every-one's reputation *(wazangela mudimo)*. There is some resentment against Léon also for refusing to cooperate in sporadic attempts to set higher fixed prices. While Khoshi Mahumbu and Mijiba Giboba also sell primar-ily to the foreign trade, there seems to be no resent-ment against them, probably because of a general sense that they, unlike Léon, are doing the best that they can.

Zangela Matangua and Mashini Gitshiola have large local clienteles, although they are obliged to rely on the Kinshasa trade for everyday expenses. They fall in between the extremes set by Gisanuna and Léon:

unwilling temperamentally to hack out masks like the latter, they will take some shortcuts to increase their production of masks sold outside. They average perhaps five to eight masks per week, and Mashini has been able to negotiate significantly higher than average prices, probably because he fills orders with unusual punctuality and carves with a style that appeals to younger entrepreneurs.

The prices are currently set by an estimation of how much work is involved in producing a given mask. Thus, a mask without eye openings will cost less than a mask with eye and mouth openings, since the latter risks splitting the wood and requires more time and skill. The most time-consuming part of any mask is the fabrication of the coiffure. Apart from the sewing, the sculptor must make large quantities of raffia threads (time-consuming work), must dye the threads black, and must obtain expensive bolts of raffia cloth for the foundation. Due to these factors, masks with elaborate hairdos cost more. To save time and money, sculptors have also begun radically to shrink the size of these coiffures. Since most middlemen tend to argue against any increase in price, masks representing young women (requiring the most elaborate coiffures of all) are seldom made. Nguedia, who produces few masks now, refuses to stint his coiffures and receives double the usual price from a few knowledgeable middlemen.

Mijiba is the only sculptor who relies entirely on selling works in foreign styles. He acquired a copy of Frère Cornet's book *Art de l'Afrique noire au pays du fleuve Zaïre* (1972) some time ago and specializes in producing copies of Luba, Songye, and other works of art. He does quite a nice job, although he frequently makes subtle mistakes since he has never seen the pieces in the round and does not necessarily understand their function. The skillful Gisanuna used to sell some foreign works as well. He seemed to enjoy the artistic challenge and probably felt less compunction about hacking them out than he did the Central Pende masks, on which he has built his reputation.

The biographies demonstrate how artificial are Western definitions of "authentic" and "fake." Dancers in a hurry may purchase headpieces intended for the foreign trade. On the other hand, a middleman with a backlog of commissions may arrive at the right moment and confiscate a headpiece intended for a dancer. Performers usually keep headpieces they admire in pristine condition (away from smoke and termites). Consequently, a cherished ten-year-old piece will look brand new. Cognizant of Western tastes, dancers (or middlemen) will "age" these treasured pieces only when they are released for the foreign market, through the application of acidic berry juices and exposure to smoke and termites. Most curious of all, dancers in search of a gimmick have inserted certain of Mijiba's "fakes" into the masquerading milieu at Nyoka-Munene and Kinguba, capitalizing on

their novelty. (See further discussion of this process under NGANGA in the appendix.)

WHO ARE THE SCULPTORS?

In 1934, Ernst Kris and Otto Kurz commented on the striking "uniformity of accounts relating to artists in the West," ranging from the ancient Greeks to the present (1979: 4). These biographical conventions include a focus on the artist's youth, when, as yet untaught, he exhibits signs of great talent (28 ff.). He is destined for greatness, he is "discovered," and yet he must overcome many obstacles in his path (30 ff.). The authors point out that life often mimics art in "enacted biography" when the individual tries to live out the model (132).

The Pende do not mythologize their artists in the Western fashion, but there are some constant themes in their biographies. What all these men share is a deep, even obsessive love for the men's fraternity and its arts. Nearly every sculptor is a hyphenated entity: sculptor-dancer (Mufufu, Khoshi Mahumbu), sculptor-dresser (Zangela, Gitshiola Léon), sculptor-drummer-composer (Mashini), sculptor-circumciser (Maluba, Kamuanga, Gabama). Historically, Pende sculptors were usually practicing blacksmiths, as Gizeza, Kamuanga, and Lumbale were, although there were always specialists. In the Gatundo region, with the decline of blacksmithing and the large market for masks, the sculptors have focused exclusively on the latter.

In the past, the more intellectual sculptors seemed drawn ineluctably to circumcision. While there is a certain analogy of skill between carving and/or blacksmithing and surgery, the circumcisers *(nganga mukanda)* were very much the scholars and the leaders of the initiation camps in the past. They were not only responsible for the surgery but also oversaw the healing process. The men's fraternity has declined among the Central and Kwilu Pende since the 1930s, but one can still count on surviving circumcisers to provide a rich and articulate knowledge of traditional education. In their honor, they receive special funeral rites, marked by the appearance of a host of *minganji* in the village (plate 1).

Since the initiation to the Central Pende version of the men's fraternity *(mukanda)* was focused ritually on the act of circumcision, the entire rite waned from the time midwives took over the circumcision of male infants.[11] Today's sculptors do not have the option of pursuing esoteric knowledge in the fraternity. Instead, they have given themselves over to the masquerades. Today, Nyoka's sculptors, like every other serious sculptor I met in Pendeland, are workaholics, who seem to take time off from making masks only for dancing them.

The connection of the sculptor in the past with esoteric knowledge, whether blacksmithing or fraternity lore,

made him a prestigious member of the community but also exposed him (with age) to accusations of sorcery. Potential young clients from outside Nyoka, for example, often sought out Gitshiola rather than his uncle Gabama, out of fear that the latter made his masks "with sorcery" *(nu wanga)*. Nonetheless, by maintaining good relations with his nephews, Gabama never suffered the isolation that Kamuanga undergoes today.

THE QUESTION OF APPRENTICESHIP

Sidney Kasfir has postulated connections among an artist's mode of training, the nature of the patronage system, and the artist's liberty to invent. From a review of the literature, she concludes that "we arrive at a continuum of possible degrees of artistic freedom ranging from the highly restrictive situation characterized by a formal apprenticeship system and conservative patronage to the very unstructured, freewheeling, entrepreneurial climate produced by an absence of formal training and societal values that support innovation" (1987: 41). The Central Pende situation demonstrates how complicated such relationships may be. Artists' training, as in our own system, can range the entire spectrum from "restrictive" to "unstructured," depending on the student's desires.

On the one hand, Maluba eschewed a formal apprenticeship with Gizeza, observed what he could, and figured it out at home by trial and error. Although the rarest pattern, this is by no means unheard of even today. All initiated males, in theory, have access to a carving area and are free to observe. Gabama may have tried to restrict this, but he is the only one. There is a certain prestige in learning by one's own force *(nu ngolo y'enji)*, as evidenced by Nguedia's pride in the fact that he started to carve before he was initiated.

Most, however, do choose to undergo a form of apprenticeship, although what this means may be wildly variable. The blacksmith Kamuanga, unrelated to his master, Kidia Mavu, traveled a short distance to work with him for "a couple of months." Gabama, who learned sculpting as a married adult with a child, may have received an apprenticeship at the hands of Maluba, but surely it was not as rigorous and controlled as that which he himself gave to the young Nguedia. Today, Nguedia keeps trying to "correct" the styles of Gitshiola's sons (what he sees as the exaggerated angularity of Mashini's work and the sloppiness of Léon's) but they turn a deaf ear.

The younger sculptors (in their thirties and forties) have considerable confidence in their own work, bolstered by the knowledge that they can sell all that they can produce. Entirely typical was the scene in which Nguedia temporarily repossessed a mask made by his "nephew" Gisanuna in order to redo the mask's thick fringe of raffia threads. Even such a small detail is strongly marked by a

sculptor's personality. Nguedia's fringe is long and limp; it droops down to hide the eyes of the dancer. Gisanuna's is short and shares the same crisp energy of his carving. When Gisanuna saw what Nguedia had done, he merely laughed and called it the "style of the elderly" *(luholo lua mambuta)*. Nguedia enjoys considerable affectionate esteem, and his younger relatives still consult him from time to time on matters of iconography, but they are not about to modify their own mature styles. The Pende, east and west, often repeat that everyone has "his or her own style" *(luholo lu'enji)*, and the sculptors tend to value most the judgments of their own peers.

In fact, in the apprenticeship situation, it is very much up to the student what he gets out of it. For several weeks, I observed an adolescent in the atelier of sculptors Zangela and Mijiba. He worked with more energy than skill, carving small mortars and masks. He profited from the others' tools but never seemed to receive any instruction, nor to ask for it. One day, another visitor asked the two sculptors why they never gave the boy any advice. "Has he ever given us so much as a cigarette?" retorted Mijiba.

Another day, Zangela's and Mijiba's neighbor and close friend decided to see what he could do. Gilembe carved a respectable first effort and was appraising it when the sculptor Mashini arrived. Although Mashini was taking a break from his own work, he could not resist picking up the adze to improve his friend's effort. He told

Gilembe to stand beside him so that he could see what Mashini was doing. As he worked, he explained that the mask was off-balance *(mbuya mulukalo)*, that he had taken off too much from the forehead, especially on one side *(mbombo ya gudia, ya guhengela)*. He had put the eyes too close together *(meso watshingina gukuatenesa)*, and one was higher than the other *(iso diko mu thunda, diko mu mbongo)*. With just a few strokes, Mashini did wonders for the proportions and gave a very succinct lesson. Undoubtedly, someone related through blood or friendship is more likely to receive an extensive education.

Still, as the case of Maluba shows, sheer talent takes one a long way. This is as true today as in the past. There is a Pindji (Mpiin) enclave not far from Nyoka in the village of Kinguba. These villagers have been steadily adopting Pende customs over the years, including masquerading. Kinguba boasts several generations of accomplished maskers but has had no history of sculpting. One of its young dancers, Mungilo, attracted by the masks, tried to develop a petty commerce in them. Frustrated by the long wait for commissions to be realized and by the sculptors' evasions, he tried to make some of his own at home. From that moment, bitten by the sculpting bug, he has never turned back. He sought out Nguedia periodically when he felt that he had specific problems to address. Although Mungilo never underwent a formal apprenticeship, his

talent impressed Nguedia, who would give him a mask to finish or a coiffure to make along with some advice.

In summary, every degree of instruction from formal apprenticeship to self-teaching exists. The former seems more likely to occur when the student and teacher are related, probably due to the expense of fees and of living away from home. Still, it is very much up to the student how much instruction he wants and when. This model is as true for the Eastern as for the Central Pende.

The Pende paradigm of artistic training parallels that described by Daniel Crowley for the Chokwe, their southern neighbors: "Art education, like so many other Chokwe cultural elements, consists of a number of distinct but more or less equally acceptable means toward a common goal, with the choice left to the individual" ([1973] 1989: 235). Crowley makes a fleeting but perceptive link between Chokwe art education and a general philosophy on teaching social skills. Pende artistic training must also be viewed in light of Pende theories of pedagogy. Before the advent of Western-style education, Pende pedagogy was predicated upon the conscious desire of the student to learn. In theory, and quite frequently in practice, the fraternity initiation camps were launched by boys who found the courage to undergo the rigors of the training in order to obtain the privileges of adulthood. Rather than set an arbitrary age or size to determine a boy's admissibility, the traditional rule of thumb was that if the boy

wanted to go, he was ready. Marriage and divorce were similarly open, save in grave cases.

The teaching of medicine, history, and many other subjects depends on the student's seeking out a knowledgeable master or mistress. In this system, there are no unmotivated students. For example, the budding historian will decide who knows the most among the people to whom he has access and will cultivate those persons, usually bringing palm wine to lubricate the discussions, over a period of years. He may even travel to cultivate outsiders. It is up to the students how far they wish to progress.

THE QUESTION OF ATELIERS

Since Pende artistic training privileges the individual, it is clear that the spreading of styles and techniques depends on that individual's mobility. The artists' biographies confirm the impression that styles move easily and rapidly. Because this is a matrilineal culture with virilocal marriage, sons usually move from their father's village after his death or after the death of his "brothers." If the son profited from sculptural education at home, he will take this knowledge with him. This is precisely what Gabama's son Khumba did when he went to work at Mubu and then Malundu. This is what Mashini and Gitshiola Léon would have done if the colonial administration had not joined their mother's village to Nyoka-Munene.

On the other hand, if a man is not exposed to sculpting in his father's village, he will have a second opportunity when he visits or moves to join his maternal uncles. This is what Gabama himself experienced when he moved to Nyoka as an adult. It is how Zangela learned his trade.

Clan and intravillage dissension provides another opportunity for the movement of styles. If a family situation becomes intolerable, it is not uncommon for men to move their nuclear families to join more distant relatives in different villages. The Pende clans are scattered throughout the entire territory. This is what happened when some of Maluba's students left to join their relatives in distant Luisa, taking some of Nyoka's masks with them and Maluba's style.

Finally, if a man is drawn to sculpting and does not have access to training at home, he may seek a master elsewhere. This is the model followed by Kamuanga, Mufufu, and Mungilo. Rarest of all, if he sees something that he admires and wishes to emulate, he may even bypass all formal training, modeling his efforts on some admired work, learning by trial and error. This was the achievement of Maluba, introducing the style of Gizeza to the Gatundo region and, from there, to the rest of central Pendeland.

Clearly, apart from the interest and ambition of individual sculptors, there is an element of random genetic chance in who has the requisite talent. Gizeza himself had a son of mediocre talent and no nephews of note. Kidia Mavu, Kamuanga, and Mufufu have left no artistic heirs in their proper villages. Sometimes men surpass their teachers: the sculptor Gulenvuka of Kifuza is usually deemed superior to the uncle who taught him; all agree that Gabama surpassed Maluba. Sometimes men do not live up to the level of their teacher: Gizeza's and Gabama's sons are prime examples.

Because of the random distribution of talent and desire, the odds of establishing a continuing atelier are remote. What occurred in the north is typical. The reputation of the best sculptor(s) jumped from village to village. After Gizeza's death, the village of Kasele lost all distinction in this regard. The artistic center for the region moved to Tsumbi, where Kidia Mavu was working. On his death, it shifted again to nearby villages where his own protégés lived.

The random distribution of talent and desire is what makes the history of Nyoka so unusual. For the village to have formed an atelier for four generations required a remarkable inheritance of talent from (classificatory) uncle to nephew (see fig. 27). Because of its opportune location, in the heart of the Central Pende population, along a major route leading from the capital to the diamond city of Tshikapa, Nyoka undoubtedly enjoyed unusual advantages in marketing that favored the growth of professional sculptors.

The possibility of making a living by sculpting no doubt encouraged many to carve who would not normally have been interested. The market has been voracious enough to accommodate the mediocre. This motivation probably lies behind Khoshi Mahumbu's and Gabama's sons' choice of profession. Nonetheless, even with their unusual advantages, Gabama's nephews could not continue to dominate the trade without considerable talent. Nyoka is unique. No atelier within oral memory anywhere in Pendeland, east or west, has left such a lasting imprint.

A CENTRAL PENDE STYLE?

Considering the number of Gabama's foreign visitors, it seems clear that some of his works must survive abroad. Maquet-Tombu noted that travelers partial to souvenirs were drawn to the Pende, where Gabama sold them both masks and pendants. She also noted that her own group acquired some of his sculptures for the next Colonial Fair in Brussels (1953: 17). One must realize that not everything he sold would have been his own work. Commonly, the elder in an atelier sells the work of his junior colleagues under his own name.[12] Today, this practice is reinforced by taxes on independent artisans. For example, as head of the family, Gabama's heir, Gitshiola Shimuna, sold under his name the work of his "brother," Nguedia, and his son, Léon.

From a sheaf of photographs, several sculptors at Nyoka independently and without solicitation identified one mask as the indisputable work of Gabama (figs. 29–31).[13] This was an unexpected windfall, as the photos were grouped randomly in Belgium for iconographic reasons. The mask represents the chief.

Nguedia justified his attribution on both iconographic and stylistic grounds. He noted that Gabama always insisted on the use of the horizontal bands of short, tight curls (sanga dia guvunga) over the brow of masks representing the chief. He also tightly worked the rest of the coiffure (figs. 29–30). Fastidious in his craftsmanship, Gabama would not take the shortcuts that other sculptors use to economize either his raffia thread or his time.

Nguedia commented that the handling of the eyebrows was classic; Gabama favored a thick, swelling, continuous brow that extended beyond the eyes, practically to the ears. The ears themselves are greatly abstracted, with a squarish helix fitted with an enormous semipyramidal tragus. They reinforce the horizontal line of the eyes and brow. He said that the handling of the nose was also vintage Gabama, retroussé to show a lot of the nostrils (muzulu wa gufuatumuga). The treatment of the eyes and mouth was also correct. Gabama preferred a mouth with a raised and pointed upper lip (fig. 30). While Gabama did vary his cicatrices, sometimes incising vertical lines on the forehead, those pictured conform to his practice.

When he first saw the photo, Mashini also sponta-
neously remarked that the mask was Gabama's. He sup-
ported Nguedia by observing that Gabama's brow would
continue practically to the ears. He described Gabama's
nose as distinctly squarish, retroussé, and flaring. He said
that the shape of the ears was diagnostic in itself (sharing
this belief with the champions of connoisseurship Gio-
vanni Morelli and Bernard Berenson); Nguedia's own
were "pure Gabama" except for being smaller (fig. 34).
Finally, he described Gabama's preference for wide-spaced
eyes (fig. 29).

Zangela considered the shape of the face to be particu-
larly distinctive of Gabama, with broad cheeks and a short
chin.[14] His eyes were wide-spaced and small.[15] His masks
also had large nostrils.[16] Zangela remarked on one trait
that he did not appreciate in Gabama: how the cicatrices
on the cheeks run off the side of the mask (fig. 30).

The terms that these connoisseurs use is critical in
defining what *style* is to the Pende. It is very easy for
outsiders to misread elements of genre as elements of
style. For instance, the Western tradition tends to picture
aristocratic women (including the Virgin Mary, a spiritu-
al aristocrat) with a long face, lowered gaze, and long,
tapering fingers. The manner of representation forms a
part of the genre; it is characterized by crisp, precise line.
These features, however, have less to do with style than
with the physiognomy of class and with the iconography

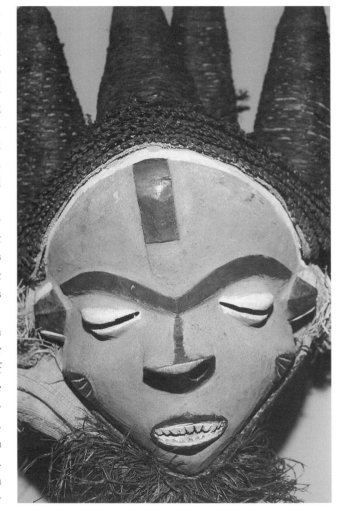

29. Mask of the chief
(FUMU) identified as the work
of Gabama a Gingungu.
(MCB 32.128. © Africa-
Museum, Tervuren, Belgium.
Photograph by Z. S.
Strother.)

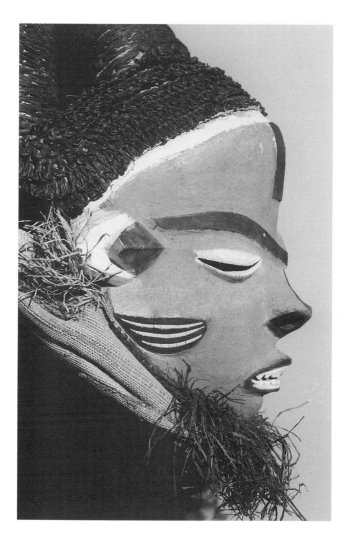

of modesty and of obedience. The same artist would picture a worker or peasant in a very different fashion. In the latter case, sketchiness of representation becomes a social metaphor for the slovenliness (read "laziness") of the subject's class and a justification, in turn, for that class's poverty. Who outside the tradition could ever identify the two representations as the works of a single individual?

When Nguedia, Mashini, and Zangela justified for me their attribution of the mask to Gabama, they talked of the shape of the face, the handling of the ear, the form of the eyebrows, the prominence given to the nostrils, the shape of the mouth, the form of the cicatrices, the manner of working the coiffure. These features define Gabama's particular style *(luholo lu'enji)*.

Strikingly, they did not discuss the "vaulted forehead," the "jutting cheekbones," or the lowered eyes, even though these features are prominent in Western depictions of the Central Pende style.[17] If we compare Gabama's mask to one of Mufufu's, who like Gabama is an artistic "grandchild" of Gizeza (figs. 23, 30), we might well describe Mufufu's style as the more aggressive. The forehead on Mufufu's mask bulges forcefully, whereas Gabama's is smoother and straighter. The latter even enhances its relative flatness with the thick, vertical cicatrice. Mufufu pulls out the nose on his mask to a much greater degree. He positively excavates the brow from the fore-

30. Profile of the FUMU mask identified as the work of Gabama a Gingungu. (MCB 32.128. © Africa-Museum, Tervuren, Belgium. Photograph by Z. S. Strother.)

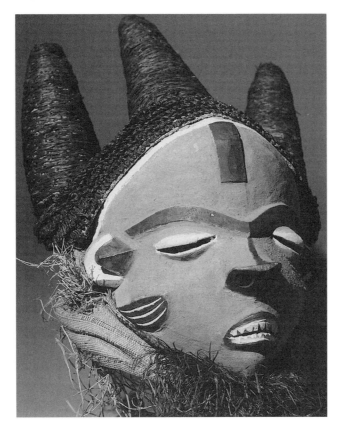

31. Three-quarters view of the FUMU mask identified as the work of Gabama a Gingungu. Gabama softens the conventions of the male physiognomy to depict the chief as one who draws on "feminine" social skills. (MCB 32.128. © Africa-Museum, Tervuren, Belgium. Photograph by Z. S. Strother.)

force of a slash across the face. He brings the chin to a point rather than rounding it as Gabama does (fig. 31).

Whereas both highlight the line of the cheekbones with a cicatrice, Gabama chooses slightly curving lines to emphasize the curving line of the cheekbones; Mufufu uses an inverted triangle to accentuate the straight line of the cheekbones. Gabama neutralizes the potential thrust of the coiffure by emphasizing the horizontal accents of the face: the seven rows of horizontal braiding above the brow; the broad face; the line of eyes, eyebrows, and ears bisected by the invented line of the tragus (fig. 29).

Although Mufufu's mask is as yet uncolored, the resulting comparison leads one to suppose that Gabama's style is the more serene (fig. 31). This conclusion, however compelling formally, is misinformed because it is based on contrasting the work, not just of two different sculptors, but also *of two very distinct genres*. Gabama's mask represents the chief and requires a modulation and softening of form completely unsuitable to the genre of POTA, which Mufufu executed. In executing the same genre, Gabama would have availed himself of many of the same conventions.

In their definition of Gabama's style, the sculptors show a clear awareness of individuality. Mashini, for example, articulates how Gabama shapes ears and distinguishes them from Nguedia's, which are similar but distinct. Mashini prefers to shape the helix in his own man-

head and brings it down to form a sharp point over the nose. Gabama's brow is carved in much shallower relief and has a blunted point. Mufufu cuts out the mouth at an extremely acute angle in sharp relief so that it has the

ner (as a half-hexagon) to coincide with the heightened angularity characteristic of his own style (fig. 40). There is no question of unconscious drift but rather of experimentation and taste. Even the conservative Nguedia demonstrates that he knows very well how Gabama shaped a mouth, although he himself prefers a more "naturalistic" form. These are small examples; nevertheless, they underscore, like the heterogeneity of training options, the openness to innovation and experimentation.

CONCLUSION

Taking into account the extreme tolerance that these men show toward individual difference, how can we define the "Central Pende style"? The Pende, east, west, and center, tend to conceive of the face as a blunted diamond. While the Eastern Pende and those living west of the Kwilu have favored an abstract reductivism of the features in a shallow facial plane, sculptors working in the north-central region took another path. They have been moving toward an increasing naturalism with a fleshing out and softening of the contours of the diamond. Torday collected a Muyombo and a Pumbu mask in this style in 1909 around Mulassa in the extreme north (figs. 76, 55).

It is unlikely that Gizeza was solely responsible, but what is clear is that this style originated in the north. Any dancer, drummer, or sculptor in the Gatundo region who graduated from the Ndende age grade in 1931 or earlier insists that the Lake Matshi region was the center for artistic activity in their parents' and grandparents' time. Not only the best masks but the best songs and the best dances originated in that area. Frequently, when one asks about the origin of a particular song or dance, the speaker will answer, "I don't know exactly, but it had to have come from downriver [gu mbongo]. That's where everything came from in those days." It is no accident that when Gabama took to the road, he went north. Although the northerners preserved their dominance in dancing and singing for several more generations, the center for maskmaking moved definitively south, based on the active agency of Maluba and Gabama.

In the discussion of Gabama's style, the sculptors notably omitted most value judgments. Gabama makes his ear one way; they style the ear in their own manner. This catholicity raises the question of the grounds on which connoisseurs weight the work of different artists. Dancers, remember, exhausted the pile of Gabama's masks before they even started on Maluba's. In the discussion above centering on distinguishing style from genre, I noted that the sculptors did not cite the "vaulted forehead" or "jutting cheekbones" as symptomatic of an individual style, because they belong to the realm of genre. It is in the exploration of the physiognomic language of genre that one discovers the grounds for aesthetic ranking.

CHAPTER FIVE

Yond Cassius has a lean and hungry look.
He thinks too much. Such men are dangerous.

—Shakespeare, *Julius Caesar*

Pende Theories of Physiognomy and Gender

In his famous essay "The World of Wrestling," Roland Barthes defines what distinguishes spectacle from drama by contrasting so-called amateur wrestling with boxing: "A boxing-match is a story which is constructed before the eyes of the spectator; in wrestling, on the contrary, it is each moment which is intelligible, not the passage of time. . . . The logical conclusion of the contest does not interest the wrestling-fan. . . . [W]restling is a sum of spectacles, of which no single one is a function [of another]" (1972: 16). In contrast to drama, the viewer's pleasure in spectacle depends on knowing precisely what will happen. If drama relies on unexpected twists and turns in the plot, on anecdote, and ultimately on resolution, spectacle juxtaposes independent scenes for our contemplation.

Barthes argues that the structure of spectacle requires instantaneous interpretation: "Each sign in wrestling is therefore endowed with an absolute clarity, since one must always understand everything on the spot" (1972: 16–17). In spectacle, we do not need several acts to judge the moral character of a performer. We perceive instantly, for example, the villain in wrestling through his outward ugliness and cruel sneers. Barthes sketches some of the codes of physique, costume, gesture, and expression that enable the spectator to read the scene at a glance (17–25).

The insistence on visual clarity in spectacle sometimes leads critics to dismiss it. bell hooks, for example, reproaches the film *Paris Is Burning* for reducing ritual to spectacle: "Ritual is that ceremonial act that carries with it meaning and significance beyond what appears, while spectacle functions primarily as entertaining dramatic display" (1992: 150). hooks's division is a false one. In fact, ritual and spectacle are often intertwined. For example, Barthes asserts that the power of amateur wrestling arises, not from entertainment, but from the spectators' experience of a more perfect world. It allows the French spectator to participate in the execution of perfect justice; the American, in the triumph of good over evil (1972: 23). "What is portrayed by wrestling is therefore an ideal understanding of things; it is the euphoria of men raised for a while above the constitutive ambiguity of everyday situations . . . [to a place where] signs at last correspond to causes, without obstacle, without evasion, without contradiction" (25). The emotional satisfaction of ritual emerges precisely from this kind of perfected vision where form and substance finally coincide.

In the wrestling match, youth and handsome form connote inner nobility. Ugliness denotes moral degradation and foreshadows base actions. But how is that "ugliness," for example, represented? What Barthes never chooses to explore is the cultural demarcation of these concepts. A foreign visitor may find obvious neither Barthes's reading of an "obese and sagging body" as "asexual" and "effeminate" (1972: 17) nor his easy connection of those characteristics to the villain and to the French (male?) audience's paroxysms of hatred. It takes someone profoundly schooled in a culture to make equivalent leaps.

The dual transparency and opacity of the signs in spectacle are critical to the understanding of African masquerade. The succeeding characters are rarely linked dramatically, with the marginalized exception of the clown's hectoring. They follow, one after the other, independent of each other. To borrow Barthes's phrase, the masquerade is "a sum of spectacles."[1] The spectator jostles for position in the crowd to glimpse each performer, who whirls, turns, emerges from unexpected angles, and is always moving. Consequently, there is the same emphasis in masquerade on visual clarity. When the young girl or the executioner or the chief appears on the dance floor, the Pende public is as "overwhelmed with the obviousness of the roles" (1972: 17) as is the French wrestling public. Part of the event's emotional satisfaction arises from the seamless integration of a character's face, movement, and persona.

Although Barthes describes the importance of physique and gesture, often clarity in spectacle depends on codes of physiognomy, the science of reading character in the face. This chapter is an exploration of the Pende theory of physiognomy that underpins any reading of the

masquerade. It seeks to delineate the code that the sculptors create and manipulate in order to communicate with their audience.

PART I. THEORIES OF PHYSIOGNOMY

In chapter 2, it became evident that the sculptor is *the last stop* in the invention process. This is because the persona of the mask must be fully conceptualized in dance before the sculptor can create a face in harmony with it. Chief Nzambi insisted on the importance of the correspondence of face and dance by means of a rhetorical question, "Do people go up to Mabombolo [the clown] to give gifts?" The answer is no, because his face makes people fearful of what he will do. The mask's face reveals its inner nature long before it makes its first gesture. The performance of the most serious mask will be flawed if the face is not of commensurate beauty.

These Pende judgments contrast with what de Sousberghe perceived as a lack of individuality and personality in the different Pende facepieces (1959: 34–35). The average viewer will not be able to distinguish among the many different masks representing young women if the facepieces are isolated from their associated costumes, props, and dances (plate 6). Viewers may well be unable to distinguish between the face of the mask depicting a man chopping down trees and that of the chief. However, most adults *will* be able to distinguish between female faces and male faces. And few will confuse the face of the executioner with that of any other kind of mask. Likewise, few will confuse the face of the clown with that of any other character. There is a clear demarcation of physiognomic classes based primarily on theories of gender and, increasingly, of age.

Charles Darwin defined physiognomy as the "recognition of character through the study of the permanent form of the features" (1873: 1). Actors may manipulate their expressions; however, physiognomy depends on the widespread belief that inner character manifests itself indelibly in the permanent features of the face (such as the forehead or eyes) and may be read by the shrewd observer. Comparison of Western and Pende structures suggests that physiognomists tend to construct tightly self-referential systems. Barthes has noted that such "paradigmatic" systems are self-contained; certain features take on meaning only in dialogue with other uniform features. He writes that "red signifies prohibition only insofar as it is *systematically* opposed to green and yellow" (1982: 211–212). Western physiognomists, ranging from Pseudo-Aristotle to Le Brun, to Lavater, and to the nineteenth-century phrenologists, have predicated their theories on the contrast between human and animal profiles (fig. 32, top).[2]

Mary Cowling writes that, while their motivations varied, "physiognomists did agree on the general distin-

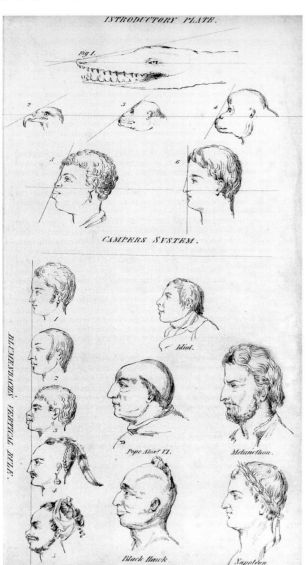

INTRODUCTORY PLATE.

CAMPERS SYSTEM.

BLUMENBACH'S VERTICAL RULE.

Idiot.

Pope Alext VI. Melancthon.

Black Hawk. Napoleon.

32. Disturbing hierarchies of nineteenth-century Western physiognomy: human/animal, intelligent/idiotic, European/other. (Falkner 1842: "introductory plate." Photograph courtesy of Yale University, Harvey Cushing/John Hay Whitney Medical Library.)

guishing features between men and animals; in particular, that the vertical profile, extended cranium and prominent nose were exclusive to man" (1989: 14). Western theorists associated these features with that ultimate human attainment, abstract thought. They further connected the straight forehead, firm chin, and straight nose to firm moral character. In contrast to this "ideal" profile, they systematically opposed the receding forehead, prognathous jaw, and retroussé nose. These latter features were associated with the animal profile, and thus by extension to animal nature as expressed through heightened emotion and sensory perception. On the basis of these features, physiognomists were able to situate both individuals and whole groups on a spectrum with respect to their relative human or animal nature. Physiognomy has been discredited in the twentieth century due to nineteenth-century excesses of scientific racism, sexism, and classism. Women, children, the entire working class, criminals, the mentally ill, and peoples outside Europe were all placed low in the physiognomic hierarchy (fig. 32, bottom). Today, physiognomy has gone underground as the preserve of plastic surgeons, trial lawyers, Hollywood screen-casters, forensic anthropologists, and everyone who has ever been unnerved to find serial murderers who look like their next-door neighbor.

The Pende have also constructed a paradigmatic system; however, they are uninterested in opposing human

and animal characteristics. To their mind, those differences are clear enough. Instead, they see gender as the most salient determinant of inner character and ontological essence. Their system establishes a sliding scale of gender, extending from a crystallized, "cool" feminine essence at one end through a spectrum of masculinity increasing in heat: feminized male, average male, and hyper-male.

The feminine is idealized as calm, peaceable, obedient, and socially oriented. There is no room in the masquerades for representations of women who subvert or flout social conventions, such as the entrepreneur or even the common social stereotype of the "lazy woman" (i.e., the woman who hates farming). There is more range in masculine representation.

The feminized male is a mediator, who has learned to "cool" his masculine aggression with positive feminine social skills. In the masquerading context, this primarily refers to the representation of the chief, who is described as a "peacemaker" (*mukandji wa athu*, a term appropriate for someone who breaks apart two fighters). Before the colonial era, chiefs seldom played an overtly political role. At trials and public debates, they were supposed to engineer consensus and reconciliation. Their ritual position as intermediary with the dead was primary. The male diviner, who often mediates among individuals in therapy sessions, may also fall into this category.

The average male is presumed to have the capacity for aggression but usually succeeds in funneling that extra energy and "heat" into various physical or intellectual projects. The final category, hyper-male, belongs to risk-takers who scorn social boundaries. It includes men with the capacity for extreme physical and psychic violence. In the masquerade, this category is wide enough to encompass the beautiful (and yet hotheaded) young man (MATALA), the old sorcerer (GATOMBA, NGANGA, etc.), the grotesque clown (TUNDU), and the executioner (PUMBU).

One must be careful to note that there is no Western progress narrative of good to evil implied in the spectrum of feminine to masculine (or vice versa). Most Pende believe that all of these personalities are indispensable to the survival of society, including the inconvenient hyper-male. In their view, the man who burglarizes your house or who steals your goats is likely to be the man who can face down a leopard or who shines in battle. While the essentialized feminine represents the fully socialized individual, no society can do without the intervention of the different masculine types.

More and more evidence is accumulating on the importance of temperature as a metaphor both expressing and shaping gender constructions in sub-Saharan Africa. Since Thompson first identified an "aesthetic of the cool" (1966, 1973), many scholars have reported that the genders are polarized as "hot" and "cool" in a variety of

African societies. Nonetheless, it is striking that the same gender is not always characterized in the same way. For example, Mandinka society of eastern Gambia and central Senegal describes the polarization of the genders in almost identical terms to the Pende, *except that they reverse point for point who has which characteristic.* According to anthropologist Peter Weil:

> Men are ideally categorized as stable, trustworthy, socially responsible, predictable, and having common sense. . . . [Men are] cool *(sumiata).* In contrast, women are, in cultural categorizations, unstable, unpredictable, lacking common sense, disruptive of society, and socially irresponsible and representative of an ever-present danger to society. These characteristics are conceived symbolically in terms of wind, fire, and being hot *(candita).* . . . Women are perceived as innately creative and energetic, while men are perceived as innately not. (1988: 156)

What has been unusual so far in the Pende evidence is their articulated spectrum of gender, including feminized male and hyper-male. This nuancing may well be the result of research orientation and translation.[3]

The switching of gender characteristics in the Mandinka and Pende systems will support arguments that gendered bodies are the product of language or socialization. This view contrasts markedly with the Pende position. Most believe that, despite local variations, the sexes have two distinctly different personalities, which result from different ontological realities. It is this truth that is reflected in what they perceive to be distinctly different faces. Both Pende and Western physiognomies are powerful systems for naturalizing social and cultural difference by making it seem innate, inalienable, and inevitable.

Social Environment

Art historians Mary Cowling (1989) and Judith Wechsler (1982) have tied the development of physiognomic theory to urbanization and to the need to make sense of a varied urban environment. They argue that class, caste, and professional differences become urgently in need of explanation (and justification) in the urban milieu. While physiognomic systems may expand in urban settings, it is likely that this conclusion is due more to a dependence on written sources than to anything else.

The Pende are rural agriculturalists who live in small-scale villages. In this environment, the perception of social difference overwhelmingly centers on gender. Class is not an issue. Professions are segregated by sex but open to anyone within the proper gender on the basis of desire and skill, including (to a degree) the chieftainship.

Pende society has fairly rigid separation of work roles. In this matrilineal society, a marriage contract is conceptualized as an exchange of the woman's food (millet, cassava, vegetables) for the man's virility. The woman pro-

vides the food and water for everyday living and in return she has the right to clothing and to sex with her husband. During marital spats, a husband will often refuse to eat his wife's cooking, even if he has to go hungry. He may feed her dinner to friends, to another wife's children, or even to his dogs. Although it may appear that the husband is cutting off his nose to spite his face, in fact this behavior does infuriate the wife, who must present the food anyway.

In more serious and long-term discords, the wife sometimes circulates in the village complaining at the top of her lungs that her husband has not slept with her for weeks or months. This seems to be a plea for other villagers to step in as peacemakers, and they do, but by this point the situation usually is beyond repair. Women may also play food games by making a "wet" and thoroughly unappealing millet bread, but if the household is polygynous, it is a risky business. Women who are seriously dissatisfied take a more direct approach: they simply leave and go home to their matrilineal kin.

While women take on the hard, daily grind of farming and food preparation, Pende men consider that they have the difficult ticket in life because the ultimate responsibility for the household rests on their shoulders. They must clear the land that the women farm. In the past, they wove raffia cloth and faced real dangers in hunting. Today, in the precarious cash economy, they must rack their brains to figure out how to earn money in order to purchase meat and clothes for the family.

In the marriage exchange, many individuals believe that the women get the better deal because her family retains control over the children. Occasionally, a man will remark bitterly that his in-laws think of him only as a "stud" producing lineage members for their benefit. Large-hearted women sometimes express sympathy for men's plight, since they must always work to another's benefit.

Men play an important role in child-rearing. Women have little time for baby-sitting. If no conscientious adolescents are available (of either sex), younger or older men will often care for infants during the day. Because the children belong to the mother's family, the father and his brothers act as a crucial buffer between the child and her or his maternal uncles. Since most illness is suspected of involving sorcery on the part of the maternal uncles, it is the man's role to diagnose, seek proper care, and pay for the cure of all his children and often for his wife, too. This responsibility is taken very seriously. In Pendeland, it is usually the fathers who take the children to the doctor and who brood over their progress. In addition, the fathers are now taking on more and more of the cost of Western-style schooling.

In Pendeland in 1987–89, "Article 15" emerged as popular slang from a joke about the national constitution,

which guarantees various solemn rights, only to conclude with the fictional Article 15: "Hustle for yourself" *(Débrouillez-vous)*. Men would constantly tell each other, "Article 15," as shorthand when one was faced with a tricky problem that would take cleverness and daring to overcome. "Article 15" expresses the male ideal. In their view, men have taken on the daily challenges of hustling for a living in a smashed economy, of outsmarting wily sorcerers to protect their families, of arguing cases publicly in court trials because they are suited by nature as the more active and clever sex. It is, however, these very qualities that also make them the more dangerous sex, and a man who excels may become a liability.

Women are honored as life-givers, both through their reproductive capabilities and through their farming. They are peacemakers, thought to be above ambition and violence. They are like the fifties housewife, both idealized and resented for her role off center stage. The men consider that the women are coddled, indifferent to the burdens that they place on the men. These views lie behind the gendered language of the Pende physiognomic system.

Learning to Read Pende Faces

Because this study is concerned with recovering the parameters of sculptural invention and innovation, it will examine the role of physiognomic theory in the production of masks through interviews with the sculptors at Nyoka-Munene. As stated, the system is paradigmatic. Certain features signify masculinity because they are uniformly contrasted to certain features signifying femininity. It should be remembered that the terms "masculinity" and "femininity" always reflect cultural definitions of gender that may have little if anything to do with biological maleness and femaleness.

THE FOREHEAD

To the Pende mind perhaps no feature is more revealing of inner character than the forehead. Any child will tell you that the feminine forehead is smooth and flat, whereas the masculine forehead is bulging and lumpy. Compare the independent testimony of the sculptors.

Nguedia observes: "The forehead of men is uneven [lumpy] [and shows that] men are mean; that of women is smooth and level." *(Mbombo jia mala jia lundamana, mala abala, [mbombo] jia akhetu jila batabata; jia gubatamana.)* The implicit metaphor operating here is that the forehead is like a wall. Nguedia is borrowing adjectives applied to wall construction in packed clay. A mud wall that is lumpy and uneven is described as *lundamana;* one that is straight and smooth and level is *batabata* or *gubatamana.* Obviously, the latter is what is considered well made, aesthetic, and desirable.

Khoshi asserts: "The forehead of women is level; the forehead of men is uneven [lumpy]." *(Mbombo ya*

mukhetu ya gubanda; mbombo ya yala ya gulundamana.) Later, he contrasted feminine and male foreheads as follows: "Women's foreheads are straight; men's are uneven [lumpy], projecting." *(Mbombo [ya mukhetu] ya gubua, ya ila basasa; mbombo [ya yala] ya lundamana, ya lundundu.)* Khoshi continues the metaphor of the wall, using adjectives to describe the feminine forehead derived from the verbs "to sleep" *(gubanda)* and "to fall" *(gubua)*, activities which describe a perfectly straight line. The masculine is uneven like a badly made wall *(lundundu)*, an adjective also applied to a back curved so that the spine protrudes noticeably *(kunda dialundamana).*

According to Zangela, "A woman's forehead is straight; a man's is uneven [lumpy]." *(Mbombo ya mukhetu ya gubua, ya gubulumuga; mbombo ya yala ya lundamana.)* Thus, Zangela makes the same contrast, characterizing the feminine forehead as "straight" with adjectives derived from the verbs "to fall" *(gubua)* and "to descend" *(gubulumuga).*

Mashini's remarks are always rich in allusion. "A woman's forehead is calm; a man's is wrinkled, uneven." *(Mbombo ya mukhetu tulu; mbombo ya yala ya gufunya, ya gulundamana.)* The key word here is *tulu*, which is derived from the verb *gutuluga*. In this contrast, Mashini's use of *tulu* suggests that the feminine forehead is smooth and straight. However, this word has a wide range

of significance. It can mean "cool," "descend/come down," "diminish (temperature)," "lower," or "calm and patient."[4] Here lies the key to understanding why the forehead plays such a key role in Pende physiognomy. Many of the words used to describe the feminine forehead resonate with allusions to descending *(gubulumuga, gubua, gubanda, tulu)*, which the word *tulu* reveals to have a conceptual link with cooling, calming, pacifying.

George Lakoff and Mark Johnson have written on the importance of "orientational metaphors" in language. These organize "a whole system of concepts with respect to one another," using metaphors based on spatial orientation. Some of the most familiar in English are up/down, in/out, front/back, central/peripheral (1980: 14). For example, in English, "up" is usually good, whereas "down" is something bad. Thus, we say that something "boosted" our spirits or that our spirits "sank"; that someone "dropped" dead but that Lazarus "rose" from the dead; that someone has control "over" another or that someone is "under" the control of another (1980: 15–16).

In Kipende, an orientational metaphor central to aesthetic rendering is that of closed/open. We must reverse the nuances we carry to this coupling from English, because for us "open" usually implies something good (because it hides nothing), whereas "closed" is undesirable because it is unfriendly and inaccessible. Thus, we prefer the "open-eyed," the "openhanded," and the

"openhearted" to the "closed-minded," "closefisted," and "closemouthed."

The Pende see things another way. Whereas an English speaker visualizes "open" as the gaping hole in a doorway, a Kipende speaker focuses on the projecting door itself as the sign for "openness." For them, "closed" implies smoothness, calm, control, coolness. It goes beyond good and desirable to beautiful. It is safe and nonthreatening. At best, "open" implies an ability to get things done, to defend oneself, but it is always ambivalent since it is linked conceptually to protrusion and thrusting aggression. It is never far from anger.

Herein lies the significance of the straight, calm, closed feminine forehead in contrast to the thrusting, jutting, bumpy masculine. When asked why men should have such a forehead, Nguedia answered that it expresses how men are dangerous, quarrelsome, mean *(mala abala)*. When I protested that Pende women seem to quarrel all the time, Zangela and Mijiba explained the difference. Women quarrel, yes, but they release their anger; it is short-lived.[5] In contrast, because the Pende detest physical violence, they train boys to suppress public manifestations of anger. Ironically, they believe that the cost of this policy is that it produces some men who nurse grudges, who brood, who seek out sorcery recipes in order to strike back in secret.

Thus, it is not surprising that in Pende society, it is men overwhelmingly who are counted as sorcerers. And men who brood are feared. It is not uncommon to hear the following accusation murmured: "The man is a sorcerer; he is always angry; he could kill someone."[6] Hence, the violence feared is more often through sorcery than through physical aggression. The external sign of the internal commotion is the furrowed or jutting brow *(mbombo ya gufunya)*.

The Pende judge the formation of the forehead with as much precision as Jane Eyre did the lumps of benevolence on Mr. Rochester's skull. If a little boy of peaceable disposition manifests a particularly protuberant forehead, the community will consider him aggressive. One day, the truth will out.

Frankly, to this researcher, it did not seem that Pende men and women on average actually do manifest distinct foreheads. Whenever I said as much, my interlocutor would grab a little boy to flourish from the crowd at hand who did show a protruding forehead. Whenever I countered with another child, they would say, "Don't look at him, look at this one." More important than an actual protrusion seems to be the symbolism of a wrinkled brow. Mashini called women's foreheads "smooth" (*"mbombo jia gubulumuga,"* from the verb *gubulumuga*, "to lower") because they do not wrinkle like the men's. He lined up a group of girls and boys and made them all look straight up without moving their heads. The girls' fore-

heads remained smooth, whereas all of the boys' wrinkled. The sculptor renders the wrinkling with rhetorical hyperbole as protrusion.

Others demonstrated that when people are angry, they pull their eyebrows together, making the forehead bulge out slightly. They also believe that since men brood more often, and therefore wrinkle their brows more often, this leaves a physical mark on their foreheads, which wrinkle earlier and more deeply than women's. Just as Western folklore uses hair on the chest to measure how "manly" an individual is (although it is a minority feature on men in the human race), so the Pende use the protruding forehead to quantify degrees of masculinity.

If some Westerners claim that the hairier the man, the more masculine he is, the Pende assert that an acutely protruding forehead signifies the hyper-male, the man who is as far as possible from the essential feminine. In this system, while there are gradations of maleness, there is only one possible feminine. The average man should have a somewhat protruding forehead, but the young man, who has not yet learned to master himself, and the sorcerer, the soldier, and the executioner, who are ruled by their aggressive impulses, must all manifest an acutely protruding forehead. Peacemakers among men, notably the chief, should show less aggression than the typical man and, consequently, a more feminine forehead.

THE EYES

The eyes are second in importance only to the forehead as a measure of gender. They also function within the orientation metaphor of closed/open used to articulate the constructions of feminine and masculine.

Nguedia explained that a man's eyelids are wide open; a woman's are closed, hooded; she looks out from slits. *(Izumbu ya yala ila zanganga; izumbu ya mukhetu bobe. Zanze!)* The word *zanze*, universally applied to women's eyes, is difficult to translate into English. The closest equivalent is probably "bedroom eyes," such as Marilyn Monroe made famous. These hooded eyes are an open invitation; they signify to the man that he can do anything with her. These are the eyes of seduction. Nguedia continued, "The hooded eyes of a woman weaken a man. Everything that she asks of you, you do without speaking, you give her. This is why we call them 'Satan,' those who lead men astray."[7] In order to help me understand the concept of *zanze*, several different people referred to the story from my culture of Adam and Eve. In order to get her way, as they tell it, Eve simply had to look at Adam *zanze. . . .*

Nguedia made a contrast to the masculine gaze. "Men's eyes are open; they show that he can take care of himself, is alert and on his toes, able to solve his own problems." *(Meso a mala a gukangula; adi mudijiga gubanganana*

gua mala.) All of these qualities are expressed in Kipende by the concept *gubanganana*. As illustrations, he gave the case of a man who refuses to let the soldiers jail his son and gets away with it; of a man who knows the law and successfully refuses to pay extortion; of a man who successfully defends himself in court. Such a man must be clever, know what's going on, and, above all, must keep his head. He must have guts. Nguedia insisted that these were indubitably masculine qualities. He claimed that at a trial, a woman will begin to speak and then collapse into tears. One can never refer to a woman as *wabanganana*, on the qui vive. Instead, her eyes are lowered (hooded) in order to show beauty (or goodness).[8]

Khoshi supported the closed/open dichotomy. "A woman has bedroom eyes, hooded, calm, cool; a man's eyes start out like a *munganji*'s." *(Meso a mukhetu alazanze, tulu; meso a yala alanguanguala ulu munganji.)* A *munganji* (pl. *minganji*) is a mask used in the men's fraternity, characterized by protruding, white, tubular eyes (plate 1). In keeping with its aggressive eyes, the *munganji* carries a whip, which the dancer uses to devastating effect on anyone he can catch. Nothing could be more of a contrast to the lowered, cool, and composed gaze *tulu* than the relentless stare of the restless *munganji*.

Zangela also continued in this vein. "A woman's eyes are hooded [she has bedroom eyes]; a man's are red."[9] His companion, Mijiba, spoke at length about how seductive men find the gaze *zanze* in a woman. The red here is a reference to how many men's eyes flush red when they drink or become angry. It is a contrast of cool with hot, of composed or contained with aggressive, of the ultimately feminine with the exclusively male.

"Women's eyes [are] cool or calm because women do not think more than men," Zangela continued. "All the charge for the house is his: the woman's clothing, the children's, [what to] drink and eat, medicines, soap, [etc.] To sleep at night, [when] Mumbu [the sorcerer] disturbs [someone's] sleep, the man [must be ready with] a protective medicine [to scare him away.]"[10] "The open eyes show that he thinks a lot."[11]

Despite some undoubted misogyny, rendering *zanze* as "bedroom eyes" does not do full justice to the term, for *zanze* represents the gaze of civilization itself. Mashini elaborated on how the proper social gaze is cool or calm *(meso atuluga)* for men as well as women and contrasted it to the wide open and dangerous gaze of a mask such as Pumbu *(meso abala)* (fig. 57). When someone's eyes are open, the gaze is predatory: the person is seeking to control others and to impose his or her will. Lowered eyes are generous and self-effacing because they relinquish that predatory stance. They give themselves up to view. Pende ethics stress that there is a communal responsibility not to provoke anger in individuals through favoritism or through inequitable distribution of goods in

society. The lowered gaze is ultimately one of power because generosity binds people to you and turns enemies into friends.

To express calm and peaceful intentions, many Pende lower their lids slightly for snapshots organized according to their own aesthetic guidelines. Essentially, they hate to see the whites of someone's eyes, associating them with anger and loss of control. Children learn early the code for anger and will flee precipitously when an adult merely opens wide his or her eyes, without so much as an angry word. Women often critique men's eyes on this basis, preferring smaller eyes with less white. What white there is should be clear, sharply delineated, and without the red flush of drink or anger. What women are admiring here is an easygoing disposition. It is assumed that a man with such eyes could never turn out to be a wife-beater.

Mashini demonstrated, however, that it is women above all who embody this gaze. Even small girls are fully socialized not to look at people directly with open eyes in the manner of little boys. They look askance, bashfully; they look down, out of the corners of their eyes, or through squinted eyes. In any case, the eyelids drop. Likewise, generosity is lauded in women (and demanded of them). This is why Mashini characterizes the women's gaze as "cool, come-hither" *(meso a gutuluga zanze!)* in contrast to the masculine version with open eyes *(meso a gukangula).*

Like the forehead, the gaze expresses degrees of masculinity. The chief as peacemaker and the male diviner as healer will have a "cooler" gaze than will PUMBU (the executioner) or MATALA (the young man). These latter Mashini characterizes as vigilant masks or masks on the lookout *(mbuya jiakelumuga)*, meaning that they look in every direction at once. A man characterized in this manner as *wakelumuga* is clever, on the qui vive, on the make.

THE MOUTH

While there was total uniformity among the sculptors, and among those interviewed in the general population, on the type of forehead and eyes suitable to each sex, other features are more open to personal preference. Nguedia, for example, felt that in real life, men and women show the same range of mouths, some full, some thin, all individual. In the case of masks, however, he insisted that the two types cannot be confused. "A man's mouth rises in the middle; a woman's is flat [thin]."[12] Again, the potential for anger is signaled.

The more peaceable the emotions, the flatter the upper lip of the mouth. A smile flattens it entirely. The Pende consider that an angry mouth, on the other hand, manifests a pointed upper lip. Among masks, PUMBU bears the most extreme form (fig. 57). Nguedia characterized PUMBU's mouth as "pouting," illustrated by the acute

angle of the upper lip, which shows that he is a "man perpetually angry, a dangerous person."[13]

Khoshi believes that women, on average, have smaller mouths than men do but that the salient characteristic to render on the feminine masks is their teeth. "You can be somewhere with a woman and a man, the woman comes [laughs] ten times against two times for the man, or three [for the man], because the mouth of the man always stays closed."[14] Khoshi's analysis, made as a comedian who closely observes his audience, is undeniable. Pende women, like American women, are socialized to smile much more frequently than men. In the same situation, Pende women always look for the joke and break out in explosive laughter, clapping their hands, while the men smile at most. The only man I ever saw laugh like a woman was a notorious sorcerer, and his cajoling manner was considered one of the tricks of his trade.

Khoshi did not consider women's readiness to laugh to be innocent behavior. He recounted that women laugh in order to sweet-talk their husbands. "If the man's angry, she will grab his arm, laugh, and cry out an endearment. And it's over. But if *she's* angry and he tries to do the same, she'll shrug off his hand: 'Stop it! [Bemba!].'" In Khoshi's view, if the serpent in the Garden of Eden had made the mistake of going to Adam first, we would all still be in Paradise. "Woman is the weakener of the man."[15]

The Pende view domination as the ability to weaken (rather than overpower) the other party. He continued by pointing my attention to the reception of the comedic mask GANDUMBU, the old widow. The women cry out, clap, laugh so hard that they bend over; the men stand there, arms folded, and merely chuckle.

Like many male field associates, Khoshi fell into a diatribe on the unfair burden that men must bear. He described how a man must worry about earning money to buy manioc, to buy kitchen utensils, to buy clothes for his wife. He must brood: what can I do to earn money? It makes him sad. The woman eats, wears clothes, that's all. In the men's eyes, the women's hard physical labor in the fields and in the kitchen does not prevent them from leading a gay and carefree life. For Khoshi, the feminine mask must show teeth in order to symbolize the relaxed tenor of her life in contrast to the masculine world of brooding and introspection.

Mashini essentially agreed with Khoshi, arguing that it was appropriate for teeth to be more evident in the feminine masks. He said that the feminine mouth opens up and down as if she is saying *"màmá!"* (an expression of surprise). The masculine widens at the sides as if he's crying out *"aye!"* (hey, you!) in anger.

Zangela explained that the sculptor Gitshiola Shimuna had taught him that an angry person has a pouting mouth

with the upper lip raised into a point. (The Pende do not make our gesture of pouting with the lower lip extended forward.) While he does not believe that there is any physical difference between the shapes of mouths for men and women, he does claim to make a distinction between "a person who pouts"—that is, who holds grudges *(muthu udi mujimba)*—without his teeth showing, and a "person who laughs" *(muthu udi mulela)*. The feminine, of course, falls into the latter category, as does the chief. Once again this division corresponds to the calm/cool versus the aggressive/hot.

Mashini agrees with Khoshi that women smile more often, especially when they feel shy or embarrassed. It is for this reason that the masculine mouth is more pointed.

THE NOSE

The nose shares a certain flexibility of interpretation with the mouth. According to Nguedia, "The nose of a male mask is retroussé; the nose of the female is straight." *(Zulu dia mbuya ya yala dia tumbo; zulu dia mukhetu dila batabata [dila diabatamana].)* Degrees of masculinity are expressed even through the nose. The hyper-male has a nose pulled out much farther than that of the average male.

Khoshi believes that women have smaller noses, with less prominent nostrils. He describes the feminine nose as "straight" *(ula batabata)* and "descending" *(wabulumuga)*. For the masculine nose, he described something close to a Cyrano-like organ with a sunken bridge and long, pulled out, somewhat retroussé tip.

Zangela, on the other hand, denies altogether that there are any differences in noses between men and women. He explained that in his sculpture, he uses the same nose for the masculine and feminine except for the masculine masks PUMBU and MUYOMBO. By convention, these have noses that protrude farther.

Zangela's skepticism contrasts with Mashini's passionate conviction: "A man's nose is retroussé with a sunken bridge; the woman's [bridge] is perfectly straight."[16] His chief emphasized: "A woman's nose is rounded down (lit. "descending"); a man's is retroussé."[17] They grabbed lots of children to show me what they meant, although I was not convinced of any sexual specificity. The ideal is that a man's nose should be broader, with more striking nostrils. A woman's may turn up slightly, but it should be narrower, with consequently less prominent nostrils. Mashini confirmed the convention of exaggerating the noses of the hyper-male masks like PUMBU and MATALA in order to convey that each is alert, active, and stylish *(gathu gakelumuga nu gabonga)*.

In examining the majority testimony, one notes a resurgence of the familiar architectural vocabulary that

continues the dichotomy of closed/open. The words describing the feminine nose are "straight," "descending," "smooth" *(batabata, batamana, gubulumuga, tonono)*. The nostrils are closed off. What I have translated as "retroussé" for the masculine nose are in Kipende the familiar words for "lumpy" and "protruding" *(tumbo, gukanduga)*.

THE SHAPE OF THE FACE

There is more consensus about the shape of the face appropriate to each gender. Nguedia commented: "Masks of women are short. The jaw and jowls of a man are long; of a woman, short."[18] Nguedia emphasizes that the whole lower half of the face should be shaped differently. "The cheeks of a man are flat; a woman's are swollen."[19] The combination of plump cheeks, short jawline, and smooth rounded forehead lends the feminine a soft, oval shape.

The masculine face should look quite different. When Nguedia talks of "flat" cheeks, he is describing the consequences of prominent cheekbones. The combination of bulging forehead, prominent cheekbones, and long jawline gives the masculine physiognomy a much more dynamic outline. When exaggerated, it becomes even peanut-shaped. Like everything else, the degree of masculinity is reflected in the exaggeration of these features. PUMBU, the archetypal hyper-male, will also have a chin

distinctly longer and more acutely angled than the average male (fig. 57).

Khoshi further delineated this ideal. The male should have a pointy chin and a sharp break at the cheekbones. The female has a "swollen face" *(pala ya gibutu-butu)*, whereas the male has a "long face" *(pala yaleha)*. "Men's cheekbones stick or bulge out; women's are flat and smooth." *(Khokhono jia mala jia lundamana; khokhono jia akhetu jia gibatabata.)* In his vocabulary describing cheekbones—*lundamana* and *gibatabata*—Khoshi returns to the metaphor of wall construction. While in the 1990s Americans have a passion for prominent cheekbones and gaunt profiles in their female models, many Pende prefer a smooth and rounded outline. It is the feminine physiognomy that is, by extension of the wall metaphor, well made and desirable. Also by extension of the wall metaphor, it is the feminine physiognomy that is "closed" while the masculine is "open" (read, "protruding").

Mashini supported this assessment. "Women's cheeks are swollen; men's are sunken" [lit. "dented"].[20] Women have "short cheekbones," and men's are "pointy."[21] In an oblique reference to cheekbones, he described feminine cheeks as "descending" *(mabutu a gubulumuga)*, in contrast to the masculine, which are "rising" *(mabutu a yala a gukanduga)*. He pointed out as well that the masculine

chin is made to look even more angular by the addition of a little beard.

THE EYEBROWS

A word is in order here on the vaunted eyebrows of Pende masks and what they teach us about reading Pende art. Used as a diagnostic feature to identify an ethnic art unit, or "national style," to borrow Wölfflin's phrase ([1915] 1950), they have received more attention by far from foreign commentators than any other stylistic feature. Ironically, the continuous brow receives little comment from Pende aesthetes. It is not a feature used by critics to evaluate the quality of a piece.

Nguedia maintains that women's eyebrows are smaller and narrower (finer) than men's. Khoshi claims that men's are bushier and more angular in arch. Mashini describes women's brows, as part of the eye unit, as "seductive" (inzumbu zanji [= zanze]). He also says that they are "cool" and "lowered" or "descending" (inzumbu ya gutuluga, ya gubulumuga) in contrast to men's, which are "raised," that is, arched (inzumbu ya guzumbuluga). Zangela did not feel that there was any difference.

Although there is some manipulation of the width and length of the brow, there was total agreement that the eyebrows are not naturalistic. Nor are they supposed to be. In reference to several points, sculptors emphasized that masks were not supposed to be portraits.

Once I asked Nguedia to compare three photographs of the mask MUYOMBO and to show me the one with the best handling of the eyebrows. He quickly pointed to one:

> The eyebrows are the most beautiful because he [the sculptor] has not imitated the form/manner of a person. If you represent [it] like the form/manner of a person, it is not good, because faces are different. If you represent the mask like a person, it is not good. So [if] a person [sculptor] represents the work like a person, he doesn't know [how to do] it. In order to represent a thing, do not make it like a person; a person is a person. I cannot be looking at you [in order to] sculpt you. We do not say that this mask resembles so-and-so. We do not embellish the face of a person, but we embellish the face of the wood that we are working. One imitates [or represents] the hairdo of a person but not the face.[22]

This speech is enlightening for a number of reasons. On the one hand, Nguedia stresses that the sculptor is working toward an ideal. He is trying to rise above the *difference* of individual faces. Khoshi also noted: "We do not fashion [it] as if [it is a] person; [it is] a thing that we represent. It is not a person; it is an image."[23] De Sousberghe's effort to find an individualized expression (1959: 34–35) was misplaced. The sculptor fashions masks, not portraits.

Pende physiognomy is more than a system of resemblance. It does not represent the accidents of how men look or how women look, although, like most paradigms,

it selects certain physical facts to substantiate its claims. All of the assertions on how men and women "are," on how the world works, reflect an abstracted understanding of human experience, of what it means to be human. In a pioneering article on African aesthetics, Harris Memel-Fotê wrote: "There is a physical-mathematical aspect of beauty, there is the ethical aspect, there is the metaphysical and meta-moral aspect. Three aspects of the same reality whose analysis and genetics constitute an ontology" (1968: 50). Physiognomy reveals that for many Pende, ontology itself is gendered.

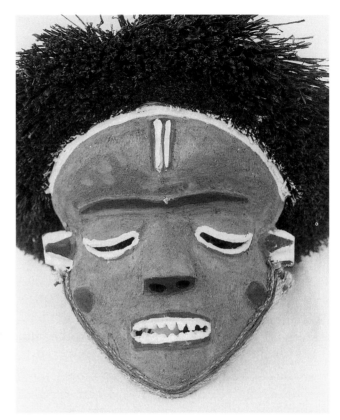

33. Nguedia Gambembo's GAMBANDA (female) mask. Nyoka-Munene, Zaïre, 1989.

PART II. PRACTICE

So much for theory. Let us now analyze to what degree the theory shapes artistic production. While collecting the data on physiognomy, I decided to observe, discreetly, to what degree the sculptors practiced what they preached. If possible, I tried to photograph examples of both male and female masks. Even though, at that particular moment, the bulk of their production was destined for the foreign market, there proved to be an astonishingly close correlation between their ideals and their practice to someone looking with Pende-trained eyes.

Nguedia

Nguedia, the dean of sculptors at Nyoka-Munene, is beginning to feel his age. He no longer fells his own trees, relying on clients to bring him wood, and his work is recognized by the other sculptors as beginning to show a certain unevenness. Nevertheless, the canons of gender are unmistakable in his work.

Let us compare GAMBANDA, a mask depicting a young woman, with MUBOLODI, the mask of a man on his way to chop down a large tree (figs. 33–35).[24] First, one notes that the forehead of GAMBANDA is smooth and flat in contrast to that of MUBOLODI, which bulges forward. The sculptor has a great deal of liberty when it comes to the cicatrization depicted on the masks. A true copy of the original patterns favored by Pende in the past would be unreadable at a distance in the masquerade. Nguedia chooses shapes that emphasize formally physiognomic differences. He gives GAMBANDA vertical lines in the center of her forehead that call attention to its smooth flatness (fig. 33). The half-oval at the top of MUBOLODI's forehead acts as an arrow to underscore the energy of its thrust forward (fig. 34).

Nguedia emphasized that, in terms of technique, the sculptor usually begins by blocking out with his adze a facepiece with bulging forehead. If the mask is to be feminine, he will take his knife and flatten the forehead. If it is to be masculine, he will take the knife and sharply cut down from the peak of the bulge toward the hairline and toward the eyes. This creates the effect of a thrusting protrusion.

For an outsider, the difference between gazes is a subtle point to appreciate, although one that does not trouble Pende critics. All masks look down in good civilized fashion, but if one looks closely, one discerns that on average the eyehole of the male masks is larger and that the eye-

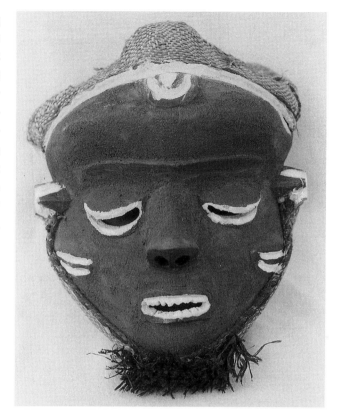

34. Nguedia Gambembo's MUBOLODI (male) mask. Nyoka-Munene, Zaïre, 1989.

lids are carved in a different fashion. On close examination, one can see that the feminine upper eyelid is rounder in form. The masculine equivalent is pulled down slightly in the direction of the mandibular angle (fig. 35). In the feminine version, the sculptor carves the upper lid at a sig-

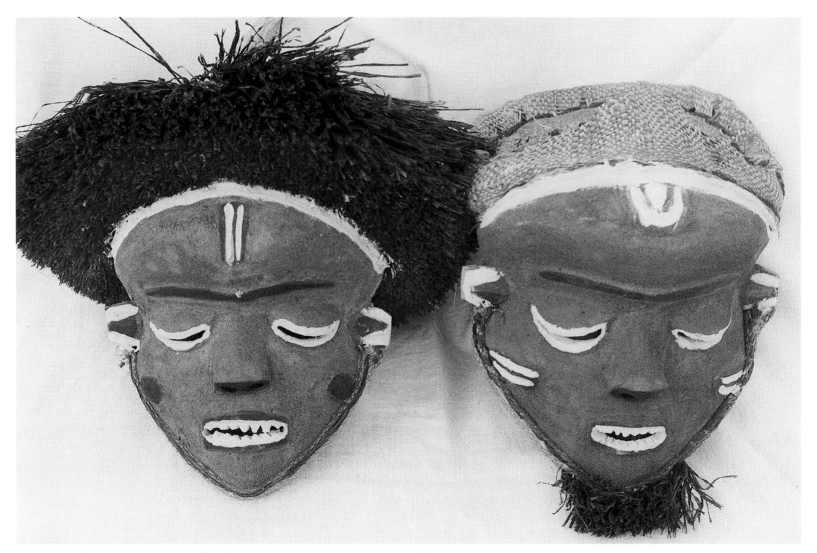

35. Nguedia Gambembo's GAMBANDA *(left)* and MUBOLODI *(right)*. Nyoka-Munene, Zaïre, 1989.

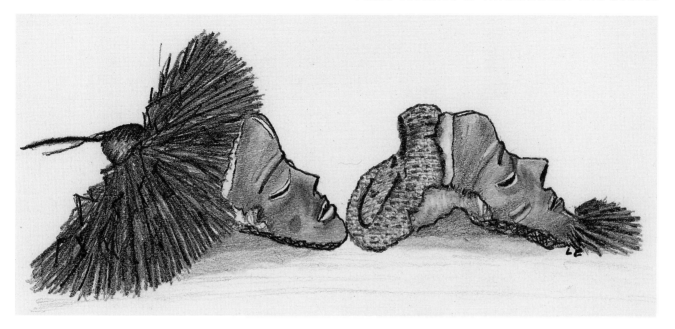

36. Nguedia Gambembo's GAMBANDA *(left)* and MUBOLODI *(right)*. (Sketched by Lisa Easton from photograph.)

nificantly more obtuse angle from the plane of the face, thereby reducing the eyehole in size and creating a more heavy-lidded, "seductive" look by leaving more flesh (wood) on the lid. Although Nguedia's handiwork is uneven, one can observe this treatment in the profile (fig. 36). Without question, the eyes, so important to physiognomic theory of gender, are the most difficult to carve.

As dean of the sculptors, Nguedia often criticizes how his "nephews" handle the cheeks and area around the nose in their masks, even taking a knife to their work to

correct it. He clearly regards these areas as critical to a correct physiognomy. On the mask MUBOLODI, Nguedia delineates the cheekbones more sharply. The sculptor achieves this effect by cutting down abruptly in a flat plane from the line of the cheekbones and excavating the "flesh" around the nose. In the feminine version, the sculptor rounds out the cheeks and leaves the "flesh" around the nose more raised (fig. 33). Nguedia also typically renders the masculine mandibular angle more acute. In the frontal view, the central hump of the mask's head-

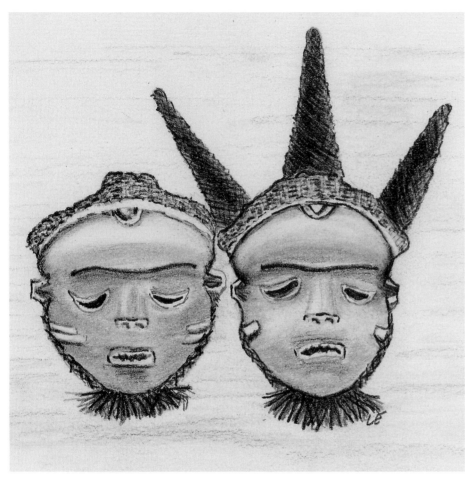

37. Nguedia Gambembo's MUBOLODI *(left)* and PUMBU *(right)*. (Sketched by Lisa Easton from photograph.)

piece and the addition of the beard (as Mashini noted) also enhance the impression of greater angularity in the composition (fig. 34). Nguedia emphasizes the soft roundness of GAMBANDA's cheeks with his choice of a round *pupu* cicatrice, whereas the lines that he chooses for MUBOLODI accentuate the sharpness of the line of the cheekbones. On the basis of the handling of the general shape of the face, it would be impossible to confuse the masculine and the feminine visages, even if the coiffures were removed.

In the other features, difference lies more in the degree of refinement. GAMBANDA's eyebrows seem finer because they taper slightly at the ends. The mouths are similar, although one can see in profile that MUBOLODI's protrudes farther (fig. 36). GAMBANDA's teeth are larger, creating the impression that MUBOLODI's mouth is open wider. MUBOLODI's nose is much larger. It turns up more, thereby revealing more of the nostrils. In regarding the profile, one can see why the feminine face is described as "straight" or "even" and the masculine as "lumpy."

If, however, we now compare MUBOLODI to PUMBU, the executioner (fig. 37), we will find that MUBOLODI looks positively feminine in comparison. The eyeholes on PUMBU's mask are enormous, his forehead bulges out farther, and his mandibular angle is more acute, creating a distinctive peanutlike shape. Although hard to see frontally, his nose and mouth extend much farther. The acute sharpness of the horns of his coiffure and of his receding

hairline can only enhance the sense of aggression and danger. The mask PUMBU always has a narrower face, thin and sharply chiseled. In this, the Pende agree with Shakespeare's description of Cassius in *Julius Caesar* (act 1, scene 2, lines 193–94):

> Yond Cassius has a lean and hungry look.
> He thinks too much. Such men are dangerous.

Even the slash on his cheek seems cruder and more aggressive than the double lines chosen for MUBOLODI.

Mashini

Mashini is at the height of his powers and confident of his ability to distinguish between the feminine and every degree of masculine. In comparing the foreheads of his GAMBANDA and basic male (as yet unnamed), one finds the gender unmistakable even though the masks are unfinished. Whereas the masculine forehead arches undisturbed, GAMBANDA's forehead rises a bit but then flattens out (figs. 38–39). Like Nguedia, Mashini adapts the forms of his cicatrices to heighten the effects of his sculptural volumes. GAMBANDA's broad, flat forehead is enhanced by the U form, whereas the blunted triangular arrows used on the masculine version call attention to the thrust of the forehead (fig. 40).

The difference in the eyes is quite clear here. GAMBANDA's eyelid is thicker on top and thinner on the bottom

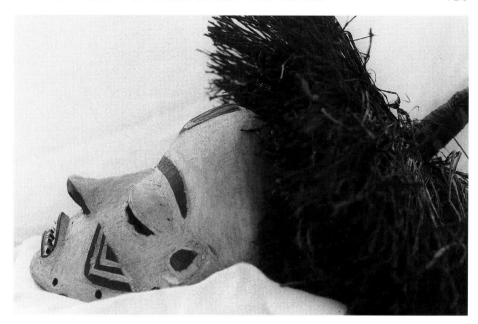

38. Mashini Gitshiola's GAMBANDA (female) mask. Nyoka-Munene, Zaïre, 1989.

because of the obtuse angle at which the lid was carved (fig. 40). It is this treatment of the upper eyelid that conveys the famous hooded gaze, *zanze*. Because the angle was less obtuse on the masculine version, the eyehole is somewhat larger, and the lids, although thick, project forcefully. This is a subtle point for Westerners to read but one fraught with symbolism for the Pende.

Mashini's style is quite distinctive in its angularity and clear separation of parts. He always uses cicatrices, whose shapes vary, on the cheeks to underscore the beauty of

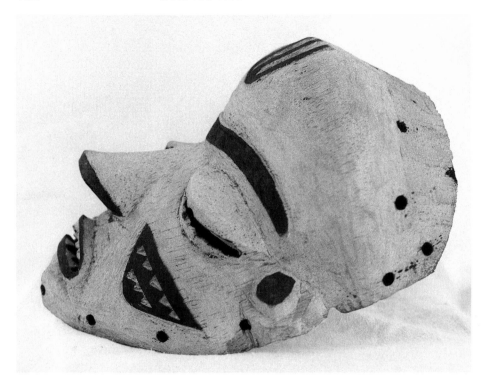

39. Mashini Gitshiola's basic male mask. Nyoka-Munene, Zaïre, 1989.

masculine counterpart's (fig. 40). Her nose, in profile, is more slender and refined (fig. 38). Despite his theories on the differences between the masculine and feminine mouth, there is no real distinction evident. The masculine version of the chin, however, is slightly extended to give him the longer face.

In Mashini's mask MATALA, all of the masculine features above are exaggerated (fig. 41). MATALA, the beautiful young man, falls into the class of the hyper-male. In Mashini's interpretation, the forehead bulges out even more, and the eyes have become significantly larger in overall size and in the size of the eyeholes. The plane of the face below the cheekbones is completely flat, and the chin distinctly pointed. His brow is refined, as befits his beauty, and yet pointed at the ends. The mouth extends a bit farther, especially the upper lip. As in Mashini's theory, the upper lip rises in the middle to form an acute angle (echoed by the lower lip) in order to convey the potential for aggression. Likewise his hairstyle, the *supi*, by jutting forward not only bounces nicely in time to the rhythms of the dance but also embodies the same thrusting symbolism.

Perhaps, the pièce de résistance in MATALA, however, is the nose. Mashini always takes great pride in its soaring distinction. It is indisputably retroussé, with a sunken bridge, and exposes enormous nostrils. One thinks of the Western physiognomists writing in praise of a large nose.

prominent cheekbones. The masculine face is narrower and hence appears longer and leaner. The broadness of the feminine face softens its lines and makes the cheeks appear rounder, plumper. Together, the broad, flat forehead and the soft cheeks on the feminine version convey a more peaceful mien.

GAMBANDA's brow is slightly less arching than her

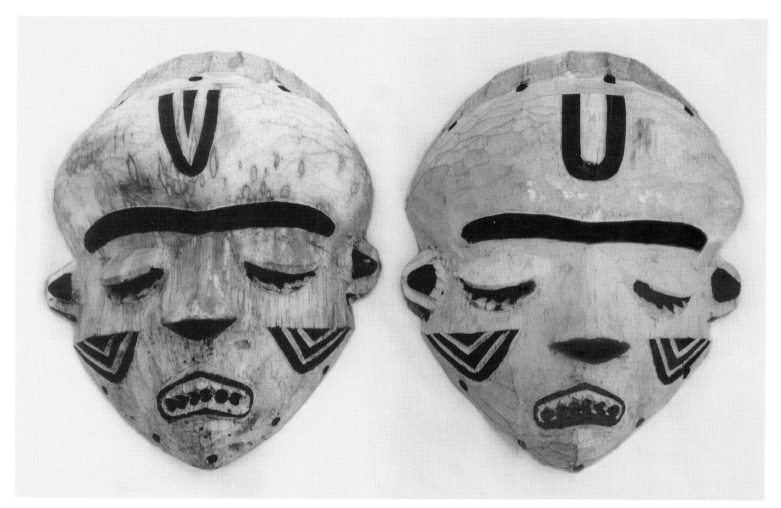

40. Male *(left)* and female *(right)* masks by Mashini Gitshiola. Nyoka-Munene, Zaïre, 1989.

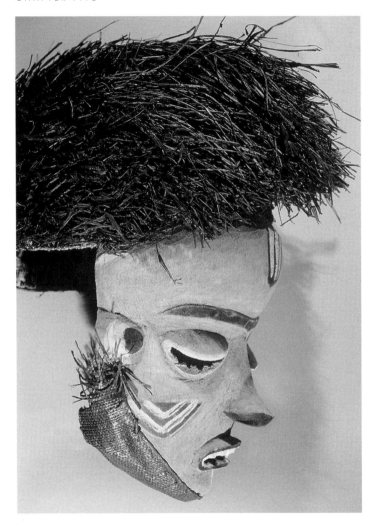

41. Mashini Gitshiola's MATALA mask (1989).

W. McDowall claimed that the Duke of Wellington "could scarcely have won Waterloo but for his nasal organ of fighting type and colossal size" (Cowling 1989: 149). The duke's rival for glory, both military and nasal, Napoleon, justified this connection of the nose with power by asserting that a large nose makes a man's respiration "bold and free, and his brain . . . lungs and heart, cool and clear" (Cowling 1989: 79).

Mashini claimed once that such a nose demonstrates the cleverness of its subject. His colleague Zangela justified a long nose along the lines of Napoleon, claiming that the more active dances, such as MATALA's, require more ventilation for the dancer inside; ergo bigger eye-, nose-, and often mouth-holes. There is a definite correspondence in the mind of the audience between the vigor of the dance and the vigor of the features of the face. The proud flip of MATALA's nose may also be deemed appropriate for a dancer who whirls, ducks, and spins. Whatever the argument, European or Pende, it is hard to ignore a sublimated phallic imagery.

Zangela

Zangela has the most personal style of any sculptor at Nyoka-Munene (fig. 17). Although Gisanuna and Mashini are the most admired, Zangela

has a large and steady clientele. He works the full range of Central Pende masks but has a special fondness and ability for the comedic characters. By examining his interpretations of the male and female clowns, one can see that the physiognomic code of gender operates even in the anti-aesthetic.

First, however, one should note that the clown masks were not originally worked in wood. The oldest villagers remember when both TUNDU and GANDUMBU wore sacks of raffia pulled over the head, with crude holes for the eyes. This was the ultimate anti-aesthetic, as crude as it was ugly. De Sousberghe witnessed some of the older type in performance when he did his fieldwork in the 1950s, although the form was already on its way out.

Nguedia recounts that a Belgian visitor suggested to Gabama and Gitshiola that they should carve the facepiece of TUNDU, the male clown, from wood and speculated that it would sell well. The sculptors were charmed by the idea. One invented the first type of wooden TUNDU with a blend of spite and wit (fig. 42). The protruding eyes are appropriated from whip-toting *minganji* (plate 1). The tubular, off-center mouth dangling a cigarette alludes to the character's ridiculous quest to be hip. The blackened face and smallpox scars mock TUNDU's delusions of seduction, for how could someone so scarred and ugly, and so ill-groomed

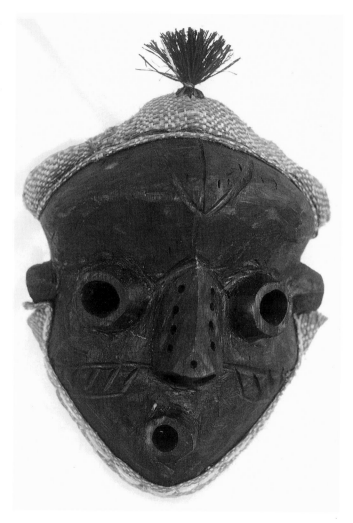

42. Nguedia Gambembo's reproduction of the first style of carved TUNDU facepieces. Nyoka-Munene, Zaïre, 1989.

as not to use redwood powder on his skin, hope to win the favor of a beautiful, young girl? Those aggressive eyes, and the links with the *minganji*, reveal that the clown falls into the category of hyper-male. One of his functions is crowd control, and he will fly in a moment from entertaining to stampeding errant children in order to get them to respect the limits of the dance arena.

The story of this mask is an interesting tale of the interrelationship between the Western and African art worlds. While the initial suggestion for a wooden-faced TUNDU came from a Belgian, both sculptors and audience have adopted the wooden facepieces enthusiastically. Dancers now would never choose to return to raffia hoods, and one can scarcely exaggerate how much the sculptors enjoy vying with each other (and themselves) in producing the *ugliest* face imaginable.

The first TUNDU prototype has long been left behind, and sculptors like Zangela seem to be working out the conceptual antithesis to their idealized masks. The wooden TUNDU was such a hit that the sculptors soon decided to give GANDUMBU, the female clown, a wooden face as well. In responding to the Belgian's desire, Gabama or Gitshiola was only following the time-honored custom of doing one's best to give concrete form to the client's vision.

In figure 43, Zangela expresses the sheer ugliness of TUNDU by caricaturing the features of the hyper-male. The entire forehead bulges forward as a pronounced lumpy mass. The eyes are enormous. The lids are pulled over as far as the mandibular angle. Their ridging calls attention to their projection outward. The cheekbones are acute. The nose is gargantuan but turns up incongruously to expose lamentable nostrils. The mouth, small and dainty on Pende masks, has become TUNDU's largest feature. It has even subsumed his chin! The cheekbones are left deliberately asymmetrical to accentuate his self-satisfied smirk. Zangela has left some of the faceting of the adze show through in the forehead and nose, rather than smoothing it over with his knife, in order to allow the blunt carving to stand as a metaphor for TUNDU's notorious lack of attention to proper grooming.

To see how far we have come, contrast this object to that other arch-hyper-male PUMBU (fig. 56). The second artist has carefully burnished the surface of the entire sculpture and carved each feature with crisp delineation. PUMBU's forehead rises only in the middle. The eyes and nose are pulled out but are proportionately quite small. Although both facepieces express an extreme of masculinity, PUMBU's version is beautiful and socially sanctioned; his dance, controlled and measured. This is what Chief Nzambi meant when he spoke of the correspondence of dance and visage. Can the viewer doubt that the visual excess of TUNDU's form is not a clue to the visual excess of his dance, in which he will grab the breasts of the feminine masks, masturbate, imitate coitus, mock all

and sundry, and generally do any outrageous thing he can dream up? Meanwhile, the crowd will respond by chanting, *"Wabola!"* (You're ugly!).

The evolution of GANDUMBU's face is particularly interesting because historically the feminine has had only one aspect: the ideal. No parallel to GANDUMBU exists among the Eastern Pende. Lately, in addition to the physiognomy of gender, sculptors have been evolving a physiognomy of age. In addition to GANDUMBU, the old widow, new masks have also developed representing the young man, such as MATALA and GINDONGO (GI)TSHI?, which take inspiration from the widespread masks featuring the young woman.

If the masculine anti-aesthetic is expressed through the *exaggeration* of its distinguishing features, Zangela chose to burlesque the feminine through age, that is, through the *deterioration* of its forms. To the Pende, an old man is dangerous, no matter how gifted a comic he may be. In contrast, a crotchety old woman is merely amusing.

Everything about GANDUMBU sags: her eyes, nose, mouth, and cheeks (fig. 44). Her mouth is toothless with age. Even in their extreme forms, however, she and TUNDU still remain true to the code of gender physiognomy. Overall, her face is

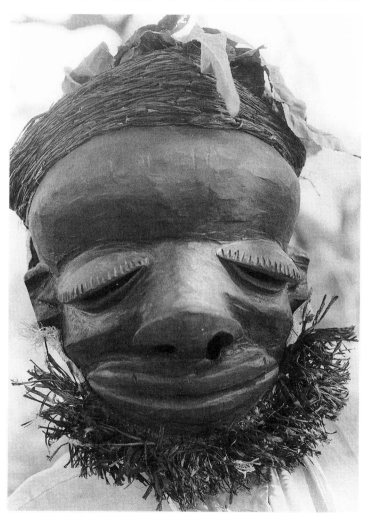

43. Zangela Matangua's TUNDU mask (male). Nyoka-Munene, Zaïre, 1989.

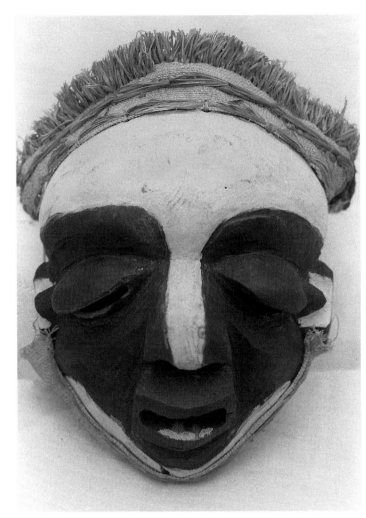

44. Zangela Matangua's
GANDUMBU mask (female).
Nyoka-Munene, Zaïre,
1989.

much smaller than TUNDU's and it is broader (GAN-
DUMBU, 9 × 6.75 inches; TUNDU, 10.75 × 7.25 inches).
The rest of her face may be sliding, but she retains a
beautifully rounded and flattened forehead, espe-
cially in contrast to TUNDU's "lumpy" one. Her nose
is rounded down at the tip so that we cannot see
underneath clearly, whereas TUNDU's tilts up
expressly to reveal his own gigantic nostrils. Her
mouth is well proportioned, even though it now
droops, and has none of the effrontery conveyed by
that organ on TUNDU. The flesh has sagged down
comically under her cheekbones, creating a curve,
but the overall shape of the face is well formed.
Zangela's style favors large eyes for both the mas-
culine and the feminine, but if one compares TUNDU
and GANDUMBU, one sees that TUNDU's lids project
out and GANDUMBU's incline down. Hers are comi-
cally enlarged but still recognizably feminine. One
has the impression, in fact, that GANDUMBU was
once a beauty. In Zangela's conception, GANDUMBU
is an aged GAMBANDA, whereas TUNDU is himself,
born as outrageous as he is outlandish.

Khoshi

Khoshi is a brilliant character dancer and recog-
nized as one of the finest Pende performers living
today. Of late, he has taken to sculpting for a living.

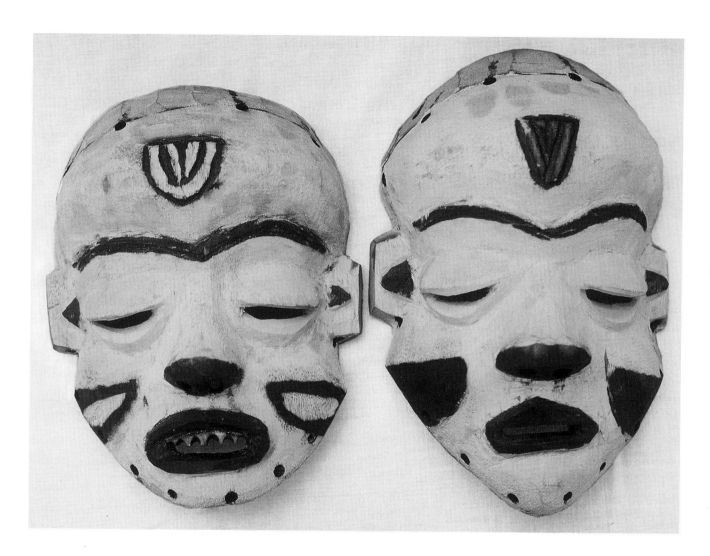

45. Female *(left)* and male *(right)* masks made by Khoshi Mahumbu for the tourist market. Unfinished. Nyoka-Munene, Zaïre, 1989.

While he makes many of his own masks, and sometimes fulfills commissions for other dancers, he works primarily for the foreign trade. At his best, his masks have a certain expressive charm, but he usually is in too much of a hurry to produce refined specimens. He cuts corners. To save time and expense, he reduces the size of the masks and reduces their coiffures, thereby conserving wood and raffia thread. He does not worry if the proportions do not come out right the first time. As Léon, nicknamed "the factory," likes to point out: the sculptor does not receive a penny more for a finer product in the trade to Kinshasa. Khoshi is the litmus test. How does a code of physiognomy manifest itself in a production sculptor?

In figure 45, the masculine and feminine may be less refined, but they are definitely recognizable. The female forehead (on the left) is flatter, although one sees this in the hairline rather than in profile. The feminine has a level, slightly rounded hairline, in contrast to the conical rise of the masculine version. Khoshi takes the easy way out, dealing with line rather than mass.

The differences in the eyes are quite subtle. The masculine version has slightly larger eyeholes. The lids are pulled over farther toward the sides, hence project more. The edges of the upper lids are handled differently on the two examples. The lids on the feminine mask have been tapered down. The nose on the female version is smaller. The nose on the masculine version is broader, more retroussé, with larger nostrils. In comparison to the work of other sculptors, these distinctions are not easy to discern.

Production sculptors rely most on the shape of the face to convey differences in gender. Khoshi has given the feminine an oval silhouette with chipmunk cheeks. This is the "swollen or plump face" (pala ya gibutu-butu) that Khoshi described earlier as part of the feminine ideal. In contrast, the masculine face has a definite peanut shape because the cheekbones are acutely angled and the chin is long and pointy. Conforming to Khoshi's ideals, the male has a "long face" (pala ya yala yaleha) with "protruding cheekbones" (khokhono jia mala jia lundamana).

Although the mouths are not significantly different, Khoshi is true to his personal aesthetic of teeth in feminine masks. He said that the one thing that he regretted on the feminine mask was the treatment of the eyebrows, which should have been finer and more level. It is the masculine mask that should have wide and arched eyebrows.

Relying on overall shape more than some sculptors, Khoshi nevertheless successfully maintains the physiognomy of gender outlined in this chapter. What he proves is that this code of physiognomy is far more than an embellishment; it is an essential rule book that the sculptor must master in order to perform his craft. Nowhere does this become clearer than in the criticism that Pende aesthetes bring to bear on the quality of art objects.

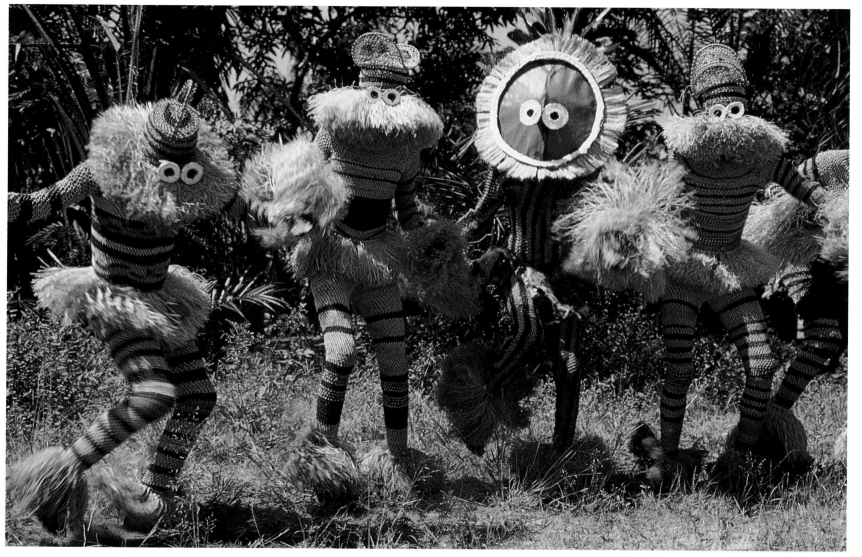

1. Pende *minganji* masqueraders, near Gungu, Zaïre. (Photograph by Eliot Elisofon, 1970. Courtesy of the National Museum of African Art, Eliot Elisofon Photographic Archives, Smithsonian Institution, Washington, D.C.)

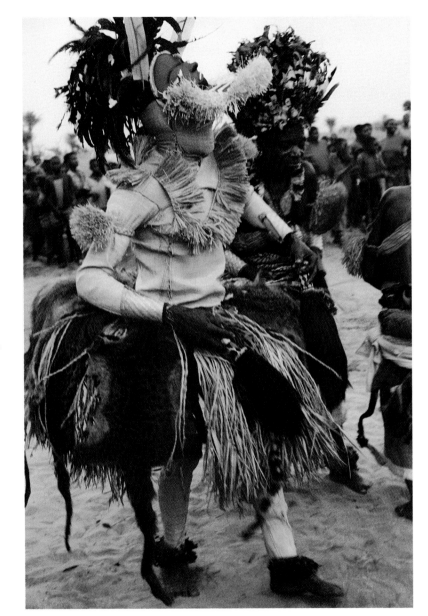

2. The performer Masuwa dressed as the mask MUYOMBO. Note the furs and raffia braids piled high on the hoop. Nyoka-Munene, Zaïre, 1989.

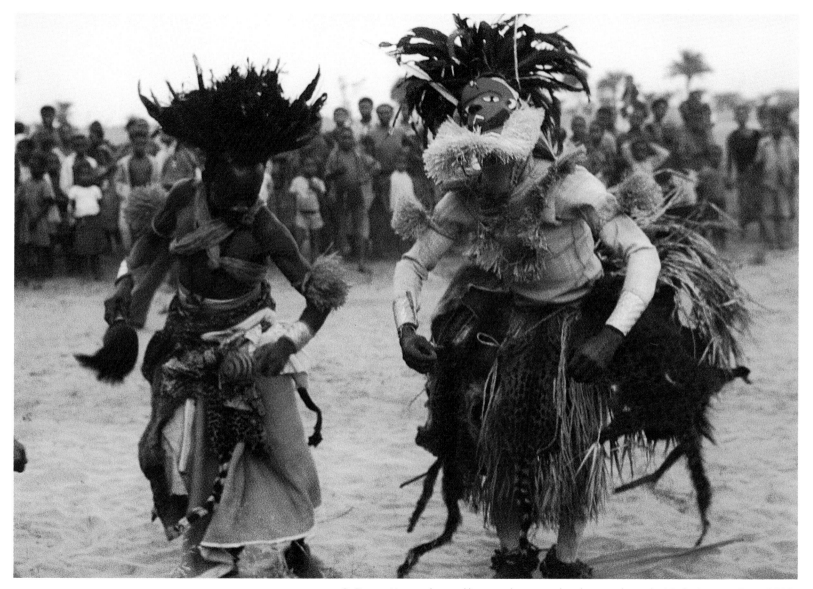

3. Dancer Masuwa honored by an audience member dancing alongside. Nyoka-Munene, Zaïre, 1989.

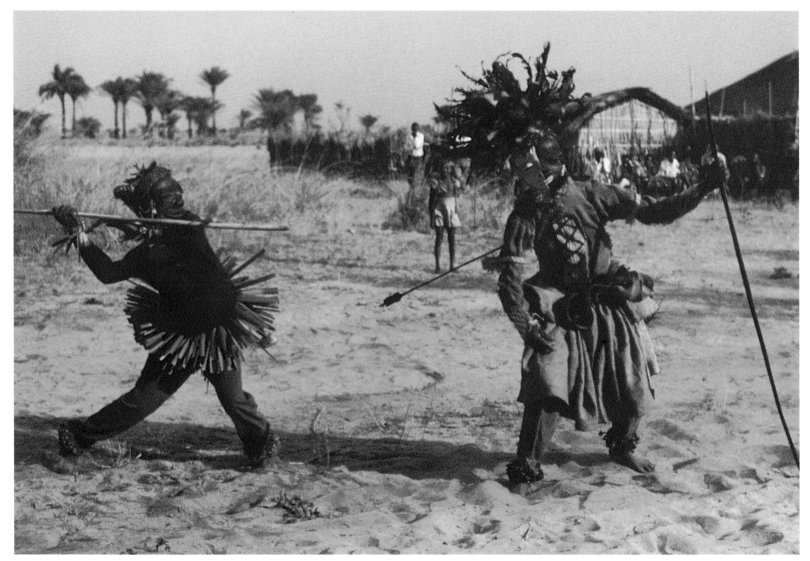

4. Khoshi Mahumbu performs MBANGU (on the right), demonstrating the mask's distinctive dance with "feints" to either side. On the left, the clown mask, TUNDU, parodies MBANGU by using his cane to suggest arrows still flying at this victim of sorcery. Nyoka-Munene, Zaïre, 1989.

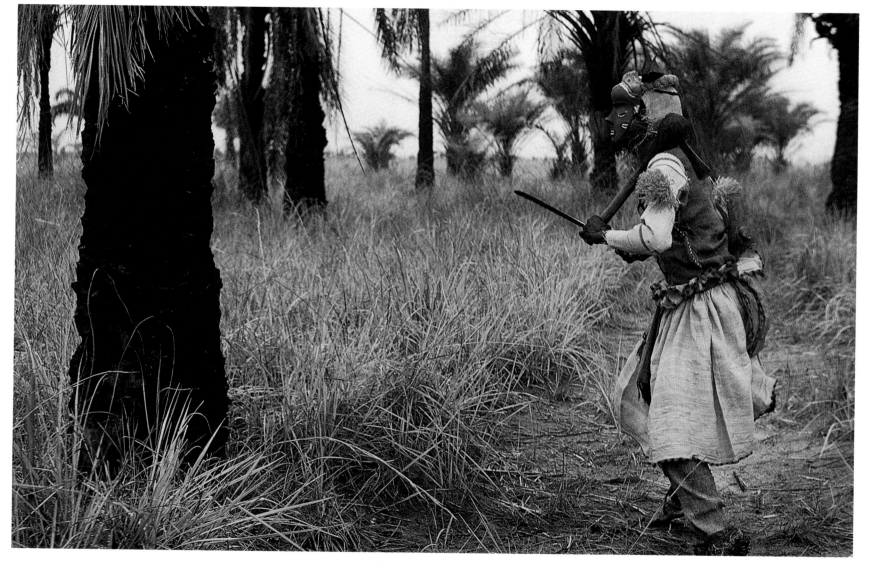

5. Khoshi Mahumbu dances MUBOLODI, a mask that mimics chopping down a tree. Nyoka-Munene, Zaïre, 1989.

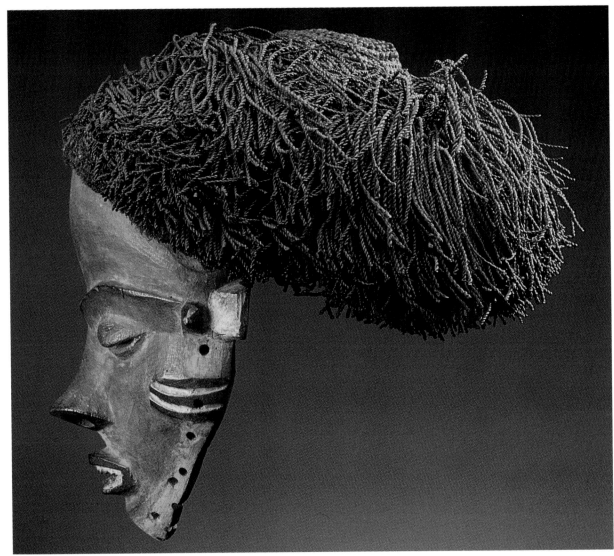

6. Profile of a female mask collected in 1934 by Territorial Administrator Maurice Matton. The visual equivalents for contained and controlled movements in dance are features that are rounded and smoothed on a shallow facial plane. (Private collection. Photograph by Franko Khoury. Courtesy of the National Museum of African Art, Smithsonian Institution, Washington, D.C.)

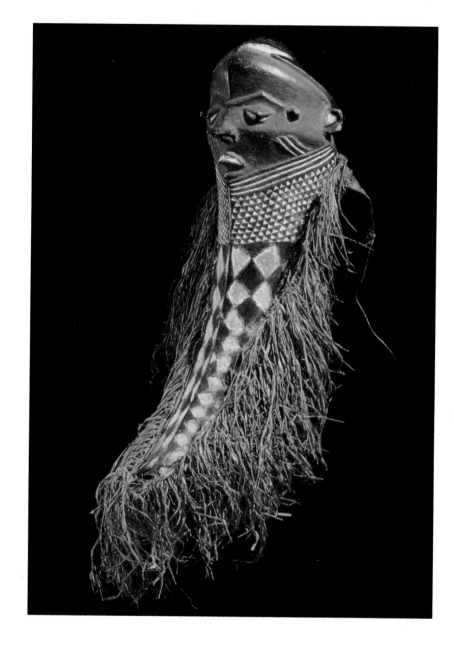

7. GIWOYO mask. L. 71.1 cm. (Photograph by Jeffrey Ploskonka. No. 85-15-5. Courtesy of the National Museum of African Art, Eliot Elisofon Photographic Archives, Smithsonian Institution, Washington, D.C.)

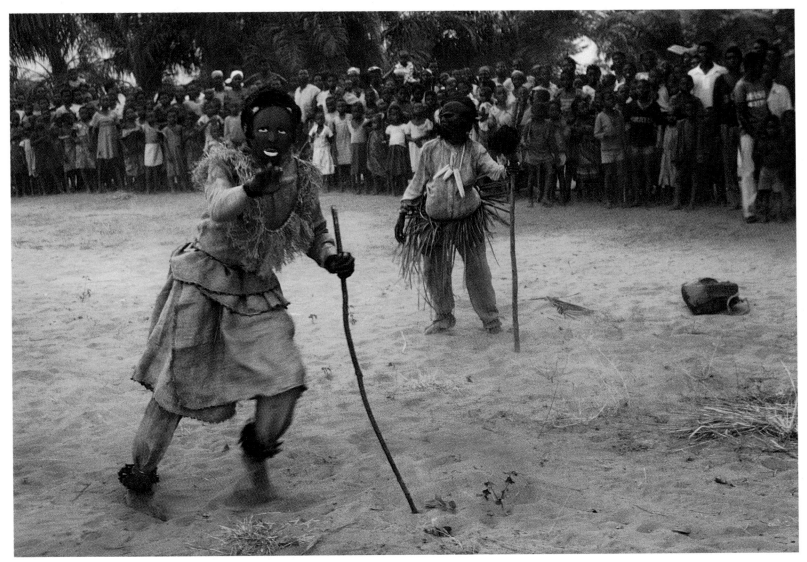

8. Gambetshi Kivule performs the mask GINDONGO (GI)TSHI?. The clown, TUNDU, lurks nearby. Note his gesture indicating (in time to the song) the question, "Are we of the same generation?" Nyoka-Munene, Zaïre, 1989.

PART III. CRITICISM

For the purpose of exploring aesthetic criteria, I carried around a sheaf of photographs, largely derived from the Africa-Museum in Tervuren, Belgium, which holds the largest collection of Pende art in the world. For a long time, whenever I asked people to choose the best pieces or to judge the quality of various objects, I invariably provoked a long silence. After observing the importance of the physiognomic conventions to the sculptors at Nyoka-Munene, I changed my method. Instead of one big pile, I separated the images into male and female and then asked field associates to select the best masculine or feminine forms *(pala ya mala yabonga yabalega, pala ya mukhetu yabonga yabalega)*. This time around, I could hardly stem the voluble responses or write them down fast enough. On this subject, everyone is an expert.

Several general favorites emerged and their criticism is quite revealing. The most popular entry in the "best masculine" contest was the Tervuren PUMBU (fig. 56). This mask may have been given an unfair advantage because "best masculine" and "most masculine" are synonymous in Kipende, and PUMBU must always win as "most masculine." Nevertheless, the appreciation of its form was overwhelming.

Zangela praised the protruding forehead *(mbombo yalundamana)*, the wide-open eyes *(meso a uhululu)*, and the nose, which turns up to show the nostrils *(muzulu, miheho ya gupaluga)*. He could not say enough to praise the handling of the mouth: "The mouth of a man must be like an angry person."[25] "[It has] a pouting mouth like PUMBU [should have]."[26] "The upper lip is triangular [raised]; women have lowered [straight] lips."[27]

Mashini admired the eyes: "The eyes are really open. The gaze is dangerous, well open."[28] He was also transported by the mouth: "His mouth is open like someone speaking in anger."[29] He singled out the "forehead furrowed" *(mbombo ya gufunya)* as in anger and the eyebrows arched *(inzumbu ya gukanduga)* as when the eyes open wide in anger. Finally, he praised the handling of the receding hairline for PUMBU, with its sharpened form.

Khoshi also admired the PUMBU for its hyper-masculine characteristics. "A man's forehead sticks out like a billy goat's; it bunches up [lit. "wrinkles"] as if he is angry."[30] "The nose is large like a big horn with a large hole."[31] "The eyes are large."[32] "The eyebrows are bushy."[33]

As a separate genre, that of the chief, one mask was also singled out for enthusiastic praise (figs. 29–31). As noted earlier, Nguedia, Mashini, and Zangela independently identified this facepiece as the indisputable work of Gabama. Nguedia gave an appreciative grunt with that superlative of Pende praise: "He knows [how to carve] masks."[34]

Zangela and Mijiba commended the work for having

46. The renowned Eastern Pende sculptor Kaseya Tambwe at work on a female statuette for the chief's ritual house, 1974. (Photograph by Nestor Seeuws. No. NS 74.752. Courtesy of the Institut des Musées Nationaux du Zaïre.)

"the face of a woman" *(pala ya mukhetu)*. Zangela particularly admired the handling of the mouth: "A man's mouth rises up, but his is less [acute], because his face shows coolness [calmness] like the face of a woman."[35] It is a mouth midway between male and female (fig. 29).

In the female figures, the big surprise came in the excited appreciation rendered to a statuette carved by the Eastern Pende sculptor Kaseya Tambwe (fig. 46). While there are serious problems in comparing statuettes to masks, the criteria applied in praise are interesting. Nguedia praised the hooded eyes *(meso bobe)*, the straight nose *(muzulu wabatamana)*, and particularly the straight mouth *(ivungu ya gubandesa)*. Khoshi felt that the eyes were just about perfect: "The eyes have a good gaze,"[36] "her mouth is truly that of a woman,"[37] "the chin is short," [38] and "her forehead is good."[39] Zangela praised the nose, mouth, and chin for similar reasons. In addition, he commented on the low cheekbones *(mabutu mu mbongo)*, the

fine brow *(inzumbu yazonda)*, and the open ear *(ditshui dia gukangula)*.

In comparing the female works, Mashini dismissed one for its "dangerous eyes; it is not a mask representing a woman."[40] He hypothesized that the dancer, short of time, had taken a male mask instead and added a woman's coiffure. Kaseya's eyes, on the other hand, are superlative. "The eyelids are lowered [or cool] as in a cool gaze. Bedroom eyes!"[41] He noted that the mouth must be very different in a statuette, which is not pierced, but approved Kaseya's form. The nose also was superb: "a little straight nose" *(gamuzulu gala tonono)*. Along with its size, he approved of its proportions. He discerned that Kaseya followed Mashini's own rule that the nose should be the same length as the forehead.

From the sculptors' responses, it is clear that knowledge of physiognomic conventions is critical to any evaluation of a mask's quality. The artists judged the objects by how well their authors achieved the ideals expressed in the four categories of feminine, masculine, feminized masculine, and hyper-masculine. Notably, they were equally comfortable in applying these criteria to figural sculpture.

CONCLUSION

Physical and forensic anthropologists claim over 85 percent accuracy in sexing skulls (Krogman 1962: 118–19;

Shipman, Walker, and Bichell 1985: 271). Three of their most reliable indicators in identifying male skulls are pronounced ridges over the eye sockets (supraorbital torus); more massive jaws, with a posterior root that may extend beyond the earhole; and a squarer chin (Bass 1971: 72–74; Brothwell 1981: 59–61; Krogman 1962: 116–19; Shipman, Walker, and Bichell 1985: 271–74).[42] The result is that the female profile is more vertical, with a smoother, rounder forehead. Because of the ridge over the eyes, the larger mastoid projections, and the blunt chin, the male face tends to be squarer in shape. The female face tends to be more oval (fig. 47).

The ambitions of Central Pende sculptors extend beyond sexing masks to rendering gendered ontologies. Their comments make clear that good sculpture is judged by how it *abstracts from physical data* to express deeper truths. Central Pende sculptors (who never refer to skulls) have chosen to emphasize the projecting ridge over the eyes that is only sometimes discernible in the fleshed-out male face. To enhance visual legibility over distance, they have transformed that ridge into a bulging protrusion. In contrast, they render the male chin as angular as the female's, despite striking physical data to the contrary. They have fused the cheekbones with the jaw and turned out the ears frontally. The "oval" nature of the female face is conveyed by slightly blunting the angle of the fused cheekbones/jawline. Increasing

47. "Sexual differences in the skull: *(left)* female and *(right)* male. Males have a more pronounced supraorbital torus, larger mastoid process, squarer chin, and stronger muscle markings on the temporal line and nuchal crest." (Fig. 15-10, p. 273, from *The Human Skeleton* by Pat Shipman, Alan Walker, and David Bichell, Cambridge, Mass.: Harvard University Press, copyright 1985 by the President and Fellows of Harvard College. Drawn by David Bichell.)

there should be a harmony between the dance and the face. Scholars have commented on how the "hot" and "cool" polarization of the sexes structures highly gendered body language in dance. In cultures where females are presumed cooler, "hot" masquerade performance has been equated with a "wide stance," broad gestures, unexpected changes of direction, whirling movements, speed, and high-energy outbursts of dance.[43] For the Pende, "cool" dance is slower in tempo and is performed either on one spot or through a stylized walk. For the Yoruba, Drewal and Drewal have observed that "cool" female dances are distinguished more by a "greatly restricted use of space" than by a difference in energy level (1983: 138).

When scholars have sought to apply African conceptions of "coolness" to African sculptures, they have fallen back on English, where "coolness" is a function of expression—or the lack thereof. At best, "cool" is described as "composed"; at worst, "aloof." The orientation metaphor of closed/open (i.e., protruding) that dominated the discourse of Nyoka's sculptors suggests instead that the hot/cool dichotomy is expressed primarily through *sculptural volume* rather than expression. In the face, the visual equivalents for broad, erratic movements of dance are protruding masses—in the forehead, nose, eyelids. As a large mass, the forehead becomes a particularly good indicator for propulsive aggression (fig. 55). The equivalents for contained and controlled move-

degrees of maleness can thus be conveyed economically over a distance by sharpening the angle of the cheekbones and of the eyelids, by pulling out the nose, and by squeezing the blunted diamond of the face at the ears to create a dynamic swelling and receding form. Most of these interpretations relate to Pende understandings of the genders as "cool" or "hot" in essence.

In masquerade, Pende commentators emphasized that

ments are features rounded and smoothed on a shallow facial plane (plate 6). The "hotter" the dance, the more protuberant the volumes. The more refined the gestures, the smaller and more clearly articulated the features. This is what Pende connoisseurs mean by insisting that one should be able to *see* the dance in the face. We can now understand why the inventors of the one-armed mask (see chapter 2) were careful to perform their new dance for Gabama. It was the sculptor's task to give the audience a perfected vision in which movement and inner character were stamped on the face through his mastery of physiognomic theory.

CHAPTER SIX

Learning to Read Faces, Learning to Read Masks

The physiognomic vocabulary provided by the sculptors in chapter 5 not only enables us to "read" Pende faces; it also supplies us with a key to individual artistic expression. Just as one must be familiar with the language and goals of the Abstract Expressionists or the Blaue Reiter in order to fully appreciate their works, so one needs to understand, "to speak," the formal language employed in Pende art. To illustrate this point, we shall consider three different artists' interpretations of masks within the same genre in the light of the physiognomic theory detailed by the sculptors at Nyoka-Munene.

MBANGU

Mbangu, the bewitched, is one of the most widespread of masks among the Central Pende. At Nyoka-Munene, it dances to the following song:

> *E e e, e e e, e e e*
> *Dibanda Mun'a Mbangu,*
> *Tuana [gu]laba gutala.*
> *Nganga jiamulowele.*
>
> Dibanda Mun'a Mbangu [name],
> We look on [unable to help].[1]
> The sorcerers have bewitched him.[2]

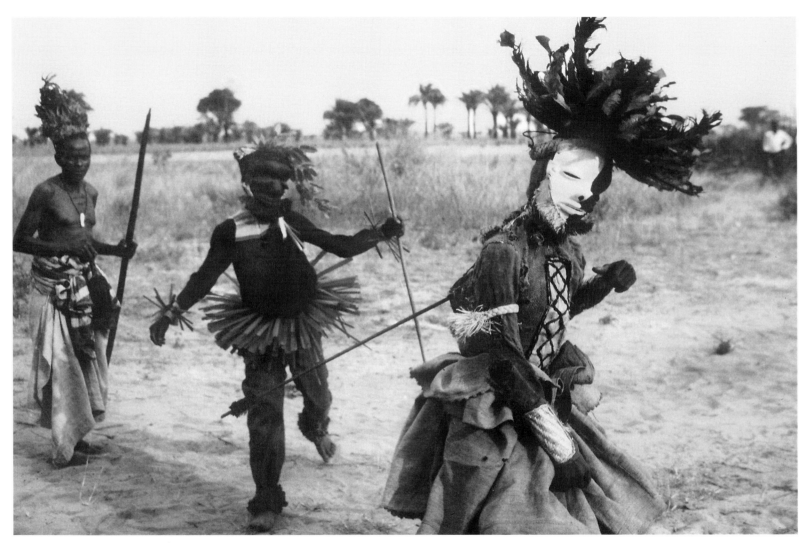

48. Khoshi Mahumbu dances the mask MBANGU. Note the arrow piercing the masker's humpback. Nyoka-Munene, Zaïre, 1989.

The masker wears a humpback from which an arrow extends (fig. 48). The arrow refers to the common metaphor of sorcerers "shooting" their prey with metaphysical arrows when they cast their spells. The metaphor communicates the perception of sudden onslaught in illness or misfortune. We say, "It came out of the blue." It is not infrequent for people to experience visions of a spectral figure shooting them with an arrow (or, in the modernized version, a *calibre douze* rifle) moments before they fall gravely ill in a coma or seizure. The arrow echoes the theme of the song: Mbangu has been bewitched.

The dancer sometimes carries a bow and arrows himself, seeking to "shoot back" at the man who attacked him. Mbangu dances, stamping twice with one foot and then lunging to that side, jerking downward with his knee *(ukatula)* and raising the shoulder on the same side *(papu ya koko)* (plate 4). The master dancer Khoshi Mahumbu, who began performing Mbangu in 1947, interprets this gesture as a feint intended to dodge the arrows of his assailant. In this metaphor, Mbangu is wounded, but he is struggling to prevent the sorcerer from finishing him off. Under his costume, Mbangu wears the wooden bells carried by hunting dogs. Their distinctive sound acts aurally to accentuate the feints of his dance and also symbolically to underscore the life-and-death struggle taking place:

Mbangu is both hunted and hunter as he searches for the sorcerer who disabled him.[3]

In a common interpretation, Mbangu's face, half black and half white, testifies to the scars of someone who fell into the fire. For warmth, people huddle and sleep around a fire. Even today, it is possible for the drowsy to burn themselves. Epileptics and the mentally ill are particularly vulnerable to serious mishaps, and the kind of supranormal dulling of the senses leading up to such an accident is characterized as the "product of sorcery" *(ima ya aloji)*. As Ndambi Mun'a Muhega posits the situation: "Mbangu was born healthy. One day sorcerers came—to do what? To bewitch Mbangu. Mbangu fell into the fire on the hearth. . . . One side was unmarked; on the other, the fire burned the skin. Then they treated him, they put medicines [on the wound] so that a scar stayed black."[4]

Mbangu is a mask that challenges us to consider our relationship with the ill and disabled. I have referred to it as "the bewitched" because of the references to sorcery in the song and in the dance; however, since the Pende worldview attributes almost all illness and personal misfortune to the malice of others, what is really at issue is chronic illness or disability and our response to it. The outlook is not hopeful: "We look on [unable to help]."

Mbangu is an old mask among the Central Pende, and the genre is easy to identify because of the unique half-

black, half-white face. Let us now consider three different artists' interpretations of the genre in order to observe how individuals may profit from physiognomic conventions to express personal insights.

Interpretation 1

The sculptor of a facepiece in Berlin (fig. 49)[5] has chosen to stress pictorially that MBANGU, the bewitched, the disabled, is himself a sorcerer. The widened eye-slits and the long, narrow face with jutting forehead and angular exaggeration of the cheekbones (lending a peanut shape to the face) will all be familiar to the reader from the previous chapter as the physiognomy of the hyper-male, and specifically, in this extreme form, of the sorcerer.

By this interpretation, the artist blames MBANGU for his own misfortune. In Pende society, as in our own, this is not an uncommon attitude. We have psychological theories accounting for the "accident prone," some speak of rape survivors having "wanted" or even having "deserved" their misfortune, and sometimes we account for disasters as punishment for past sins.

In Pendeland, serious physical challenges are usually linked to someone's bid for wealth or power. In the town of Kombo-Kiboto, for example, people frequently point to the plight of one man suffering

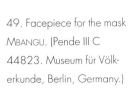

49. Facepiece for the mask MBANGU. (Pende III C 44823. Museum für Völkerkunde, Berlin, Germany.)

from a spinal deformation and humpback as a cautionary tale. The victim himself cheerfully recounts how he once was a nimble and incorrigible livestock thief. As he understands it, after issuing repeated warnings, the chief at last gave the "green light" to local sorcerers to strike (probably with polio). He spared the young thief's life but efficiently deprived him of the agility necessary to continue his thefts. In this case, the victim enjoys a certain peace of mind because he has acknowledged that he was acting outrageously and needed to be stopped.

In this interpretation, by rendering MBANGU as a sorcerer himself, the artist may well be delivering a popular moral counsel equivalent to Christ's caution: "[A]ll they that take the sword shall perish with the sword" (Matthew 26:52). MBANGU's dance, *with this face*, is a lesson that those who seek illicit power through sorcery risk being struck down themselves one day.

Interpretation 2

Another frequent response to the disabled, the infirm, and the elderly is simple mockery. By their disadvantages, they make us aware, and even proud, of our own strength and capacities. Significantly, it is comedic dancers who are drawn most often to perform MBANGU, and one of its most common incarnations is as a comedic mask.

Comedy is clearly the artist's intent in figure 50.[6] Frequently, sculptors depict MBANGU with a face pulled down on one side by a paralysis of the facial nerve.[7] Victims of such a palsy lose control over all their facial muscles on one side of the face. The neurologist Dejong describes their appearance: "The affected side of the face is smooth, there are no wrinkles on the forehead, the eyebrow droops, the eye is open, the inferior lid sags, the nose is flattened or deviated to the opposite side, and the angle of the mouth may be depressed" (1979: 186). Dyken and Miller add that the relaxed muscles make the cheek look flaccid (1980: 300). Although the drawing in their text deliberately exaggerates the symptoms of the condition (fig. 51), they stress that at rest there usually is no more than "a mild asymmetry" evident to the eye (300). It is when the victim tries to talk or change expression that one becomes aware of the problem. Facial palsy is fairly common because it can result from myriad conditions, including brain hemorrhage, tumors of the base of the skull, middle-ear infections, syphilis, leprosy, diabetes, and mumps (Haaf and Zwernemann 1975: 48; Dyken and Miller 1980: 300).

Bell's palsy, a common form, is particularly associated with the middle-aged to elderly (Gilroy 1990: 356). MBANGU's coiffure places him squarely in this age group. He usually wears a *gifuatu* hat with feathers from the guinea fowl, coucal, or great blue turaco (de Sousberghe 1959: 43) (plate 4). More rarely, the mask dances with *lumbandu* (leaves worn on the crown of the head). The

51. An example of facial palsy. (Courtesy of Paul Dyken and Max Miller. Dyken and Miller 1980: 85, fig. 4-2.)

50. Facepiece for the mask MBANGU. (Courtesy of the ethnographic collection, Katholieke Universiteit, Leuven, Belgium.)

effects of Bell's palsy are usually transitory, but the prognosis for other forms varies. It is another malady inevitably attributed to the intervention of sorcerers, who are believed to have "snacked" on the twisted side.

In the piece under consideration, the sculptor has also carved small holes over the mask's entire left eyelid. Such small holes represent smallpox scars and appear on comedic masks like TUNDU with the express purpose of rendering their subject as ugly as possible (fig. 42). These holes, however, normally appear on the nose or cheeks of the mask. In the case of MBANGU, because of the twisting of the face, they would be lost on the reduced surface of

the nose and cheek. The artist uses their position on the eyelid to increase the visual complexity of his composition by adding a note of asymmetry to the mirror reflection of the two eyes.

What renders such a mask comedic rather than tragic is the free exaggeration of its forms. The blunting of the nose, the loss of the brow (always a centerpiece in the *mbuya jia ginango,* "the masks of beauty"), and the sly smirk of the mouth practically pulled over to the jawbone act to caricature MBANGU and to distance the viewer from his plight. Pende masks usually demonstrate a grave demeanor constructed by balancing the strong horizontal line of the eyes with a strong vertical built around the nose. The sculptor plays with the convention here by reifying the invisible centerline where we do *not* expect it: in the forehead (with the rigid division of black and white). He then perverts it wildly in the nose, just where we *do* expect to find it. By displacing the center of balance, the sculptor renders MBANGU less than human. He becomes cartoonish and his behavior the subject for laughter. De Sousberghe recorded the following song used for the mask at Gungi (1959: 43): *"Gibola-bola, mazulu ahenga"* (very ugly thing [with] twisted nose). As they do for the clowns TUNDU and GANDUMBU, in this version the singers call MBANGU to the dance floor with raucous insults.

Interpretation 3

The third rendition of MBANGU that we shall consider (fig. 52) is one of the great masterworks of Pende art surviving in museum collections. Its exquisite composition has made it a favorite comparison to *Les Demoiselles d'Avignon* (figs. 53–54) for those critics grappling with the nature of Picasso's understanding of African forms (Rubin 1984: 264–65; Samaltanos-Stenström 1987: 66). In discussing another Pende work, William Rubin eloquently captures what is so appealing to Westerners in these masks: "In sculpture, there are two things that are essentially alien to one another: volume and surface linearity. . . . The two things are in opposition. The surface belongs more to drawing, and the other—mass—is more proper to sculpture. What I think is so nifty in this Pende mask is the way in which intense mass and surface drawing are made to cohabit" (1987: 60).

Rubin's observations are also very apt for the MBANGU mask under examination (fig. 52). The crisp articulations of the brow, eyelids, nose, mouth, and cheekbones may all be read as linear, and yet their position at the frontiers between volumes makes them essential to the perception of the latter. The tension between volume and line is extraordinary. The artist also shows a profound inventiveness in playing forms off each other in the face. The arching brow becomes thin and refined on one side, broad and

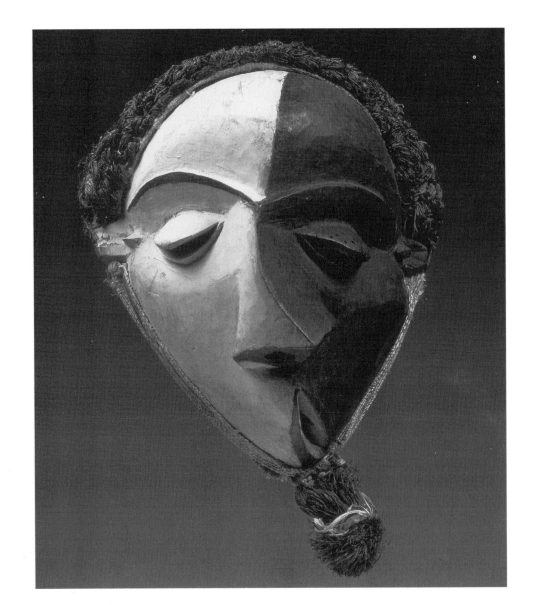

52. The mask MBANGU. (Ekt. 339 [RG.59.15.18]. © Africa-Museum, Tervuren, Belgium. Photograph by R. Asselberghs.)

emphatic on the other. The mouth echoes the shape of the eyes but is turned on its side. The pronounced curving cheekbone of the black side mirrors in reverse the line of the brow on the right side. The eyes are similar, and yet the pocking on the black eye makes them startlingly different. The artist uses formal modulations like these to reinforce the theme of radical difference between the two sides established by the sharp opposition of black and white in the bisected face.

Although noting astonishing similarities in the use of asymmetry in Picasso's painting and in the Pende mask (which Picasso could never have seen), William Rubin underscores what he sees as a radical difference between the two: "We should keep in mind, moreover, that even the most violent distortions in the African *masques de maladie* were based upon facial disfigurements that existed in reality; the artist essentially imposed his people's traditional stylization upon physical data. Picasso's distortions, on the contrary, were an invented projection of an internal, psychological state" (1984: 265). Implicit in Rubin's judgment is the truism that African artists are not concerned with interior states. His use of the word "stylization" is also suggestive. Stylization results from convention and simplification, from reflex action, not from creative thought. In fact, one could say that it results from a *lack* of creative thought. The discussions of physiogno-

my in the previous chapter have broached the subject of the expression of interior character through form. In the discussion of this particular Mbangu, I seek to illustrate how far from stylization this mask really is.

The artist has chosen to stress an entirely different aspect of Mbangu from the moralistic vision of the first interpretation or the comedic translation of the second. His theme is pathos, which he renders abstracted and cipherlike.

First of all, one has to consider the composite nature of the representation of Mbangu's physical state. Unlike what Rubin suggests, this is no simple stylized illustration of any one given malady. There are references to five or more physical complaints! Mbangu wears a humpback. If he does not carry a bow and arrows, dancers avail themselves of a cane to indicate his physical weakness. The black-and-white division of his face often suggests that he fell into the fire due to sorcery, and the fact of falling into the fire itself hints at some other medical condition (e.g., epilepsy). Often, but not always, his face shows a distortion on one side reminiscent of facial paralysis, but there are also marks at times indicative of smallpox.[8] Bearing the arrow of his bewitchment, Mbangu has become a composite sign of illness and disability, of all the misfortunes that can happen to one. Unlike Gatomba, the one-armed masker described in chapter 2, Mbangu's form

(face and costume) rises above narrative. Its ambiguity is central to its message.

The diagnostic black-and-white coloration deserves further comment. It also is no simple illustration of a burn, as often suggested. The Abbé Mudiji has proposed an alternative reading: "Struck by a partial facial paralysis, as it is said, he has remained lying on one side, [hovering] between illness and death."[9] The Abbé Mudiji interprets black as the color of illness (1981: 265). Certainly, in Pendeland it is the color of sorcery. Supporting his thesis is the fact that any deformed features will appear on the black side (burn, facial nerve paralysis, smallpox).

The Abbé Mudiji then proposes that white is the color of death and of the otherworld (1981: 265). As he observes, face masks usually have red faces, representing the redwood paste that the Pende once used to soften and lubricate their skin. Thus, he interprets red as the color of health and life (265). MBANGU, with his black-and-white face, lies between illness and death.

As a modification of his interpretation, I

53. Pablo Picasso, *Les Demoiselles d'Avignon* (Paris, June-July 1907). Oil on canvas, 8 feet x 7 feet 8 inches (243.9 x 233.7 cm). 1997 Estate of Pablo Picasso/Artists Rights Society (ARS), New York. (The Museum of Modern Art, New York. Acquired through the Lillie P. Bliss Bequest. Photograph ©1996, The Museum of Modern Art, New York.)

would suggest that color symbolism in the masks is usually positional or situational. While white certainly can stand for the otherworld, this is an erudite reading, the most common one being the association of white with the kaolin used in all healing rites, both physical and social. Kaolin, found in streambeds, draws its symbolic force through its connection with "cooling." When a suspected sorcerer gives kaolin, he is promising to "cool" his rancor; when a healer rubs it on his patients he is acting to "cool" their fever and calm their fears. By extension, chiefs, uncles, and parents rub it on their charges in order to show welcome and good wishes or good intent. These practices suggest that the bicoloration may refer to MBANGU at the crossroads between healing (health) and illness. This reading is by no means antagonistic to the Abbé Mudiji's, as it is the ancestors in the otherworld who are the ultimate guardians of an individual's health and prosperity.

Significantly, in the great majority of cases, MBANGU is white on his right side. In Pende symbolism, the right side is considered the strong one, as the right hand usually is. The left side is so connected with sorcery and death that the first rule of etiquette learned by a child is to eat and

54. Pablo Picasso, *Les Demoiselles d'Avignon* (detail) (1907). (The Museum of Modern Art, New York.)

offer objects with the right hand alone.[10] It is no accident in this image that Mʙᴀɴɢᴜ's normal, "healthy" features occur on his right side. The artist of the third interpretation opposes a healed and whole side to one marked by deformity.

Now consider the subtle dialogue occurring between the two sides based on physiognomic language. On Mʙᴀɴɢᴜ's right and healthy side, marked by the cooling white kaolin clay, the artist has depicted a handsome visage. It has the elements that the Pende feel appropriate to the masculine form: a projecting forehead, marked cheekbones, arching brows, and projecting eyes, although all but the eyes receive a muted, even "feminized" expression. The artist renders all proportional and harmonious under the gracefully curving brow.

On the other hand, witness the distortions wreaked to Mʙᴀɴɢᴜ's left and weak side. By keeping the upper line of the eyebrows level on both sides but greatly thickening them on the deformed side, the sculptor achieves a masterful sense of the face being dragged downward on that side, while preserving the harmony of the whole. On Mʙᴀɴɢᴜ's left side, in accordance with the description of facial paralysis noted above, the corner of his eye and the line of his cheekbone angle downward. The sculptor has twisted the nose and mouth over to a great degree. Haaf and Zwernemann observe that this is not an accurate description of facial paralysis, in which the tip of the nose twists in the *opposite* direction of the downward pull of the mouth (1975: 48) (fig. 51). Whatever the clinical assessment, the artistic license is necessary to preserve a face sharply divided into healthy and deformed. Unlike the sculptor of the comedic mask, this artist does not completely undermine the balancing vertical of the nose. The serpentine vertical line dividing black from white wavers back and forth but is adequate to ballast the form.

Nonetheless, the physical deformations are only part of the story. Not only have Mʙᴀɴɢᴜ's nose and mouth been pulled out of line, there has been a sad transformation of character as well. In contrast to the shapely and smooth brow on his right, that on the other side shows a delicate sharpening and protrusion. The artist has used his knife to trace a horizontal crease in the forehead by removing slightly more of the wood below at the juncture with the brow. He has made a sharp excavation into the eye cavity underneath the brow for the sake of visual drama. He has also pulled out and sharpened the tips of the eyelid on the black side. He has chiseled the cheekbone on Mʙᴀɴɢᴜ's left side to a ridge and cut straight down with his knife to create the flat cheeks described in chapter 5. There is none of the gentle rounding with the knife that is evident on the other side. Finally, the artist, by pulling the nose so far over, has made it very long and sharp tipped.

The reader will recognize from the previous chapter all of these changes as belonging to the physiognomy of aggression. In favor of preserving the harmony of the whole, the artist has made the transformations subtle, but to the trained eye they are unmistakable. William Rubin's assessment that there is no "projection of an internal, psychological state" (1984: 265) is flawed. The artist has gone far beyond the simple illustration of a physical illness to comment upon the toll illness or permanent disability takes on the psyche.

In *A Leg To Stand On*, the neurologist Oliver Sacks recounts the discovery of his own "rancor and malice" (1984: 178) during a long convalescence:

> I saw the school team practicing rugger, a sight I normally enjoy. I was surprised and appalled at a spasm of hate in myself. I hated their health, their strong young bodies. I hated their careless exuberance and freedom—their freedom from the limitations which I felt, so overwhelmingly, in myself. I looked at them with virulent envy, with the mean rancor, the poisonous spite, of the invalid; and then turned away; I could bear them no longer. Nor could I bear my own feelings, the revealed ugliness of myself. (1984: 176–77)

Although Sacks had been a doctor for years, it took his own painful and prolonged convalescence to discover what a heart-felt and hate-filled emotion envy can be for the chronically ill or disadvantaged.

Few Pende could have been so naïve as Sacks since envy is the vice most despised—and feared—among them. When a masker performs, he will often take the precaution of wearing or burying protective charms. He worries about his rivals, but even more about the envy and spite that his skill might awaken among the old and failing. The former might seek to ruin his performance, but the latter, when their rancor is awakened, could seek his life. Athletes have the same fears. It is believed that these same envious types, when they pass on to the otherworld, are prone even to envy the living.

The old men most targeted as sorcerers are quite often those in declining health who have become frail and irritable. The mask Gandumbu, the old widow, illustrates this point also (fig. 11). Old, neglected, and irritable, Gandumbu's most beloved gesture is the *mikumbu*, the clapped curses that she throws against the young girls who tease her. Her behavior reflects some of the frail old women in the villages who, suffering from a sense of ill-usage, will call out a litany of complaints and curses for twenty minutes at a time. Because women are rarely suspected of sorcery, the audience greets Gandumbu with affectionate amusement, but a man of her age who grumbles and snaps will be regarded with loathing and fear.

Sacks's advice to himself was: "'You may *feel* it, but be sure you don't *show* it'" (1984: 177). The Pende artist who sculpted MBANGU would have considered this a futile wish. The brooding and covetousness that a sense of disadvantagement evokes must leave its mark on the physiognomy. The Abbé Mudiji remarked: "But one of the hidden reasons for the appearance of evil in the realm of goodness is envy, an inner perverted sentiment of man, and [of] the sorcerer that we can become, even without our knowledge."[11] In the physiognomy of aggression that the sculptor has depicted on the ill side of MBANGU's face, we see precisely the "sorcerer that we can become" if subjected to similar trials.

What then is to be our reaction to this MBANGU, suffering as he is both in body and in soul? The answer is found in another widespread version of MBANGU's song:

> *Ta gulela mukwenu.*
> *Ta gulela mukwenu.*
> *Nganga jiamulowele,*
> *Luwanda, Mun'a Mbangu.*
>
> Do not mock your neighbor.
> Do not laugh at your brother.
> The sorcerers have bewitched him,
> Luwanda, Mun'a Mbangu [name].[12]

According to this line of reasoning, our proper response is compassion. Anyone can fall prey to misfortune, to sorcery; MBANGU did not bring his troubles down on himself.

Moreover, he is our brother, our neighbor, our friend, and deserves our support.

CONCLUSION

If the previous chapter argued for the critical role of physiognomic theory in recognizing genre, this chapter maintains that it is also crucial to understanding the language of individual expression. The three different artists discussed responded in very different ways to the theme of the disadvantaged. All working within one genre, they nonetheless drew different interpretations. One saw MBANGU as a sorcerer who had brought on his own doom by playing with fire. The second portrayed MBANGU as a comic buffoon. The third gave brilliant expression to the destruction physical illness can wreak on personality. MBANGU is by no means unique, and future studies of individual genres and artists must come to terms with the physiognomic language of their subjects.

There were indications of similar personal expressions in chapter 5. Nguedia's TUNDU (fig. 42) with the protruding eyes and lips makes reference to the violent underside of the clown's comedy, to the uncontrolled behavior that society cannot tolerate. Zangela's reinterpretation of the female clown, GANDUMBU (fig. 44), as an aged GAMBANDA (the ideal young woman) lends the character a certain poignancy unique in the genre. Like the artist of the third

interpretation of MBANGU, Zangela solicits our compassion in understanding the forces that might transform a beautiful young woman into a crone made crotchety through a sense of ill-usage. Even Khoshi, in his insistence on the importance of teeth in feminine depictions (as an expression of feminine superficiality), demonstrates a vocabulary of personal expression based on physiognomy.

Since the publication of Freud's *Totem and Taboo* in 1912–13 (1950), Western art theorists have tried to dismiss African creativity either as an archetypal outburst emerging directly from the unconscious, unmediated by the mind, or as an unthinking repetition of "tradition." The study of physiognomy as a grammar that artists use to formulate individual expressions has the power to expose the empty fallacy of the passive African artist.

CODA

Before Thomas Kuhn, Heinrich Wölfflin wrote in 1915, "Vision itself has its history" (1950: 11). Despite the insistence of art historians that learning to read images is a cultural skill rather than a natural skill, there have been only a few isolated observations on how African societies manipulate visual language to convey meaning. As chapter 5 argued, what is fascinating about the theories of physiognomy articulated by the sculptors of Nyoka-Munene is not how they describe a fixed iconography of types but how they allow for a range of individual expression within and across genres.

Mbangu, the bewitched, is not an isolated instance. Consider three different representations of Pumbu, the executioner, another easily recognizable genre. In an example collected by Torday in 1909 (fig. 55), the strong forms of Pumbu's face testify to a formidable character. The mask's forehead bulges out and is marked by a ridge.

The eyes and nose also protrude forcefully. The sculptor contrasts these bluntly shaped volumes with the sharp, linear incisions articulating the borders of eyebrows, nose, and mouth. Pumbu's mouth is large, thickly lipped, and wide open. The upper lip rises precipitously in an expression of internal choler. In Pende terms, this is the representation of a robust man, at the peak of considerable physical prowess, a man inclined to aggressive action, a man who shouts more often than he whispers. No one form on the face is subordinate to another. There is no modulation or softening of forms—or of character.

Contrast this representation to that of another Pumbu mask (fig. 56). One sees immediately the pointed horns of the coiffure and the jutting forehead, eyes, and nose that identify the genre. But what a difference! If the first sculptor emphasized that the type of man who becomes a Pumbu fits our stereotype of a marine sergeant as loud,

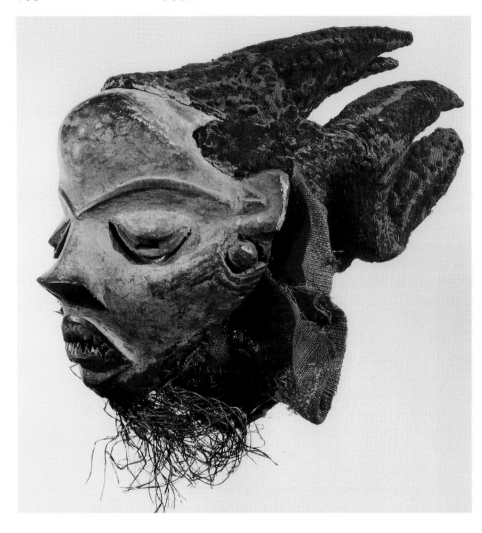

55. PUMBU mask collected by Torday. (Courtesy of the Museum of Mankind, British Museum, London.)

brash, aggressive, able to get the job done, this second sculptor has depicted PUMBU with the face of a beautiful young man. The face is quite peanut shaped, but there are no sharp ridges to mark the forehead or nose. The forehead juts out but is softly modeled. The nose seems pulled out like soft clay instead of being sharply cut into shape. The cheekbones protrude significantly, but the modeling, as well as the curved and broadly drawn scarification, softens the effect. The mouth is subordinated, much smaller and daintier than in the first work. The chin recedes rather than juts forward. Whereas the first sculptor has capitalized on the crisp, angled transitions between planes left by his primary carving tool, the adze, the second has used his knife to round off and smooth over all transitions (as in the eyelids).

This softened representation of PUMBU is unexpected. By stressing PUMBU's youth and unformed character, does the sculptor wish to convey that the executioner is only a tool of higher orders? Or that, in the grand scheme of things, his actions are just?

If so, another artist had a very different message. In an example acquired in 1913 (figs. 57–59), the sculptor has harnessed every means in his power to convey how extra-

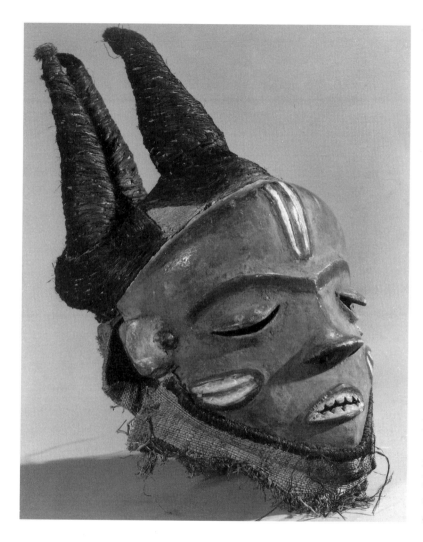

ordinary and horrifying it is to dare take human life, even if socially sanctioned. PUMBU's forehead is truly bulging and "lumpy"; it comes to a peak just over the dip in his brow (fig. 58). The sculptor has used his knife, not to soften, but to bring the nose, the ends of the coiffure, and even the receding hairline to razor-sharp points (fig. 59). The lines of the cheekbones read almost as a gash. The eyelids have been pulled straight out and make the eyes gape open unlike any equivalent Pende mask known (fig. 57). Deep excavations of the knife make the brow loom out with as much rhetorical emphasis as forehead, eyes, and nose. The mouth is enormous, acutely angled. The chin is as forceful as the forehead. The overall shape of the face is quite narrow and peanut shaped. This is the most hyper of any hyper-male mask. It is a face meant to terrify and to hypnotize. It is the very face of a killer in action.

The face represented on the Torday mask, roughly contemporaneous, which looked so robust and aggressive above, seems mild in contrast to the razored extremes of the third work. The second

56. PUMBU mask. (RG.53.74.3821. © Africa·Museum, Tervuren, Belgium.)

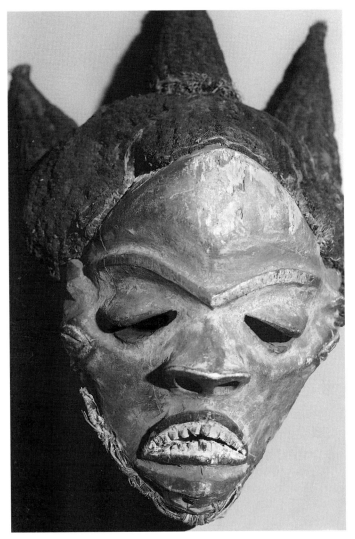

57. Pumbu mask acquired in 1913. (MRCB 15424. © Africa-Museum, Tervuren, Belgium. Photograph by Z. S. Strother.)

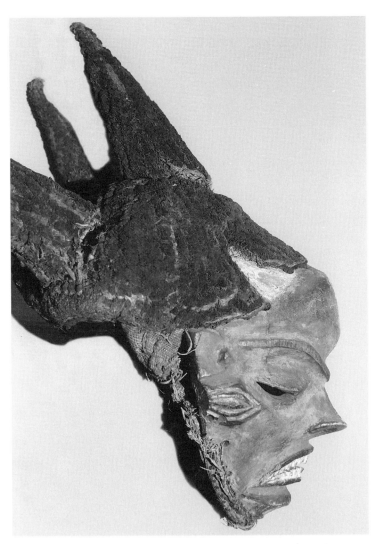

58. Pumbu mask acquired in 1913. Profile. (MRCB 15424. © Africa-Museum, Tervuren, Belgium. Photograph by Z. S. Strother.)

example could almost be mistaken as feminine in comparison.

Murder mysteries tell us that in the right circumstances anyone can commit murder. Most Pende are dubious. They argue that there is a special class of men, *ngunza,* who walk apart. These include the successful hunters of the most dangerous prey (leopards, lions, Cape buffalo) and the takers of human life. These men *willingly* choose to face consequences that make most of us shrink in despair. Even if socially sanctioned, even if occurring in war, even if undetected, the person who takes another's life will have to grapple with the victim's spirit all of his days. If the *ngunza* is lucky, perhaps only his dreams will be troubled, but folklore is full of the eventual repercussions on either the man or his family once supernatural protections fail. How many of us would choose to take on such a fate? Even if these men are useful to the society as hunters or soldiers, they are unpredictable, because there is no empathy for others to temper their will. They are described as *wabala,* a word meaning both "dangerous" and "cruel." The third sculptor has given PUMBU the harsh face of the *ngunza,* stranger to compassion.

Within a genre, individuals can manipulate physiognomic conventions, sharpening, softening, changing expected contexts, sometimes mixing signals, as a means of personal expression. In this respect physiognomy

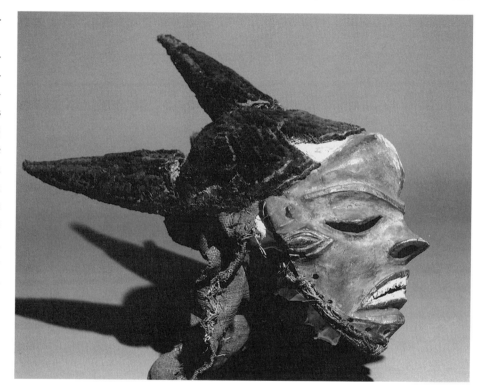

grants the sculptors a language to say many different things on a given theme.

There is evidence to suggest that gendered codes of physiognomy extend far beyond the Central Pende. Within Zaïre, there is a good deal of visual evidence. For

59. PUMBU mask acquired in 1913. (MRCB 15424. © Africa-Museum, Tervuren, Belgium. Photograph by Z. S. Strother.)

example, to Pende-trained eyes, it is inevitable that Sala Mpasu masks, characterized by enormous bulging foreheads and stout, projecting noses, would be armed with machetes and form part of a military society. The forehead again seems connected with male gendered aggression. As Robert Farris Thompson has suggested in another context, eyes deeply recessed in shadow seem cognate to protruding white eyes (1974: 159).

Among the Kuba, despite a very different stylistic language, the chief characteristics distinguishing the female Ngaady Mwaash (fig. 60) from the "coarse commoner" Bwoom (fig. 61) are all too familiar. Sculptors work Ngaady Mwaash on a shallow facial plane. In this example, the alternating diamond pattern drawn from textiles underscores visually the flat smoothness of her brow. Likewise, the tear marks that wrap around her cheeks draw attention to their soft plumpness. The eyes are closed in slits. The nose and mouth project little and are further "closed" by the descending line of beads. The overall shape of the face is oval and the size somewhat below natural proportions.

In contrast, Bwoom is easily recognized by

60. African, Kuba dance mask, the female Ngaady Mwaash. Carved wood, polychrome, glass beads, cowrie shells, cotton cloth and string. H. 11 9/16 inches, W. 9 1/8 inches (29.7 x 23.4 cm). (Courtesy of the University of Michigan Museum of Art. Gift of Al and Margaret Coudron.)

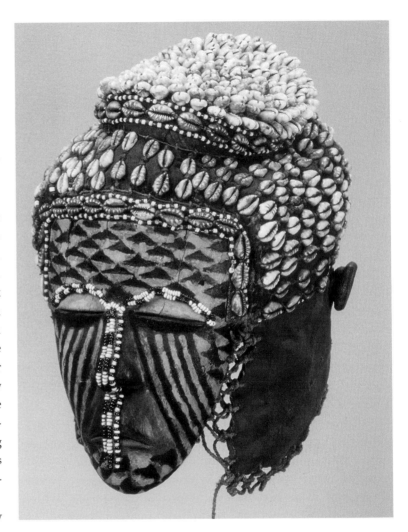

his oversize proportions and his bulging forehead and nose. Quite often, his cheekbones will be sharply angled as well. Artists frequently set off the forehead and cheekbones in copper, which would burn in the sunlight and draw attention to these masculine qualities.

In the greatly abstracted masks of the Songye, one could not find a stylistic language farther from that of the Central Pende; yet, once again, one catches familiar resonances. In the case of the Songye, we also have invaluable documentary evidence. Dunja Hersak writes that male masks are characterized by strongly protruding eyes, nose, mouth, and crest and by vivid coloring (1990: 141). The Songye have extended into space the aggression of the jutting masculine forehead through its transformation into a menacing crest (fig. 62). Largely white female masks show a smooth, flat brow and nose and crescent-shaped eyes (Hersak 1990: 141) (fig. 63). As large as the female nose and mouth might seem contrasted to Pende works, they appear rather petite when compared to the extremes that male Songye masks can achieve. The masks are differentiated in movement as well, the female masks having a more formalized and contained dance (141).

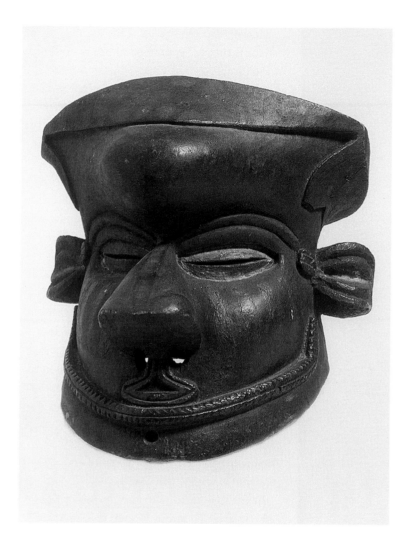

61. African, Kuba BWOOM-type mask (male) (ca. 1960). Wood. H. 12 3/4 inches, W. 9 1/4 inches, D. 11 7/8 inches (32.3 x 23.5 x 30.2 cm). (Courtesy of the University of Michigan Museum of Art. Gift of Marc Leo Felix, Brussels.)

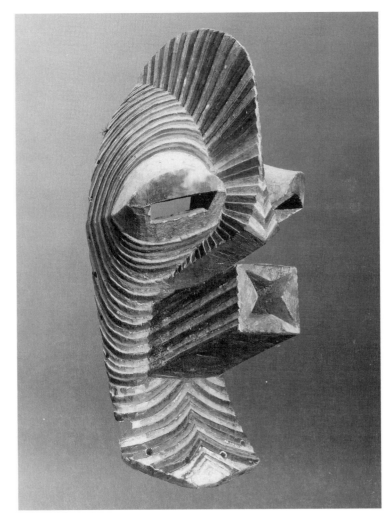

62. Mask (Kifwebe) (Zaïre, Songye, ca. 1930s). Note the "masculine" facial features. Wood and pigment. H. 71.2 cm. (© The Cleveland Museum of Art, 1996. Purchase from the J. H. Wade Fund, 1972.2.)

Hersak also reports on differing degrees of maleness that are expressed in the relative size of the foreheads (i.e., crests), but in the Songye case the males are divided *by age* rather than by character (1990: 141–42). Sculptors give *smaller* crests to junior masks as a statement on relative degrees of social power rather than of simple aggression.

In the Songye example, gender serves less as an end in itself than as a metaphor deployed to communicate different messages about the role and agents of sorcery and witchcraft *(buchi)*. Hersak reports that the male maskers "run frantically throughout the village flailing their sticks, inflicting punitive ills and absolving them through payment" (1990: 142). They represent active and schooled agents bent on social intimidation of wrongdoers. In contrast, the female maskers emerge to "animate benevolent spirit forces" through quiet performances that aid procreation and the matrilineal inheritance of witchcraft (141–42). No doubt, despite visual parallels, as one probes the individual ethnographic matrices, distinct messages and uses of gendered language will emerge.

In the case of funerary sculpture in Kongo, Robert Farris Thompson found the depiction of

half-closed eyes to be significant, although he does not describe it as a gendered gaze. "The name of this gesture of the eyes is *meeso malembalala*. The term refers both to half-closing the eyes, and to the setting of the sun. Indeed, this inward gaze symbolizes a discussion shared between two worlds, concentration upon an issue shared between the living and the dead" (1981: 132). In Thompson's suggestion that the hooded gaze symbolizes a blurring of the worlds of the living and the dead, we may find a clue for the original elaboration of the slitted gaze for Pende maskers. If this gaze, described by the Pende as "cool," apes the half-closed eyes of the dead (as will be suggested in chapter 7), it is all the more fitting for the original context of the masquerades (as found among the Eastern Pende), in which the masquer-aders evoke the invisible dead, who dance in communion with the living.

Like the Pende, Thompson notes that the Kongo believe that hooded eyes are a dignified mode of self-presentation suitable for kings and the nobility, as they represent deep thought and serious contemplation. However, they may also be assumed to show deference *to* authority (1981: 132). In 1668 Olfert Dapper described "averting the eyes" as a gesture of respect toward officials at Loango (in Thompson 1981: 132). Thompson draws parallels to some

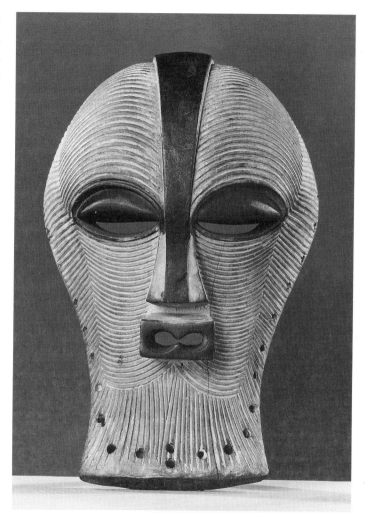

63. Songye female mask (AF 5115. Courtesy of The University Museum, University of Pennsylvania, Philadelphia. Neg. no. S8-4969.)

African American children who avoid eye contact with elders as a mark of deference (132).

The body itself is a field of representation, and there may be echoes of similar complexes of ideas in societies that do not sculpt or paint. Pende theories of physiognomy are acted out in the body. As already noted, adults who wish to intimidate naughty children open their eyes wide to expose the whites. At the investiture ceremony of Eastern Pende chiefs, the chief's "father" will dance alongside with wide-open eyes and flourished blade in order to warn rivals not to even dream of disputing the selection process.

Sylvia Boone associates the "slitted eye" among the Mende of Sierra Leone with discretion and restraint but, paradoxically, also with flirtation and accessibility (1986: 178–80). She writes: "The gentleness of the sleepy eye attracts both men and women; it is uncritical, unthreatening, and thus comforting and receptive, making one desire closeness" (178). She observes that many Mende women cultivate hooded eyes for purposes of flirtation: "When an eye is slitted it can only look a short distance straight ahead; by shutting out everyone and everything else and then focusing her gaze exclusively on her beloved, the woman invites dalliance and promises a warm response" (178). The feature distinguishing between the gesture of flirtation and of respect seems to be whether or not the hooded gaze is fixed on its object—or averted.

Pende men insist that women display the *zanze* hooded gaze. I never noticed it except sometimes when women and girls composed themselves for photographs. Later, it occurred to me that I might not have seen the *zanze* look because I myself am a woman and the gaze may be intended for men (whether as a gesture of respect or flirtation). Among the Dan of Liberia and the Ivory Coast, Eberhard Fischer and Hans Himmelheber found that women commonly lower their eyes: "Eyes of women should be narrow as slits, so to achieve this effect, many Dan women do not open them entirely, and the resultant heavy lidded look makes them appear to be a little drowsy all day long" (1984: 182). On certain ritual occasions, women will also paint their eyelids with "white paint which hardens on the lid and stretches it downward" (184). Fischer and Himmelheber note only that this is an "ideal" of female beauty, but it is probable that the hooded gaze is part of the same ontological gender construction as it is among the Pende.

The Dan provide the best-documented parallel of gendered visual language to the Pende. Fischer and Himmelheber, citing sculptor Tompieme, categorize face masks on the basis of gender: "'Gentle' masks, without a beard, with narrow eyes and an oval face were described as *gle mu*, female featured masks; masks with angular, usually pentagonal silhouettes, with a beard and tubular eyes were described as *gle gon*, male featured masks. All animal face

masks and all exceptionally large masks were likewise described as male" (1984: 9). In addition, Fischer and Himmelheber note that the eyes of "male" masks "may be deep-set triangles beneath a bulbous forehead, or may be protruding tubular forms. Noses are more pronounced and larger" (9). The Dan complex is uncannily close to that of the Pende. Feminine masks are characterized by slitted eyes with plump cheeks and rounded chins (hence an oval silhouette). The masculine version shows strong cheekbones (hence a "pentagonal" silhouette) and protruding eyes, forehead, and nose.

Strikingly, the visual range of Dan masks also shows the same spectrum of female (fig. 64) to male (fig. 65) to hyper-male (fig. 66). However, a critical difference in the Dan system is that sculptors will mix codes in order to better describe the character of various masked personae. For example, Thompson found a mask, Gaa Wree-Wre, used to preside over disputes that combined leopard's teeth and war bells with a cool feminine gaze, highlighted with kaolin, and feminine brow and coiffure (1974: 161–62). Gaa Wree-Wre's persona benefits from cool ("femi-

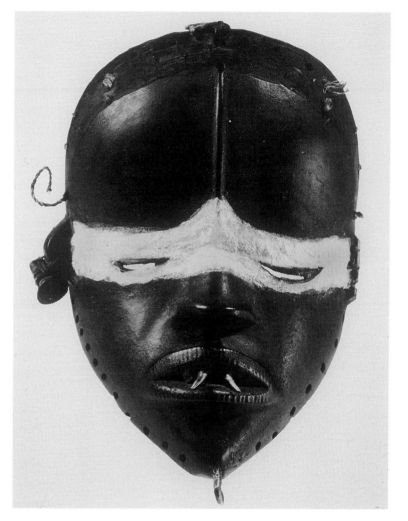

64. Dan, Liberia. Wooden mask with "feminine" features. (Peabody Museum, Harvard University. Cat. no. 37-77-50/2791. Photo no. N31210. Photograph by Hillel Burger. © President and Fellows of Harvard College. All rights reserved.)

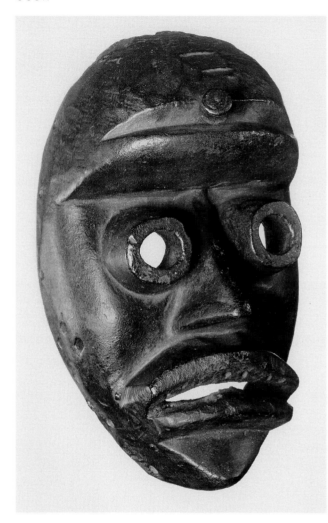

65. Dan, Liberia. Poro secret society mask. Note the "masculine" facial features. (Yale University Art Gallery. Gift of Mr. and Mrs. James M. Osborn for the Linton Collection of African Art.)

nine") reflection but does not shrink from the most severe judgments, as symbolized by the references to war and the frightening executioner of the forest. In another case, a mask used to escort convicted criminals to execution juxtaposes feminine brow and eyes with a "horrific projecting snout sprouting monkey fur" (159). The sculptor may have mixed gender codes in order to convey that the sentence had been reached fairly, through due process without hot passion, and yet will require animal-like ferocity to execute.

The Pende do not bring in animal imagery and do not often mix overt codes in the same way as the Dan (e.g., slitted feminine eyes with male nose), but the sharpening of some feminine and the softening of some masculine representations (as in the discussion of PUMBU above) may be read in this way. Some sculptors may give the old widow an angular "masculine" face in order to express her brooding sense of ill-usage. She will always be recognizable nonetheless due to her distinctive coiffure. This may have happened also with rare masks representing the "prostitute." Similarly, it seems that the physiognomy of the chief was born when the sculptor Gabama consciously "feminized" the male face.

Literary critic Hans Robert Jauss has observed that the reception of genre is built on a knowledge of the relationship *between* works in the genre (1982). This is an important point for understanding the flexibility of the visual

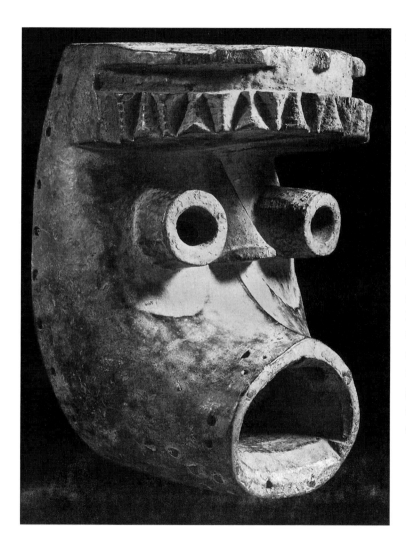

imagery discussed above. These are profoundly relational systems. One cannot jump systems and compare a Pende masculine and a Songye feminine mask without risking misinterpretation. At the same time, familiarity with the range of expression within the genre is critical. Neither the softened nor the razored PUMBU masks discussed at the beginning of this section would have any "meaning" without existing in dialogue with many other representations of PUMBU. In fact, the more, the better. One could add to Jauss's comment that the reception of genre is also built on knowledge of the relationship *between genres.* PUMBU also takes shape against GAMBANDA the female mask, against MAZALUZALU the chief, and so on. By searching through African masks for the ideal "type," critics have treated variations almost as mistakes from some lost "norm" and have disguised the ability of these works to respond as open texts both to individual expression and to critical interpretation.

66. Dan mask collected by Hans Himmelheber. (On loan to the Rietberg Museum, Zurich.)

THE HISTORY

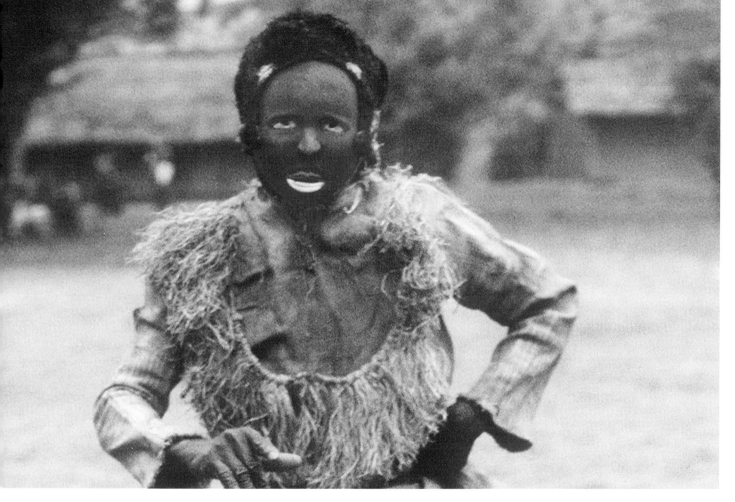

OF INVENTION

CHAPTER SEVEN

A Precolonial Pende Art History?

Because the processes of invention outlined in part I rest on contemporary field exegesis, some readers may wonder about the historicity of artistic invention. I am often asked: "But is this creativity a product of the colonial era?" In the art historical literature on the Pende, despite repeated references to the creation of certain masks, there has been a tendency to treat them as a homogeneous and synchronic block. Considering the dearth of documents available, is it *possible* to write a history of Pende masquerading in the precolonial period? And how?

Because there are few documents, we must be somewhat inventive ourselves in how we approach the problem. One may hypothesize that the masks most widespread geographically are probably the oldest. This assumption rests on the simple model of the "age-area hypothesis," which argues that "wider distribution generally means longer time depth" (Vansina 1970: 169). It is not a perfect method. As will be demonstrated by the history of the mask GINDONGO (GI)TSHI? in the Conclusion, it *is* conceivable for a mask to spread quickly. However, the rule of thumb used by some Pende field associates in gauging the relative ages of certain importations was: the older the importation, the more changes that will have been introduced into the songs, in particular, but also into the

mask's headpiece and its dance. These Pende are enunciating a general tenet of linguistics that a greater diversity of dialects occurs in areas that have been settled longer. The southern United States shows more dialectical diversity in English than does California. In other words, change happens over time. GINDONGO (GI)TSHI? may be spreading, but the fact that its song is identical everywhere points to its recent invention. In the Pende context, it seems likely that older structures will show more variety.

Herein develops the problem. If changes are being introduced, how will we recognize the kinship of certain forms? Art history has championed the use of systematic comparisons of objects as the means to isolate individual, cultural, and historical characteristics. However, part I has argued that the "mask" is more than the object (the headpiece) to the Pende. It is more even than the headpiece together with a costume.

An expansion of categories is in order. By classing masks as "genres," rather than as "headpieces," one widens the field of investigation from form to the relationship of form and content. Moreover, one demonstrates a commitment to exploring the historical shape of categories within the originating society. Jauss writes that "literary genres are to be understood not as *genera* (classes) in the logical senses, but rather as *groups* or *historical families*" (1982: 79–80). The "'family similarity' manifests itself . . . in an ensemble of formal as well as themat-

ic characteristics" (82). The idea of family resemblance is helpful because it allows for the recognition of historical relationships, even as individual elements change. In particular, the inclusion of thematic elements allows one to see that certain masks may be reinventions of older masks. Chapter 2 discussed how TATA GAMBINGA added foreign exoticism to the diviner genre and how GABIDI-MUAMBA modernized the mask of the stranger. Careful comparisons of the masquerading ensemble, of thematic as well as formal characteristics in headpieces, costume, and dance, make possible a history of genres in Pende masquerading.

Fortunately, we can profit from the long separation between the Eastern and Central Pende, probably dating from the eighteenth century, to make systematic comparisons of masks on both sides of the Loange River in order to investigate whether or not there was a common corpus that preceded their separation. This method is not unlike the comparative reconstruction championed by historical linguistics to hypothesize ancestor forms of divergent dialects or languages stemming from a common root.[1] If such a common corpus exists, one can then identify a canon of genres of considerable age. One can apply the same method within the Central Pende region, arguing that masks with considerable range are likely younger than the masks shared by both Eastern and Central Pende but older than the plethora of localized masks.

Through these approaches, one builds a layered art history of genres.

In attempting to write a history of Pende masquerading, the comparative method must loom large. However, we must first know *what* to compare, *what* constitutes the object of study in its *indigenous* context. This is why part I had to precede any history. Before one can dare a history of masquerading, one must understand how the society understands what a mask is and how it comes to be. In terms of Pende masquerading, we do well to remember Gitshiola Léon's axiom from chapter 2: "You can't just invent a mask . . . you need a dance!" Because the mask *(mbuya)* in the Pende imagination begins with the dance and is indissoluble from it, one must include performance in any comparison of masked characters.

For example, although both Eastern and Central Pende dance a mask called Pumbu, the forms of the facepiece itself are so disparate that they seem to demonstrate no affinity whatsoever (figs. 67, 56). What can the reductive abstraction of the Eastern version, hardly recognizable as a human face, have to do with the expressive naturalism of the Central Pende work?

The fieldwork in part I suggests that the names and songs of masks are not necessarily a reliable

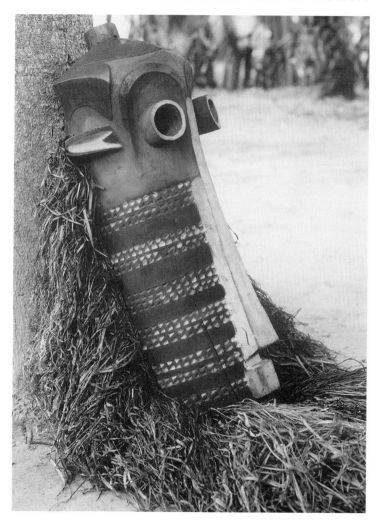

67. Eastern Pende Pumbu mask owned by Chief Kingange. Kingange, Zaïre, 1988.

source for identifying common historical origins. The names of masks can change several times within the lifetime of one individual, and songs can move from one mask to another. In the case of PUMBU, it is not the name but the core of the dance that demonstrates that the Eastern and Central versions descend from a common ancestor (figs. 92–93). Both masks appear, restrained by cords, wielding machetes until the crescendo of the dance, when the mask frees itself and the crowd recoils in fear.

Critical similarities in the function and core meaning of the two PUMBU masks argue against chance similarities or separate invention. Is it possible that either the Eastern or Central Pende borrowed the mask one from the other? Following the Pende and linguistic argument above on diversity, it seems unlikely. The very fact that the form of PUMBU's facial covering has been radically reinterpreted, and that the dance rhythms and songs have changed, suggests that the masks have been separated long enough to diversify and argues against a recent appropriation by one side or the other.

Identification and then careful comparison of long separated masking "twins" like PUMBU provide unique evidence of a history of invention. They also permit a structural analysis of tradition, that is, of those institutions and discourses deemed important enough to continue into the present, albeit in ever evolving form.

De Sousberghe notes that the Pende insist on distinc-

tions between masks which come from the upper Kwango in Angola (i.e., which preceded the Pende migration north) and more recent creations (1960b: 527). He listed five of the masks that he believed belonged to the older category: GIWOYO, MUYOMBO, POTA, FUMU, and PUMBU (1960b: 528). Using the methods described above, I will argue in favor of a canon of seven mask genres predating the separation of the Central and Eastern Pende. These genres are based on the following pairs of masked "twins" in the two traditions:[2]

GIWOYO/KIWOYO
MUYOMBO/KIPOKO
GINJINGA/KINDJINGA or MUNYANGI
POTA (Central POTA/Eastern POTA)
TUNDU/KINDOMBOLO or MABOMBOLO
PUMBU (Central PUMBU/Eastern PUMBU)
Central FEMALE MASK/Eastern FEMALE MASK

This study focuses on the Central Pende and will only introduce Eastern Pende material to make an argument for relative antiquity or to explain certain contexts that have become obscured in the west. Full publication of the Eastern Pende material will occur elsewhere.

GIWOYO/KIWOYO

Perhaps the most obvious yet most mysterious pair in the two traditions is the mask GIWOYO, known as KIWOYO

among the Eastern Pende. It is universally described as one of the very oldest masks, one that "came from Angola."[3] The Eastern Pende often refer to it as the *lemba* (maternal uncle) of the masks, meaning that it is senior in age and authority, even if it is not the most dynamic. On both sides of the Loange River, the headpiece is similar. It is composed of a face with a long, tapering projection below the mouth (fig. 68).[4] Unlike the masks discussed in part I, the eyes are not pierced, although they are depicted as half-closed. A thick raffia fringe hangs down from the edges of the entire projection.

The Gɪwoyo masks that Torday, Frobenius, and Starr collected demonstrate that the distinctive Eastern and Central Pende styles were already established in the early twentieth century. Although unmistakably the same genre, Frobenius's speciman from 1905 from Ngulungu on the Kasai River is carved with quintessential Eastern abstraction (fig. 69). The face is conceived as a flat plane from which the forehead, eyes, and nose jut forth. The eyes are rendered as horizontal half-moons, and above them the arching eyebrows (formed not through relief but from the juxtaposition of planes) meet to give the face an elongated heart shape. Torday's example, probably collected in 1909 among the north-central Pende, demonstrates a taste for more three-dimensional modeling of the face, with prominent forehead, sunken eyes, and rising cheekbones. Both the nose and the eyes are given more

naturalistic, albeit heavily stylized treatment. From chapter 5, the reader will recognize the protrusion of forehead and nose as describing the male physiognomy. Other early examples demonstrate the full range of masculine features, with thrusting forehead, strongly marked cheekbones, sharply protruding eyelids, and the extremely angularized treatment of the nose, eyebrows, mouth, and chin (plate 7).

Much speculation has been expended on the interpretation of the projection extending from the chin. Most Westerners, perhaps thinking of images of Father God with his long white beard, have assumed that it represents a beard.[5] This suggestion never fails to astound Pende spectators, who rarely see a beard surpass an inch or two. The technical name for the projection is *gilanga*, but Central Pende sculptors often refer to it humorously as a "snout" *(mutumbi).*[6]

Critical to understanding the form of Gɪwoyo is how it is read in performance. It is the only Pende mask worn on top of the head like a baseball cap (fig. 70). The performer bands his face below the nose with raffia cloth. His eyes and nose are free but disguised by the long, raffia fringe that hangs down from the sides of the projection. The headpiece and face banding are sewn tightly to the costume. Nonetheless, due to its length, the headpiece tends to flop up and down during the dance if left unsecured in the front. Consequently, sculptors drill a small hole in the

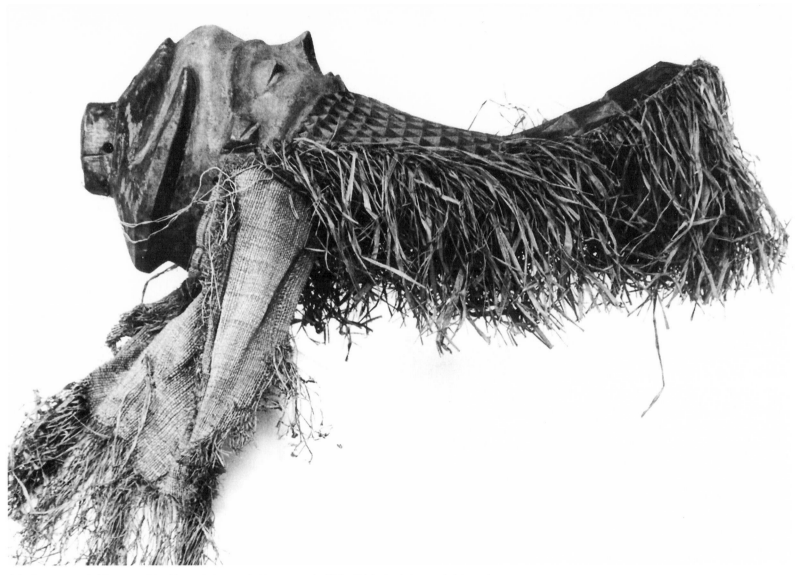

68. Gɪᴡᴏʏᴏ mask. (Courtesy of the Musée de Louvain-la-Neuve, inv. A. 138, © Musée de Louvain-la-Neuve.)

middle of the projection so that a cord can be drawn through it.[7] The dancer will hold the cord tightly between his teeth to stabilize the mask when he performs.

The advantage of leaving the nose and eyes free is that the dancer can breathe fully, unhindered by the heat and close quarters of a face mask. Barefoot, he can also see well enough to avoid the shards of palm nuts or sharp sticks that may be in his path. This is particularly important for GIWOYO, because the Central Pende dance it in the bush near the village or on its fringes (fig. 71). Even at the most active part of the dance, when the raffia fringe is thrown this way and that, the audience is unable to make out in the distance the dancer's eyes, which are thrown into shadow by the projection.

Since the headpiece perches on top of the head, the audience seldom views it frontally in performance as they would a face mask. Instead, the headpiece is designed to be viewed in profile, and the sculptors have given its features chiseled articulation to read well from a distance. The exegesis of Mashini Gitshiola on this mask is striking: "This GIWOYO shows a cadaver in the coffin. The 'snout' shows the body of the person in the coffin. The sheets are put over the cadaver.

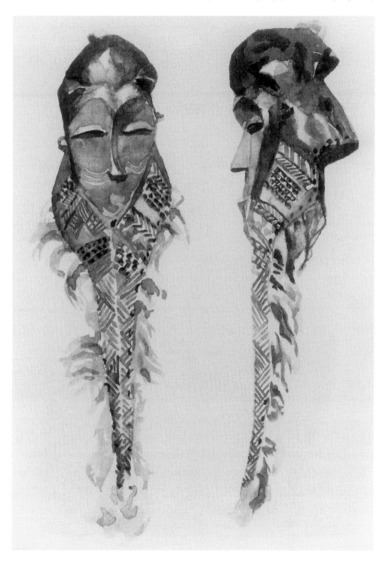

69. KIWOYO mask collected by Frobenius in 1905 at Ngulungu among the Eastern Pende. (Frobenius 1988: photo 14.)

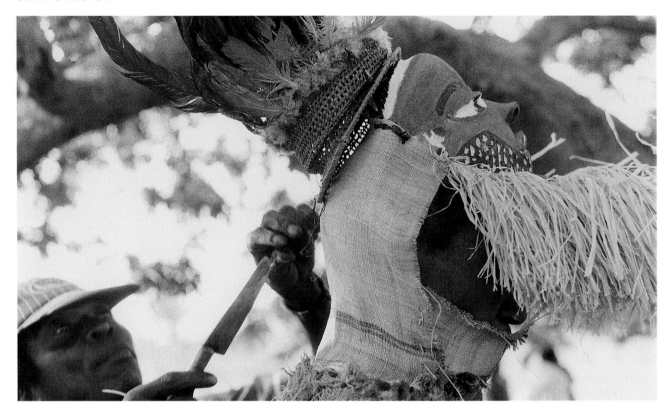

70. Zangela sewing Khoshi into the costume for GAMBUYA GA MALELA, a mask of the GIVVOYO genre. Nyoka-Munene, Zaïre, 1989.

The lines cut [around the jawline show how] when some-one dies, his face stays outside, all the body is covered."[8] He argues that the mask represents a cadaver on its funeral bier at a wake.[9]

If possible, the Pende like to wait one or two nights before they bury their dead. The women wash the body, lay it out, and cover it with a sheet. Once this sheet was made of raffia cloth; later, white "Amerikani" cotton cloth replaced it. In the past, they would sometimes pull the sheet up to the chin and cut a band to cover the mouth and

tie it closed. In that case, the chin was exposed. Often they used the band but would pull the sheet up under the nose, leaving the ears exposed. For better viewing of the body, they propped up either the head or the entire torso with pillows of rolled cloth and left the eyes half-open.

Mashini's interpretation is visually compelling (plate 7). The depiction of a cadaver explains the half-open eyes with their unfocused stare. Truly, as Mashini described it, "eyes like that show a cadaver."[10] The manner of propping up the head of the corpse for viewing explains the obtuse angle at which the face of the mask is joined to the projection in most examples. The elegant abstraction of the body explains the tapering form of the projection, which, in many cases, curves up at the end as feet would do (fig. 68). The mouth hangs partly open. For aesthetic reasons, the artists have chosen to reinforce the jawline with the end of the covering sheet and to depict the mouth unbanded (plate 7).

Mashini's formal analysis is revelato-

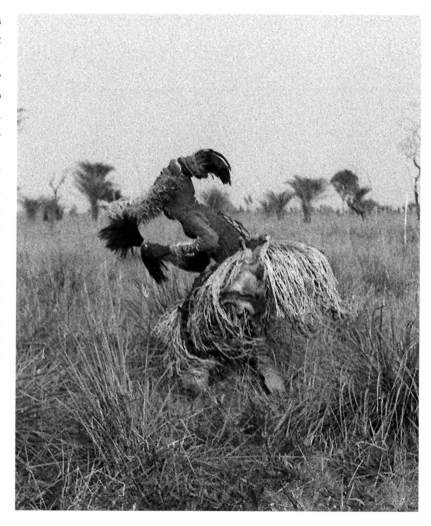

71. Khoshi Mahumbu dancing the mask Giwoyo in the bush. Nyoka-Munene, Zaïre, 1989.

ry and fleshes out the tired cliché used in public discourse before women and children that the masks represent *nvumbi*. *Nvumbi* is usually given the glamorous translation of "spirit of the dead," but its more everyday sense is "cadaver." Frobenius reported that an old man had claimed that in earlier times each man danced a mask with the name of a dead person in his family (1988: 64). If Frobenius's source were correct, one could speculate on whether there might have been a savanna complex of funeral rituals of which Pende masquerading formed a part.

The Aluund (Lunda) of Mwaat Kombaan, to the south of the Central Pende, once performed the initiation ceremonies *mungong* (for men) and *tshiwil* (for women) as periodic funerary rites for groups of recently departed family members.[11] At the end of the ceremony, at dawn, a nephew or niece would "replace" each deceased family member by taking on his or her name and bracelet. It was feared that without these marks of respect and remembrance, the spirits of the recently departed might linger in the village and cause harm. The *mungong* and *tshiwil* do not employ masks, although the former does involve a dramatic nighttime dance in which initiates paint their bodies to look like skeletons. The Chewa of Zambia do use masks to close the mourning period and to separate the spirit of the deceased from the cemetery and the village so that it can be freed for the cycle of reincarnation (Yoshida 1993). It is possible that GIWOYO might represent an

archaic survival of a ritual in which the masquerade ushered the spirit of the departed out of the village.

Mashini's formal analysis is not entirely unexpected in the literature. The half-closed eyes of Central Pende physiognomy made Frans Olbrechts recall death masks.[12] Drawing on Olbrechts's intuitions, anthropologist Fritz Kramer writes of Central Pende masks: "The face of the *mbuya* mask marks a boundary between life and death; the fullness of life is still reflected in the countenance of the dying person, but it already has something of the transfiguration of death about it" (1993: 143). Kramer may be right in his speculation that the "gloomy, sad faces and fading eyes of the *mbuya* masks have their origins in these masks" (i.e., GIWOYO and MUYOMBO) (1993: 151). One wonders if GIWOYO's cadaver-like gaze informs the lowered eyes of the face masks.

Considering GIWOYO as a *nvumbi* also explains some oddities of his performance among the Central Pende. GIWOYO is first glimpsed at a great distance *in the bush* (fig. 71). He approaches the dance floor in a wide zigzag. He is bent over slightly and slides his feet forward until he reaches the point of a zigzag, when he swoops his head around and goes in the other direction. When he reaches the short grass at the edge of the village, he falls on his knees (fig. 72), bending forward somewhat so that the audience can glimpse the headpiece better. He swings his head from side to side repeatedly *(guhunga muto)* as he

quickly flicks his *minyinga* (fly whisks made of ram's beard) to the side.[13] He does not bend over to show the mask vertically, because it does not shake well like that. When he has finished, he stands up and runs in place, moving backward slowly (fig. 12). Gɪwoyo usually wears a bell on his buttocks to accentuate the footwork of this part of the dance. It rings out *kleng-kleng-kleng* as he recoils. And as he moves backward, he waves his fly whisks up and down in front.

Gɪwoyo is the only major village mask to perform entirely in the bush.[14] Part of the audience's experience of Gɪwoyo entails craning the neck to discern his approach through the long grass. Even when Gɪwoyo dances on the fringe of the village, most of the audience sees him only at great distance. (Photos can be deceiving in this respect because the photographer may be permitted to move closer than the general audience.) At a masquerade at Kinguba (10 August 1989), the cognoscenti and even passersby sharply criticized the dancer Mungelu Ngueze for performing Gɪwoyo on the dance floor rather than

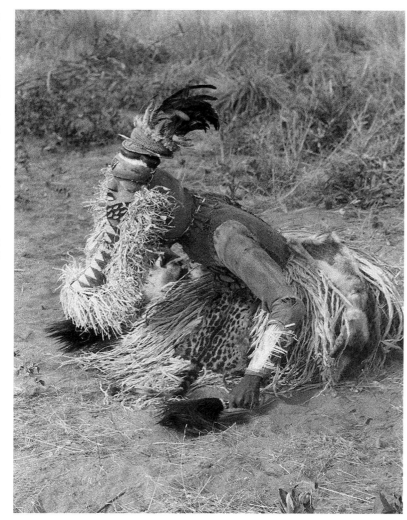

72. Part of Gɪwoyo's dance takes place on his knees on the outskirts of the village. Nyoka-Munene, Zaïre, 1989.

keeping to the fringes (fig. 12). Dancer Khoshi Mahumbu stressed that if GIWOYO has left the bush, he is *not* doing his signature dance but the *mizembo,* a gently swaying popular dance that maskers sometimes perform in order to rest and regain their wind.

The distance and the difficulty in seeing GIWOYO thus build an element of mystery into the performance. The crowd naturally hushes as it strains to see what is happening. Mashini's interpretation suggests an explanation for the extremely unusual feature of dancing a village mask in the bush. Many Pende still believe that the spirits of the dead linger in the bush on the borders of the village. Someone who wishes to contact a deceased relative need only go to a tree on the fringes of the village to direct his or her prayer. It is the voices of the dead that one hears distantly in the wind that sweeps across the high grass.

MUYOMBO/KIPOKO

If GIWOYO/KIWOYO is the most obvious set of twins shared by Central and Eastern Pende because of the resemblances in an unusual headpiece, the pairing of the Central MU-YOMBO and the Eastern KIPOKO will surprise many. The two masks could not look more dissimilar: the former has the general shape of GIWOYO, with a shorter projection; the latter is a helmet mask in the shape of a human head, very abstracted in style, provided with long nose, ears, and

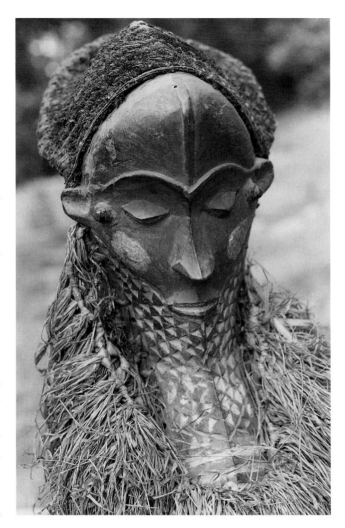

73. MUYOMBO headpiece. (Private collection) 1994.

bulbous eyes (figs. 73–76). Any argument for linkage must spring from the dance history of the two masks.

One noted above that the headpiece for GIWOYO is worn on top of the skull of the dancer, thereby leaving the eyes and nose free. This mode of dress has the advantage of giving the bearer clear vision and easy respiration, but the very length of the headpiece, extending to 80 centimeters in older masks, makes it nonetheless a difficult mask to perform. Although the dancer holds tight to the mouth cord attached to the middle of GIWOYO's projection, the headpiece has a tendency to bounce up and down on the wearer's head during the vigorous parts of the dance. Performers often complain of headaches afterward. Because the headpiece's projection is so long, and because dancers tend to concentrate their eyes on the ground,[15] there is also the danger of running into something. At a performance I witnessed of KIWOYO at Kime in 1988, the dancer slammed his headpiece against a palm tree within minutes of his appearance. The force of the blow cracked the mask and forced KIWOYO's hasty exit. If the headpiece had actually broken in two, or if the performer had tripped, he would have faced a heavy punitive fine. Because of these hindrances, GIWOYO does not dance for long periods.

It seems likely that performers desiring a headpiece more suitable to vigorous performance urged sculptors to modify the original GIWOYO genre by shortening the projection. The mask MUYOMBO shares with GIWOYO the

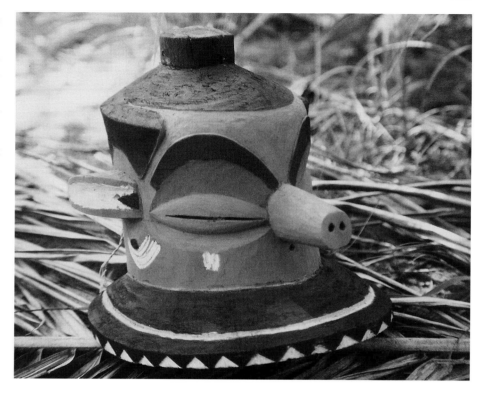

74. KIPOKO mask. Kingange, Zaïre, 1988.

basic form of a male face (identified by protruding forehead, angular cheekbones, jutting nose, etc.) extended at the chin by a projection, but that projection is much shorter (fig. 73). MUYOMBO's headpiece also sits on the head differently. Instead of resting flat on top of the head like a baseball cap, the face is angled down the forehead with the

aid of the hatlike *tumba,* which anchors it in place (plate 2).[16] The soft *tumba,* made from a palm bamboo frame covered by raffia cloth, provides a feather-light but secure mounting for the smaller headpiece. Dancers enjoy unrestricted respiration and do not complain that it bounces up and down (fig. 77).

The historian Bengo Meya-Lubu interpreted MUYOMBO as representing a cadaver on his bier, as Mashini did so convincingly for GIWOYO.[17] The changes introduced into MUYOMBO have simply been targeted at rendering the headpiece more practical for vigorous dance. The process is continuing. As exigencies for disguise of the dancer lighten, performers are presently commissioning smaller and smaller MUYOMBO headpieces, even as they speed up MUYOMBO's dance and make it more acrobatic.

MUYOMBO is the most beloved of Central Pende masks because it incarnates the quality *lulendo. Lulendo* is beauty with something more: style, flair, a "look." It implies a unique presence, but a cultivated one. There is no natural *lulendo.* It comes as the result of artistry, of hard work and calculation. The word seems to have been appropriated from Kikongo to expand the Kipende equivalent *ginango.* The latter is a

75. The KIPOKO mask supervising a ritual during Chief Kende's boys' initiation to the men's fraternity. Ndjindji, Zaïre, 1987.

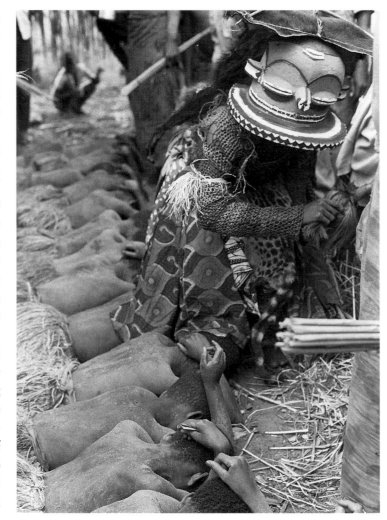

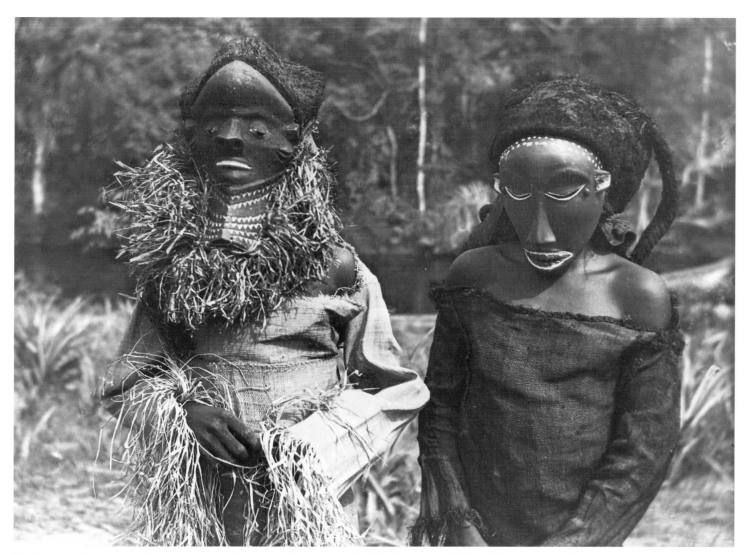

76. The masks MUYOMBO and NGANGA NGOMBO (the diviner). Photographed by Hilton-Simpson in 1909 at Mulassa during the Torday expedition. Note that the MUYOMBO mask is worn incorrectly in order to show it off better. (Courtesy of the Royal Anthropological Institute, Photographic Collection, London.)

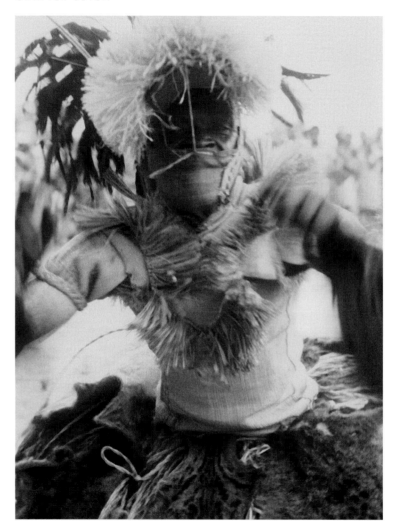

77. Masuwa benefiting from the free respiration permitted by the mask MUYOMBO. Nyoka-Munene, Zaïre, 1989.

wholly positive term for beauty. One might translate *údi mu ginango* with quiet approval as "he or she is well-dressed." There is more ambiguity in *údi nu lulendo*. It carries the emphasis "he or she has *style*," but there is a certain anxiety that it borders on vanity *(gudihala)*, that the person is working too hard to set him- or herself apart. Women who resist working in the fields may be accused of *lulendo*. Whatever ambiguity there might be in *lulendo* for people, there is none in discussions of masks. They are outright creations of artifice destined for the stage; their *lulendo* should be manifest.

High-fashion models on the catwalk cultivate a certain movement as well as a certain expression. Someone may wear beautiful clothes, but with poor posture, or clumsy movements, he or she falls short of *lulendo*. It is a term that encompasses one's total self-presentation. It refers as much to body carriage as to dress. It is in this sense that MUYOMBO incarnates *lulendo*. Spectators marvel as much at the fastidious beauty of the costume as at the controlled grace of the dance. One of MUYOMBO's most popular songs captures this double achievement:

Mawe! Mawe! Mawe, Ngoma!
Mawe! Mawe! Mawe, Ngoma!
Mawe! Ngoma wajile mu lulendo.

Mawe is an expression of delighted surprise. *Ngoma* (lit. "drum") is a popular men's name. The song praises a former dancer: Ngoma came with *lulendo*. It captures the moment when the audience first glimpses the perfect union of his costume and his stylized approach. It encourages his successors to live up to his standards.

Men who become renowned for dancing MUYOMBO have a different character from other dancers. They are perfectionists. There can be no holes in their body-suits; their furs cannot be moldy and balding; their foot rattles must be of the very best quality. The extra care given by the dancers Masuwa and Gifembe a Pinda to their costumes is representative.

Masuwa, revered as a star among the Central Pende, has sewn himself a body-suit of high-grade raffia cloth (plate 2). He leaves the ends open so that before a performance he can actually sew it onto himself, thereby rendering it tightly formfitting, without unsightly gaps or bulges. He commissioned his headpiece from the temperamental but esteemed sculptor Gisanuna. He spent years combing the forests for the tiniest of seeds to make foot rattles that sing out with a cheerful sleigh-bell tonality *(sambu jia nzuela).* They are of such high quality that a rival tried first to buy them and then to extort them

from him under some pretext. At a time when game is rare and most dancers are forced to cut up antelope skin into strips, his hoop is provided with ten furs that somehow look like new. Gifembe a Pinda of Kinguba has likewise spent years acquiring the materials to perfect his costume (fig. 2). No one has more furs on his hoop, a thicker ruff on his headpiece, more feathers in his hat. He wears matching tights and pullover. To lend gravity to his gestures he has adopted a chief's sword *(pogo ya khusa).* Older now, Gifembe has lost suppleness as a dancer but tries to compensate with a lush visual presentation. MUYOMBO is the one mask held up to absolutely rigid quality expectations in costume.

Because of the investment in *lulendo,* it is recognized that MUYOMBO's dancers require longer to dress than other performers. Part of MUYOMBO's persona is that he has to be teased onto the floor by a series of invitation songs:

Call: *Muyombo!*
Wa wa Aza. Wa wa Aza.
Mulengigo!

Response: *E e e e e e e yaya*

Call: *Yo u muza. Yo u muza.*
Mulengigo!
E e e e e yaya

Muyombo!
They're coming. They're coming.
[Your audience is here.]
Don't go away!
He's coming. He's coming.
Don't go away!

Awe mawe! We mawe!
We mawe! Mutamege nu ngoma.

Ahhh! Ahhh! [There he is!]
Call him [in] with the drum.

The crowd swells with the arrival of MUYOMBO. Because it is the most popular character, a masquerade will typically have two or more performers for the mask.[18] One saves the best for last, so that he has the largest audience and so that he does not upstage his juniors. If there are two master dancers at the same performance, everyone enjoys the rivalry, which is taken very seriously by the dancers, who often come equipped with charms and protective amulets.

Wooed by the singers, MUYOMBO finally appears, and the crowd goes wild. He approaches on his toes, bent over, making a beeline for the master drummer. He brings his arms into his chest, one after the other, flicking his fly whisks to the left and right *(gunyigisa minyinga)* (fig. 9). He will swing the headpiece from side to side repeatedly *(guhunga muto, gudihunga)*, stop, turn to the right and then to the left, lift up one knee and flip up the hoop in back *(gutupula)*, and then recommence. Once he arrives

on the floor, he will give the master drummer a small present of money to show his appreciation. A skillful dancer of MUYOMBO will be praised by cries: *Gu malu gualeluga!* ([He's] light on his feet!) The most admired dancers perform the fast footwork in place *(gutshia-tshiela)* high on their toes while their fly whisks continue to flick left and right. At the crescendo, the dancer goes lower and lower as members of the audience come forward to praise him by dancing alongside (plate 3) or by beating the ground in his wake with palm fronds.

Master dancer Khoshi Mahumbu's praise of his associate Masuwa's performance of MUYOMBO on 29 June 1989 offers both a good description of MUYOMBO's steps and hints at how each generation reinvents masquerading dances. Khoshi praised Masuwa for the beauty of his costume *(gubonga gua tenue)* and for the way he approached the dance floor, like dancers in the past, with style and flair *(guza gua mambuta nu lulendo)*. He contrasted how young dancers will step 1-2-3 and then dip their heads down, neglecting the rest of their bodies, with how Masuwa approached, remaining bent over and yet moving all of his body, especially the elbows. To maintain the bent-over position for a long time requires great endurance.

When Masuwa finally arrives, he greets the women and encourages everyone to clap in counterrhythm to the drums before he starts the part of his dance characterized by furious footwork *(gutshiatshiela)* punctuated by vig-

orous lifts of his hoop. Khoshi again contrasted Masuwa's style with that of younger dancers. The young go from foot to foot, 1-2-3-hop, then they stamp, pause, and swing the hoop, all very fast. Masuwa performs in a previous style by emphasizing grace and control. Dancers in the past came pitter-patter, pitter-patter, paused (gave no stamp), then they brought in one knee and brought up the other on the outside to make the hoop swing up on the same side and to swing out the cords *(nyanga)*. This movement in the Bandundu region is called a *pule;* the verb is *gutupula.*

At a Kinguba masquerade, I saw Masuwa dance with a tree (fig. 78), making gestures of tapping palm wine and using his fly whisks to pantomime chopping down the tree with an axe. At Nyoka-Munene he also threw his leg up and around a bush in the *pule* kick. Masuwa explained that this belonged to the *mizembo,* the popular dance that the masks may do to rest, offer some variation, and show off the range of their skills. It is much less tiring because there is no furious footwork *(gutshia-tshiela).* MUYOMBO will always do some, but POTA and GINJINGA will also typically do so.

Until recently, MUYOMBO would always

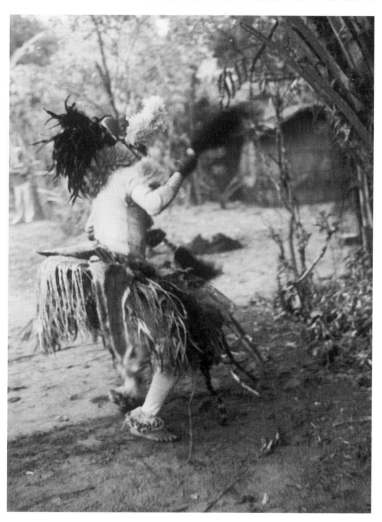

78. Masuwa dancing the mask MUYOMBO before a palm tree. Kinguba, Zaïre, 1989.

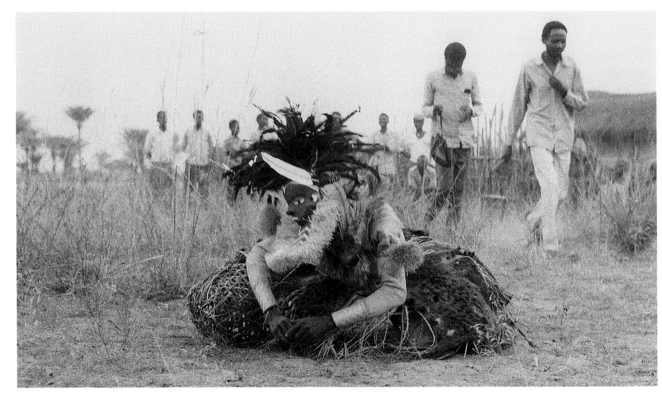

79. Masuwa performing the mask MUYOMBO's pantomime of how the women prepare millet-cassava bread. Nyoka-Munene, Zaïre, 1989.

begin the *mizembo* by pantomiming the tasks of women. He would particularly concentrate on the pounding of millet with heavy pestles, sifting out the chaff, and sitting down to mimic the preparation of millet-cassava bread *(musa)* (fig. 79). A skillful mimic might render other women's tasks as well, such as stalking grasshoppers or harvesting millet. He might also imitate some men's tasks, like tapping wine or cutting down trees to clear the fields. Field associates in the north corroborated Masuwa's remarks. Mufufu of Makulukulu added that one MU-YOMBO dancer performed a popular pantomime of fishing, all interwoven with his fast footwork. Masuwa's com-

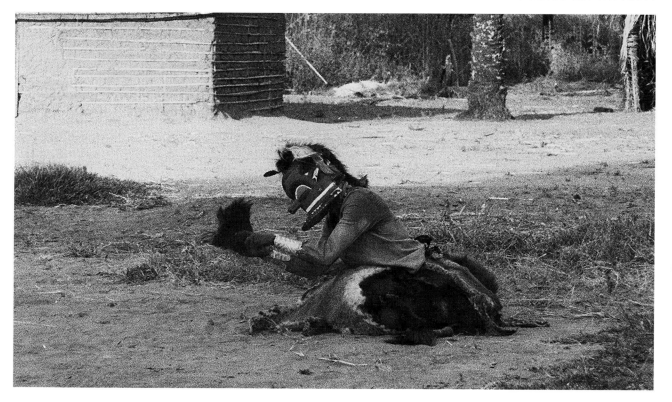

80. The mask KIPOKO performing the pantomime of how the women prepare millet-cassava bread. Ndjindji, Zaïre, 1988.

ments seem to indicate that the *mizembo* originated in MUYOMBO's actions of imitating the women and then evolved into a popular dance for most of the masks.

Khoshi Mahumbu emphasized the distinctiveness of MUYOMBO's *mizembo* dance: "MUYOMBO imitates women pounding their long pestles all the time. When TUNDU grinds flour, he imitates the women while making pelvic thrusts [against the pestle], and [shows how] they wash [by throwing water at the vagina.][19] Khoshi is making a distinction here in the tone of the mimicry. MUYOMBO is respectful and his performance full of beauty, while the clown TUNDU uses any pretext for bawdy jokes.[20]

MUYOMBO typically will prepare the millet-cassava bread on his knees (fig. 79). Khoshi emphasized the dancer's skill at pantomime. He does all the preparations and you see him even cut off the *musa* before your eyes. He does this all with stylized gestures that are lovely to see. There are even certain drumrolls for when the *musa* is cut and drops—splotch!—onto the plate. MUYOMBO will make gestures of grinding the millet flour, then sifting it. He will mimic how a woman hoes in the fields, blending the motion with his dance by giving a hoeing gesture, stepping back and doing his furious footwork, giving the hoeing gesture, etc. In the past, Khoshi even saw dancers bring out women's pestles or fishing baskets as props. When MUYOMBO incorporates their activities into the masquerade, the women in the audience go crazy. Khoshi pinpoints this as the moment when the women throw ears of corn, calabashes, and money onto the dance floor. He regrets that although people loved this part of MUYOMBO's dance, young dancers dismiss the pantomimes today in Franco-Kipende as *gestes de passé* in favor of more "modern," contemporary popular dances.

In review, MUYOMBO's performance presents five distinctive characteristics for its genre: (1) The extraordinary emphasis on *lulendo*. (2) The involvement of the women in the masquerade. Although women usually have some interaction with the comedic masks TUNDU and GANDUMBU (the old widow), this remains peripheral and is not foregrounded on center stage. MUYOMBO is the only mask to deliberately court the women's involvement as part of his performance. He does this primarily through (3) pantomiming the women's daily preparation of millet-cassava bread. (4) The predominance of *pule* (the semicircular kicks) in his dance. Many masks can incorporate some *pule*, but these kicks are mandatory in MUYOMBO's performance and critical to assessment of the quality of the dance. (5) The predominance of his gestures of flicking the fly whisks. Many masks hold fly whisks but their movement is not incorporated into the dance as it is for MUYOMBO and (to a lesser degree) for the related GIWOYO.

As explained in chapter 1, in the aftermath of the disastrous 1931 and 1963–65 rebellions, Central Pende masquerading has emphasized its entertainment function and minimized its ritual function. Although all of the characteristics above are recognized as central to MUYOMBO's persona, few Central Pende now care to speculate on how these aspects of MUYOMBO's performance may have evolved in the original ritual context that they have rejected. For such an interpretation, we must turn to the Eastern Pende, where the ritual context is alive and well, and where there is a mask that shares all of the distinctive qualities of the MUYOMBO genre: KIPOKO.[21]

When asked, "Which is the most beautiful mask?" few Eastern Pende fail to answer, "KIPOKO." It is felt that this mask surpasses all of the others, not just in its headpiece

but in its costume, song, and dance as well. KIPOKO is as fully beloved as MUYOMBO for its style and flair. However, as noted above, no pairing of MUYOMBO with the long-nosed helmet mask of the Eastern Pende could rest on the form of the headpiece. It is the dance that provides the key for linking these two seemingly disparate masks. KIPOKO, like MUYOMBO, keeps his fly whisks flicking, he also involves the women in his dance, and pantomime of their daily tasks is central to his performance (figs. 79–80). MUYOMBO's signature dance step, the semicircular kick *(pule)*, embroidered as it is by the hoop and cords, is none other than the *shapi*,[22] the signature dance step of the mask KIPOKO, the kick that he uses to activate medicine and to heal the infirm and infertile (fig. 81).

For Eastern Pende exegetes, the dance for KIPOKO, called the Lukongo, is a *summa saltationis*, a compendium of all knowledge in dance (fig. 82). Chief Nzambi stresses the encyclopedic nature of the dance: "The dance of Lukongo shows the characteristics of chieftainship: physical courage, wisdom and eloquence, the hunt, and the audacity to do whatever is necessary. The Lukongo shows also how to sow, harvest, cook, how women walk, the work of the diviner. However, the dance of KIPOKO is [above all] the dance of the chief."[23]

He explained that KIPOKO may come out with two fly whisks or an adze in the right hand. With these props, from time to time, he will mimic a hunter aiming his gun at a bird or monkey, a man chopping down a tree, a man drawing palm wine; he will pantomime women hoeing their fields to sow, and later harvesting; he will imitate how they peel manioc carrots and pound them to make flour and how they use the flour to make cassava bread (fig. 80). In short, anything that falls within the province of daily life is open to the genius of the dancer. Chief Nzambi pointed out that all men learn the Lukongo during their initiation to the men's fraternity. Nonetheless, when KIPOKO performs the Lukongo with mastery, it represents the chief, just as when someone speaks with authority, it comes from the chief, although everyone learns to talk.

Ironically, to the eyes of outsiders, the most important parts of the dance can seem like insignificant improvisations. When the dancer gets farther and farther "down" and reaches out lightly on one side with a fly whisk to sweep the ground, it seems like a casual flourish. In fact, this is a signficant gesture in which the dancer can both signal the drummer that he wants to change the rhythms and also "sweep away" evil spirits that may be lingering in the village, causing illness or malaise. It is a wish for a "white village" *(dimbo diabuka)*, that is, a healthy village, free of illness, sterility, and personal discord.

Later, when he pauses in his energetic dance to use his fly whisk in a pretense of peeling a manioc carrot, it can seem like an excuse to catch his breath. The genius of the

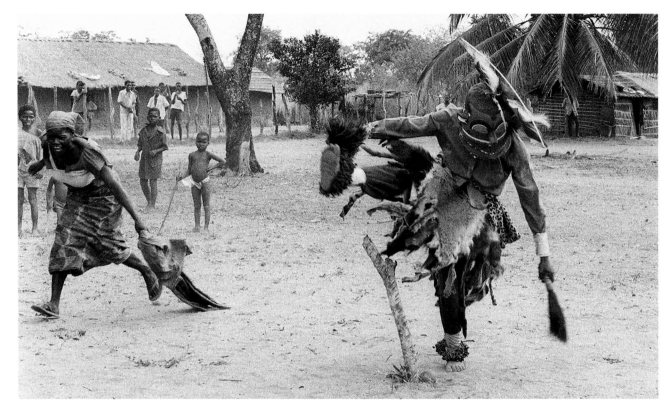

81. KIPOKO performs a semi-circular sweep kick *(shapi)* to activate protective medicine buried under the short stick at one end of the dance arena. Note the woman on the left trailing him with a cloth. Kime, Zaïre, 1988.

Pende lies in the fact that these quiet moments *are* ways for the dancer to rest while remaining on the dance floor in addition to being imbued with significance. Around Ndjindji, KIPOKO is fondly nicknamed MBUNDJU as a pun on the word for "mist." The play on words emphasizes

that KIPOKO is a mask like the mist, which can linger for hours. Often the first on the dance floor, the alternation of hard dancing with restful moments allows dancers to continue until sunset and the closure of the masquerade.

If KIPOKO's dance is encyclopedic, the most important

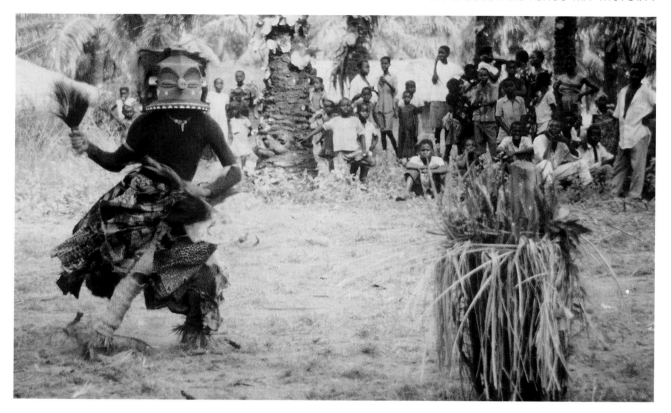

82. Kɪᴘᴏᴋᴏ's classic dance.
Kingange, Zaïre, 1988.

part of its mimicry has to do with food production. One famed dancer, Mbuka Makungu, stressed that pantomiming the women's sowing, grinding, peeling, etc. (fig. 80) is *the* most important part of the dance because it reminds the audience of the purpose of the masquerade: to aug-

ment the production and health of the population. "[Kɪᴘᴏᴋᴏ] shows that we dance the masks in order to augment the food, children, and health of the *kifutshi* [the environmental microcosm necessary to the survival of any village]."[24] Thus, the Lukongo is a type of danced

prayer for the ancestors' continued beneficence. This is why every boy is required to master it at his initiation to the men's fraternity.

The full significance of the Lukongo was revealed on the first day of a masquerade for Chief Kingange in 1988. All day, the dancing had lacked enthusiasm and had been bedeviled by mishaps. To my surprise, minutes before the affair ended, Chief Nzambi, who was visiting, got up and began to perform the Lukongo. When Nzambi began his masterful rendition, the crowd went wild. It gained all of the animation that had been lacking all day. Young men and old went up to give him little gifts of money in praise. In particular, the floor was flooded by women, trailing after him with pieces of cloth, throwing handfuls of millet in his direction, and crashing down carrots of manioc onto the dance terrain. One woman boogeyed after him, alternately raising up a newborn infant and then touching it to the ground.

When I asked him why he had gotten up to dance, Nzambi explained that he had felt sorry for me: I had come from so far away to see masquerades and the entire day had been flat because the experienced KIPOKO dancer had gotten too drunk to perform his duties well. Consequently, the day had not been consecrated to the dead, and they had not come to dance among the living. It was like writing a letter and then not sending it. By performing the Lukongo, Nzambi had recalled to the village its purpose in

dancing the masks in the first place: thanksgiving for the harvests and children of the past year.

Because women do the bulk of agricultural work and bear the children, they are particularly concerned in this kind of thanksgiving prayer. Among the Eastern Pende, women will dance their gratitude and petition by joining KIPOKO on the floor. They may throw down millet, cassava, or corn as samples of the staples that they need to survive. They also will dance clothes and goods such as purses that they have bought with the previous year's harvest surplus (figs. 81, 83–84). The woman dancing the baby was offering her thanks for desired fertility. Because KIPOKO is a helmet mask (unlike MUYOMBO), the women may come as close as they like, as long as they do not touch. KIPOKO in this case dances with them, not *as* a spirit from the dead, but as a visual marker for the invisible participants in the festivities.

The Pende do not believe that a person's character is miraculously transformed at death. A mean and miserly personality becomes if anything even more jealous and envious on the other side. It can be difficult to ask the dead to protect the village because the spirits of the mean and jealous *(tupolongongo tuabola mitshima)* can sabotage the paths of communication. Hence, the flicking gestures of KIPOKO's and the other masks' fly whisks are intended to sweep away these unwelcome participants.

When KIPOKO throws his powerful semicircular kick

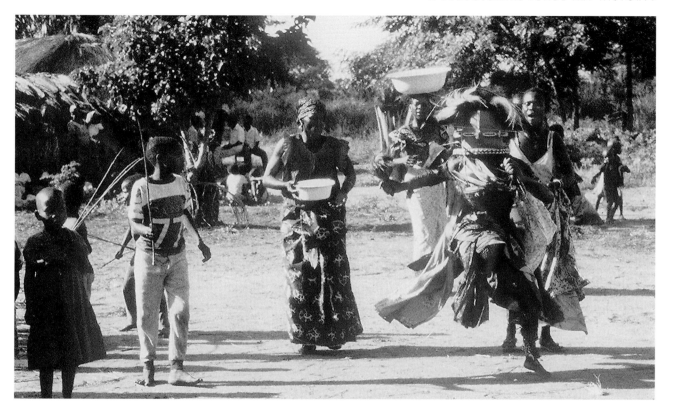

83. Women dancing with the mask KIPOKO, throwing down millet, and jangling cooking basins. Nzambi, Zaïre, 1988.

over stashes of medicine on the dance floor (fig. 81), he is asking for the ancestors' protective embrace for the entire village. At the close of the masquerade, individuals in need of a helping hand will come. The frail, the infirm, and the infertile will kneel down before him, covering themselves with a cloth. KIPOKO will perform the Lukongo for this special audience, throwing each leg over them in the same semicircular kick to cover them with a shell of protection that will block the entry of the evil spirits or sorcerers who may be responsible for their afflictions.

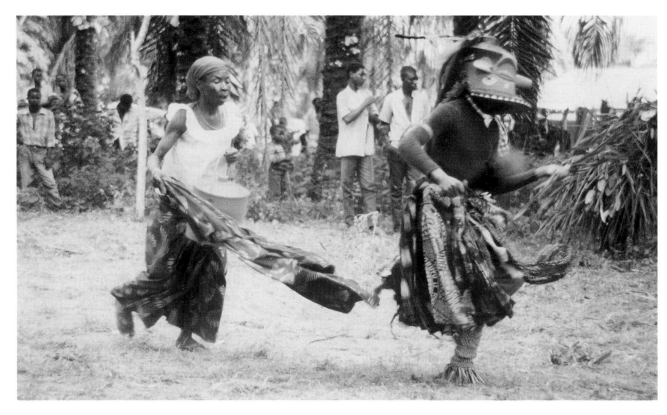

84. Chief Kingange's first wife trailing the KIPOKO mask with a cloth and a kitchen bowl bought with money from last year's harvest surplus. Kingange, Zaïre, 1988.

The beloved KIPOKO represents everything warm and nurturing about the chief's role as intermediary between the living and the dead. Every chief, of every degree, has the right to KIPOKO. Typically, sculptors exaggerate the eyes, nose, and ears while rendering the mouth diminu-tive or nonexistent (fig. 74). Thus they convey that the chief should benefit from a kind of sensory hyperactivity in order to know all that is happening in his village but should be slow to speech, lest hasty words render a bad sit-uation worse. Not only should he see and hear all, but

through his nose he should be able to ferret out the "smell" of sorcery and the odor of stolen meat as it cooks.[25]

The emphasis on beauty and style, the semicircular kicks, the pantomimes of village activities, and the involvement of the women strongly suggest that MUYOMBO and KIPOKO sprang from the same root. It is likely that MUYOMBO once had a central role, like KIPOKO, in fulfilling the masquerade's purpose of achieving a communion between the living and the dead.

It is impossible to determine whether one may preserve an older form, or whether they have both evolved away from some lost prototype. At first, it seems striking that the Kwilu and Eastern Pende, widely separated, both have helmet (or "bell") masks shaped like the human head, whereas the Central Pende do not. This fact suggests that KIPOKO may represent an older form. However, both groups have neighbors with bell-shaped helmet masks, who may have inspired later, independent inventions. The stronger argument may be that MUYOMBO represents the more conservative form because its headpiece is so close to that of GIWOYO, whose form predates the separation of Eastern and Central Pende in the eighteenth century. Derivation from a GIWOYO-like mask might even explain the mysterious shelflike protrusion from under KIPOKO's chin (figs. 74–75).[26]

There are always women who push at the restrictions placed on them vis-à-vis the masks. Among the Central Pende, because popular masks like MUYOMBO, GINJINGA, and POTA expose the upper half of the face of the dancer, the crowd of noninitiates must be kept at a certain distance where the projection or fringe throws the dancer's eyes into shadow. At a performance in Makulukulu in 1989, a woman who wished to go up to dance with the female mask GABUGU was warned: "If you do, you'll pay." So the woman stayed on the fringes of the floor, but she mirrored GABUGU's gestures so well that the chief threw her a bill in praise.

Women in the Kasai have succeeded in seizing a more direct role for themselves in the masquerade. They participate very actively in the chorus for the masks, and as I discovered when a neighborhood funeral emptied the village of Kingange of most of its women on the second day of a masquerade, their absence can rob the festivities of all their joy and animation. Dancers in fact compete for the the women's ululating cries of praise *(miyeye)* and find it hard to concentrate without them. Most important, women have seized access to the dance floor, as described above for KIPOKO, although the oldest men in the Kasai claim that this was not always the case.

Far from showing that the religious significance of the masquerade is in decline, the women's active colonization of the masquerade expands on the ritual logic of the occasion. After all, they are most directly concerned with food

production and infant mortality, which the masquerade addresses. Their role in the masquerade has become so assured, so appropriate, and so enjoyable that the first wife of the chief and the wives of the chief's ministers are obliged to attend, to encourage the dancers with *miyeye,* to dance with KIPOKO, to throw down millet, etc. When the funeral mentioned above emptied the village of Kingange of women, the chief's first wife was ordered to stay by her husband and to doggedly pursue her duties toward the masks (fig. 84).

What happened here? Were the women able to win this advantage *because* the masks were already more disguised than their Central Pende equivalents? Or is it more logical to think that it became more desirable to *increase the disguise* of the headpieces in order to decrease the distance between the masks and the women? In the latter case, the development of KIPOKO as a helmet mask makes perfect sense. We will see that there is a similar movement in increased diguise in two other related masks, MUNYAN-GI and POTA.

GINJINGA/KINDJINGA (OR MUNYANGI) AND POTA (CENTRAL POTA/EASTERN POTA)

In the discussion of MUYOMBO, it became clear that the weight and size of a headpiece can significantly shape (or inhibit) a masker's dance. MUYOMBO and KIPOKO have

powerful dances, but one always senses the element of control and restraint. In order to provide dancers with the maximum freedom to execute the "hot" movements appropriate to young men's strength and extravagance, Pende long ago developed a special genre of masks with small, unobstructive headpieces. The pairings of GINJIN-GA/KINDJINGA and the Central and Eastern POTA provide an example where the headpieces proved more conservative than the dances, although the form of the dances responds to the same aesthetic goals.

It is not style that links the Central and Eastern versions but their distinctive positioning. The faces of the Central Pende masks GINJINGA and POTA are largely identical. They strongly resemble those of GIWOYO and MU-YOMBO with their half-closed, unpierced eyes; however, GINJINGA and POTA have no chin projection *(gilanga)* whatsoever (figs. 23–24). Performers position them slanting somewhat farther down the forehead than for MU-YOMBO.[27] They are held snugly in place by the same raffia-covered hat frame (fig. 85). Performers have further reduced the coiffures. Whereas GIWOYO and MUYOMBO wear hats of feathers (the bigger, the better), performers of GINJINGA and POTA pin only a large leaf or two to the back of the head. The dancer's eyes and nose are free, obscured only by the raffia fringe attached to the mask's jawline.

Likewise, the Eastern KINDJINGA and POTA are worn

perched on the forehead, held in place by a raffia-covered hat frame, which, however, is shaped like a pillbox hat (fig. 86). Both can be quite small, about 5–6 inches, and are growing smaller (figs. 87–88). The faces are abstracted in the Eastern style. There is a range of forms but the two are sometimes interchangeable. Both may have pierced or unpierced eyes, a carved crest decorated by alternating dark and light triangles *(kaji-kaji),* and a fringe of ram's beard around the jawline. In the Eastern genre, it is the hat covering that distinguishes the masks. KINDJINGA wears a crest of blue feathers (fig. 87); POTA's hat is covered by a mane of twisted raffia cords (fig. 88). Women's increased involvement, especially with regard to POTA, has necessitated increased disguise of the face with raffia cloth (fig. 89).

Since the headpieces are feather-light, the dancers of these masks have incredible freedom of movement with the same advantages of good respiration and sight lines. Field associates everywhere speak with something like awe of the dance of GINJINGA and KINDJINGA. Both are characterized as showcasing the athletic skills of young men.[28]

Khoshi Mahumbu stressed that the rhythms for GIN-JINGA are very fast and difficult. Not every drummer can successfully hold the beat. He praised the dance but emphasized that the performer must be exceptionally strong. The mask executes more *gutshiatshiela* (fast alter-

nating footwork) than any other genre, and it shakes its hoop with energy and verve (fig. 90). *Gutshiatshiela,* GIN-JINGA advances, *gutshiatshiela,* he backs up. He turns to the right, *gutshiatshiela,* he turns to the left, *gutshia-tshiela.* He swooshes his hoop to each side by stepping

85. The sculptor Mufufu demonstrating the proper positioning of a POTA mask on the head. Makulukulu, Zaïre, 1989.

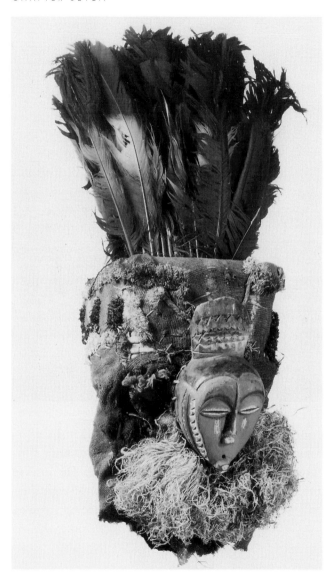

86. Eastern Pende KINDJINGA
mask collected by Himmel-
heber in 1938–39 among
the Bakwa Nzumba. (No.
III.9511. Courtesy of the
Museum der Kulturen, Basel.
Photograph by P. Horner.)

forward with one foot and then slapping down the hoop on the same side while twisting his arm toward the back. Then in the blink of an eye, he whirls around and recommences. The fast alternating steps make the foot rattles resound across the dance floor. The younger sculptor Mashini remarked that if anything the dance is picking up speed and that the dancer needs unusual strength . . . as well as good knees.[29]

Although the gestures and steps are different, the striking emphasis on strength *(ngolo)* and energy continues in GINJINGA's homonym in the Kasai. At a performance at Chief Nzambi's masquerade in 1989, the performer came running out, leaping straight to the drummers. One felt immediately the greater freedom of this mask to leap, run, twist, and turn because the dancer could breathe so much more freely and was not hampered seriously by his costume. Unlike KIPOKO, this mask is famous for leaps and flexibility. In Sh'a Meya's words, "he jumps as if he's trying to fly."

KINDJINGA's blue feathers mimic the cocky crest of the great blue turaco *(Corythaeola cristata)*, known to many Europeans in Zaïre as the bulikoko or blue pheasant (figs. 86–87).[30] Dancers have wittily substituted the bird's larger and more recognizable tail feathers for use in the mask's crest, called *kindjinga*. By metonymical extension, the entire mask is known by this name in the northern Nzumba region. Elsewhere, it is better known as MUNYANGI.[31]

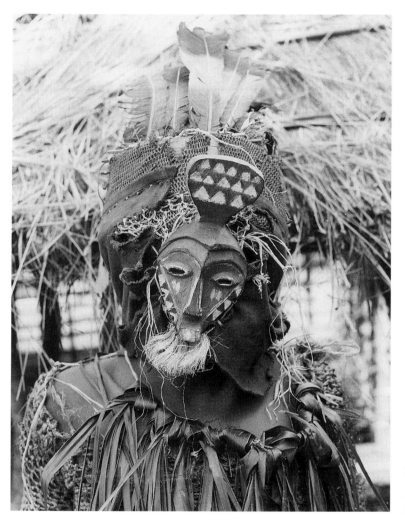

Field associates described his proper dance as jumping forward with both feet "like a bird," trembling, and then performing *mateketeke*, the amazing shoulder rolls of men's dance. MUNYANGI does not *represent* the turaco, but it does share some of the familiar bird's beauty and agility. Because the bird inhabits dense forest, it hops more than it flies, and runs with remarkable speed and ease along the high branches. Similarly, MUNYAN-GI races here and there.[32]

Like its Central Pende homonym, the dance of the Eastern version stresses vigorous hip movements. Two of MUNYANGI's most popular songs emphasize this ability:

> *Munyangi e e e e! Munyangi e e e e!*
> *Munyangi ku mabanda!*

> Munyangi! Munyangi!
> Munyangi of the furs!

Eastern dancers heap up furs to accentuate vigorous hip movements in the way that Central Pende performers use the hoop. The song emphasizes that MUNYANGI's most striking characteristic is his ability to make the pile of furs fly out through powerful stamping and hopping from foot to foot. Singers

87. Eastern Pende MUNYANGI mask. Ndjindji, Zaïre, 1988.

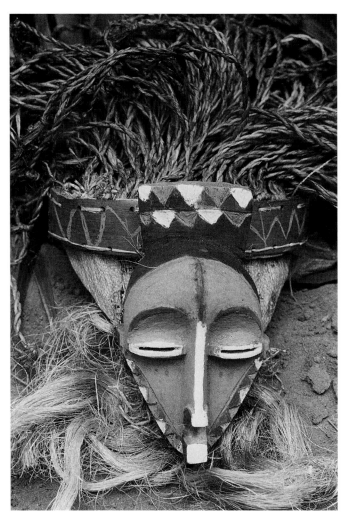

88. Eastern Pende POTA mask. Ndjindji, Zaïre, 1988.

intone this refrain to encourage the dancer to shake his furs. In another version:

Munyangi wa fumu wasudika ndjindji nu kholoma.

The chief's [mask] MUNYANGI dresses in serval [or civet?] and leopard.

This reference to rich furs alludes also to the vanity of this mask, which is often described as the "young man" of the masquerade because of the care (ideally) given to his costume and the extravagance of his leaps and bounds. Aged Chief Kikuba, once a renowned dancer of MUNYANGI, emphasized that the mask's performance should incorporate lots of high kicks and fantasy. Both GINJINGA and MUNYANGI extravagantly burn energy on the floor and dazzle the audience. They dance for short bursts and then retire.

The Central and Eastern versions of POTA likewise stress high aerobic outbursts of dance. An Eastern performer commented that he prefers POTA over other masks because they are heavy and give him a headache. With POTA, he is unencumbered and free to do what he likes. He also enjoys the opportunity for pantomime.

POTA's dance is difficult to isolate among the Eastern Pende because it shares so much with that of KIPOKO. In fact, the mask has evolved into becoming something of an adjunct for KIPOKO. De Sousberghe photographed POTA aiding KIPOKO in healing by dancing over the ill

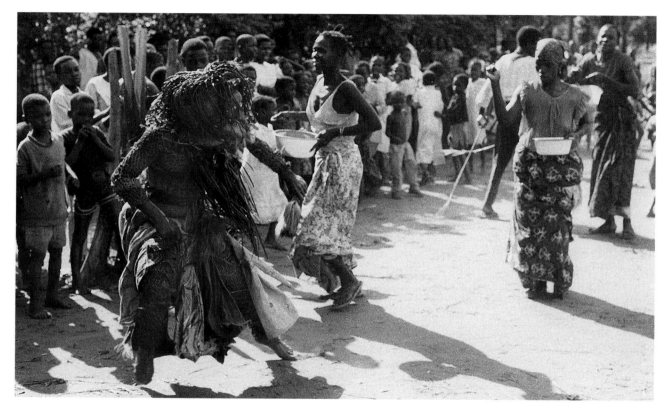

89. Women honor the Eastern Pende POTA mask danced for Chief Nzambi. Ndjindji, Zaïre, 1988.

in 1952 at Ngimbu (1959: figs. 67–68). I witnessed the same phenomenon at Nzambi in 1988. Because of POTA's freedom of movement, it performs more of the semicircular kicks than any other mask, even KIPOKO, although it rarely takes over KIPOKO's ritual duties. Today, when there is so little game, POTA dances with a profusion of lapeted and brightly colored wrapper cloths borrowed from the women (fig. 89).

Eastern Pende today are puzzled themselves about the mysterious twisted cords on POTA's costume. Their func-

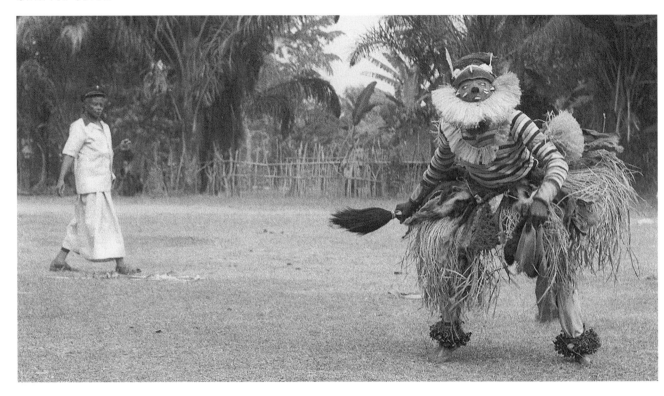

90. Bundula Ngoma
performs the mask GINJINGA.
Kinguba, Zaïre, 1989.

tion is much more comprehensible in the mask's Central Pende cognate. The latter performs with a hoop at the waist and a belt at the neck covered with a great quantity of twisted raffia cords. In fact, POTA is sometimes called POTA-MISHINGA. *Mishinga*, or *mihota*, is the name of the twisted raffia cords found in such abundance on the cos-

tume. However, *leaves are attached to these cords* (fig. 20). Delhaise described the mask in 1924 as "covered with grass to simulate a leafy tree."[33] Field associates stressed that the quantity and functionality of the leaves (how well they cling to the costume) were more important than any symbolism.[34] The performers have reason to be con-

cerned about leaves falling off because POTA executes a very active dance requiring great endurance. De Sousberghe recorded that it is known for its leaps and that some claimed that past dancers would even bound onto the roofs of houses (1959: 47).

There is remarkable unity in the descriptions of POTA's dance throughout north and central Pendeland.[35] The mask appears first in the distance, taking little steps and holding a palm branch. The headpiece is completely hidden by a square of raffia cloth. Master dancer Khoshi Mahumbu stressed the mystery of POTA's arrival. Because it is covered over by leaves, with the arms and headpiece hidden, the audience could even mistake it for an animal approaching in a big heap of leaves.

The dancer begins to lift his feet in fast succession on his toes *(gutshiatshiela)*. From time to time, he sweeps the leaves tied around his neck over each shoulder in succession as he "shivers" *(gudigita)* his shoulders, moving his elbows in and out. This movement from men's dance makes the leaves shiver and shake. Once POTA arrives on the dance floor, he lifts off the raffia cloth hiding his headpiece and deposits it on the ground, shivering all the while. Once it is down, he begins to perform a violent *gutshiatshiela* across the dance floor that sends the cords flying out. He punctuates the footwork with high semicircular kicks (as among the Eastern Pende) and the shoulder shivering. He ends each segment by throwing the rope of

leaves over each shoulder in succession before changing direction.

Significantly, all the performances that I witnessed of GINJINGA and POTA among the Central Pende were deemed failures. Masuwa regretted that the first dancer became "chilled."[36] Of all masks, GINJINGA should be "hot" like the men's wild fraternity masks, the *minganji*. This dancer did not perform for long and then left the floor. At the second performance, the drummer, disgusted, severely criticized how the dancer made use of his hoop (see chapter 3). The dancer began punctuating his footwork by slapping the ground with the piece of raffia cloth that he held in his left hand, but then he grew tired and began to flap it instead against the hoop. Critics of Khoshi's performance of POTA at Nyoka-Munene described it as "tired" *(zogolo-zogolo)*. Although the headpiece leaves the eyes and nose free, the costume itself is quite heavy because of the cords and leaves; it takes endurance to do the high kicks and to make the leaves shiver as they should. Few young men today among the Central Pende are drawn to these masks and middle-aged dancers rarely have the stamina necessary to perform them correctly for extended periods.

These criticisms are revealing because they stress the importance of the high aerobic outbursts in the dance in capturing the audience's imagination. Dance criticism contrasts in metaphor the "heat" of life with the coolness

of death. Some performances (like MAZALUZALU, the chief) are admired precisely for their soothing coolness. However, GINJINGA and POTA are meant to dance "hot" and are essential to the overall purpose of the masquerade. Muhenge Mutala (chapter 1) spoke eloquently of the ability of dance to rejuvenate both individuals and the village itself by driving out the "chill" of illness and disinterest. The pyrotechnics of GINJINGA and POTA are meant to warm us all by catching us up in their enthusiasm. With such an understanding, it is not surprising that performers were concerned to perfect headpieces that would allow them to dance with all their strength and might. Excitement is contagious.

TUNDU/KINDOMBOLO OR MABOMBOLO

TUNDU and KINDOMBOLO are masks that, like MUYOMBO and KIPOKO, could not possibly be linked together through the appearance of their headpieces (figs. 43, 91). And yet they represent the same aesthetic expressed in the very different stylistic languages of the Central and Eastern Pende: the anti-aesthetic. Their grotesque form and behavior show to us how ludicrous we look when we disregard social conventions and think only of ourselves.

TUNDU has always shown a great variety of forms. As recounted in chapter 5, it was a Belgian who first solicited a wooden facepiece for TUNDU from the sculptor Gabama

or Gitshiola (fig. 42).[37] Previously, some had covered the face with the crocheted material *(njianjiala)* used in the costumes of the *minganji* maskers' body-suits (plate 1). The back of the head was covered by woven raffia cloth. There were no eyes or nose.[38] Others had made a raffia hood with crude holes punched for the eyes. The only feature represented was a little black beard of dyed raffia thread. De Sousberghe notes a variation in which the performer would use raffia cloth blackened with the resin *muhafu (Canarium schweinfurti)* (1959: 40). The advantage of the *njianjiala* was that (as for the *minganji*) it allowed the performer to breathe normally. Because TUNDU must stay on the floor for long periods, this was a critical factor in costuming, then as now. The light weight also facilitates sudden sprints when TUNDU chases children who crowd in on the dance floor.

The following account of an impromptu Sunday masquerade at Makulukulu in 1989 gives the flavor of a typical performance. Several men dressed TUNDU with an oversize black face mask (h. 25 cm, w. 18 cm) and tacked a leaf onto the back of his head. For the costume, they rolled up a ball of clothes to make his stomach bulge. Then they split a palm frond and cut off the ends to make him a tutu and arm tufts in parody of the hoop and arm bracelets that some of the elegant masks wear. The dancer donned tattered pants and tied down the ends with palm fronds. He attached a raffia sack to a walking stick made from a split

palm bamboo. The sack held crude little leaf packages meant to represent the little packets of meat and fish used to woo women. He also added a little calabash *(kapungu)* of the kind used in administering enemas. His helpers sewed the ends of the headpiece onto his shirt and they added a Western-style tie of dried palm fronds. They also gave him a phallus made from palm bamboo.

At 4:50 p.m., TUNDU ran onto the floor and stuck his cane with its sack into the ground. At first, he ran up and down to group the children and show them how to clap supporting rhythms. Then he performed his signature dance, a caricature of intercourse, with his cane substituting for a woman. TUNDU dances around the stick, which he holds with both hands in front of him. When the drums boom, he bends his knees and gives a sharp pelvic thrust *(mathengo)*. The bouncing swollen stomach underlines the movements of the thrusting pelvis. At Makulukulu, TUNDU also fell on the ground and pretended to be the woman during coitus. He then took out the small calabash and pantomimed giving himself an enema. After finishing, he sat down and masturbated, at which sight the hundred or so children present whooped and laughed. TUNDU made coy signs at various young girls in the audience, offering them his ludicrous courting gifts. To the amusement of all, the girls would rebuff him by yelling insults *(Wabola!* "You're ugly!"). From time to time, with lightning speed, TUNDU would suddenly break and chase kids,

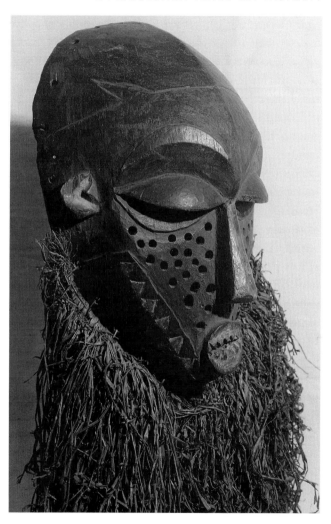

91. Eastern Pende KINDOMBOLO mask. (Felix Collection.)

or throw dirt at them, as a means of keeping them polite and on their toes. After a while, he pantomimed to the girls: "You've refused, so I'll put away all of my tempting packets." He also aped going to the bathroom and wiped his buttocks with the stick.

TUNDU's proper dance mimics the rhythm of intercourse. He leans forward, holding his cane with both hands on the top. He will do a fast alternating step *(gutshiatshiela)*, like a running step, then stamp left, do more footwork, then give two stamps left, two stamps right, etc. He goes faster and faster, the steps become more and more exaggerated, alternating long bursts of *gutshiatshiela* with an occasional stamp. At the climax, there is a mighty pelvic thrust forward against the cane, and then he will fall down exhausted. At this point, one performer pulled out a cigarette.

Although TUNDU's dance is by far the simplest of masking steps, the explicit references to sex inhibit most dancers. As both Palata (1957: 11) and de Sousberghe (1959: 41) note, the thought of performing bawdy routines before close female relatives is too embarrassing. At Mukedi in 1989, two different TUNDUS tried to woo the audience, but although they performed all of the usual bawdy and caricatural skits, they generated little laughter. In addition to a flair for the outrageous, good comic timing is essential to this mask's success.

TUNDU is sometimes called the "chief of the dance floor" *(fumu ya luwa)* because he is always present from the beginning to the end (fig. 18). He mimics each mask's dance—like a black shadow (fig. 19, plates 4 and 8). For example, when he hears MUYOMBO's songs, he will prepare the audience by showing how the other mask will dance. When MUYOMBO arrives, TUNDU may watch or run over to joke with the women. From time to time, he will return and either parody the masker or do a clumsy rendition of the dance to make everyone laugh at his lack of aptitude.

Frobenius recorded in 1905 the presence of oversize face masks with enlarged eyes among the Eastern Pende, called KINDOMBOLO or MABOMBOLO (1988: 64, photo 11). This form has remained conservative. A. Maesen collected a mask strikingly similar to Frobenius's in the 1950s (de Sousberghe 1959: fig. 85).[39] Another variation may be small and drilled all over with holes, representing smallpox scars (fig. 91).

However different the forms of TUNDU and KINDOMBOLO appear from each other, they are greeted in the same fashion by the crowd with cries of *"Délinquant!"* and *"Wabola!"* (You're ugly!). Both seek to grab the breasts of the female masks, both spend long periods on the floor, parodying the other performers, both joke a lot with the women, and both police the crowd by organizing the children into choirs and chasing after those who get too close. The anti-aesthetic appears in the Eastern examples

through the proportions of the face (too big, too small) and in that efficient sign for repellent ugliness: smallpox scars.

CENTRAL PUMBU/EASTERN PUMBU

The PUMBU headpieces of the Central and Eastern Pende (figs. 55, 67) bear even less physical resemblance to each other than the proposed twins MUYOMBO and KIPOKO or TUNDU and KINDOMBOLO. Yet the core of their dance is identical (figs. 92–93). PUMBU, as conceived by the Central Pende, has been domesticated into a character of folklore, the executioner. For the Eastern Pende, the mask represents something more.[40]

The Pende universally gloss PUMBU as representing *ngunza*. *Ngunza* signifies a person, usually male, who has drawn human blood. Soldiers who have killed in battle fall into this category, as do circumcisers. Hunters who have killed leopards, lions, crocodiles, or other ferocious beasts are included. So are the spirits of these animals, which are considered to have the capacity to take revenge on their hunters. Sorcerers who have killed may be included, although they have not literally drawn blood. Whether socially sanctioned or not, taking human life is not considered something that everyone is able to do. It requires physical courage and a disregard for consequences that one must respect as well as fear—even in a murderer.

In the Central Pende conception, PUMBU is not just any *ngunza* but the man once delegated (in secret) to kill a stranger at the time of the investiture of a new high chief. At Pidi-Samba, field associates recounted that as the official inauguration approached, the chief-elect would send a minister *(kapungu)* to this man with a cock in a symbolic purchase of his services. Nothing needed to be said outright. The *ngunza* would seek out a stranger, whom the chief had never seen, to execute quietly. It was thought that if the chief knew the victim, the victim's spirit would be more likely to seek revenge and make the chief ill. The purpose of the execution was to acquire a spirit to provide a ghostly guardian for the chief to protect him from the machinations of his rivals and enemies.[41] The mask renders visible what normally is not.

In the masquerade, PUMBU is one of the dramatic masks that appear as twilight approaches, when the crowd is at its largest. Anticipation is built up by the furious dance of the mask's helpers, who precede it. One or two men come out dressed as *ngunza*. They wear the blood-red feathers of Lady Ross's violet turaco *(Musophaga rossae) (nduwa)* at their temples.[42] Their foreheads are streaked with a stripe of kaolin. In their left hands, they carry a square of raffia cloth; in the right, they flash a two-bladed sword *(pogo ya khusa,* for which a machete is often substituted). Field associates at Makulukulu explain that *ngunza* carry a square of raffia cloth in order to blindfold their victims.

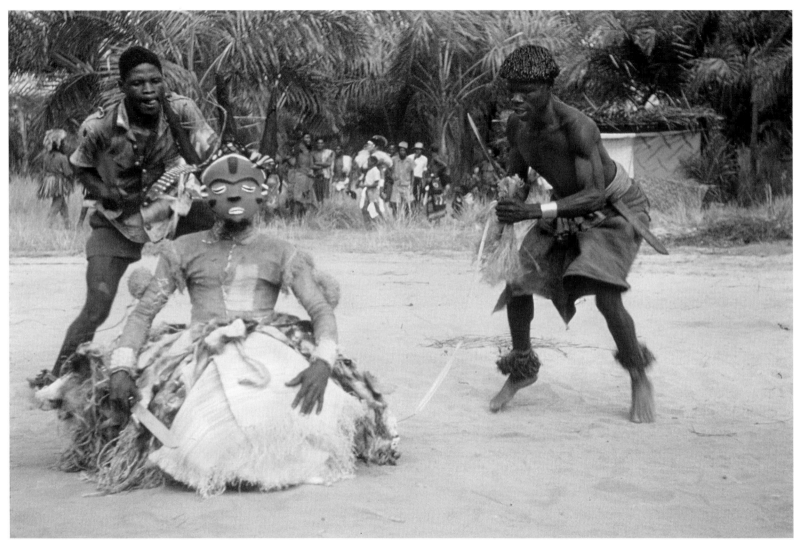

92. The Central Pende version of the mask PUMBU, machete ready, pausing before the storm of furious action. Note the cords restraining him. Nyoka-Kakese, Zaïre, 1950s. (Photograph by Léon de Sousberghe.)

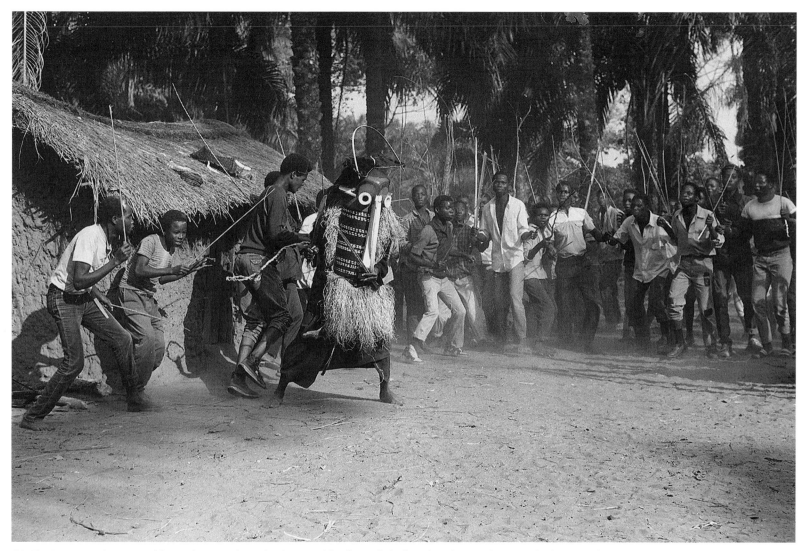

93. The Eastern Pende version of the mask PUMBU, danced at the time of the illness of Chief Kombo-Kiboto (Mukanzo a Kilumbu). Note the cord restraining PUMBU. Ndjindji, Zaïre, 1987.

Even a circumciser will do this so that a boy will not be able to recognize and curse his surgeon.

The singers will start to call PUMBU:

Matadi e e! Matadi e e! [or Ginyama e e!]
Muenya Ginyama, tudi gumibigila! Mayamba e!
Call: *We e e!* Response: *Ee e e!*
Muenya Ginyama, tudi gumubigila!
Gakuma gaguwendele gale. Yaya, [i]za!

Matadi may be the name of a former great dancer. *Ginyama* is archaic and the exact sense is lost, but the cries are understood as names for PUMBU.

Muenya Ginyama, we are calling you!
[We want to see] the flourishes of your hoop!
Muenya Ginyama, we are calling you!
Your reputation has preceded you.
Sir, please come!

The singers woo Pumbu onto the floor as they do MU-YOMBO, flattering his skill and reputation.

The helper or helpers reappear with the mask. They keep a cautious distance and restrain the mask's progress by pulling on cords tied around PUMBU's waist. Conveying the sense of restraint imposed on him, PUMBU comes out with his hands crossed over his chest, sometimes holding his shoulders. He has hidden his sword, and sometimes also a knife, under his hoop. PUMBU will perform alternating footwork *(gutshiatshiela)* furiously, stamping 1-2-3,

1-2-3. At some point, he will flop down on his knees and maintain a still, Buddha-like mien while his helpers take over his dance, performing with all their might while keeping hold of his cords. It is the calm before the storm.

After he has gathered his strength, PUMBU will rise suddenly and take out the hidden sword. The singers intone:

Pumbu ya nyanga e e!
Yabatula mafunvu e e!
Mama yaya e e!

The common interpretation of *nyanga* is "twisted raffia braids" such as those used in abundance on PUMBU's hoop. It distinguishes PUMBU as one of the masks that dance with a hoop. Khoshi Mahumbu proposes an interesting alternative. He observes that the related verb, *gunyanga*, takes unusual constructions; for example, *muthu udi ya gunyanga* indicates a "person who is angry all the time" or "who holds a grudge." He would therefore interpret the song:

Pumbu is always angry!
He is cutting the cords [that restrain him]!
Oh, mother! Oh, older sibling!

When PUMBU takes out his sword, he starts to do a true executioner's dance *(kuhala)*, flourishing the blade in the

light. His footwork picks up speed: now he stamps 1-2, 1-2, and swings his knees to alternating sides. His foot rattles ring out louder and louder as the excitement mounts. He will turn to one, then the other, of the men holding his restraining cords. Some dancers tantalize the audience by rubbing their blades up and down the cord, as though they are sharpening it. All of a sudden, with terrible force, Pumbu will cut through the cords. Free at last, he will advance, dancing with all his might. Field associates testify that in the past, the crowd would stampede back at this dramatic moment. At Nyoka-Kakese, they emphasized that even the chief would flee before Pumbu.

The song shifts:

> *Umonyi muenyi, [u]shiya diago a a a!*
>
> If you see a stranger, kill him!

Pumbu, the chief's executioner, is on the prowl, looking for a victim to protect the chief's ritual house. De Sousberghe recorded an alternative:

> *Phumbu, wamonyi mwenyi somba,*
> *mbatushimbiga.*
>
> Pumbu, if you see a stranger, kill [him.]
> We will pay [the fine]. (1959: 48)[43]

There were not many travelers in the past. The second version refers to the fact that the place of the stranger was most often filled by a slave, recently arrived, whose owner would need to be reimbursed. There is a third variation, which makes the same reference:

> *Ushiya gaye, mbatufuta mueka.*
>
> If you kill, we will liquidate the debt [by replacing the slave with] another person.

Understandably, in the past Pumbu was not a mask whose performer received gifts in praise. Who would dare approach someone flashing a sword in his face![44]

Even with this classic dance, performers would try to make a distinctive mark. For instance, Gisashi a Sefu of the Ndende generation, initiated ca. 1931, would stress Pumbu's ties to the chief by arriving on the dance floor carried in a colonial "tipoy" (a chair slung between poles and carried by two to four young men on the shoulders). Gisashi would start to dance while sitting on the tipoy and would then jump down to continue. The sculptor Gabama loved this innovation, but no one else adopted it. Gisashi was also a dancer of Muyombo, and this is a common pairing for performers since both masks require a certain fastidiousness of costume and dance step.

In the past, performers would usually stain the raffia cloth of Pumbu's body-suit red with either redwood paste or *gisongo (Bixa orellana)*. Today, many prefer to wear red shirts or turtlenecks to symbolize Pumbu's propensity

for blood. They also often add feathers to symbolize *pungu*, predatory birds, at the temples. The significance of Pumbu's unique physiognomy and coiffure was detailed in chapter 5.

Among the Eastern Pende, Pumbu is also described as "the chief's executioner" *(ngunza ya fumu)*, but the characterization of the mask is subtly different. The Central Pende have developed Pumbu almost into a village character, interweaving his dance with songs related to the folkloric execution of a stranger during the chief's investiture. The Eastern Pende have transformed Pumbu into a counterpart of Kipoko. If the latter represents everything warm and nurturing about the chief's role, the mask Pumbu depicts the courage that the chief must sometimes muster to address life-and-death issues. Like Kipoko, Pumbu takes the form of a helmet mask resting on the shoulders, except that the "face" extends down to the performer's navel.[45]

Whereas any chief may own Kipoko, Pumbu is a mask reserved for a few of the Eastern Pende's most powerful chiefs. Unlike the other village masks, it dances only when special problems occur, such as a paramount chief's serious illness or a regional epidemic or famine. It often adopts the chief's own dress clothes (including blazers today) and circulates to subordinate chiefs and lineage heads to collect a small present as a form of tribute.

Pumbu performs holding a soldier's bow and arrow in one hand and a sword or machete in the other. He performs the *kuhala kua ngunza*, the "executioner's dance," which is built around a walk with a stutter-step backward so that he progresses slowly, flourishing the blade in his hand. It is a dance meant to build tension as the executioner approaches his victim. Sometimes people do the *kuhala* before or after they slaughter an animal.

Pumbu strains against the cords that bind him to one or more young men (fig. 93). More young men accompany him, bearing whips and singing Pumbu's song: "Are you afraid?" The young men all come from the age grade that would be drafted if war were declared. At the climax of the dance, Pumbu whirls to cut the cords that held him in check. During a performance at Ndjindji, the crowd fled in terror, shouting, "Have pity, sir!" *(Maleba, tata!)*. The men fled as well. Only the old chief Kombo was exempted.

Pumbu must kill something before he reenters the chief's ritual house, where the headpiece is stored. Ideally, he will catch a chicken or goat that strays across his path. When this does not happen, the masquerade's organizers will bring something to him behind the chief's ritual house at twilight. At Kingange, Pumbu and the chief sat together in rattan armchairs behind the chief's house at twilight, overseeing the ritual sacrifice that closes a masquerade among the Eastern Pende.

The Eastern Pende have generalized Pumbu's signifiers

by not referring to any one event or execution. By fusing with the chief, Pumbu represents the executive branch of his office, which must sometimes deal with war and execution.[46] The Central Pende have particularized Pumbu by referring to one event. They have kept his identity separate from that of the chief's, although linked. Nevertheless, despite these differences, the distinctive core of the mask's dance remains identical among the Eastern and the Central Pende: Pumbu appears, restrained by cords, performing the *kuhala* dance by flourishing his sword. At the climax, he loses all patience and whirls around to cut the cord, at which point the crowd flees before him, beseeching moderation.

If Tundu and Kindombolo represent an anti-aesthetic, the two forms of the headpieces for Pumbu convey an aesthetic of fear. Chapter 5 related how the chiseling and sharpening of the Central Pende physiognomy defined Pumbu's character as a hyper-male (figs. 57-59). The Eastern Pende convey the same characteristics in a very different style through their emphasis on the protruding, white-rimmed eyes (figs. 67, 93). Many Pende associate wide-open eyes showing lots of white with rage. The message of such eyes for both Pumbu and the whip-toting *minganji* is: get out of here or something awful may happen! Couched in very different formal language, the message of the two headpieces is the same: this mask is dangerous.

CENTRAL FEMALE MASK/EASTERN FEMALE MASK

Pende on both sides of the Loange River usually refer to the mask representing the young woman by its generic category, "the female mask" *(mbuya ya mukhetu;* pl. *mbuya jia mukhetu)*. Not surprisingly, the generic woman is visualized as the young woman. By far, the most frequent name for the mask that one finds across Pende country is Gambanda, spelled Kambanda by the Eastern Pende.[47] Many will use the names Gambanda/Kambanda interchangeably with Mbuya ya Mukhetu to refer to the genre category. In addition, the Central Pende have developed a plethora of names for masks in this genre that reflect the different dances that the mask may perform: Galuhenge, Gagilembelembe, Gatambi a Imbuanda, Gakholo (= Éliza Solo), Gabugu, Odoma, and so on.[48] In the spirit of innovation outlined in chapter 2, dancers will add novelty and fashionable allure by changing the name, the dance, and perhaps some element of the costume. Nonetheless, all the varieties belong to the one genre representing the young woman and have the same physiognomy.

In form, the two face masks Gambanda and Kambanda are quite similar (figs. 94–95). Both capture the feminine aesthetic articulated in chapter 5, with slitted eyes, smooth, relatively flat forehead, and smooth, plump

cheeks. The style of the Eastern counterpart is somewhat more angular and builds on a shallower facial plane (fig. 95).

The costume is identical. Both wear wigs mimicking the graceful hairstyle discussed in chapter 2. Both wear fake bracelets. Both dress in the wrappers preferred by contemporary women (figs. 10, 96). The dancers, usually slight men or adolescents, wear fake breasts, which, again conforming to contemporary norms, they tend to cover with bra or cloth. Part of the mask's persona has always stressed its fashionable contemporaneity, and this has made its costume more open to updating than that of many other older masks.

Field associates on both sides of the Loange, when pressed by the alien question "Who is GAMBANDA?" describe the female mask as "the wife of the chief."[49] However, as Chief Nzambi explained, this is not a literal characterization but a reference to her rich self-presentation, marked by beautiful and costly clothes, by lots of redwood make-up, by ropes of *jigita* (chapter 3), and especially by the bracelets on her ankles and wrists. In other words, GAMBANDA dresses

94. Frontal view of a female mask collected in 1934 by Territorial Administrator Maurice Matton. (Private collection. Photograph by Franko Khoury. Courtesy of the National Museum of African Art, Eliot Elisofon Photographic Archives, Smithsonian Institution, Washington, D.C.)

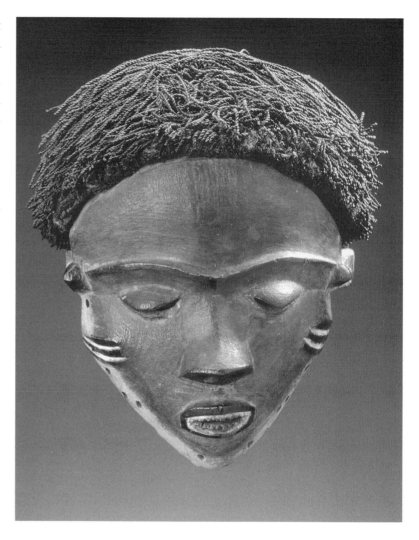

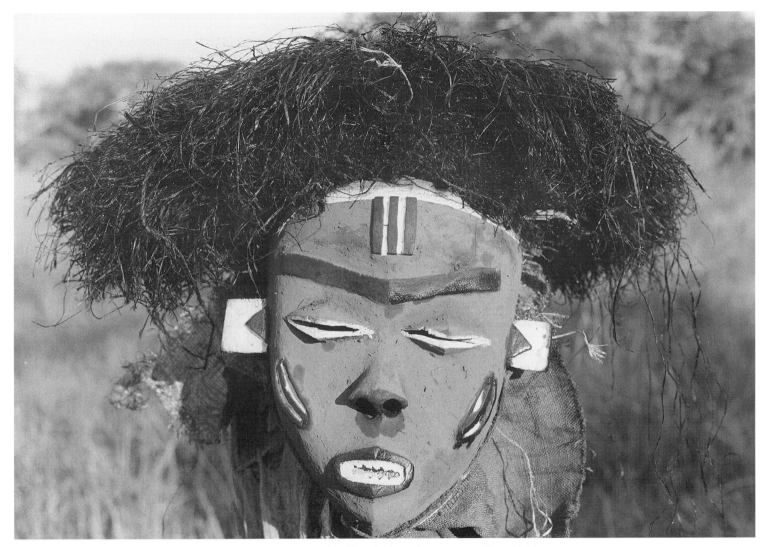

95. Eastern Pende KAMBANDA mask representing the young woman. Sculpted by Kilembe Mukanyi. Suangy, Zaïre, 1988.

like the beautiful young girl liable to become the trophy wife of a high-status male. As in Hollywood films, part of the pleasure of masquerade lies in seeing the lavish costumes.

On both sides of the Loange, the female mask dances to the rhythms of contemporary popular dances and performs little comedies with a mirror and comb to suggest her vanity and preoccupation with appearance. She is inevitably harassed by the clown mask, who will present caricatures of courting gifts and attempt to squeeze her breasts, to pinch her bottom, or even to force intercourse on her from behind. Among the Eastern Pende, she will also sometimes carry a hoe and mimic women's agricultural duties (fig. 96). In the Bandundu, GAMBANDA never works.

As stated in chapter 2, there is no better example of the centrality of dance to the Central Pende understanding of invention and innovation in masquerading than the restless permutations of the female mask. While the features of the physiognomy remain true to an ideal-

96. The Eastern Pende KAMBANDA performing at a masquerade for Chief Kombo. Note the hoe in "her" left hand and the woman who is ululating in praise while she honors the dancer with cloth. The facepiece was one sold by a Chokwe peddler. Ndjindji, Zaïre, 1987.

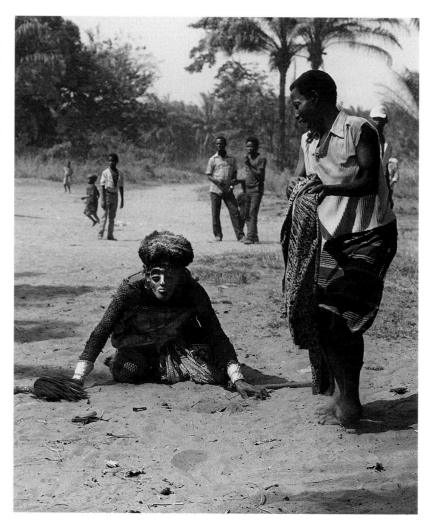

ized representation of youthful feminine essence, the dance follows the fashions of the moment.

Despite the little comedies with mirror and comb, the young female masks are always classed as *mbuya jia ginango*, "masks of beauty." This designation refers in part to the ideal of female physiognomy represented in the face but also to the component of fashion represented by the contemporaneity of dress, dance, and sometimes hairstyle. Whereas *ginango* for the male masks is signaled by fine materials, careful grooming, and most often by flair in movement, fashion is a key component in the feminine achievement of beauty.

In performance at Kindamba near the Kasai River in 1989, an itinerant dancer of GAMBANDA appeared with the mask's hair laced with plastic flowers, combs, and baubles. Around her waist, she wore ropes and ropes of *jigita*. Her clothes included a fancy long-sleeved pullover. She performed the latest dances. At Makulukulu in 1989, GABUGU made much of her vanity by looking in a mirror incessantly. Her dressers had shortened her wrapper to the knee length worn by young girls. Notably, when the chief criticized this, the dressers protested: "But she's young!"

Not only the clown will dance with the female mask. At Makulukulu, a man from the audience came up, incorporating some of the clown's dance which the TUNDU on the floor was too inhibited to execute. The man danced with GABUGU, looking down at her groin and caressing her

breasts. Significantly, no man would ever attempt to take similar liberties with a woman in public! The phenomenon of dancing with a mask is institutionalized as *gukoba mbuya*. As often happens, the individuals inspired to dance are encouraged by praise gifts. The chief himself honored the man with a present.

MBUYA YA MUKHETU, the female mask, represents the contemporary fashionable young woman. It adapts contemporary popular dance among both the Central and the Eastern Pende. Among the older masks, it is unique in its emphasis on mimesis, or resemblance, both in its facepiece and in the union of physiognomy, dress, and dance. As remarked in chapter 3, much of the pleasure of the performance lies in seeing a man mimic exactly the distinctively gendered body language of Pende women.

Many writers have compared Pende masks to the "types" of the commedia dell'arte (e.g., Kochnitzky 1953b: 9; Jean Vanden Bossche 1950: 5–6). This has been misleading because, as argued, the oldest masks GIWOYO, MUYOMBO, GINJINGA, and POTA are far from being simple representations of village characters. Even TUNDU and PUMBU do not conform to this representation. There is no TUNDU in the village who can get away with the same outrageous behavior. The Central Pende PUMBU is very much an abstraction of a folkloric figure no one ever sees. It is GAMBANDA who comes closest to the idea of a "type" and who, as such, posed a potent model for the Central Pende.

A HISTORY OF GENRES

In summary, Giwoyo, Muyombo, Ginjinga, and Pota may form the core of the oldest Pende masks. They are found on both sides of the Loange River, and the Central Pende evidence seems to suggest that they were all derived from the Giwoyo prototype showing a cadaver on its funeral bier. They are all worn on top of the head or slanting down the forehead and depict the same unfocused, half-open gaze. The diminution of the projection that abstracts the tapering body of the cadaver on Giwoyo seems to be related to the desire to free the dancers for more vigorous performances. Muyombo, Ginjinga, and Pota all became progressively freer in movement as the length of the projection diminished.

Literary critics today commonly describe genres as institutions. Fredric Jameson writes: "Genres are essentially literary *institutions*, or social contracts between a writer and a specific public, whose function is to specify the proper use of a particular cultural artifact" (1981: 106). Building on the work of Hans Robert Jauss, Tzvetan Todorov adds: "It is because genres exist as an institution that they function as 'horizons of expectation' for readers and as 'models of writing' for authors" (1990: 18). In the case of Pende masquerading, establishing the canon of masks helps to specify what "models" performers draw upon and what "expectations" the audience brings to the dialogue.

The comments on Pota by Nyoka's dean of sculptors are helpful here in understanding the oldest core of masks. "Pota [is a] mask. Pota does not 'represent' anything, except its dance [= itself]."[50] Nguedia prompts us to realize that the key question is not "What does a mask represent?" (in the vein of the commedia dell'arte) but rather "What *is* a mask?" On this point, field associates are very clear: a mask is a *hamba*. A *hamba* is a tool (a "transistor") facilitating contact between the living and the world of the dead.[51] The masks are unique *hamba* in that they fulfill their role in performance. Masks such as Giwoyo, Muyombo, Ginjinga, Munyangi, and Pota were originally intended to help the audience make such contact. They are abstractions and not designed to be easily reducible or graspable.

Drawing on linguistics, Jameson notes that a speaker ensures a particular reception for his or her communication by marking it through intonation, gestures, context, etc. (Jameson 1981: 106). Filmmakers rely on darkened theaters to aid viewer concentration; in their films, they will often use rain to underscore sad events, and they depend on certain conventions in music to cue the viewer to the proper response to the scene at hand. In masquerading, performers use foot rattles, drumrolls, cos-

tume, sight lines, and many other devices to solicit a certain experience from the audience.

The devices shaping the reception of this oldest core of masks persistently block easy access. Because of the dancers' exposed eyes, they are all performed at a certain distance. Giwoyo dances off in the bush at twilight. Instead of normal human attire, Pota appears as a shivering mound of leaves, and the others wear layers of furs and twisted cords held out by hoops. All of these factors mark the masks off from the quotidian. The older masks are austere, mysterious, not to be qualified. They are *mbuya*. They create for the viewer an experience of wonder and mystery. Giwoyo's reception is hushed and attentive. Muyombo incarnates beauty, but an abstracted and purified one. Pota and Ginjinga are explosions of energy.

To this core the Pende long ago added the gesture of mirth, the ugly and all too human Tundu, whose obsession with food and sex and the body only heightens the otherworldliness of the previous masks. Pumbu, the beautiful and the terrifying, allows the audience to peek into Pandora's box and savor a shiver of fear from a safe vantage point. And finally, like Hollywood all too often, Gambanda introduces woman in one incarnation as the beautiful young girl. The central core of mask genres provides models for experiences ranging from awe and mystery to fear and comedy.

Institutions have a history. Through systematic comparison and close analysis, we have been able to identify some differing applications of masquerade among the Pende. Whether to involve the women and noninitiates more closely or for other reasons, performers and sculptors in the Kasai chose to increase the disguise of the masks. Although they kept Kiwoyo, they made their central mask, Kipoko, into a helmet mask. They began to cover the faces of the dancers of Ginjinga/Munyangi and Pota with raffia cloth *(kiminiominio)* in order to allow the public to approach the masks without seriously diminishing the ability of the dancers to breathe. The fringe hanging below the wooden faces perched on the forehead was enough to disguise the shape of the face underneath the cloth. Whatever the initial motivation, women have profited from the increased disguise to carve a vital role for themselves in the masquerade.

The Eastern Pende have emphasized a close rapport between the masks and the chief, as intermediary between the living and the dead. Indeed, in the Kasai the chief is the one owner of all village masks. The forms and roles of Kipoko and Pumbu have been adapted to express different aspects of chiefly duty and prerogative.

The clowns in both regions are outrageous and sometimes malicious. The Central Pende treatment of Tundu, however, has gone much further in linking the clown to a

Rabelaisian delight in the body and sex that makes a clear division between certain human-oriented masks and the core of otherworldly apparitions.

Finally, Todorov poses the question: "Where do genres come from?" He answers: "Quite simply from other genres. A new genre is always the transformation of an earlier one, or of several: by inversion, by displacement, by combination" (1990: 15). Although we cannot know what came before GIWOYO and the central core of masks, the truth of his statement is evidenced by the continuing evolution of masks.

Torday's collection, dating from 1905 and 1909, provides invaluable art historical evidence for the unique trajectory of Central Pende art history. He acquired headpieces for the female mask and for PUMBU (fig. 55) that both exhibit a curious conflation of the cadaver-like, fully carved eyes of GIWOYO, MUYOMBO, POTA, and GINJINGA with the pierced openings of the conventional face masks used today. He also collected the only known example of MBANGU, the bewitched (see chapter 6), that is carved as a forehead mask with unpierced eyes on the model of POTA.[52] There are a few other known anomalies, such as an unidentified mask in the Clausmeyer collection of the Rautenstrauch-Joest Museum in Cologne (Volprecht 1972: 143–44, fig. 148). The Antwerp Etnografisch Museum has another dramatic PUMBU with both carved and pierced eyes from before 1920 (fig. 97).[53] The existence of these transitional forms suggests that in the early twentieth century sculptors began to make face masks with a more naturalistic representation of the eye by carving upper and lower eyelids and leaving the eyehole itself open. The larger significance of this shift seems to be an expanding role for face masks and, most probably, a more mimetic masquerade presentation.

Ironically, for those performers seeking novel constellations to distinguish themselves, the mask of the young woman proved to be one of the most potent models. If POTA does not "represent" or "resemble" anything (gufuegesesa), GAMBANDA does. In distinguishing it from other masks, field associates will stress the naturalism of the physiognomy: "KAMBANDA has the eyes of a person and the face of a person."[54] Significantly, the face mask genre is linked to more naturalistic costuming, mimicking everyday dress. The dances may be drawn, as in GAMBANDA's case, from contemporary village dances. Other face masks have dances that embroider on distinctive work motions (chopping down a tree, sitting in state, divining, cocking an arrow, trapping grasshoppers, etc.). Face masks offered an almost inexhaustible fount for innovation and personal distinction. Because most incorporate at least some comedy, the face mask expansion indicates increasing emphasis on entertainment in the masquerades.

The following five masks are very widespread among the Central Pende but (with one exception) are unknown

among the Eastern Pende: Fumu or Mazaluzalu (the chief), Mbangu (the bewitched), Mwenyi (the stranger), Gandumbu (the old widow), and Nganga Ngombo (the diviner).[55] Of these, the composite Mbangu described in chapter 6 is the only one whose dance is almost hieroglyphic in its abstraction. The other dances are based on very naturalistic and imitative movements. One can easily understand that Mbangu was originally conceived as one of the forehead masks, as the Torday evidence suggests. Over the years, the Central Pende have added many more "types." Local villages have more recently essayed the palm wine tapper (Gangema), the drunk (Tshiopo), the sorcerer (Nganga), the widower who doesn't know how to cook or take care of himself (Itebega), and so on. De Sousberghe has noted that the explosion of types among the Central Pende did not occur among the Eastern Pende (1959: 63). The extraordinary elaboration of codes of physiognomy among the Central Pende probably relates to this multiplication of types.

As Todorov observed, people mix and match genres. The easiest way to transform standard forms is by changing the sex. Consequently, in later generations someone created a female diviner (Nganga Ngombo Mukhetu) as a blending of the female mask with that of the diviner. The old woman (Gandumbu) is a blending of the female with the clown role. Gandumbu keeps getting reformulated— as an immodest old fisherwoman (Gatua Ulu), as a senile

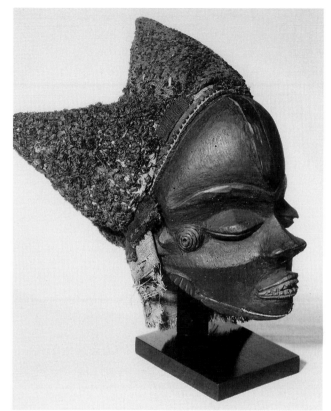

97. Pumbu mask collected before 1920. Note the eye-slit pierced below the fully carved eye. The uniform black color probably results from the inadvertent application of pesticide. (No. AE.551. Courtesy of the Etnografisch Museum, Antwerp.)

old woman (Gin'a Gabuala), as the single woman (Ndumbu), as "She Who Walks Naked" (Gawenji a Thowa). Another easy transformation is through the blending of the stranger or the foreigner with a genre.

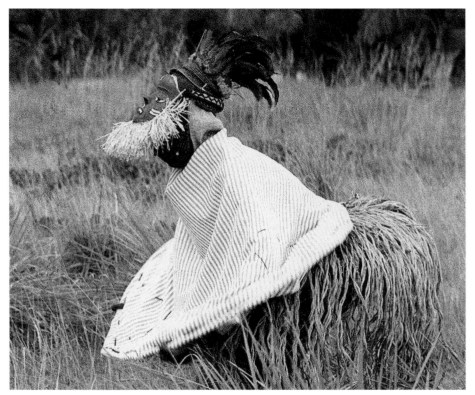

98. GABATSHI (G)A NYANGA performed by Khoshi Mahumbu. Nyoka-Munene, Zaïre, 1989.

TATA GAMBINGA (see chapter 2) is an example, with its fusion of the diviner with certain Ding practices. GABIDI-MUAMBA makes the eternal stranger into a Luba trader. Sometimes one creates a new character by exaggerating one aspect of another's personality. Thus, the lewd GATUA ULU of the Mapumbulu age grade or GIBANGO of the 1940s took to the limit the female and male clowns' propensity for bawdiness.

As in Hollywood film, comedy blends easily to create new genres (e.g., musical comedy, romantic comedy) or to give a new look to an old one. Thus, many of the types in the masquerades are couched in humorous form: the man cutting down trees (MUBOLODI), the wine tapper (GANGEMA), the person suffering from bedbugs (SANYA), the stamping European (GIKITSHIKITSHI), the one-armed sorcerer (GATOMBA), etc.

As described in chapter 3, the new genre MATALA, the stylish young man, is the late inversion of the classic mask representing the young woman. In a sense, it is also a reinvention of MUYOMBO the stylish as a more naturalistic face mask. Because GAMBANDA had become associated with outdated dances from the women's healing societies, GABUGU took inspiration from MATALA to reassert the commitment of the female mask to contemporaneity. As Todorov writes: "Not only because, in order to be an exception, the work necessarily presupposes a rule; but also because no sooner is it recognized in its exceptional status than the work becomes a rule in turn, because of its commercial success and the critical attention it receives" (1990: 15). New masks that become popular establish themselves very quickly as models capable of generating variations.

Some dancers have also aspired to renew the sense of awe and wonder in performance. The inventors of GABAT-SHI (G)A NYANGA fused the standard POTA headpiece with the mystery of GIWOYO's dance in the bush and with a startling new costume that took advantage of Belgian materials (fig. 98). The inventors of GALUSUMBA, a very old mask in the Central Pende region, took the standard GINJINGA/POTA headpiece and added a hieroglyphic dance based on a certain bow-hunting gesture.

Probably because of the huge prestige of dancers among the Central and Kwilu Pende, performers did not relish the idea of ceding the floor when their knees grew too stiff for GINJINGA or they lost the wind for POTA. In the second layer of genres, in the chief (FUMU) and the stranger (MWENYI), Central Pende launched a new category—"striding masks" *(mbuya jia gudiata)*—that expanded the pantomime of TUNDU's and MUYOMBO's *mizembo* to the core performance. Instead of a dance proper, these masks stride about in a stylized, "cool" *(gulatulu)* fashion and take part in some dramatic characterization that relies on acting more than on physical force. Like the female mask, they wear ordinary clothes. Eastern Pende commentators find these masks peculiar and foreign.

Because of the historicity and institutionality of genre, if one has enough information to follow clusters of inventions, one can gain a window onto the interests, hopes, and outlook of a period. Television critics attempt to do this when they study shows like *The Waltons* to explore changing definitions of the American family or analyze shows like *Happy Days* for what they reflect about class consciousness during the recession of the 1970s (Newcomb 1982: 77–88, 198–205). The next chapter will analyze the life and demise of a genre during the colonial period for what it may say about the men who created it.

The *mafuzo* masks combined elements of the PUMBU and GIWOYO genres to invent an entirely new experience for the masqueraders and their audience. From GIWOYO, performers adapted the idea of the mystery and awe one creates by performing off in the distance, in the bush. From GIWOYO and the other masks worn on top of the head, they realized that one can disguise a lot through simple distance. From PUMBU, they adopted the idea of a corps of helpers who precede and accompany the mask in order to keep the crowd at a requisite distance. From PUMBU also, they took inspiration in using visual and musical cues to orchestrate an experience of fear.

CHAPTER EIGHT

Masks in the Colonial Period

In the 1910s–30s, a series of older men among the Central Pende of Zaïre invented and sold concessions to a revolutionary new category of masks: *mbuya jia mafuzo*. Including life-size puppets, lumbering maquettes of fierce animals, whirling barrels, and wriggling snake dancers (figs. 99–101), this group of masks seems as opaque and incomprehensible in its "taxonomy" as the apocryphal Chinese Encyclopedia made famous by Borges (1981: 142) and Foucault ([1966] 1970: xv). Indeed, most of them would not even be recognized by Westerners *as* masks. Already by the 1940s, new generations increasingly preferred to replace these inventions with comedic characters danced with facepieces. In serious decline by the 1950s, the *mafuzo* masks have all but disappeared since Independence in 1960. Today they are usually dismissed as "masks of sorcery" *(mbuya jia wanga)*.[1]

SOMETHING WITCHING THIS WAY COMES

It is the mode of presentation that defines the *mafuzo* as a distinct subset of village masks. To the Pende mind their presentation is far more extraordinary than the bewildering array of forms that the masks take. The word *mafuzo* is derived from the verb *gufuza*, "to blow on," and signi-

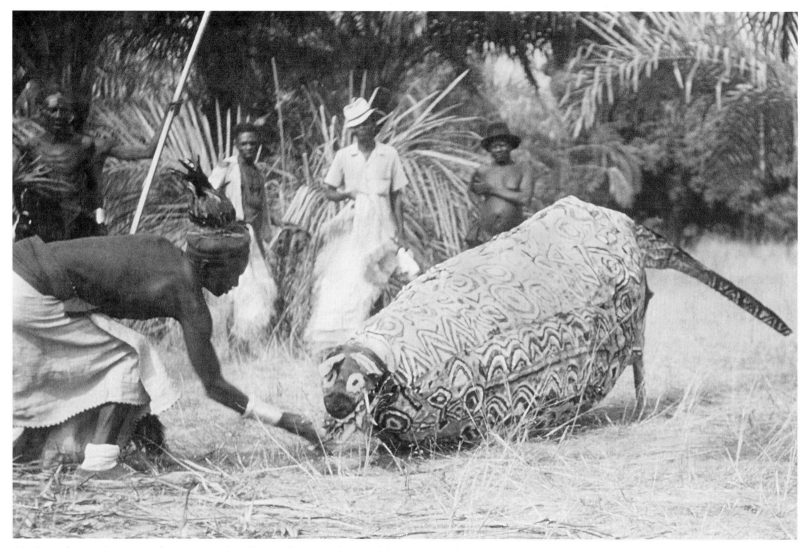

99. The *mafuzo* mask PAGASA performing at Nyoka-Kakese (mid-1950s). (Photograph by Léon de Sousberghe.)

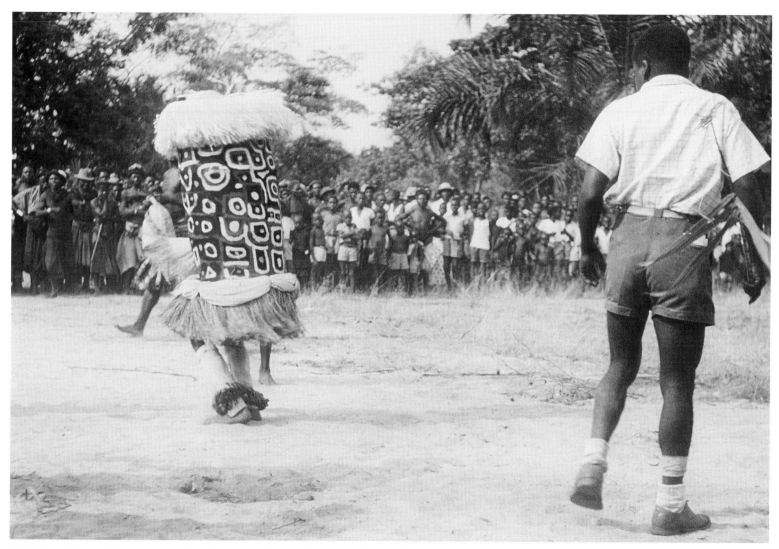

100. The *mafuzo* mask KOLOMBOLO at Nyoka-Kakese (mid-1950s). (Photograph by Léon de Sousberghe.)

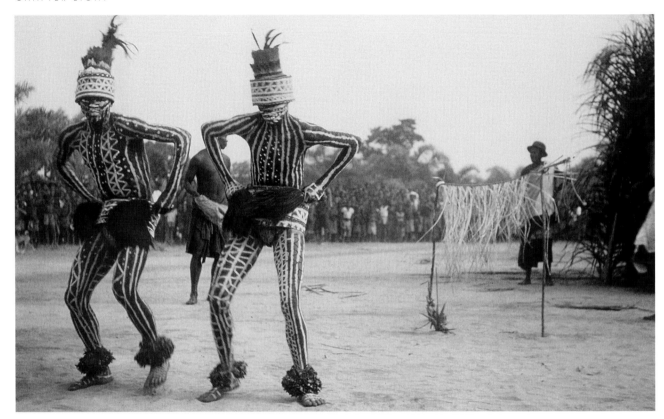

101. The NYOGA (snake) masquerade at Ngashi in 1956. Dancers rely on body-paint and distance from the audience to disguise individual identity. Note the special "backstage" shelter built on the dance floor for the performers, which is marked off by a palm fringe signifying prohibition. (Photograph by Léon de Sousberghe.)

fies "something blown." The most outstanding characteristic for these audiences is that each mask is accompanied by male helpers *(enya mafuzo)* who blow mysterious substances in the direction of the crowd.

These helpers cultivate the most frightening appearance possible by dressing like the helpers of PUMBU in the garb of *ngunza*. [2] At their temples, they wear long feathers (substituting for those of the extinct predator *pungu*) or the blood-red feathers of the *nduwa (Musophaga rossae)*. They rub kaolin down the forehead and across the

mouth. In one hand, they fan a square of raffia cloth *(gupupa mbala)*, which the crowd connects with the executioner's blindfold. At the least, the square of cloth makes spectators uneasy for fear of what the dancers might be hiding inside it. In the other hand, they carry the traditional sword *(pogo ya khusa)* or, by substitution, a machete or whip. They brandish this weapon, twisting it in the sunlight as part of the *kuhala* dance performed to mark death by blade.

If their appearance were not fearsome enough, these helpers blow kaolin powder from their palms in the direction of the crowd as they dance forward. The audience, fearing an airborne sorcery agent, stampedes backward in panic and keeps to a respectful distance. This effect, like the scary music in a Western horror film, sets the mood for the reception of the frightening apparition to follow.

The *mafuzo* dancers surviving today refer to this gesture as "our gimmick" *(gadilo g'etu)*. There were two reasons for maintaining distance between the crowd and the mask. One was to add to the sense of mystery and danger; the other was practical. Many of the masks were constructed over a basketry frame. Distance obscured the sight of the feet of the dancer(s), which might well be exposed underneath. Another practical reason was to hinder people from figuring out how the "trick" was done. The technique for making and dressing standard village masks was open to any initiated male, but the devices used

for the *mbuya jia mafuzo* had to be purchased. Thus, even initiated males were kept at a distance from these masks, an extraordinary development.

Kaolin is a beneficial substance in Pende thought, but spectators who were not in on the secret had their own ways of interpreting what they saw. Muyaga Gangambi, the first to identify the *mafuzo* category by name, speculated that the powder was composed of kaolin mixed with medicines made from tree and animal parts, by analogy with the blown concoctions prepared by specialists to protect men from the spirits of people or animals they intend to kill or have killed (1974: 134). Most spectators link the powder to those that dancers sometimes blow on themselves in the manner of charms. For example, men commonly blow powder from the *sengu* plant on fraternity maskers in order to enable them to run super fast without tiring. Many also assume that the powder neutralizes the sorcery tricks of rivals *(gulebesa ngolo jia ima)*. There is a fear that sorcerers, jealous of the acclaim of a certain dancer, might bury sharp shards of palm nut kernels in the sand or dig little holes in the dancer's path to make him trip. While these are common concerns of maskers, they relate to private ambitions and are dealt with in private. The open blowing of powder is particularly inappropriate at a masquerade, whose function is to *unite* the village, not disperse it. Whatever the motive, no one wishes to get in the way of unknown potent substances, and a common

nickname for the *mafuzo* has become "masks of sorcery" *(mbuya jia wanga)*.

The connection in the minds of many spectators with sorcery is only strengthened by the unusual things that some of these masks do and by the advanced age of the present holders of the concessions. The young today tend to see them as the property of old men, who are synonymous in their minds with sorcery.

ANIMALS OF THE BUSH

It is the psychological preparation of the spectator that unites the heterogeneous forms of the *mbuya jia mafuzo*.[3] The blowing substances and the presence of the *ngunza* signal the arrival of an out-of-the-ordinary and frightening apparition. The largest subset of the *mbuya jia mafuzo* depict dangerous animals of the bush: the Cape buffalo, the leopard, the lion, the crocodile, the snake, the elephant. Although the Eastern Pende incorporated characteristics of some wild and domestic animals into the superstructures of the face masks used by the men's fraternity, masks intended for the village on both sides of the Loange River were completely anthropomorphic.[4]

Like the regular masks, the *mbuya jia mafuzo* are very much village specific. As Muyaga notes, only a relatively small number of villages perform masks from this category, and among these, most will dance only one or two

(1974: 174). In order to fully understand their unprecedented form, let us examine the most widespread: PAGASA, the Cape buffalo *(Syncerus caffer)*.[5] PAGASA is recognized just about everywhere, whether or not the village dances it. It is also one of the few still performed, although almost exclusively at state-sponsored festivals.

The makers of PAGASA adapted outside skills to form the barrel of the animal's body from a basketry frame, over which they layered blackened sheets of raffia cloth (later, cement sacks or burlap) (fig. 102).[6] They left the bottom of the basket open and attached a wooden facepiece in front (fig. 99). The original prototype for the headpiece was very simple and abstract, but younger sculptors have preferred to elaborate on the form and to naturalize it. Sometimes they embed bits of glass or mirrors into the eyes of the facepiece to flash reflected light into the eyes of spectators. Although it is worn like a face mask, there are no eyeholes, and the dancers must rely on assistants to guide them verbally: "Take a step to the right to avoid the tree and then walk straight ahead . . ." Two men, one standing behind the other, bend over and support the basketry frame on their backs. The man behind moves the tail, which is made from a cord. The feet of the dancers are exposed, but it does not matter, because the mask never leaves the grass on the fringe of the village.

People recount that dancers often added dramatic gestures. Sometimes the man behind pushed out mud from

under the tail to simulate defecation. Sometimes an assistant would "feed" the bush buffalo by pushing grass or leaves into a hole just under the mask's face (fig. 99). Muyaga reports that the mask advances, retreating a little for every step forward, but without foot rattles (1974: 142). The stutter-step is adapted from the *kuhala*, the same ritualized dance performed by the *ngunza* accompanying the mask.

At both Nyokas, the chorus sings the following:

> *We! Eh he! Pagasa yamukuata!*
> *Muenya Mbango gashigo pushi.*
> *Pagasa yamukuata!*

> We! Eh he! The Cape buffalo has caught him!
> The resident of Mbango [did] not [run] fast [enough].
> The Cape buffalo has caught him!

The song refers to the deadly speed of the African buffalo. Responsible perhaps for more hunters' deaths than any other animal, the wounded Cape buffalo is particularly dangerous because of its tendency to circle around behind its pursuer to attack from an unexpected angle. According to Arthur Bourgeois, zoologists consider the species capable of nursing a grudge; if a wounded animal recovers, it may strike humans later, unprovoked and unpredictable (1991: 19). Heavy, fast, and willing to attack, the Cape buffalo makes a formidable opponent. The

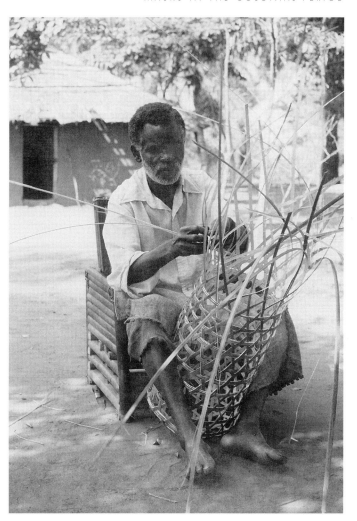

102. Chief Kikunga-Tembo (Kangoro Kanyama) weaving a chicken basket of the style that served as a model for the *mbuya jia mafuzo*. Kikunga-Tembo, Zaïre, 1987.

masquerade provided the opportunity to glimpse this killer from a vantage point of safety.

Territorial Administrator Delhaise penned a particularly graphic description in 1924 of a performance at Kilembe that supports this interpretation: "[Pagasa] runs on four feet and tosses his head from right to left, which [action] makes the spectators flee. He has, in back, a bag of mud that he drops from time to time to imitate buffalo manure. The assistants threaten him with bows [and arrows] and with rifles. They shoot at him with blanks and he falls. They rush forward and take off the cloths of his costume [lit. 'his clothes'] to mimic skinning [the animal]. The women cry with joy."[7] Ndambi Mun'a Muhega supports Delhaise's account. He notes that in his own village, Kitombe-Samba, the drama has a special note of verisimilitude because the men who accompany the mask are proven hunters of dangerous animals, and one of the dancers was himself the son of a hunter gored to death by a Cape buffalo (1975: 290, 292).[8]

Ndambi recounts that the mask plays to the women spectators, who are particularly gleeful to see it killed (1975: 290). The bush buffalo is known not only for threatening hunters but also for rooting up the fields where the women have invested so much labor. In an unusual introduction of drama into the masquerade, the villagers triumph over one of their worst fears.

PAGASA seems to have been the first *mafuzo* mask to

travel and one of the most enduring. At Nyoka-Munene, they attribute the introduction of PAGASA and several other *mafuzo* masks to the sculptor Maluba from the Milenga age grade, initiated ca. 1885–90 (see chapter 4). Maluba had sojourned at Kasuele, near Lake Matshi, where several new *mafuzo* masks were then creating a sensation. At Nyoka-Kakese, they relate that Gatshaka of the Mingelu generation (initiated ca. 1901–3) introduced PAGASA to their village when he invited Kihuele of Mbelo village in the north to come demonstrate. In the north, independent sources confirm that Kihuele of Mbelo was indeed a renowned dancer of PAGASA.

The model that PAGASA offered of representing a frightening animal of the bush by building a body around a basketry skeleton was a potent one. Dancers quickly adapted the structure to other animals for added novelty. Several villages in the central region performed a mask representing the elephant (NJIAMBA) (fig. 103).[9]

In their descriptions of this mask, Muyaga and Ndambi are agreed that the elephant created a particular sensation among spectators. Muyaga attributes this to the rarity of seeing a real elephant and the incongruities of the animal's appearance: "The elephant is a dangerous animal that a lot [of people] have not yet seen; the children keep on hearing that the elephant is a big animal with a big head [and] little eyes."[10] Ndambi notes that the crowd was curious to gauge its size and its manner of walking (1975:

103. The elephant mask of the Bakwa Nzumba among the Eastern Pende (1926–30). Some Bakwa Nzumba made an elephant mask during the initiation to the men's fraternity. It is the only kind of maquette known among the Pende to precede the maquettes of fierce animals used in the *mbuya jia mafuzo*. (Photograph by Frank J. Enns. Courtesy of Katharine Enns.)

296). Both remark that although the crowd was eager to examine the mask, they were forced to observe it from a considerable distance, where it appeared briefly in the bush on the edge of the village, striding very slowly (Muyaga 1974: 166; Ndambi 1975: 298).

Ndambi imagines the elephant saying: "I give birth to one offspring, because if I were to give birth to many,

famine would reign in the village."[11] If Cape buffalo were capable of tearing up women's fields, elephants were capable of completely destroying them in their search for food. Nevertheless, unlike the buffalo, the women do not exult in the killing of the elephant. Instead, Ndambi reports, in honor of its bringing forth only one offspring (like humans?), they send the mask corn, hoping to bribe the

elephants that it represents not to destroy their corn and manioc fields (1975: 300).

Galeba of the Mapumbulu generation (initiated ca. 1916–19) at Nyoka-Munene adapted the basketry frame to make KHOLOMA, the leopard. Nguedia Gambembo recounts that Galeba danced it three times, twice in the old village (before 1949) and once in the new, but that no one has continued it since his death.[12] Nguedia would make the basketry body for him, and either Gabama or Gitshiola would sculpt the face.

Galeba appropriated a well-known song for it:

> *Kholoma, nzangi ya khombo!*
> *Tumutanda gilema.*
>
> Leopard, thief of goats!
> We have skinned him.

Leopards, stealing needed poultry and livestock from the fringes of the village and threatening women and children at the water source, had once been a very real concern. As in the Cape buffalo performance, the song emphasized triumph over a formidable enemy.

Sh'a Kapela of Nyoka-Munene, also initiated ca. 1916–19, tried to introduce a mask representing the lion (KHOSHI). Like the Cape buffalo, it was a "blind" mask, and the dancers had to be led verbally by their helpers. Its distinctive feature was its mane.

Nyoka-Kakese was noted for its performances of masks from the *mafuzo* category, among them GIKWAYA, the Nile crocodile. Again, they built the body around a chicken basket frame and covered it over originally with raffia cloth. Later, they adapted cement sacks when those became available. Whereas the Cape buffalo and the elephant were somewhat naturalistic in form, GIKWAYA and the leopard relied on stock designs of oscillating red, black, and white diamonds or spots (called *kaji-kaji*) to represent the scales of the reptile or the spots of the big cat. It used no song but adapted a rapid and strongly marked drumbeat like that used to scare (and distract) the boys during their circumcision. De Sousberghe photographed a performance of this mask at Nyoka-Kakese in the 1950s.

The Central Pende distinguish between two types of crocodiles; GIKWAYA represents the larger variety, which prefers deep water. Muyaga calls it "the meanest of all animals."[13] A crocodile attack is a fearsome sight. Muyaga describes folklore on how the reptile seems to hide where people like to wash or cross and how it seems to play with its human prey before dragging him or her underwater. Worse yet, it always leaves a little behind, after feeding, "to let them know that the person is dead" (1974: 136).

In the Pende worldview, such a sudden and horrific death could never qualify as accidental. For this reason, Ndambi connects the mask to the story of a crocodile that

attacked a child in 1929 who was attending a mission school. Villagers accused a man named Mudiandambo ("eat a little"!) of putting the reptile in the Lwanji River to bring him the child for his nefarious purposes. Since then the mask has been connected in people's minds with sorcery and they are not happy to have it performed (1975: 314).

Ndambi's story highlights a theme uniting all of these creatures. The Cape buffalo, the elephant, the leopard, the lion, and the crocodile compose *the* major tribute offerings presented to paramount chiefs. Failure to pay tribute of any one constitutes a declaration of independence and is cause for investigation or hostilities. All are creatures capable of taking human life, who are regarded therefore as alternative bodily forms that chiefs and powerful lineage heads can assume to go hunting. Because of these animals' close association with chiefs, the latter are barred from eating their flesh, although they preserve their skins, teeth, claws, or horns as emblems of their power.

These animals also act as familiars for sorcerers. Arthur Bourgeois recounts Yaka folklore on the Cape buffalo that details the metonymical connections of these animals with sorcery. Like sorcerers of evil intent, they are "nocturnal rovers" (1991: 19). Their astonishing ability as large animals to vanish when injured and then to attack from an unexpected direction is likened to the sorcerer "preying upon an unsuspecting foe" (21). Bourgeois notes: "Witch powers are said to permit its owner to be in several places at once, travel long distances in a few moments or transform the human witch into an animal, for example, a wild boar, leopard, crocodile, or buffalo in order to stalk and kill one's enemies" (21). In short, there is something more serious taking place here than a light-hearted theatrical representation. The *mbuya jia mafuzo* enact visions of devouring power barely kept at bay on the outskirts of the village. These animals began to appear in masquerades just as (or just after) they were becoming rare or extinct in Pende country.

MACHINES OF SORCERY

The themes of menace and sorcery are present in the other masks in the *mafuzo* category and explain the connections conceptually linking their diverse forms. The dancers of MBUNGU, which is composed of two large stuffed figures representing a man and a woman, would use thin strings to make them wave and move their arms in a naturalistic fashion (fig. 104). While this seems familiar and nonthreatening to Western audiences through the realm of children's puppetry, it was the reification of a common folk belief that criminal sorcerers

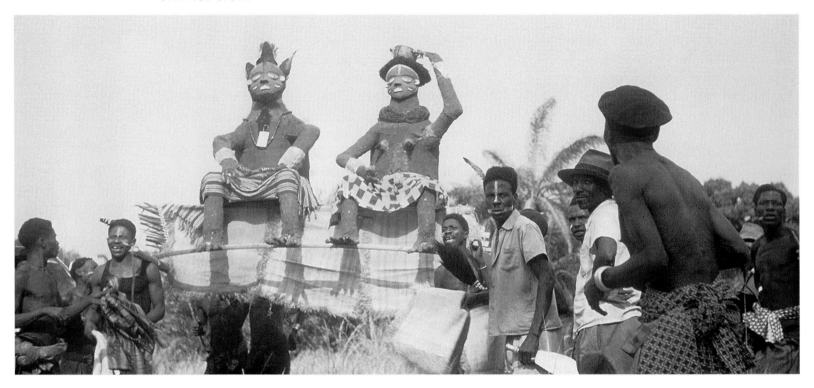

104. The *mafuzo* mask MBUNGU performing at Nyoka-Kakese in the mid-1950s. (Photograph by Léon de Sousberghe.)

could create mechanical dolls to do their nefarious bidding.

Mbungu is the queen of the termites. She sits in the center of the termite hill but does not speak or work. *Mbungu* is also the term for the immobile butterfly or moth chrysalis, whose wings are still tightly bound together. By extension, one often hears the phrase "Look, you're as silent as a *mbungu*."[14] At Ngundu and in the north, they refer to the same mask as GIHUNDUNDU, which signifies in Kipende "someone who does not speak."[15] The names of the mask indicate that, like the dolls sent on missions by sorcerers, the chilling characteristic of the mask

lies in its silence. Although the figures move, they do not control their own destiny.

KOLOMBOLO, too, belonged to this realm (fig. 100). The body was made of a rotating barrel marked with the *kaji-kaji* spotting of a leopard or crocodile. Its name, "Cock," punned on the little red crocheted hat the dancer wore with a crest of blood-red *nduwa (Musophaga rossae)* feathers. There was also a thick ruff attached to the top, which bounced and flew out with the barrel's movements.

When the organizers announced that KOLOMBOLO would dance, the audience hushed. One of the helpers would wander here and there, searching for KOLOMBOLO. He cried out: "My Kolombolo, if you've gone upriver, if you've gone downriver, cry so that we can hear you."[16] KOLOMBOLO finally revealed itself by crowing like a rooster: *"Ko lo gué! Ko!"* Then the drums began pulsing.

The dancer spun the barrel so that it would transform into a whirling blur. From time to time, there was a dramatic break when the drums and singing suddenly stopped. After a moment of silence, KOLOMBOLO crowed and then the drums and songs recommenced. When he crowed, the dancer stuck out his head, disguised by the red-feathered head covering, to see where he was going.

The mask KOLOMBOLO most definitely does not represent a cock, despite its crow. The dancer of the mask at Nyoka-Munene, a Pumbulu (initiated ca. 1916–19),

described the paradox of the mask's appearance.[17] He stated that one performed KOLOMBOLO "for fun" *(manzangi)* but that people found it scary because it wore a ruff and hat like the *minganji* fraternity masks; it was spotted *kaji-kaji* like a leopard; it was coming from the bush. The sculptor Gisanuna described the reaction of the spectators to KOLOMBOLO's appearance: "The crowd has to wonder: 'What is it? [With] no arms! Off in the bush! *Ima ya wanga'* [a sorcery machine] . . . !"

The mask MBAMBI, too, orchestrates a vision in the bush of an extraordinary machine, as high as a palm tree, topped by a face mask, that appears suddenly in an unsuspected direction and waves its arms (fig. 105). It rises out of a palm frond enclosure. It is preceded, not by the usual helpers dressed as *ngunza,* but by the mask MBOLOKOTO, which performs with a chief's sword and shares the elongated form of the Eastern Pende PUMBU mask.[18] It is used precisely because it is both unique in the Bandundu region and frightening. While the audience has their eyes riveted on this unusual sight, the assemblers of MBAMBI are hard at work assembling the framework so that when they finish, the crowd will turn to see the apparition completely formed. At a performance at Gungu in 1989, they handled this quite skillfully so that the spectators were taken unawares.

MBAMBI is primarily associated with the village Ndumbi a Gabunda. Everyone assigns it to the *mafuzo*

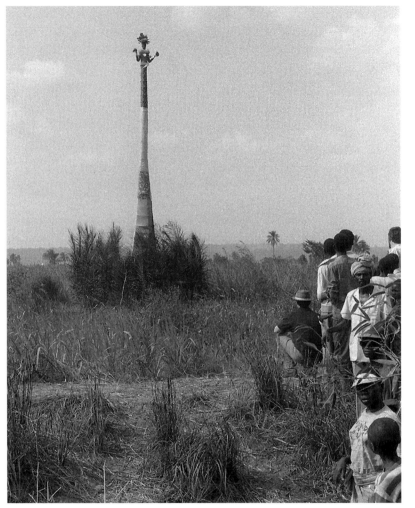

105. The *mafuzo* mask MBAMBI, constructed on the outskirts of the 1989 Festival de Gungu.

category—except the owner of the concession, Mazanga a Gimbadi, who refers to it as a "light-entertainment mask" *(mbuya ya pamba)*! Nevertheless, he noted that although he is perfectly willing to sell the secrets to MBAMBI's construction, he never gets any offers because everyone assumes that sorcery is involved and because the cost is high (a goat). He attributes its origin to Kafunvu a Kimbinda, of the Makulu generation (initiated ca. 1870–75), who worked out the idea for the tower and topped it off with a GINJINGA-style facepiece. If Mazanga is correct in attributing its origin to someone of the Makulu generation, MBAMBI may predate the emergence of the *mafuzo* masks and may have been incorporated into the category later by popular association.

Pulu, of the Mingelu age grade (initiated ca. 1901–3), held the concession for many years.[19] MBAMBI traveled a great deal for bravura performances in other villages and for state festivals. Dancers from the Mingelu generation also tried to introduce it into a few outside villages like

Mukedi and Ngunda. Mazanga claims that it was he who added the idea of the torso and the arms waving fly whisks during the 1950s; however, he may be grandstanding.[20] At Gungu, two men stood inside the structure and pulled on cords to move the arms (fig. 105). Mazanga, a member of the Pogo jia Mesa age grade (initiated ca. 1938–40), is one of the youngest men associated with a *mafuzo* mask.

THE BETTER TO GOBBLE YOU UP

Ginzengi (or Gimbombi a Kumba) is, like Pagasa, another of the oldest and most widespread of the *mbuya jia mafuzo*. Delhaise added it to his original list in 1924: "Important figure. Two-headed man . . . arrives dancing very heavily. Dressed up in a lot of cloth (indigenous) to increase his volume. Sits in the middle close to the chief. Carries a knife on his back; a bow and three [arrows?] in hand. Must frighten the children and women when he arrives; [w]omen and children flee; only the men stay."[21] Ginzengi represents the multiheaded monster of folktales, Gimbombi, which catches and swallows people. Like the animals and the machines, it is classed as "something [a creature] from the bush" *(gima gia mu foto)*.

Master dancer Khoshi Mahumbu supports Delhaise's claim that it is a mask that dances "heavily." Khoshi describes Ginzengi as "a mask for the elders; his dance is slow [lit. "cool"] and stately like that of Mazaluzalu [the chief]."[22] It is not a mask that performs in place with high aerobic outbursts and strongly flexed knees. Instead, it advances by taking a small step back for every step forward.

Field associates across the central and northern regions are agreed that Ginzengi was originally made by tying together two to five separate masks in a row on a strip of palm bamboo. The dancer would look through the one in the middle (de Sousberghe 1959: fig. 103). For the masks they often used Muyombo, Ginjinga, and Pota, but sometimes other masks, too. Sometimes, as a variation, performers would make Ginzengi female by joining two female facepieces. Around 1980, Gibao a Gasanji from Kimbunze came to Nguedia Gambembo with the idea of carving Ginzengi as a helmet mask with three heads. The dancer Khoshi saw the result and liked it because it would allow the performer to dress himself. He has carved and danced this form of Ginzengi many times since (fig. 106). To lighten the mask, he has cut open a space in the back, which he closes with netting.

Because Ginzengi is a striding mask it wears a handsome, pleated, raffia wrapper. Ideally, the male version will carry a chief's sword in one hand *(pogo ya khusa)* and fly whisk in the other. The female version never carries a sword. Feathers are attached at the temples, which substi-

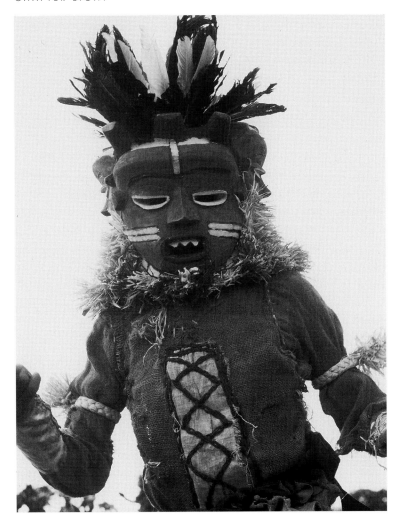

106. The multiheaded *mafuzo* mask GINZENGI performing at the 1989 Festival de Gungu. Danced and sculpted by Khoshi Mahumbu. GINZENGI has more heads in order to have more mouths to gobble up everything in his path.

tute for those of the predator *pungu* bird, now extinct. Field associates from the center and the north stressed that performers wear a piece of the woven *kiala* mat reserved for chiefs around the chest, which is decorated with a *kaji-kaji* design (in this case interlaced diamonds). As with almost all of the *mafuzo* masks, GINZENGI is danced in the bush on the edge of the village.

Delhaise rightly noticed the terror of the children because the multiheaded Gimbombi features prominently in folktales designed to frighten children from wandering off into the bush, where they could lose their way or run across snakes and other dangers. In these tales the savanna is described as the den of wild animals, sorcerers, and the envious and ill-spirited among the dead *(tsupolongongo)*.[23] Naughty children frequently fall prey to Gimbombi. His lair is full of "a great many children, big, well-fed, all slaves," along with every kind of stolen village livestock.[24] The noise of all the crying, bleating, baying, clucking, crowing, etc. is deafening (Van Coppenolle and Pierson 1982: 110).

Gimbombi is described as a *"sorcier et*

mangeur d'hommes" (Van Coppenolle and Pierson 1982: 111) and a *"mange-tout"* (145) because he consumes (takes in) everything from people to calabashes. In one tale, when the villagers succeeded in killing a Gimbombi, they heard a baby wailing in his enormous stomach. Then they found six men, some dogs, some calabashes, three chairs, six bells, three corn baskets, enough palm oil to fill eighteen calabashes, about twenty rings of copper (formerly units of currency), some women's wigs, ground pepper, nineteen hoes, and thirty-six knives (145). Gimbombi's enormous stomach is a sign of his greed, and his multiple heads (which can number up to two hundred or more) signify his terrifying ability to take in all that he desires. He has more heads in order to have more mouths. The destructive ability of sorcery is described through the metaphor of "eating," and *"[l]es sorciers-mange-tout"* (139) are frightening apparitions of the greedy and antisocial, who know no limits.

EXTRAORDINARY SIGHTS

In the heyday of the *mafuzo* masks, dancers in search of a gimmick took some of the same shortcuts described in chapter 2 for the regular village masks. Already in 1924, Delhaise reported the dance of the mask GANGONGA, the stilt-walker. Although it appears wearing a MUYOMBO mask, GANGONGA seems to have been appropriated from the *mungong*, an Aluund (Lunda) funerary ritual. It is danced with a song from that ritual and carries a sword in one hand and a fly whisk in the other.[25] The Central Pende adapted the *mungong* in the mid-1930s as a secular dance society, but it seems likely that the Pende bordering on the Aluund would have borrowed it at an earlier date.[26] As noted in chapter 1, these Pende, as well as those west of the Kwilu, are much less interested in masking and have a close relationship with the Aluund of Mwaat Kombaan. The *mungonge*, as the Pende call it, is rare today among the Central Pende but continues in these regions (nourished by state festivals and occasional television performances). From Delhaise's note, it is clear that the Central Pende began to dance the stilt-walker as a *mafuzo* mask well before they appropriated the rest of the rite.

Muyaga describes the mask as one that involves a lot of prohibitions for the dancer *(mbuya ya mikhwala)* (1974: 92). Due to the danger of falling, assistants were more than usually concerned with providing the stilt-walker with protection from the envious and ill-spirited. At Nianga-Kikhoso, where they once had three dancers of GANGONGA, the dresser would blow a special powder on the performer. Among its key ingredients were fragments from the nest of a swallowlike bird *(galanda)* whose eggs

107. Painting a NYOGA (snake) masquerader at Kahungu in 1974. (Photograph by Nestor Seeuws. No. NS 74.612. Courtesy of the Institut des Musées Nationaux du Zaïre.)

never fall out of their nests, even when the nests are built in precarious positions, because the nests are so well woven with feathers and rags. Muyaga reports that GANGONGA strides with long steps *(guthaula mathambo)* and that he may even clack his stilts together to the beat (1974: 94).

Because the *mungonge* involves some sleight of hand and magic tricks (e.g., feigning to pierce the cheek with an arrow), outsiders connect it to sorcery practices and find it both fascinating and frightening. In the *mungonge*, the stilt-walker appears at dawn and is part of a complex ritual symbolism (de Sousberghe 1956). GANGONGA appropriates the stilt-walker from its ritual complex merely to astonish the crowds.

The NYOGA (snakes) are perhaps the most surprising member of the *mafuzo* category. Dancers usually appear as a pair, covered with red, white, and yellow body-paint in zigzag and diamond designs (figs. 101, 107). They perform upright a synchronized, wriggling dance remarkable for its suppleness, which recalls the locomotion of snakes on the ground (de Sousberghe 1959: figs. 59–62). Ndambi claims that

the dancers become intertwined and move backward (1975: 284, 286).

Although the dancers do not wear headpieces or face masks, together they form the Nyoga (snakes) and are classified as *mbuya jia mafuzo* (masks). They rely on face-paint and distance to prevent personal identification.[27] They appear out of a shelter of palm fronds constructed especially for them as "backstage" (fig. 101). Helpers stand by to keep the crowd at a distance of fifty yards or so. If they see sweat trickling down a performer's body and blurring the designs, they signal the dancer to return to the shelter to renew his body-paint.

It appears that performers at Munzombo based the Nyoga on a dance borrowed from an antisorcery movement in the early 1930s.[28] This would make the Nyoga one of the very last *mafuzo* masks to be invented. Perhaps due to the dance's original connection with a religious movement, the dancers are strict about maintaining a fast of several days before they perform (de Sousberghe 1959: 58; Ndambi 1975: 284).

In the case of both Gangonga and Nyoga, it appears that certain villages among the Central Pende appropriated dances from neighbors less interested in masquerading. As chapter 2 relates, this is common practice; however, it should be noted that the dances appropriated for *mafuzo* performances already had a scary aura. Ndambi

reports folklore that the Nyoga are connected with sorcery and that they cannot appear without "eating" someone (1975: 286, 288).

THE CHIEF AS SORCERER

Not every *mafuzo* mask developed a following. At Nyoka-Munene, Njio and Pulugunzu, launched by members of the Mingelu age grade, linger only in name. At Ngunda, Nzambi (also Mingelu) invented a *mafuzo* mask, Maloba. Dressed in a beautiful wrapper, it carried a chief's sword *(pogo ya khusa)* and performed to the tones of the iron bell of the chiefdom *(muangala)*. Some even shot off guns for it as they would have at the investiture of a chief. The elderly chief of Ngunda (Ginzungu Lubaka) insisted that Maloba was a *mafuzo* mask because of its connections to the chiefly insignia *(ufumu)*.

The association that the chief of Ngunda makes between the *mafuzo* masks and the chiefdom identifies a thread linking many of these diverse manifestations. The animal masks, remember, represent creatures that are considered familiars of high chiefs. The puppetlike couple represented in Mbungu travels on a colonial "tipoy" (a chair slung between poles and carried by bearers on their shoulders). Because of the tipoy and the type of face masks used on the mannequins, de Sousberghe identifies

the couple as the chief and his wife (1959: 56). MBAMBI, and indeed almost all of these masks, are accompanied by *ngunza* like PUMBU, the chief's executioner. GINZENGI wears designs from the chief's mat (used for pomp at trials and other public hearings), dresses in a chief's wrapper, and carries his sword. The *mafuzo* masks present a negative image of chiefly power eclipsing the chief's mission as nurturer, as peacemaker, as the "granary" of his people.

One story reinforces the connections of sorcery and the chieftainship. At the village of Kamba, Sh'a Ndeya Gambembo originated a *mafuzo* mask, which he called KAFUNGA. This seems to have been a normally attired masker; however, he had helpers carry him about on a tipoy while he waved his fly whisks like a chief coming out of seclusion for his investiture. During the performance, KAFUNGA approached a child. The next day, the child died, creating a rumor that someone must die every time this particular mask appeared. Understandably, that was the end of KAFUNGA's career. The appearance of the chief at the time of his inauguration is imbued with both beauty and ominous import because of the widespread belief that someone must die to provide the new chief with a ghostly bodyguard. The mask MALOBA also seems to have built on this association. Such a connection is strikingly different from the conception of ordinary *mbuya,* which are linked to healing and reconciliation.

THE CENTRAL QUESTION OF THE *MBUYA JIA MAFUZO*

The *mbuya jia mafuzo* present an extraordinary chapter in Pende art history.[29] They are unique in incorporating large models of animals into the canon of village masquerading. They are unique in both village and fraternity masking in being promulgated through concessions. For the first time, not all initiated men had access to every mask.

Central Pende are agreed that most *mafuzo* masks have their origins in the north before 1930. The sculptor Maluba, of the Milenga generation (initiated ca. 1885–90), imported PAGASA, the Cape buffalo, from the north to Nyoka-Munene. Gatshaka, of the Mingelu age grade (initiated ca. 1901–3), brought Kihuele of Mbelo in the north to Nyoka-Kakese to introduce PAGASA. MBUNGU, as noted above, came from Kasele in the north to Nyoka-Kakese; GIKWAYA, from Luende. GINZENGI seems to have a northern origin, although no one can pinpoint the source. Gimasa Gabate, a Pumbulu initiated at a young age ca. 1919, was responsible for introducing GIKWAYA, the crocodile, to Nyoka-Kakese in the 1930s. He and his friends identify this as one of the last *mafuzo* masks to be imported south. Gimasa invited the inventor, Kibungula Jacob of Luende, to teach them the mechanics

of the performance. Kibungula is a Mbuun, who lives on the Pende frontier, where they have acquired the taste for masking from the northern Pende.

Once the model was launched (1) of selling the knowledge used to make the mask as a concession, (2) of dancing in the bush, (3) of using helpers dressed as *ngunza* blowing powders to keep the crowd at a distance, and (4) of using basketry frames for maquettes, locals could build on the precedent to launch variations on the genre: KHOLOMA, the leopard; KHOSHI, the lion; NJIAMBA, the elephant. Even MBAMBI, with its unique history, borrowed the trick of waving arms with strings (invisible from a distance) from the northern MBUNGU.

The *mafuzo* evolved into a category of ominous apparitions.[30] Everything about the detailing of these masks was intended to be scary: GIKWAYA's rapid drum pulse; the spotted light-and-dark designs *(kaji-kaji)* proper to chiefs, leopards, and crocodiles; the incorporation of glass or mirrors to flash reflected light into the spectators' eyes. True to the stress on novelty outlined in part I, later innovators on the genre appropriated the snake dancers (NYOGA) and the stilt-walker (GANGONGA) from different contexts. Others sought to build on the dire reputation of the chief at the time of investiture (KAFUNGA and MALOBA).

Nonetheless, it is the persistent and marked references to *wanga* (sorcery) that make this category unique. There were the helpers, dressed as takers of human life, blowing mysterious powders in the direction of the audience. There was the fact that one had to pay for the knowledge and the right to make such a mask—as one would have to do for a sorcery recipe. There were the connections with sleight-of-hand magic tricks (using strings to wave the arms of mannequins, walking on stilts, raising a tower as tall as a palm tree in the blink of an eye) that required the dancers to keep chaste and to keep fasts so that they could achieve the proper concentration to pull off the performance. And then, there were the apparitions themselves, sorcerers' familiars, sorcerers' machines, sorcerer-monsters, and sorcerer-chiefs, erupting ominously from the bush into village life.

With only a few exceptions for older sculptors, the men associated with introducing and dancing the *mbuya jia mafuzo* are overwhelmingly from two age grades: the Mingelu (initiated ca. 1901–3) and Mapumbulu (initiated ca. 1916–19).[31] I could find no case of a member of the following age grade, Ndende (initiated in 1931), who invented a mask from the *mafuzo* category or introduced one from elsewhere into his village. There are, however, some examples of Ndende who *continued* their father's or uncle's concession.[32] Although men from these generations continued to dance the *mafuzo* masks in the 1940s,

the younger age grades were uninterested. There have been few performances since Independence except in the context of state festivals, a pattern begun in the 1950s. The central question of the *mbuya jia mafuzo* therefore is why mature men of the age grades Mingelu and Mapumbulu were so drawn to incorporating frightening apparitions into the village masquerading milieu.

A RETURN TO LAUGHTER

The men of the Mapumbulu age grade, who matured in the 1920s, are remembered as committed masqueraders. Lest their association with the dark *mbuya jia mafuzo* give a distorted image, it should be remembered that their members were also responsible for the genre of the modern young man in Matala (chapter 3), for rejuvenating the genre of the diviner in Tata Gambinga (chapter 2), and for many comedic masks. These include Sanya, whose dance mocked the itching of someone suffering from bedbugs; Gangema, the drunkard who must tap his own palm wine; Gimuanga Thugu, a variation on Muyombo; Kulungu a Ndambi, a "mask of beauty" that did not find followers. Members of the Mapumbulu generation may have invented, but certainly became renowned dancers of, Madikweleta (the scratcher) and the bawdy Gatua Ulu (in the genre of Gandumbu), who took advantage of the abbreviated dress used by women fishing to flash a large red vulva.[33] Notwithstanding these touches of humor and beauty, they preferred to end their masquerades with the appearance of *mafuzo* masks.

The Ndende generation, initiated ca. 1931, in contrast, are remembered for their dancing but not as great inventors of masks. They continued to reinvent and perfect the personae of Matala and Tata Gambinga. In a fusion of the female mask with the genre evolving in Matala of the modern youth, Ndende in the north probably launched Gabugu, the modern young woman. Ndende also seem to have been responsible for Gatambi a Imbuanda, one of the variations on the female mask that appeared with one or more "babies" in the form of dolls. It was not an Ndende but a mature Pumbulu, Mushila, who invented Galubonde, the mask that mocked a dishonest colonial police officer (chapter 2), during the 1930s or perhaps early 1940s.

Masquerading experienced a reflorescence in the next two age grades, Pogo jia Mesa, initiated in the late 1930s, and Solomogo, initiated in the mid- to late 1940s. Miteleji Mutundu, the inventor of Gatomba, and many other field associates recall nostalgically that there were dances almost every Sunday. The spirit of masquerading after World War II in the late 1940s and 1950s, however, was very different from that which reigned under the Mapumbulu. De Sousberghe speculated on the decline of the *mafuzo* category in the 1930s (1959: 39). There were

only occasional, fitful performances of these masks by older Mapumbulu and Ndende. De Sousberghe noted that MBAMBI, for example, was reborn for the state festival in 1958 after a lapse of more than twenty years (1959: 39). The dark vision of the *mbuya jia mafuzo* no longer spoke to aspiring dancers.

Instead, the young men of the succeeding age grades are known for an explosion of comedic masks. GATOMBA, the failed sorcerer, and GIKITSHIKITSHI, the stamping European of chapter 2, belong to this period. Other comedic masks include MATABUANGA, GIN'A MUKOMBO, GASUSWA, and the lewd GIBANGO, NDUMBU, and GAWEN-JI A THOWA. In addition, succeeding dancers of the popular masks representing modern young people, MATALA and GABUGU, increasingly played up the humor of their prancing and preening. Observers in the 1950s even report masks representing prostitutes (de Sousberghe 1959: 49–50), a conception foreign to both previous and subsequent interpretations of the female mask. Probably the inventors of such masks were responding to another aspect of modern life and hoped to attract viewers through the novelty of the presentation. Other popular masks were centered on the palm products that had become the foundation of the modern economy for the Central Pende: GABIDI-MUAMBA, the merchant in search of palm nuts from chapter 2, and SH'A KASANDA of Muke-di, which pantomimed the extraction of palm oil. This period of frequent dances and comedic interludes came to a definitive end with the devastation of the Mulele Rebellion, 1963–65.

To understand what these masks represent, we must explore not just their cultural context but also the historical moment in which they were danced. We cannot interview today the inventors and innovators of the *mbuya jia mafuzo*. When I conducted my fieldwork, in 1987–89, only a few of the youngest members of the Mapumbulu age grade were left. However, it is suggestive that the life span of the *mbuya jia mafuzo* exactly coincides with that of the two age grades that bore the brunt of the establishment of the colonial state.

We know very little of how these generations experienced and understood the colonial transformation of their society. Can Central Pende masquerade provide evidence of the interior life of its audience during the Belgian occupation? Can the life and demise of the *mafuzo* masks tell us anything new about what T. O. Ranger calls "the giddy variety of existential experience" built into the structures of colonialism (1975: 2)?

THE RESHAPING OF PENDE SOCIETY

De Sousberghe has dated the Mingelu initiation to the period just before the establishment of the first posts of the Compagnie du Kasai (hereafter abbreviated CK) in

Pende country, ca. 1901–3 (see chapter 1). As Mabaya Mutumbangolo emphasized in 1974, the Mingelu were the last generation to reach adulthood in precolonial Pende society.[34] The Mapumbulu were initiated quite late, ca. 1916–19, probably due to social disruptions.[35] The efflorescence of the *mafuzo* masks, 1910s to early 1930s, coincides with the period of effective colonial occupation, forced labor, and the metamorphosis of the chief into an "agent of the state."

The lives of the Mingelu changed greatly within a few years of their graduation. Although the Compagnie des Magasins Généraux du Congo had opened the first trading post in Pendeland after 1888 (Sikitele 1986: 190–91), the Congo Free State and its commercial policies made little impact on the Pende before 1903. In 1891, the Congo Free State made porterage a legal obligation for the African population. The implications of this law hit after the state created the CK in 1901 and granted it a commercial monopoly that extended into Pendeland.

For our purposes, focusing on the Central Pende, a critical date is 1901, when the company La Loange from Antwerp opened the post Bienge on the left bank of the Loange River, upstream from Lake Matshi (Kodi 1976: 396 n. 2). Its goal was to exploit rubber from vines found along the river. When the CK took control of its monopoly, ca. 1902–3, it decided to move the post Bienge onto the well-populated savanna near Mukedi. The riverine sources of rubber were almost exhausted and the company hoped to exploit the rhizomes of the rubber shrub *(Landolphia thollonii)* (de Sousberghe 1963: 13; Sikitele 1986: 232 n. 76, 263). Their agent, Oscar Bombeeck, also moved the CK post Dumba at this time from the river to Mulassa, on the Pende-Mbuun frontier. It was this post that Torday and Hilton-Simpson visited in 1909.

To "encourage" trade, the state demanded a tax in rubber supposedly equivalent to 40 hours of work per month. If this were not heavy enough, a report compiled in 1904–5 admitted that in fact the quantities required demanded considerably more than 40 hours' labor to fill. Whole families were obliged to go camping in the bush several times per month to seek rubber supplies far from their homes (Sikitele 1986: 502). The lion's share of this work fell on the Mingelu, in their twenties.

The density of the commercial presence increased. The historian Sikitele reports that by 1906, all of Pendeland west of the Loange was crisscrossed by a system of commercial counters and posts (1986: 265–66). By 1908–9, each trading post had a personal arsenal of forty to sixty Albini rifles and, thus armed, exacted the rubber quota by flogging resisters and by holding women as hostages (506–8). At this period, there was no supervision whatsoever governing the behavior of commercial agents

(462–64). If they were not satisfied with the quantity or quality of the rubber, they would exact "fines" in more rubber or in livestock. For all these reasons, villagers would try to hide their young men, women, and livestock in the forest. Agents would respond by burning the houses of individuals or whole villages and by flogging chiefs and lineage heads.

By 1910 a record number of European agents were present: 29 in Pendeland and 16 at border posts, including 7 at Mulassa, 2 at Bienge, 2 at Kitombe. There were also 77 agents at Dima, who no doubt toured the region periodically (Sikitele 1986: 270–72). Until 1910, the post Bienge alone (near Nyoka-Munene) was producing a whopping seven tons per month of rubber—all through forced labor (de Sousberghe 1955b: 26 n. 3). When the CK lost its commercial monopoly, the situation grew worse through fierce competition for scarce resources. Portuguese firms placed 34 agents by 1912 (Sikitele 1986: 283).

As bad as things were, they grew worse. As historian Maryinez Lyons observes: "Conquest was inseparable from tax because conquest was *for* tax" (1987: 152). Between 1910 and 1916, the state effectively took control of Pendeland west of the Loange. After 1910, Belgian colonial officials with military escorts started systematic "tax" collection among the Central Pende. In that year, the state imposed a head tax to be paid in money by men, with supplements for polygynous households.

A number of organizational changes were initiated to facilitate this tax collection. A decree of 1910 required ethnographic inquiries to establish chiefdoms sympathetic to the government. In 1913, the first *territoires* were organized to better administer the interior. From 1913 to 1931, the colonial administration took an increasingly direct role in selecting Pende chiefs and regrouping clans and villages, actions which provoked bitter land and political disputes that continue to this day (Sikitele 1986: 323–27).

The proof of the tightening noose of the state comes in the desperate armed resistance mounted by individual Central Pende villages from 1916 to 1919 (Kodi 1976: 403–4; Sikitele 1986: 695–96, 952). In response, the government founded the military post of Kilembe in 1916 in the heart of the Central Pende. Frustrated, the people turned to passive resistance, which led territorial officials to appoint and depose chief after chief from 1919 to 1920. It was the mature Mingelu, who figured prominently in these acts of resistance, who began to invent the *mbuya jia mafuzo*.

Sleeping sickness broke out among the Kwilu Pende and their neighbors during this period. In 1916, with a mandate from the state and fearful of the dangers to one

of the most populous labor supplies in the Congo, the Catholic missionary Ivan de Pierpont began forcing villages to relocate from valleys near water supplies up onto the plateau away from the supposed source of infection. As well as rebuilding, villages were also forced to regroup in larger units, to strip the area of all vegetation, and to align themselves along the road. The victory over sleeping sickness is still lauded as one of the triumphs and justifications of the colonial state. Ironically, recent research indicates that it was their own forced-labor policies that provoked the epidemics by weakening the population and by forcing men to work away from home, where they had not built up natural immunity (Lyons 1987; Giblin 1990).

De Pierpont's journal testifies to the terror provoked in 1919 by the arrival of a white man: "When I arrive on the rise that dominates the Lutshima valley, I see from afar all the villages emptying of their inhabitants, carrying off all their belongings: chickens, goats, pigs. Useless to go there: I will see no one. I modify my itinerary and spontaneously present myself at the hamlet of Moansa. General and frantic flight . . ." (1921b: 267).[36] De Pierpont found this experience repeated in village after village well into the 1920s. As he himself recognized, flight was the people's only recourse to protect themselves from losing their men and livestock to the exactions of colonial agents and risking their women to rape. His journal reveals the Pende and their neighbors to be living under stress, poised to flee at the approach of the white man or his minions.

The Abbé Gusimana conveys how intimidating the mysterious physical exam for sleeping sickness (which could result in a lumbar puncture) was in this racist atmosphere:

> A nurse (ndombi) shouts out in the village: "Tomorrow, at the first cock's crow, you will wash with hot water your necks, your heads, and your bodies. For the white man does not touch the dirtiness of blacks." The people ran to the stream to gather leaves called "mienge" in Kipende, by way of soap. Around 2:00 in the morning, the people poured water into their terra-cotta pots and boiled it, with the intention of removing the oil from the neck and face [head]. Mama practically scalded my neck with leaves plunged into the hot water. If your neck is dirty, you pay a fine. (1970b: 64)[37]

If someone received the dread diagnosis (which doctors admitted was often inaccurate), the person would be arrested to make sure that he or she received the required injections of atoxyl (Schwetz 1924: 5–8). Inevitably, it sometimes looked like the examiners themselves were spreading the disease, as apparently healthy people would die after receiving the injection (1924: 37).

The Mission Médicale Antitrypanosomique du Kwango-Kasai continued de Pierpont's work. It achieved most

of its objectives from 1920 to 1923, although it continued into the 1930s. Nyoka-Munene, for example, was moved in 1922.[38] (It was moved yet again, along with Nyoka-Kakese and Kimbunze, in 1948–49 to the top of the plateau.) The government profited from the mission's work because the newly regrouped and aligned villages were much easier to keep under surveillance. Dr. J. Schwetz writes that part of the mission's mandate was to profit from the required physical examination by making an accurate census (1924: 1). Pende avoided censuses as much as possible because of the abuses that tax collectors and labor recruiters made of the information. Sabakinu Kivilu deems Schwetz's censuses of 1917–24 highly successful (1974: 132–33), no doubt due to the military escort.

With the crushing of resistance, the Mingelu and the newly initiated Mapumbulu faced the complete transformation of life as they knew it during the late 1910s and 1920s. Sikitele, profiting from evidence collected following the Pende rebellion of 1931, has been able to document that the increased presence of the state after 1913 did nothing to curtail the license of commercial agents in this area, despite periodic government reforms or complaints (1986: 462–64, 540–44). Tax money had to be earned from European traders, who successfully controlled the terms of exchange.

Following crises in rubber prices on the world market, the economy among the Central and Kwilu Pende switched definitively over to palm products, 1915–21 (Sikitele 1986: 547–48). The factory at Kinguba opened during this time. In the beginning, the merchants bought calabashes of palm oil that had been prepared in the village by traditional means. While the harvesting of palm fruits was less onerous than rubber collection, the burden of forced porterage was severe. Gimasa Gabate (a Pumbulu of Nyoka-Kakese) and his father (a Mingelu) were forced to carry oil many times to Kikwit (195 kilometers). He reports that the Portuguese officials of the CK would arrive out of the blue and command: "You and you and you: take this to Kikwit." If you refused, you were arrested and whipped. The worst part was that they would arrive abruptly and the men would have to leave immediately, without time even to eat or to gather proper provisions. It was a long journey to go hungry. Since they did not know people along the way, they were obliged to bury cassava bread in order to have something to eat on the return. If they happened to have some food on hand, they might have to take along a young boy to carry it. First they carried calabashes of palm oil, then small kegs, and finally they rolled drums.[39] Significantly, the Mingelu adopted the name "sheen" to commemorate this early period dominated by forced porterage of palm oil.

From 1915 on, commercial agents applied enormous pressure, particularly in the north around Lake Matshi,

the apparent birthplace of the *mbuya jia mafuzo*, where there were large natural groves of oil palms (Sikitele 1986: 550–51). As the palm market became important, merchants began to exact palm fruit for small local presses and palm kernels for processing in Europe. These hand presses were inefficient and required huge quantities of fruit, along with teams of workers. One particularly effective strategy that agents developed involved leaving a machete or bolt of cloth in front of a house, along with a certain number of sacks. If the sacks were not filled, they would threaten the householder with arrest and prosecution by the state for theft. Reports in 1931 demonstrated that this so-called advance system operated throughout the 1920s, despite a decree outlawing it in 1916.[40]

As the colonial administration tightened its hold in the 1920s and 1930s, there seemed to be no aspect of life left untransformed. The burden of forced porterage became so scandalous in the colony as a whole that the Commission pour la Protection des Indigènes labeled it "intolérable" in 1919 (Sikitele 1986: 467). In response, the government made the construction of roads a priority. Ironically the hated road-building corvées for men, women, and children increased the stress on the population in the 1920s.[41] Hunting was banned. As a result of moving the villages up onto the plateau, women found their work significantly increased because fetching water

suddenly became an onerous burden. Beginning in the mid-1920s, agricultural monitors required families to produce set quantities of various agricultural products and to sell them at fixed prices. They replaced the indigenous system of field distribution by forcing the women to farm in squares on assigned plots, no matter what the fertility of the soil (Sikitele 1986: 1252).[42] Administrators would periodically arrest a certain number of larger boys for service in the colonial army (La Force Publique).[43] They took advantage of the initiation to the Mapumbulu age grade to raid the camps in the bush for larger boys to serve in World War I. The families of these boys mourned them with wakes as if they were officially deceased. Workers were also recruited at gunpoint among the Central Pende for the Huileries du Congo Belge, a Unilever concern.[44] In the early years, these workers suffered an extremely high mortality rate due to the poor food and conditions in the work camps.

The so-called sanitary laws proliferated as the state remade the Pende village in the mid-1920s and early 1930s. In addition to rebuilding along the road, villagers were constrained to mark off their houses one from another with fences, to set the houses away from the bush by a certain distance, and to build latrines. Beginning in the early 1930s, women were required to give birth in lying-in centers, where their sons were circumcised.[45]

Roads, paths, and the local spring were inspected for litter (Sikitele 1986: 1263). The multiplication of these laws under the usual threats of enforcement through fine, arrest, and whipping made the arrival of the *agent sanitaire* as dreaded as that of any other colonial official. Gampamba Lushinge recounts the common perception:

> Those who did not fence off their houses were arrested, thrown into jail, and subjected to a heavy fine. One would say that all the whites who came into the villages sought to exploit us or to make a profit. Thus the doctor imposed on us the work of latrines.... When someone did not build his latrine, he paid a fine; when someone did not clear his yard, he paid a fine; when someone did not fence off his house, he paid a fine and when someone did not have the money to pay the fine, he was arrested and sent, with a rope around his neck, to the Territory where he was thrown in prison. (In Sikitele 1986: 69)[46]

In 1989, the latrine was still perceived as a sign of the state's exploitation. Many Pende, sensitive to smell, believe that it is much more sanitary when the population density is low to disperse into the bush. Required to build latrines, numerous people view not using them as personal acts of resistance and self-determination.

In short, in a twenty- to twenty-five-year period, the members of the Mingelu and Mapumbulu age grades experienced the transformation of every aspect of life as they knew it. From birth to burial (and even during the intimacies of moving their bowels), the colonial state was peering over their shoulders. One could not hunt, farm, build, or even practice medicine as one wished. The body itself became subject to invasion through injections and lumbar punctures. All of these changes were always accomplished under the familiar litany of threats of fine, arrest, and whipping. The nicknames given to various colonial agents tell the whole story: Mundele Ngolo (the Violent White Man), Nyoga (Snake), Attashio! (Pay Attention! or Beware!), Pilipili (Hot Pepper), Makasi (Anger), Defini (It's Definite!), Ngolo Mingi (A Lot of Work), etc. The state itself became identified under the old nickname of Stanley: Bula Matadi (The Breaker of Rocks).

This was the life of the creators of the *mafuzo* masks. The historian Sikitele unites oral history with documentary evidence to paint a grim picture of a people subject to almost "anarchic" labor demands (1986: 464; vol. 2 passim).[47] The abuses of the system climaxed after the beginning of the world depression in 1929, when producers responded to falling prices by extorting more production and paying less. The Kwilu Pende rebelled in 1931. Although they were brutally subjugated, the subsequent investigation led to better surveillance by the state of commercial enterprises.

COLONIAL SOCIETY

The age grade Pogo jia Mesa was the first generation to arrive in the initiation camps already circumcised, ca. 1938–40. This event is important symbolically in marking the first generation to have been born and to have grown up entirely within the controls of the colonial state. They grew up living in amalgamated villages on the plateaus, in houses fenced off from each other, farming in squares, used to the periodic visits of tax collectors, of *agents sanitaires,* and of *moniteurs agricoles.* Many of the boys had spent some time in schools organized by the missions, now dotted across the territory.

A thoughtful drummer at Nyoka-Kakese described the change in attitude of his generation by pointing to the changes in funerary customs. The Pende once covered graves with broken pots and plates as well as peanuts, chickpeas, and other foodstuffs. No one had worried about children disturbing the graves because most people avoided cemeteries altogether for fear of troubling spirits of the dead *(nvumbi).* In contrast, as a boy the drummer and his friends started to raid the cemeteries after funerals in order to eat the peanuts. The *nvumbi* had no terrors for this generation brought up in the wake of the failed rebellion of 1931.

The Ndende (initiated ca. 1931), who saw something of what the Mingelu and Mapumbulu generations experienced, make the distinction that they and the Pogo jia Mesa never suffered like their fathers because forced porterage had ended. In the 1930s, the system of roads that the Mingelu and Mapumbulu had built allowed agricultural products to be moved by truck directly from the villages. The obligatory work parties were now devoted to maintaining the roads rather than to the back-breaking burden of building them.

All of this is not to say that their problems were over. Their labor was still exacted through a system of taxes and corvées. From 1942 to 1947, considerable duress was used to reintroduce rubber production among the Central Pende. Mulambu Mvuluya has shown that war production fell entirely on rural populations, reinforced by harsher penalties and increased restraints on free movement for fear of rural flight (1974: 36). Historians attribute the rapid growth of cities during and after the war to a desire to escape the onerous demands on farmers (Jewsiewicki 1973: 156–57; Tshibangu 1974: 291). Administrative reorganization in Pendeland led to an explosion of land disputes after 1948 that continue into the present. People deeply resented persistent colonial meddling in succession.

The colonial system itself changed after World War II as the economy boomed, 1946–57. More safeguards were

in place on labor recruiters, especially for women and children. However distasteful a tour of duty at the palm plantations might be, it no longer resulted in death or debilitating malnutrition. And one began to see a return for one's labor as improved safeguards ensured better pay. Men even began to volunteer for work in order to bring home a sewing machine or bicycle (Sikitele 1986: 1239). Industrial goods started to make a real impact on people's lives. Significantly, the Pogo jia Mesa took the name "Table Knives" rather than something associated with forced labor, as had the previous three generations.

CONCLUSION:
THE QUESTION OF EXPERIENCE

How did people experience the violent reshaping of their lives? Africanist historians are increasingly turning their attention to this question. As noted in chapter 1, we know that the Mingelu and Mapumbulu generations came to identify themselves by reference to forced-labor policies. The name Mingelu refers to the sheen on palm oil when it is heated during the extraction process. The Mapumbulu (soldiers) took their name in remembrance of their members torn from the initiation camps to fight in Europe during World War I.

The evidence of the masks suggests that their creators experienced the early colonial occupation as a sorcery attack. The *mbuya jia mafuzo* were born as the colonial state took control of northern Pendeland in the 1910s. As reviewed above, the unprecedented series of masks launched by the Mingelu and Mapumbulu are united by references to devouring power encroaching on the borders of the village. They speak to the inability of the village to maintain the integrity of its borders against the demands of merchants, tax collectors, labor recruiters, medical officers, missionaries, and agricultural monitors. The fear of being eaten alive, of being *consumed,* is what unites ravenous animals with the multimouthed monster GINZENGI and with the image of the chief on his inauguration day. The masks witness to a real fear of annihilation.

There is a growing literature sketching parallel beliefs in Central and East Africa (e.g., White 1993; Roberts 1993). In his work on the dream diary of a Cameroonian freedom fighter, historian Achille Mbembe argues that because colonialism was perceived as the practice of "criminal sorcery," it had therefore to be opposed by men able "to see the night" (1991: 120).[48] Controlling the day was dependent on controlling the night since what happened in one domain was linked to what happened in the other (101). The night was a "redoubtable universe. A place of potential 'consumption' [devouring]. . . . it could also be converted into a space for personal protection, in

dangerous situations" (102).[49] Dreams served as places of mediation between the living and the "otherworld" (102).

Masquerades are another site of such mediation between worlds. One may wonder if members of the Mingelu and Mapumbulu age grades were also trying to take control of the invisible when they launched the *mafuzo* masks, to strengthen themselves through victories over their worst fears, as in the mock death of Pagasa, the Cape buffalo. At the least, the birth of the *mafuzo* masks provides further evidence to support Mbembe in his assertion that "colonial violence did not touch only on the physical space in which the native evolved. It touched on the foundations even of the imaginary" (1991: 119).[50] Subject to censorship and surveillance, the Mingelu and Mapumbulu nonetheless found means to exteriorize their experience of being subject to *consumption* on the most literal level.[51]

The *mbuya jia mafuzo* are dressed in the language of power through their references to the symbolism and insignia of chiefs. As such, they also speak to the perversion of authority when knowledge of the supernatural becomes criminal sorcery, directed at personal profit. Significantly, this message was brought home to the Central Pende in the 1920s when chiefs were transformed from ritual intermediaries into petty despots, whose badge of authority had become the whip. The state wished appointed chiefs *(chefs médaillés)* to accompany territorial officials for "tax" collection and to execute punitive measures (flogging, seizing livestock, even burning houses) (Sikitele 1986: 694). To ensure their ruthlessness, they were personally threatened with flogging and arrest if their people did not produce enough palm products for the CK (557) or rubber for the state during World War II (1265). They were also alternatively threatened and paid off by Huileries du Congo Belge recruiters to provide men for the hated detail at Lusanga (589–91, 585). They acted as agents for the state with real power and little accountability to their own people. They made ugly decisions about which lineages had to sacrifice men to the army or children to the missionaries. They harried the population about conforming with the agricultural and sanitary laws. In exchange, many claimed the privileges of colonialists, for example, being carried in a tipoy, exacting free food and water, eating out of sight (765–66).

Belgian commentators themselves noted repeatedly that these policies had resulted in an enormous loss of respect for chiefs. From 1937 to 1948, a major administrative reform created larger administrative units, *secteurs*, to assume responsibility for taxes, agricultural quotas, trials, and so forth. It was too late, however, to salvage the reputation of local chiefs. Eastern Pende, who did not

know the harsh regime of palm oil, remark today on how surprising they find the disrespect with which Pende west of the Loange River treat their chiefs.

The resurgence of masquerading during the 1940s and 1950s is due in part to the disappearance of traditional avenues of male prestige. Chiefs, judges, and elders had been discredited as colonial straw men, who profited from the state's exploitation of the young. Hunting was banned. Smelting had disappeared. Blacksmithing was first forbidden and then reduced by the sale of imported goods (Sikitele 1986: 1215). Circumcisers were replaced by nurses or midwives in maternity wards. Dancing remained as one of the few major avenues open to young men seeking distinction.

The comedic masks of the 1940s and 1950s provide evidence of a radically different mental stance from that of the *mbuya jia mafuzo*. They seem to indicate that younger generations, born into the colonial system, achieved an ironic detachment from the occupation. To some extent, they ignored the invaders, or they made light of them (as in GIKITSHIKITSHI and GALUBONDE; see chapter 2). They proclaimed their independence by a forceful reassertion of "tradition" even as they modernized the masquerade through numerous changes (e.g., divorcing it from ritual contexts, individual proprietorship of masks and costumes).

The selective "traditionalism" constructed by the Pende in the wake of the 1931 rebellion became a tool to needle the invaders even as it reminded the people of who they were. Hairstyles became a source of silent contention. Belgian administrators and missionaries would not hire skilled workers unless they cropped their hair. Ideologically, they claimed that elaborate hairstyles encouraged people to be lazy by spending too much time on matters of personal vanity when they should be increasing production for the state. In response, more Pende than ever began to dress their hair. Foreigners fretted over the defiance (Hoet 1936a; Maquet 1954k: 10). The Jesuit J. Hamerlinck reported to his superiors that the Central Pende did not join the 1931 rebellion but continue "obstinately to hold themselves aloof from everything European."[52] In 1953 the musicologist Maquet noted the continuance of indigenous hairstyles and redwood powder skin lotion (unusual by this point in the colony). He wondered over the fact that the Pende were willing to adopt bicycles, bells, even phonographs, but not Western clothes (1953: 1). Traditional hairstyles went definitively out of fashion only at Independence.

The Central Pende found their most distinctive mode of resistance in their masquerading from the late 1930s to 1950s. In the populous area around the Protestant mission of Mukedi, masquerading and the boys' initiation camps

became sites of fierce contention. Erma Birkey, one of the founding members of the Mukedi station, wrote ca. 1938: "[W]e should have an attendance of four thousand instead of four or five hundred. . . . The native drum does not attract as many to church as to the dance" (in Weaver 1945: 193). Lubu of Mukedi reports that he and his friends often goaded the missionary Vernon Sprunger, who once ran from the church to argue with the masquerade's organizers. Sprunger finally won the day . . . by breaking the lead drum!

Sundays became contests for crowd size. At Nzaji, the Pumbulu Muhenge Mutala recalls with glee how they used to start the drums just as the church bells rang on Sunday. In contrast to the usual order of things, the performance would begin not with the clowns but with Mukedi's most popular mask, the elegant SH'A KASANDA, in order to lure women from church.

In 1945, Territorial Agent Cabiaux wrote recommending the deposition of Sefu Nzamba, chief of the Gatundo, precisely because the people were masquerading too much:

> [H]is authority is great, he obtains what he wants when he wants. The village of Mukedi is for him a dance floor and a brewery, he has at his service around thirty "Minganji" dancers. They dance absolutely every day—next to the chief's enclosure. The healthy adult men [who should be working] are his suppliers of palm wine.
>
> Life at Mukedi is summed up by dancing and palm wine, the recognized chief rules this life.
>
> P.S. I underline that they dance indisputably every day.[53]

Chief Sefu Nzamba is affectionately remembered today. Cabiaux correctly interpreted his endorsement of masquerading as a treasonous act of solidarity with his people.

Jean Comaroff reports that "collective dance and song" became points of conflict in South Africa as well. She speculates that one of the reasons that colonialists responded so negatively was because "activity of this sort was also a dramatization of the vitality of the system it represented" (1985: 151). The booming drums and the crowds united in song and dance spoke forcibly of an alternative identity to the one that the foreigners were trying to construct with their square fields, fenced houses, and cropped hair. Although colonial officials came to promote Pende masquerading in the 1950s, it remained a source of contention with some missionaries for many years.

Cultural historians have sometimes argued that popular culture can provide unique access to the viewpoints and experiences of classes deprived of voice by hegemonic political systems. Within African studies, some pioneering works have used popular-culture manifesta-

tions,[54] but they have predominantly focused on urban or urban-originating forms. And yet, the colonial experience was overwhelmingly endured by rural peoples. So-called traditional forms have been ignored because, in the mind of many scholars, "traditional" implies a static pre-colonial practice unable to speak to "modern" life. The evidence of the life and demise of the *mafuzo* masks argues instead for the responsiveness of some traditional forms to political realities. By following clusters of inventions in masquerading, one learns something of history as well as art history.

CONCLUSION

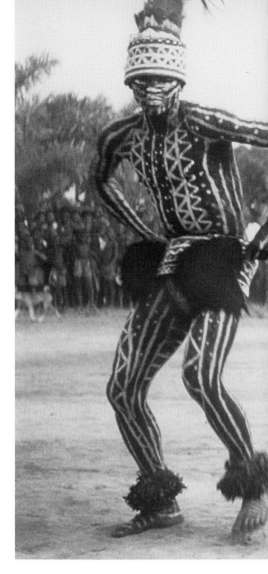

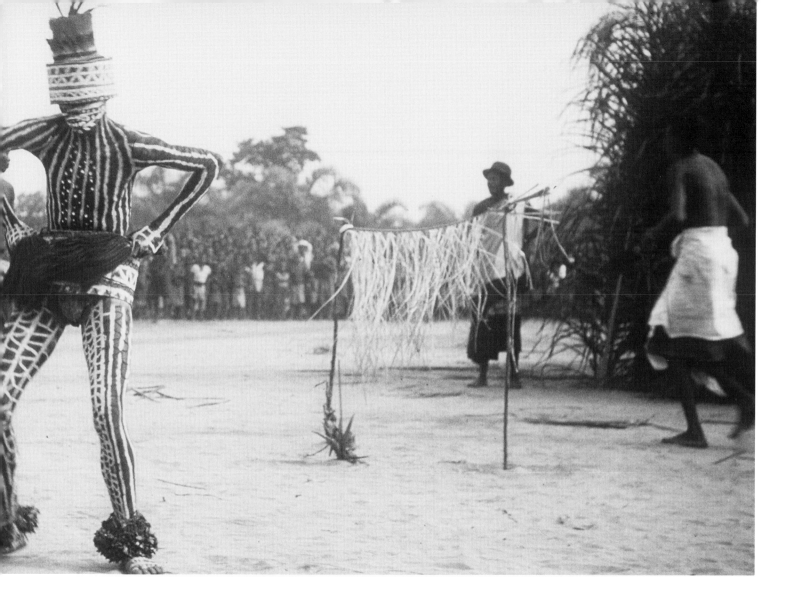

The Role of the Audience in Invention and *Re*invention

In 1990 playwright August Wilson took *The Piano Lesson* to Broadway.[1] Audiences in six major cities across the country had already savored its exploration of the role of history, what he calls "legacy," in daily life. Partway through the play's run in Washington, D.C., the playwright changed the ending to his work.

The first version of the play, built around the story of the struggle between a woman and her brother over ownership of the family piano, left its resolution up to the audience. Spurning the advice of his Yale Repertory and Broadway director, Lloyd Richards, Wilson stuck by his guns: "Having set up the situation in which the question is who gets the piano, in the original ending I never said what happened to the piano. To me, it wasn't important. . . . But I found out that it wasn't over for the audience, which kept saying, 'Yeah, but who gets the piano?'" (in Rothstein 1990: 8). Wilson recounts that he resisted changing the ending to the play at first because he did not wish to choose between the different positions championed in the play by the sister and brother. With time, he realized that in fact he had chosen between them in the course of writing the script. "So I decided to keep the lights on for another 60 seconds on stage so the audience can see what happens" (8).

The dialogue with the audience and director that Wilson describes is more typical than not of performance arts. Nonetheless, modernist criticism, enamored of the image of the *auteur*, of the lone genius, tends to underplay the importance of such exchanges, if it recognizes them at all. The standard text of Shakespeare's *King Lear*, for example, is the product of editors who united the substantially different 1608 and 1623 versions of the play, adding text, subtracting text, and choosing among variations on the basis of their own taste (Harbage 1969: 1064, 1104). Although one theory claims that the language of the earlier (and longer) version was "corrupted by the faulty memories of actors" (1064), it is just as likely that Shakespeare made changes himself in accordance with the responses of both the actors and the audience. If students of Western cultural studies have turned their sights only relatively recently to the problem of contended readings and to the audience in reader-response criticism, it is not surprising that Africanists have also tended to obfuscate the role of collaboration and dialogue in creativity.

In part I, we considered the role of dancers, songwriters, drummers, and sculptors in the invention of masks. Now we will explore how these men interact with one last critical team player: the audience.

GINDONGO (GI)TSHI?

To isolate the role of the audience in the development of a mask, we return to the central question that opened this inquiry: "Whose ideas?" *(Matangi a nanyi?)* In the case of GINDONGO (GI)TSHI? (plate 8), adults and children alike will tell you that the mask's history began with the ideas of Gambetshi Kivule of Kinguba (fig. 108). The following is based on his testimony.

Gambetshi grew up in his father's village, Madibu. There one day, around 1970, when Gambetshi was approximately twenty years old, he climbed up a mango tree on the path leading to the fields. Anyone who has been to Zaïre knows how choosy people can be about mangoes. They insist on fruit at its peak, when it is both sweet and juicy.

So, just as Gambetshi was balancing precariously in the tree, stretching to reach that perfect mango, he heard a voice below tell him: "Hey, throw that down for me!" It was a middle-aged woman on her way to the fields. He threw down the fruit and then repositioned himself in the branches to reach out for another fine, juicy mango, when the same scene repeated itself. One after another, each woman who passed wanted him to throw her down a nice, sweet mango.

Finally, Gambetshi lost his temper and cried out to a

108. The sculptor Zangela Matangua sews Gambetshi Kivule into his costume for the mask GINDONGO (GI)TSHI?. Nyoka-Munene, Zaïre, 1989.

group of petitioners below: *"Nu ame, nu aye, gindongo [gi]tshi?"* Literally, this translates: "Me and you, which generation?" Gambetshi was complaining about how the old always send the young to do things for them. It was a protest against the gerontocracy upon which Pende society is based. He might want to give mangoes to a girl his own age, as a courting gesture, but why should he strain himself to give them to women who were as old as his mother? "Are we dating, that I should gather mangoes for you?" The women below laughed.

Nevertheless, each day when Gambetshi climbed the tree, the scene repeated itself. On the third day, when Gambetshi went to the stream to wash with his buddies, he started to put the words of his complaint to music and to work out a dance. At night, he taught the song to other young people and refined the dance with their feedback.

Some time later, when a masquerade came up, Gambetshi sought out the master drummer Lutumbu. He sang the song for him and showed him how he wanted to dance, and Lutumbu worked out the rhythms for the drums. At that time, there was no sculptor in Madibu itself, and Gambetshi did not have the means to go elsewhere to commission a headpiece. He adopted a trick used by little children who wish to copy the masks: he took a large calabash and cut out holes for his eyes and used an old burlap sack for his costume. Despite his meager costume, the dance was a resounding success. Gambetshi is the Fred Astaire of the Central Pende, an extremely gifted dancer who covers the entire dance arena but seems to float effortlessly, without fatigue. His gestures are clear and graceful.

Encouraged by the crowd's response, Gambetshi worked slowly to achieve his vision of the mask. When he had the opportunity, he went to the sculptor Khumba (Gabama's son), who worked in a nearby village, to place his commission. Gambetshi, by this point, had a very clear conception of his character, and he insisted to Khumba that he wanted a mask that looked as much as possible like a "modern" young man.

In Gambetshi's mind, modernity was associated with naturalism. He had to insist most emphatically on abandoning the visual codes for which Central Pende masks are known, such as downcast eyes and a continuous brow. The sculptor Khumba thought that the standard physiognomy developed with the mask MATALA for the genre of the young man (chapter 3) would have been far more appropriate. Khumba wished to sculpt the facepiece with sharply chiseled features conveying a young man's taut muscularity, with bulging forehead and disproportionately large eyes and nose (fig. 41). Despite the dispute, Khumba finally had to bow to the tradition of meeting a client's wishes. He then created a work unique in Pende masquerading for its soft modeling, naturalistic proportions, fleshy mouth, and painted, rather than carved, eyes

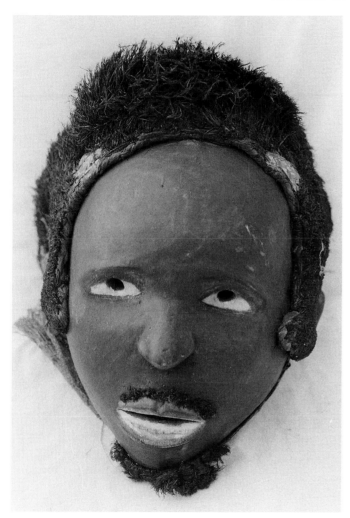

(fig. 109). Gambetshi also insisted on the "retro" hair-style then popular with young men devoted to up-to-the-minute fashion. To increase the naturalism, Khumba made this in the form of a detachable wig.

Bit by bit, Gambetshi accumulated the rest of the costume (fig. 110). He dances GINDONGO (GI)TSHI? with a body-suit made from handsome and rare reddish-striped raffia cloth. He wears a traditional men's wrap-per that allows for free striding, rather than the hoop laden with furs and raffia cords. He also invested in a superior (and expensive) pair of foot rattles *(nzuela)*, seeking the cheerful tinkling sound reserved for the most beautiful of masks. Instead of mimicking the red coloration of the other face masks (in reference to the redwood lotion formerly used by Pende as skin condi-tioner and makeup), Gambetshi employs a shade clos-er to skin tone. He arrives on the scene with a walking stick and carries a sack made of the same handsome raf-fia cloth as his body-suit. After an initial circling of the arena, he will lay down these props or dance with the cane in his left hand.

Gambetshi has devoted his career to the elaboration of one single mask. Central Pende dancers, like film stars, tend to fall into the category of "leading man" or "character actor." Most dancers are associated with only one mask during their lifetimes, and this is espe-cially true if the mask is one renowned for its beauty

109. The facepiece for GINDONGO (GI)TSHI? commissioned by Gambet-shi Kivule from the sculptor Khumba at Mubu. This work is unique in Pende art history for its soft modeling, naturalistic proportions, and painted eyes. 1989.

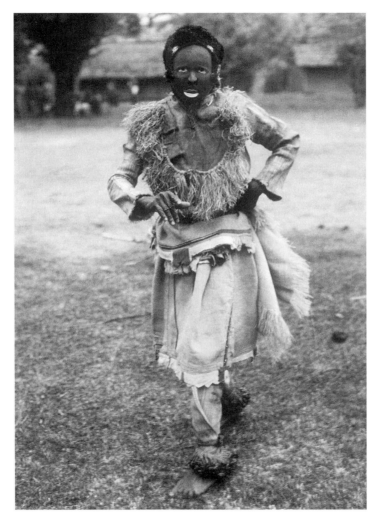

110. Gambetshi Kivule performs as the mask GINDONGO (GI)TSHI?. Kinguba, Zaïre, 1989.

and style. When Masuwa steps onto the floor as MUYOMBO (plate 3), or Gambetshi as GINDONGO (GI)TSHI?, their ardent fans may actually obstruct the performance in their eagerness to honor them. Performers like Khoshi Mahumbu (plates 4–5, fig. 98) who dance a wealth of different masks are far rarer. Like character actors in film, they are admired for their skill and variety and yet somehow never manage to achieve the glamour and acclaim of the leading men.

THE IMPORTANCE OF DANCE GESTURES

To understand the mask GINDONGO (GI)TSHI? it is crucial to understand the dance gestures. Gambetshi emphasized that the inspiration for the mask lay in a youth's protest against gerontocracy. However, Gambetshi is no longer twenty years old. In his early forties now, he is nicely placed in the age hierarchy, and some of the frustration of youth has been tempered by the privilege of age.

When Gambetshi dances the mask, he will gesture periodically, as he covers the dance floor, in time to the song. He will gesture at a young girl (*Nu aye? "And you?"*), showing her height with his open hand, palm down (plate 8). Then he will turn his hand away, making a gentle wave of nega-

tion, responding in gesture to the song "Me and you, which generation?" with "No, you and I are not of the same generation." Like a staircase, his gestures mount in height, until he reaches someone his own size. Then he may nod and lift his hands in a cup shape to indicate "Yes, this girl has breasts; she is mature enough." At this point, his foot rattles sing out, *cha-cha-cha*, to mark the crescendo of the dance.

Unlike most other masks, GINDONGO (GI)TSHI? completely covers the large dance arena and never stops moving. Gambetshi dances at great speed. Spectators are struck by the beauty and skill of the performance, murmuring comments such as "How light he is on his feet!" "Whatever did he put in his foot rattles [to make them sing like that]?" "That man knows [how to dance]!"[2] Many remark on the smoothness and suppleness that make Gambetshi appear to float above the ground *(kwendesa kosa)*.

One remembers Todorov's observations discussed in chapter 7 that new genres transform earlier genres through inversion, displacement, combination, and so on. Once a genre succeeds, it immediately becomes the model in dialogue with which others work. With GINDONGO (GI)TSHI? Gambetshi has transformed the relatively new genre of the modern young man, whose history was traced in chapter 3. He achieved this by combining the wrapper appropriate to masks in the striding category *(mbuya jia gudiata)* with a totally new all-over-the-floor step. Vigorous masks, like MATALA, the founder of the genre, come out and perform in one place. They usually highlight the power of their dance by wearing a hoop. Striding masks, designed for older dancers, adopt a stylized, "cool" walk across the floor. They rely on pantomime, rather than heavy dancing, for drama. It is the way that Gambetshi manages to cover the floor while maintaining vigorous footwork, so that his foot rattles sing out, that impresses people. It is a new *style* of movement to represent a new generation of young men.

Not long after Gambetshi began to dance his mask, others began to copy it. Very popular with young men, the mask has spread in every direction. That is, *the dance* has spread in every direction. Not one of Gambetshi's admirers has cared to copy the facepiece that Gambetshi designed, preferring to return to the model that the sculptor Khumba tried to persuade Gambetshi to wear in the first place (fig. 41).

Even the dance, or more specifically the hand gestures, have undergone some modification. Significantly, the gentle and stylized gestures that Gambetshi uses to say "I stick with my generation" have been transformed. Other dancers direct their gestures, not at young girls, but at boys of various heights shorter than the dancer's. Whereas Gambetshi indicated the height and then used a gentle wave to say "No, we're not of the same generation," his

followers have reinterpreted that mild negation into a backhanded slap of the hand. "Are we of the same generation?" "No?!" *Slap!* The message here is: "Then get back in your place."

Each time this gesture is made, it is greeted with uproarious laughter. Amazingly, a mask inspired by a protest against the status quo has come full circle to reinforce its claims.

ANALYSIS

In examining this case study, we can greatly broaden our understanding of how masks develop in Central Pende society and what invention can mean in this context. As the sculptor Gitshiola Léon emphasized in chapter 2: "You can't just invent a mask . . . you need a dance!" It is critical to note that the invention of masks always begins with the dance. The impetus to originate new masks comes almost entirely from young, unmarried men seeking fame, who thus put a priority on novelty. Gambetshi was unusual in working out the dance and the song largely by himself. Often, these are team efforts.

Not everyone invents a song or dance from scratch. The competition for laud and acclaim is intense enough to encourage young men to capitalize on the topicality of popular songs or dances that they import from their neighbors or urban centers. They then retool the appropriated rhythms and lyrics to the masquerade context. Nonetheless, the story of GINDONGO (GI)TSHI? underscores the lesson that no one man can claim to be solely responsible for the invention of a mask. There must always be at least three men involved: a dancer, a drummer, and a sculptor. Gambetshi had to seek out both a professional drummer and a professional sculptor.

Although dancers usually "invent" (come up with the idea for) the mask, it is still hard for Westerners to accept that the sculptor is usually *the last stop* in the invention process. Gambetshi went to the sculptor with a clear conception of the character and how he should look. He described to Khumba that he wanted not just the face of a young man but that of a *modern* young man with a fashionable coiffure. In other words, as outlined in chapters 4 and 5, he identified the mask's physiognomy and genre for the sculptor. What is extraordinary is that Gambetshi even insisted on the development of a unique style, apparently connecting naturalism with modernism. Since GINDONGO (GI)TSHI? represents a modern young man, it was important to its dancer that it have a "modern" *form.*

Anthropologist Roy Wagner has argued in his book *The Invention of Culture:* "A great invention is 'reinvented' many times and in many circumstances as it is taught, learned, used, and improved, often in combination with other inventions" (1981:136). Thus, generation after generation has rediscovered fire, for example, and fitted it to

changing contexts as electricity (light), as central heating (warmth), as rocket launcher (energy), as Christmas tree lights (decoration). In the same way, each performer and generation reformulates the masks for evolving social roles. No invention is sacrosanct. Each dancer, drummer, and sculptor who follows contributes to reinventing the mask.

In the project of performing, or reinventing, the mask, audience reaction plays a critical role. Wagner underscores that all invention is predicated upon convention (1981: 51–52). There is "a dialectic of convention continually reinterpreted by invention, and invention continually precipitating convention" (69). In the case of the performing arts, the audience is capable of reifying the voice of convention that sets the boundaries for what the artist may or may not say, provides his or her vocabulary, and, in Wagner's terms, provides the actors with their "motivation" (51).

In August Wilson's case, the audience expressed through their disappointment the strong American convention that dramatic tension be resolved at the end of a work. Rather than regarding this negatively, as restricting the artist's liberty, one can consider it in a positive light as forcing the playwright to think through, himself, the very dilemma he had posed for the audience. In the end, Wilson decided that it was not an insoluble problem after all, that he did have a position on the relationship of an individual with his or her history, and certainly the play benefits from this realization.

For GINDONGO (GI)TSHI? Gambetshi, in an interior dialogue with convention, took the sting out of his own words when he transformed the mask from a protest by youth into a gentle romantic whimsy. His audience (including future dancers of the mask), however, reinterpreted his gestures at another level, as a reinforcement of the status quo. At a performance I witnessed by another dancer, not one spectator interviewed was unaware of the implications of the reinvented backhanded slap.

The audience, therefore, plays a crucial role in the development of the mask. The crowd responds positively to some features and negatively to others. There are myriad masks that find no following and disappear. The reactions of the audience can change over time. The *mbuya jia mafuzo,* once a sensation, no longer appeal. Anyone is free to innovate, but will their invention be deemed worthy of (to use Wagner's term) *reinvention?*

A TELEVISION MODEL

Lest the dynamism of the Pende mask trouble those accustomed to regarding masks through the simile of Western sculpture or painting, let us demystify it by refiguring the model of analysis. What happens if we shift the analogy from Western sculpture to television shows?

I choose TV shows rather than film purposely, to stress not only the capacity for internal change but also the critical role of continuing audience response.[3] As in the creation of a TV show, the invention of a mask is a team effort, involving artists of varied visual and acoustic skills. As in a TV show, the "inventor" is usually credited as the person who first came up with the idea, even though the contributions of others, such as producers, actors, musicians, and costume designers, can significantly shape the eventual product.

A familiar example of this kind of teamwork comes from the popular show *Star Trek*. NBC, trying to predict audience reaction, told the "inventor," Gene Roddenberry, that his original idea was "too cerebral" and ordered him to shape the show in the nature of a Western set in space, with lots of physical action. They also told him to get rid of the female first officer that he envisioned, so inappropriate for a Western. The transformation of operational metaphor here is no less significant than for the mask GINDONGO (GI)TSHI?

Once the show was televised, the audience's reception of various characters had to be taken into account. For example, although the producers hated the concept of Mr. Spock, and told Roddenberry to get rid of him, they had to bow to their audience's enthusiasm. The actors made contributions as well. When James Doohan tried out a Scottish accent, the character of Mr. Scott was born, complete with national mannerisms. The point is that we are not so unused to dealing with creative teamwork in the arts as we pretend.

Once we factor audience reaction into our analysis of the masquerade performance, we must begin to consider what historical and sociological factors shape that audience reaction. In this, again, popular-culture criticism can lead the way. We are not surprised to find television shows like *The Waltons* used to explore changing definitions of the American family, or shows like *Happy Days* analyzed for what they reflect about class consciousness during the recession of the 1970s (Newcomb 1982: 77–88, 198–205).

To return to GINDONGO (GI)TSHI? let us reconsider audience reaction. Gambetshi's followers have turned a beautiful performance into a ludic one. Why those peals of laughter? By slapping the smaller boy, GINDONGO (GI)TSHI? is essentially saying: "You thought that you were entitled to address me as an equal?" *Slap!* "Get back in your place." I have been referring to this as a confirmation of traditional gerontocracy, but something more is going on. This is the same kind of derisive laughter with which many young men among the Central Pende greeted Reagan's bombing of Libya in 1986: Khadafy thought that he could act anyway that he liked; he thought that he could claim a political role equal to Reagan's on the world stage. But *slap!* He had to get back in his place. (How stu-

pid could he be?) This laughter is a confirmation of the futility of the powerless to change the system.

This kind of slapping down, in fact, is *not* typical of the consensual society that Pende traditional culture encouraged. It is, however, typical of the political experience of both the colonial and the postcolonial regimes. The entire political climate has been shaped by the big man/little man metaphor, where the bigger will never allow the smaller to move up and share power.

The cynicism of Gindongo (gi)tshi?'s reinvented slap was reflected in "Article 15," the witticism discussed in chapter 5. In this joke, often repeated in 1987–89, the national constitution secures various rights, useless in a devastated economy where survival can be the only preoccupation, finally decreeing in the putative fifteenth article the right to "hustle for yourself" *(débrouillez-vous)*.[4] Individuals, especially young men, facing hard times tell each other "Article 15" as shorthand for "the times are rough, and no one above, much less the state, is going to help." The reformulated Gindongo (gi)tshi? like the witticism about "Article 15," equips its audience to face the situation with humor and resolve.

In judging audience reaction to a mask, we must consider as well the historical, even political, climate at the time of the mask's inception and at subsequent performances. Despite the volatility of Central Pende masquerading, some masks *do* endure. Whether a mask stands the test of time depends in part on whether it can outlive its topicality to be reinvented for new contexts. Some of the core canon of masks described in chapter 7 that have endured for so long are now losing that relevancy. While the beauty and style of Muyombo continue to make the crowds marvel, the mystery and awe of Giwoyo no longer appeal to younger dancers. Changes are fast overtaking Zaïre, and we will have to see if the mask Gindongo (gi)tshi? retains its comedic appeal.

ZAÏRIAN POPULAR CULTURE WRIT LARGE

Gambetshi insisted to the sculptor that his mask should represent a "modern" young man. The connection between Gindongo (gi)tshi? and its political and social context raises the question of the validity of the analytical distinction separating "traditional art" from the new arts springing up in the cities. Anthropologist Johannes Fabian questioned this comfortable division operating in his own analysis, wondering how much the concept of popular culture (usually associated with urban centers in Africa) may "reflect, and perhaps, exaggerate the gap between rural and urban African masses" (1978: 329). He endeavors to uncover the "common, shared discourse" (in a Foucauldian sense) underlying three different facets of popular culture (music, religion, painting) in Shaba Province, Zaïre (316). Michel Foucault argued that *contemporary*

scholars from many different disciplines "employed the same rules to define the objects proper to their own study" ([1966] 1970: xi). This section will consider whether there might not be such a "shared discourse" operating between two discrete social practices, Central Pende masquerading and Zaïrian painting, the former classed as "traditional" and the latter as "modern."

The most common understanding of "popular culture" is that of "contemporary cultural expressions carried by the masses in contrast to both modern elitist and traditional 'tribal' culture" (Fabian 1978: 315). As a concept, it irritates many social scientists because of the term's historical dialectical tension with the category of the "fine arts," hence issues of quality (see Jewsiewicki 1991: 151 n. 3).

At the moment there are vociferous debates swirling around "popular culture." For example, who constitutes "the masses"? Would "consumer culture" be a better description? Does the motor for cultural formations come from the capitalist world market or from marginalized subcultures? Karin Barber gives an excellent overview of some of the concerns special to Africa (1987). For my purposes it is not necessary to enter into this definitional debate. I merely wish to stress two widely recognized qualities of popular culture that are worth examining in the traditional arts: its nature as an open text and its appeal to a wide audience that cuts across societal divisions.

Roy Wagner posits a very useful formulation deriving from music criticism. "Popular culture" is "interpretive culture," allowing for the free "reinvention of the subject" (1981: 61). "Thus we define 'popular music' as that which, unlike 'classical music,' admits of interpretive changes according to the performer's 'style.' When a piece by Beethoven, Rossini, or Rimsky-Korsakov is 'interpreted' by resetting the words, retooling the orchestration, we say that it has been 'popularized,' 'jazzed up,' that it is now a 'popular' piece" (61 n. 4). The receptivity to change and reinterpretation that Wagner identifies is, of course, exactly what charged the term with a negative valence in another era in opposition to the presumed universality of "high culture." Today, in the wake of the dissolution of faith in universals, this same receptivity to change is precisely what charges the term with positive valence and makes it the attractive focus of research. Removed from elitist bias, "popular culture" is a useful term stressing both its nature as an open text and its appeal to a mass audience.[5]

In regarding Zaïrian painting, Westerners are sometimes distressed to discover that artists routinely paint many different versions of the same theme. Because these artists work in a familiar medium, people tend to transfer their expectations from the late-twentieth-century Western art world, where they think in terms of "prime objects" and "copies." In a brilliant essay, the historian

Bogumil Jewsiewicki deconstructs such expectations (1991). He notes that in fact the artist Chéri Samba is not content until he has worked several renditions of a theme (131). These themes may be considered in the light of improvisations on familiar subjects whose very familiarity "invites the participation of all present" (130). These works are not copies, since their goal is not exact duplication. They are often executed from memory (130). Jewsiewicki observes that some themes disappear if they do not find customers. The painters are "very sensitive to the reactions of their public" (134). This is true not only because of financial dependence; they also desire popular approval.

Jewsiewicki's description echoes the structures of masquerading outlined in previous chapters.[6] The dancer coming to the sculptor to commission a mask operates with the same expectations of familiarity and reinterpretation. The dialectic between "repetition" and "diversification" (Jewsiewicki 1991: 134) is the same. And most important, there are the same close ties with the audience. A new theme will not fly without the approbation (hence understanding) of the clientele.

In another essay on collective memory, Jewsiewicki argued that its major theme (in both contemporary biographies and urban painting) has been the expression of domination in Zaïrian power relationships. "As 'laicon' of social practices, one's first reaction when confronted with power is passive submission, silent suffering, and/or flight. Revolt is represented in historical accounts as some foolish gesture, as individual frustration" (1986: 217). The response to power that he outlines is exactly the theme articulated in the transformed GINDONGO (GI)TSHI? Jewsiewicki further emphasizes the fact that the "indigène hierarchy" is as implicated as the state in the oppressive vision of power (219). In this elegant juxtaposition of state and local oppression, Jewsiewicki reveals the line of connection between the rural and the urban masses.

Although (at least before the crisis beginning in 1990) Kinshasa, Lubumbashi, and other centers are developing true urban classes of four generations or more, the constant movement between city and country of very large segments of the population calls into question any facile divisions between urban and rural populations. The financial base for many urban families in Kinshasa lies in the countryside, where they utilize family and ethnic ties to pursue trade. In Pendeland it is difficult to meet a man who has not at some time visited the "big city," whether Kinshasa, Kikwit, Tshikapa, or Ilebo. Because Pendeland lies within reasonable distance of several urban centers, a fair number of women also travel, either for trade or for family funerals. A large percentage of young men today try to make a go of it in the city or in diamond mines near Tshikapa. When their dreams crash, they are forced to return home to the village. Their fathers and grandfa-

thers traveled to Djoko Punda, the great palm planta-
tions, or Tshikapa.

These young men constitute a recognizable cluster in
the village, where they try to preserve as much of urban
culture as possible. Their income goes overwhelmingly to
acquiring the fashionable attire of the well-dressed resi-
dent of Kinshasa ("Kinois"), for which prominent display
of a watch is deemed essential. Their lives revolve around
leisure activities of conversation, urban music (through
the radio), soccer, and seduction, while they wait for the
opportunity to return to the city.

They prefer Kinshasa's bottled beers to the local palm
wine. Because they perceive their stay as temporary, they
put off marriage and house construction. Consequently,
they are forced to use their bedrooms as their salons,
which they decorate along Kinois principles, with photos
torn from rare magazines (substituting for paintings). Lit-
erate and francophonic, they bear an amazing resem-
blance to the *flâneurs* who emerged in Paris in the nine-
teenth century. For one and all, part of the appeal of the
city lies in the opportunity to escape the threat of sorcery
and the constant, nagging responsibility to the extended
family.

It is this self-styled "modern" young man, baptized a
sapeur since the 1980s, who is represented in many urban
commercial signs. It is the same *sapeur* who appears in the
village masquerades in the genre of the chic young man

(MATALA; the LUNGELO version of GABIDI-MUAMBA; GIN-
DONGO (GI)TSHI?). What Jewsiewicki calls "theme," Szom-
bati-Fabian and Fabian posit as "genre," which they define
as "complexes of form, content and presentation" allow-
ing the placement of almost any painting into a category,
often labeled by the clientele (1976: 1). Their preliminary
list of genres (5) in painting bears witness to many of the
same preoccupations as the genres in Central Pende mas-
querading, although they are expressed in radically dif-
ferent forms.

The synthesizing theme of dominant, exploitative,
inescapable power underlies much Zaïrian painting
(developed since Independence in 1960) and twentieth-
century masquerading among the Central Pende. While
paintings express this concern frequently through quasi-
historical images (as in the genre Colonie Belge), Szom-
bati-Fabian and Fabian explain that they also do so
through depictions of the devouring mermaid and power-
ful animals (1976).

In the masquerading milieu, there is an occasional
mask that addresses the power of the state directly
through its agents (e.g., the corrupt police officer and the
stamping European described in chapter 2), but in general
the predominant mode is to present the image of devour-
ing power through agents of sorcery. Thus, one notes the
development at the beginning of the colonial era of a new
category of masks: the *mbuya jia mafuzo,* which repre-

sent dangerous animals of the bush (the familiars of the chief and other sorcerers), as well as sorcerers' dolls, multiheaded monsters, and other strange and threatening apparitions. NGANGA (the sorcerer), GATOMBA (the bewitched), and many other masks invented during this century express this theme as well. For several years after Independence, the Gikalambandji, in a new synthesis of dance and masquerading, used costumed actors to represent a nefarious sorcerers' reunion.

While other motifs operate in the masquerades, the presence of these dark themes in the twentieth century is inescapable. In his social history of frothy Offenbach operettas, Siegfried Kracauer demonstrated how in a period of rigid censorship and political oppression, popular-culture forms like operettas can flourish as an indirect means of criticism against the government (1938). T. O. Ranger found that the Beni *ngoma* dance performed that function in Tanzania (1975). Masquerades, the popular culture of the rural Central Pende, proved similarly responsive to eloquent, if disguised, expressions of discontent and suffering during the colonial era (above all, in the *mbuya jia mafuzo*) and in the postcolonial regime. Even the lighthearted *sapeur* of GINDONGO (GI)TSHI? cannot escape the web of power relations. As reinvented by Gambetshi's audience, he must learn that wherever he goes, he must slap or be slapped into place. All that remains is the infamous Article 15: *Débrouillez-vous.*

Further Notes on Certain Mask Genres

FUMU OR MAZALUZALU (FIGS. 29–31)

> *Fumu y'etu, Mazaluzalu e e! We ya ya!*
> Our chief, the one who floats!

The chief's mask is an excellent example of the close connection between naturalistic facepieces and comedy. Around Nyoka, this widespread figure is called MAZALUZALU, "the one who floats," or FUMU Y'ETU, "our chief." In the north, the conception differs slightly although the performance is much the same. The mask's name is LEMBA DIA FUMU, "the chief's maternal uncle" or "the chief's counselor." It appears in the evening when the crowd is largest and may close a masquerade if there are no *mafuzo* masks present. MAZALUZALU enters the arena, flicking a thick fly whisk in each hand as he executes a stylized, high-stepping walk that makes the voluminous pleats of his wrapper swish back and forth.

As the mask crosses the floor, one to two helpers will weave in and out in time to the beat, shifting a chair or stool from one place to another in order to keep the masker dancing and shifting angles. TUNDU the clown will often mock MAZALUZALU's exaggerated elegance by prancing alongside. Finally, the dancer reaches the chair. In a performance witnessed by de Sousberghe in 1955–56,

the performer made a little comedy of insisting that someone sweep the dust from the chair (field notebook, "Kipende, 1955–56," p. 14). When he finally sits, the crowd cries out: "Oooh!" After a pause while the performer sits and flicks his fly whisks, he rises and "dances" directly off the floor. An excellent vehicle for older men, MAZALUZALU is treated with the same affectionate familiarity as GANDUMBU, MATALA, or a host of comedic masks.

GABATSHI (G)A NYANGA (FIG. 98)

Gabatshi (g)a Nyanga,
Galushinge wa gimana mayanga e e!
Iya ya ya e e e he he.

O Gabatshi (g)a Nyanga,
Little porter of twisted raffia braids,
The bowstring has outlived the hunters!

GABATSHI is connected with dancers from the Milenga age grade, initiated ca. 1885–90, to the Ndende, initiated ca. 1931. It fused the headpiece of POTA with the mystery of GIWOYO performing in the bush on the fringes of the village. Its real claim to novelty lay in its costume, which was based on the fabric *piya* sold by the Belgians in stores. No longer available, *piya* is described as a red fringed shawl,

perhaps in Scottish plaid. The masker wrapped the cloth around his neck and then fixed it to a hidden hoop floating above his hips (fig. 98). Below, he wore a second hoop, heavy with cords of twisted raffia.

During the performance, the dancer manipulated the hoop, twisting it, making it tremble, flipping it up in front or back. At the climax of the dance, he would swoop the hoop over his head as he spun around, hands hidden by the fabric, raffia braids flying. He finished with powerful semicircular kicks *(pule* or *shapi).* In its day, the dance was much admired and drew ululations of joy. The song, through analogy with the bowstring and the hunters, praises the mask as one that will outlive several generations of dancers.

At Nyoka-Munene GABATSHI was last danced before the village was moved in 1949–50. Because it is a difficult mask to visualize, Khoshi Mahumbu offered to reenact it for my benefit at a masquerade in 1989 (fig. 98). This reenactment created a sensation. Women ran forward to get a better view but were pressed back. Two excited old men ran up to the dancer to counsel him to bend over more and to warn him to stay in the bush, not to come onto the floor, as the mask must seem as though it is floating along without feet. Despite the unevenness of the grassy terrain, GABATSHI glided smoothly in and out of sight. Critics regretted the lack of true *piya* cloth, the

omission of the lower hoop, and the skimpiness of the twisted cords.

Dancers also used to perform this mask at Nyoka-Kakese, Kinguba, Nianga-Kikhoso, Kitombe-Samba, and in the north. It appeared under various names, such as GIPUPA or GATAPA. Except for field associates at Kitombe-Samba, everyone reported that it danced in the bush on the edge of the village.

Although there are few masks today built on the genres of GIWOYO and POTA, masks like GABATSHI demonstrate the historicity of the process of mixing mask genres and of adding novelty to established genres through new materials or dance steps. Dancers have merely shifted their models to face masks from the older forms, which were perched on the top of the head.

GANDUMBU (FIGS. 11, 44)

Gandumbu e e! Koko ha pala!
Nanyi wagutumine, koko ha pala?

Gandumbu e e! Hand in front [of the crotch]!
Who sent you, hand in front?

GANDUMBU, the crotchety little widow and female clown, is one of the masks that can steal the show. It is also one of the most widespread of Central Pende masks. At a perfor-

mance by Gambembo Nguedia at Nyoka in 1989, young men streamed onto the floor to dance with GANDUMBU. One man swept the ground before the performer in honor. Women lobbed ears of corn from every direction as praise gifts. The pandemonium and joie de vivre were infectious.

The sculptors at Nyoka find puzzling the conventions for charring GANDUMBU's face black and then applying white kaolin to the forehead, nose, and jaw (fig. 44). Pende widows once rubbed ashes on their faces so that their tears would leave a trail across their cheeks. Some hypothesize that the recent convention of applying kaolin is borrowed from a Mbuun mourning practice; however, GANDUMBU does not wear widows' mourning dress. As mentioned in chapter 5, the charring of comedic masks like TUNDU and MUKUA MAUDI indicates that they do not take care of themselves or practice proper hygiene in applying reddish skin lotions. Many read GANDUMBU as a parody of certain old women who do not like to go all the way to the spring to wash.

The most-admired dancer of GANDUMBU among the Central Pende is Mandala Gansanzo of Mubu. Like most professional performers, Mandala has devoted considerable effort to the elaboration of his masquerading costume. He wears a tightly fitted, long-sleeved burlap shirt equipped with very long and full breasts (fig. 11). There

are large raffia tufts on the arms and woven bracelets at the wrists. The mask wears earrings made of small calabashes and a necklace of bamboo beads. GANDUMBU's vanity is hindered by poverty. Like the male clown, she does not realize how absurd her costume is. The dancer's raffia pants are covered by black "rags" (cut from raffia cloth and antelope skin) that sway with her dance. As props, she carries a field basket with a little work hoe. Mandala usually adds a *gibabo,* a fishing-rod-like tool used to snare grasshoppers (fig. 11).

GANDUMBU's entrance *(guza)* is one of slow, stylized frailty. Bent forward, she uses the grasshopper tool as a cane, advancing three steps forward, pausing to move her shoulders back and forth, and then continuing. When she arrives, she puts down her basket with a stutter-step. She then picks up her hoe and begins to dance more vigorously with the hoe and left arm raised in a distinctly gendered manner. GANDUMBU's characteristic motion is to keep the shoulders moving in and out with the hands raised and the head shaking from side to side. GANDUMBU's dance is one stressing control, rather than strength, and mimicry of feminine gendered body language in old age.

Since the masks are mute, the clowns TUNDU and GANDUMBU rely on pantomime for their unusual interaction with the audience. The women, particularly the young women, go wild over GANDUMBU, whom they treat in the joking manner reserved for "grandparents." GANDUMBU

may show off her fine breasts or costume to the young women. At Kinguba, sixty to seventy responded by yelling out teasing insults, inciting GANDUMBU to perform her signature gesture of clapping at them with cupped hands *(guta mikumbu).* This well-known women's gesture usually accompanies the curse "May you die" *(Muata gufua).* Some people age with grace. Others respond to their increased frailty with ill-tempered self-pity. GANDUMBU pokes fun at the behavior of the latter, who can shout out litanies of complaints for hours at a time.

GANDUMBU often will hook her left hand over her right shoulder in a gesture of sadness. She may also use a hand to cover her crotch, exposed by the rags. The song refers to the latter gesture. Periodically, she will also hold her arms out, curved upward slightly, and shake them to gesture: "Should I come?" The crowd of young women will respond: "Come here! Hurry up!" Then, as she hobbles in their direction, the women will flee. Like Charlie Brown, GANDUMBU always falls for the trick. Her anger keeps the game funny. When the performer finally left the floor at Kinguba, he left over one hundred young women chanting: "Come back, girlfriend!" *(Iza, associé!)*

As with the male clown, smooth comedic timing is essential. Mandala is famous for punctuating his performance with slapstick effects; for example, he will make his "breasts" twirl or hit against each other or flop up and

down. Pantomimes often form welcome additions to the performance for experienced dancers. Mandala executes an elaborate pantomime of stalking grasshoppers, one of the few protein sources available to older women. At first, Gandumbu misses and makes gestures of petulant fury. Finally, her stealth succeeds, and her manner becomes gleeful as she drops the succulent treat into her basket. De Sousberghe records the same pantomime.

Many dancers have launched variations on the genre of Gandumbu as a bawdy female clown. Gatua Ulu (the grinder of fish poison) was particularly popular among the Mapumbulu generation in the 1920s at Nyoka-Kakese and Kinguba. She played on the undress of women engaged in fishing. Older women prepared a poison that would stun fish when it was released into a stream. Khoshi Mahumbu imported Gawenji Thowa (She Who Walks Naked) into Nyoka-Munene from the Pende-Mbuun frontier in the 1950s. The performer painted female genitalia with red *gisongo* juice and sewed pubic hair made from dyed corn silk onto his body-suit. Reproaches from elders that his flashing was insulting to women led Khoshi to abandon Gawenji after two performances. Gin'a Gabuala (the little stutterer), another comedic mask, pantomimed the shaking and forgetfulness typical of some older people (with Parkinson's or Alzheimer's disease?). Gifundo, of the Solomogo generation, introduced another variant, Gin'a Mukombi.

How the spectators and the performers "read" Gandumbu seems to depend on how individuals respond to single women. Age and gender definitely play a role. Some empathize with the vulnerable position of widows without children (or without responsible children). Some men express uneasiness at the alleged sexual freedom experienced by single women, including widows. They point to the bawdy courting comedies that Gandumbu will perform when the male clown is around. Depending on the outlook of the spectator, Gandumbu's gesture of covering her crotch may evoke a sense of modesty in poverty—or be taken as a mocking reference to masturbation in the oversexed single woman. While misogyny undoubtedly plays a role in the latter view, it is not explicitly moralistic. Gandumbu is not "bad" but is merely in a precarious position. The volatility of the mixture of sympathy, malice, and affection makes Gandumbu a particularly rich mask persona, open to reinvention by each new generation.

GIWOYO (ALSO KNOWN AS NZAMBA AROUND MBELO) (PLATE 7; FIGS. 12, 68–69, 71–72)

There is quite a range in length among headpieces for Giwoyo. The Abbé Mudiji has calculated that the average length is 60 cm (1979: 170 n. 5); however, it seems that

older masks were often considerably longer. Frobenius's specimen from 1905 (fig. 69) measures 80 cm long and 20–23 cm wide; Torday's piece at the Museum of Mankind (British Museum) from ca. 1909 (1910.4-20, 475) measures 70 cm long, 26 cm at its widest (the ears), and 8.75 cm at its narrowest; the masterwork at the National Museum of African Art (85-15-5) is 71.1 cm long (plate 7); Tervuren's example collected in 1911 (2876) reaches 65.5 cm (Mudiji 1979: 170 n. 5, 176 n. 16).

Mudiji has proposed using 45 cm as the cutoff point between GIWOYO and MUYOMBO, which has a similar but shorter headpiece (1979: 170 n. 5). This is a useful rule of thumb, although some larger MUYOMBO surpass some smaller GIWOYO, including the fine example of GIWOYO published by the abbé himself, which measures only 51.5 cm long and 18.5 cm wide (1979: 170). A surer diagnostic is the presence of a wooden topknot on GIWOYO and a fabric hat on MUYOMBO (figs. 68, 73).

Mudiji has proposed a reading of the mask as an "ancestor"-mediator based on an interpretation of its song and when it appears. He builds on an etymology proposed by de Sousberghe, who linked GIWOYO's name to -woyo, which can mean "spirits of the dead" in Kikongo (1960b: 507). Mudiji links this Kikongo word to monyo in Kipende, "le souffle ou le principe vital, l'âme, etc." (1979: 192 n. 35). Mudiji records a version (189)

almost identical with the widespread song quoted below that I found used for GIWOYO:

> *Munyangi a Pembe*
> *Kumbi diaya he e e Giwoyo we he e e*
> *Munyangi a Pembe*
> *Kumbi diaya he e e Giwoyo we he e e*
> *O Giwoyo e e he e e*
> *O Giwoyo e e he e e*
> *Munyangi a Pembe*
> *Kumbi diaya he e e Giwoyo we he e e*
> *Giwoyo e e e he e e he e e*

Kumbi diaya literally means "the sun is going away" but is used colloquially for "time is passing," a polite form of "hurry up." Mudiji proposes to take the line at its literal level as an invitation to GIWOYO to come protect the living from the dangers of the night and to ensure the return of the sun (1979: 192–93). He makes much of the fact that GIWOYO is one of the last masks to perform, as twilight approaches (193). Twilight is the hour most likely for the living to meet the dead. *"Le masque giwoyo apparaît à la limite entre le jour et la nuit, entre la savane, son monde et le village, monde des vivants. Il agit en médiateur"* (193).

The trouble with this reading is that *kumbi diaya* is the most common line in masking songs and is by no means reserved for GIWOYO. It is universally glossed as a means

for the drummer to remind maskers that others wish to dance when they are hogging the floor or taking too long to dress. One of many examples that could be cited comes from a song for GANDUMBU:

> O Gandumbu diaya e e
> O Gandumbu diaya e e
> Kumbi dia Gandumbu diaya . . .
> E e e
>
> O Gandumbu, it is passing . . .
> The time of Gandumbu is passing
> [i.e., why don't you come out?].

The "hurry up" message of masking songs is reflected in another of GIWOYO's refrains, documented by Muhenge Mutala of Nzaji (initiated ca. 1921):

> Wagikambele Giwoyo. Azoge e e!
> We he e e wa mama a ha!
> Gia mutamba wa tunda, gia mutamba wa mbongo.
> Giwoyo, kumbi dialaba guya!
> Walabele guwenda
> Giwoyo a Pembe.
>
> You have sought Giwoyo. May it come out!
> From upriver, [or] from downriver.
> Giwoyo, time is passing uselessly!
> You have walked for nothing
> [i.e., You have come out so late, there's no time],
> Giwoyo a Pembe.

The song is addressed to the *dancer*, as most of these songs are, and encourages him: you've gone to all the trouble to get the GIWOYO mask, now come out and dance before it is too late. The reference to directions ("upriver" or "downriver") underscores that one never knows exactly where GIWOYO will appear. While it is suggestive that GIWOYO comes out at the gloaming hour, field associates stressed that one must not make too much of this fact, as masqueraders keep their most dramatic masks for last, when the crowds are at their largest.

In the text of the first song, Mudiji also proposes a sophisticated reading of *Munyangi a Pembe* ("*Munyangi a phemba*," in his version). *Munyángi*, with a high tone, is a common word signifying "mask." *Munyangi*, with a low tone, signifies a person who sprays, sprinkles, or spreads. In singing, as Mudiji himself notes (1979: 189 n. 32), tonal differentiation is disguised because everything is sung with high tones. Mudiji interprets the phrase as a double entendre meaning both "mask covered with kaolin clay" and "spreader of kaolin clay," favoring the latter (189, 192). Because kaolin is used in benedictions to show goodwill and is also the color of death, Mudiji concludes that the singers are praising GIWOYO for his ability to bless the living (192–93).

Field associates, including those in Mudiji's home village, Nyoka-Kakese, found this reading ingenious but

unconvincing. They preferred the everyday interpretation of "white mask." While this could refer literally to the large amount of white found in the decorative patterns covering Giwoyo's tapering projection, they took it at the metaphorical level as "beautiful mask." (To make matters more complicated, they all insisted that *pembe* was a foreign word, possibly Kikongo, and was not a sung version of *pemba*, the word in Central Kipende signifying "kaolin.")

Although Mudiji has the right intuitions, it is important to stress that one must not depend too much on the verbal in Pende masquerading contexts. Masquerading songs, unlike fraternity songs, are primarily oriented toward encouraging fine performance, not toward symbolic explanation or moral exhortation. When masquerade songs are sung at trials, the emphasis on performance is retained. They are used to say things like "hurry up!" or "you have spoken incredibly well." For example, Tundu's song may be used when the crowd feels that a speaker is incoherent or illogical. The song for Gabatshi (g)a Nyanga, "the cord that exhausted the hunters," will be sung when audience members feel that a speaker has exhausted the judges by never directly answering their questions. Field associates at Nyoka-Kakese intone Giwoyo's song to encourage someone to get to the point: "You were the one who accused so-and-so; why aren't you ready to argue the case?"

Mudiji writes that *"comme le masque lui-même ne parle jamais chez les Phende, sa signification doit apparaître dans son nom, dans son chant et autres expressions verbales révélatrices, dans ses éléments symboliques (couleurs, attributs) et dans sa mimique, au point de jonction entre le temps et l'espace de représentation"* (1979: 192). Scholars tend to be logocentric, but all the evidence of part I demonstrates that the genesis of a mask begins in the dance and that any "deep meaning" therefore is most likely to be found in the performance context. Giwoyo, whose name has remained unchanged over so long a period, may be an exception, but in general names will not offer reliable evidence of historical origin or signification. As recounted in chapter 2, songs change over time and can be appropriated from other contexts. Their primary function in masquerading is to offer a quick, recognizable signature tune for each mask, like an advertising jingle on television. The musicologist Maquet concurs (1954k: 10). Costume may give some general hints about character (young/old, male/female, tidy/slovenly) but, as explained in chapter 3, first obeys the rules of articulating form and motion. It is in the coordination of the performance and the facial component designed to suit it, in the collaboration of dancer and sculptor, that one must look for the signification of a mask.

MBUYA YA MUKHETU
(THE FEMALE MASK)
(PLATE 6; FIGS. 10, 94–96)

The female mask has many names and dance styles, the most widespread being GAMBANDA. Because of the close similarity of forms between Central and Eastern Pende masks, de Sousberghe assumed that the Eastern Pende had borrowed the female mask from the "Katundu" (1959: 63). He posited that such borrowings were the result of the travels made by Central Pende before 1930 when they were under the administration of Tshikapa (59 n. 1). Although the style of Eastern Pende sculptor Kilembe Mukanyi at Suangy (fig. 95) does seem to be in dialogue with that of Gabama's workshop at Nyoka-Munene, it is extreme to attribute the origin of the female mask among the Eastern Pende to such a recent date.

The German adventurer Frobenius, who visited certain important Eastern Pende villages in 1905, recorded no fewer than three masks representing female characters, including "Moanamanda," probably *mona wa manda*, "child of the ruling clan" (1988: 64). Himmelheber collected three female masks among the Eastern Pende in 1938: TSCHIMOANA, KIBELU, and KAMBANDA (1960: 351, figs. 35 and 273, plate XI). In fact, the young woman plays a part in a majority of the masquerading complexes on the Central African savanna.

Frobenius noted a tendency, still popular among the Eastern Pende around Ndjindji, to purchase the female mask from their Chokwe neighbors (1988: 64). Pende think that Chokwe sculptors excel at this mask. What Chokwe peddlers sell today is not unlike the mask SSUN-GU collected by Frobenius in Kitangua at the beginning of the century (1988: fig. 421). Other Eastern Pende may well have bought facepieces from Central Pende passing through, as de Sousberghe suggests, but this does not indicate that the female mask does not have a long history among the Eastern Pende.

During the twentieth century, and probably earlier, new fashions in dance have regularly swept through Pende-land with all the force and excitement of the Beatles' initial visit to the United States in 1964. Many of these have been secular, but some were associated with healing rites aimed at treating women's health problems *(mahamba a akhetu)*. The persona of the female mask, always attuned to fashion, responded to the changing tastes. Widespread field associates are agreed that *Central Pende* performers of the Mingelu and Mapumbulu generations (initiated ca. 1901–3 and ca. 1916–19 respectively) privileged the celebratory dances associated with the women's health rituals.

These rites (Khita, Gimbanda, Khula, Kanvumbi) were organized around a period of rest and seclusion for the woman, who might be suffering from infertility, gynecological problems, loss of weight, or general weakness. Overseen by women, these rituals were serious and yet practiced in a clublike atmosphere that made them enjoyable to those involved. The rites treated the ailing woman like an initiate to a secret society. At its conclusion, her husband or maternal family was obliged to mark her recovery by throwing a party similar to the coming-out ceremony for initiates to the men's fraternity. The apogee of the event would occur when the healed individual demonstrated her regained health and beauty by executing the rite's signature dance.

Many of these dances accentuated arm movements with large tufts of raffia on the upper arms *(masamba),* and hip movements by means of a thick tutu of cut raffia *(gikhukha)* around the waist (fig. 10). Most of the dances adapted to the female mask by the Mingelu and Mapumbulu generations seem to come from the rite Gimbanda. Because of the female mask's emphasis on contemporaneity, this may indicate that these were the generations that adopted the rite.

The mask GALUHENGE takes the name of the danced walk that was originally used on the last day of Gimbanda but that was then adapted to several other of the healing rites as well. The drummers and singers would call to the initiates to come out of their retreat:

> *Galuhenge e e! We Galuhenge ukalamana!*
> *Nganga jia Gimbanda jiamana ikelegelo.*

> Galuhenge! Galuhenge, get ready [to come out]!
> The priests of Gimbanda have exhausted the sieves.

According to initiate Gin'a Khoshi Ndemba, the sense of the song is: "Be quick! Dance well and show that you're healed because the women in charge are bankrupting the family." By reference to the sieve, the singers joke that the specialists exact many chickens and other goods for the patient but sift out most for themselves.

A common variant plays on a pun:

> *Galuhenge e e! We Galuhenge, ukelumuga!*
> *Ngoma jia Gimbanda jiabanda ha khalagaga.*

> Galuhenge! Galuhenge, be clever/dance!
> The drums of the Gimbanda rite are sleeping at the door.

The verb *gukelemuga* means (1) "to swing the head from side to side during the dance," (2) "to be attentive while walking, looking to the right and left," (3) and, by extension, "to be clever or prudent." Here the sense is: "Be clever and get well quick. The drums are waiting."

On the last day, the initiates would come out of seclu-

sion in line, swinging their arms to the rhythms, each disguised by a piece of raffia cloth. When their husbands had paid the organizers, they would take off the raffia cloth and begin to dance the signature steps of the specific rite.

So popular was the secret society format that at least two secular dance societies were also organized as initiations involving a short retreat. The Giwila is the most famous of these, a secular transformation of the Aluund (Lunda) funerary *tshiwil* discussed in chapter 7. The mask GAGILEMBELEMBE commemorates another. Because GAGILEMBELEMBE wears a *gikhukha* and arm tufts like those worn by the initiates in some of the healing rites, younger field associates sometimes assert that the dance "Gagilembelembe" was also associated with healing rites. Nevertheless, knowledgeable field associates sharply disagreed, distinguishing it from Khita or Gimbanda. They insisted that the Gagilembelembe dance was a "fad" (*muvuma*, from *mouvement*) and a "game" (*saga*) performed "for fun" (*kiese kiaakuata*). The last masked performer at Nyoka-Kakese was of the Mingelu generation and the last initiates at Ngunda were of the Mapumbulu generation, now long dead. Women in Pendeland do not live as long as men due to the exactions of childbirth and agricultural labor.

Central Pende of the Mapumbulu and Ndende generations also initiated a brief vogue for dancing the female mask—this time with a wooden doll *(gakishi)*, representing "her child." These wooden figures could reach a height of three feet and were provided with clothes and hair to add verisimilitude. The Musée Royal de l'Afrique Centrale (Africa-Museum) has a doll and performance photo in its collection. The mask would arrive carrying the child on its back, lay it down to perform a popular dance, and pretend to nurse it before leaving the floor. This is foreign in conception to the Eastern Pende, who emphasize that the mask represents a young girl. Some of the variants on the female mask were GAMBANDA, GAMBANDA WADI, GANDONGO, and GAHUNGA A ISHISHI.

After the Mingelu and Mapumbulu generations added novelty to GAMBANDA and GALUHENGE by executing the dances of the healing societies, Pende on the northern frontier reasserted the emphasis on contemporaneity in the female mask and the link to popular dance by launching the mask GABUGU. The healing societies seem to have lost relevance for the Central Pende in the 1930s, and the oldest women initiates date from that era. This was precisely the generation that launched GABUGU. The sculptor and blacksmith Kamuanga (from near Mbelo) attributes its invention to René Masalai of Ngombe-Muyanji (near Koshimbanda). In a story similar to that of the invention of the mask MATALA (see chapter 3), René originally wanted to capitalize on the novelty of a "new" mask and so per-

formed the female mask to a catchy rhythm danced by the Mbuun peoples on their frontier. Either René or a later innovator stressed the contemporaneity of GABUGU by giving her a fashionable hairstyle, with hair combed forward in the *supi,* or *buki,* style. The Mbuun dance that René adopted did not have the long-range appeal of the foreign dance that inspired the mask MATALA. Later performers have danced GABUGU to whatever catchy rhythm is currently in vogue.

The variations on the female mask are legion. Luhanda and Puku of Nyoka-Kakese also adapted Mbuun dances from Mungaï. In the late 1950s, ÉLIZA SOLO danced to Kwilu Pende xylophone rhythms. In the north, one was called SANGA IMANA NGIMBO, "the hair that exhausted the songs" (i.e., the ability to praise it). Part of its persona involved being late and requiring a lot of coaxing before it would take the floor. ODOMA and BEMBETE are contemporary versions that perform dances by those names. At the 1989 Festival de Gungu, the female masks most often performed the Bambamba dance, which then reigned supreme among the youth. And so on.

Although a female mask may be named for one or another dance, the masquerader may choose to execute any dance associated with women. For example, at a masquerade at Nyoka in 1989, the young dancer Gabuangu announced that he would perform GATAMBI A IMBUANDA. This mask has a long history at Nyoka-Munene and is associated with the deceased dancer Gindandu, of the Ndende generation. The song is well remembered, but its sense has become enigmatic:

> *Gatambi a Imbuanda e e! We yaya!*
> *Gahunga a Ishishi! wa a a!*
> *Ndaga yazuedi ngina, yene tuvua.*
>
> Little fisherwoman of crayfish! Heh!
> Young woman who catches grasshoppers! Heh!
> What the old woman said, that's what we
> heard [or did].
> [i.e., We did what the old woman told us to do.]

The mask wears the thick tutu of healing rites (fig. 10), but no one now remembers the connection. Gabuangu's intention in invoking the name seemed to be to create interest in seeing an archaic mask. When he danced, the drummer actually played the rhythms for GALUHENGE and GAGILEMBELEMBE. Meanwhile, TUNDU the clown tried to entice the female mask's interest by making a great show of counting his money.

NGANGA NGOMBO (THE DIVINER) (FIGS. 7, 17, 76)

> *Nganga Ngombo imuza.*
> *Nganga Ngombo, (i)za uponge.*
>
> Nganga Ngombo is coming.
> Nganga Ngombo, come [and] divine.

There once were three kinds of health professionals at work in traditional Pende medicine. The first, *musagi*, was equivalent to a pharmacist and treated symptoms like headache or fever with herbal remedies. He or she did not diagnose causes. In the case of serious illness or chronic complaints, the patient's family would seek out a diviner *(nganga ngombo)*. The rarest but most reliable and desirable diviner was considered clairvoyant, chosen by the dead as their mouthpiece to counsel the living. Often, this person was female and experienced a short but intense career. She did not accept payment for her services and would speak directly, without subterfuge. Most often, however, families had recourse to interpretive diviners who were male and who had learned their craft as part of their study of sorcery *(wanga)*. The latter specialists were deeply distrusted because of their association with professional sorcerers, because they could demand heavy fees, and because they often spoke in riddles. Their performances could be highly theatrical and involved musical instruments.

The Nganga Ngombo masquerade is a composite of the two different categories of divination. The performance fuses a representation of the initiation dance for the clairvoyant diviner with a pantomime of the sniffing diagnosis once used by the interpretive diviner.

Clairvoyant diviners would undergo a retreat when their power manifested itself. During this period, they would be tested and learn to regulate their gifts. At their public debut, there would be a celebratory dance at which all such diviners in the region appeared dressed with large shoulder ruffs of raffia *(gikhukha)*, which accentuated the distinctive shoulder rolls of their dance (fig. 7). Women would wear bras of genet or palm civet fur. Men would dress their hair in horizontal braids *(mikotshi)* to embellish the distinctive head movements of the dance (figs. 7 and 76). The mask Nganga Ngombo mimics the dress and dance of this coming-out celebration.

Interpretive diviners did not undergo a retreat and initiation dance. In one popular form of divination, the specialist held a large horn (from the roan antelope *[thengu]* or the sitatunga *[nvudi]*) in the left hand and sometimes a small gazelle's horn between the little and ring fingers of the same hand. The true diviner's horn was empowered by various leaves and medicines. During the performance, the specialist shook a large rattle in his right hand and sniffed dramatically at the horn(s) to distinguish among the odors (as individualized as fingerprints) of the dead, criminal sorcerers, and ritual violations that might be responsible for the patient's problems. This action of detection or diagnosis through smell is known as *guponga*. A helper would play a miniature talking drum *(mukhokho)* to heighten the drama of the diagnosis. In the masquerade, Tundu or an audience member sometimes takes charge of this instrument.

The Central Pende today dance the female mask NGANGA NGOMBO MUKHETU more frequently than the male variant. In a highly acclaimed performance at Kinguba in 1989, Khoshi Mahumbu entered, rolling his shoulders backward and gently pumping his arms up and down. He held a horn in the left hand, a rattle in the right. Gentle sweeps of the head emphasized turns of direction. Once arrived on the floor, an assistant laid out a cloth of raffia with a number of mysterious bundles. Khoshi's dance picked up in tempo and he signaled a change in rhythm with his rattle. He fell on his knees and drove the horn into the ground to receive tips. He sniffed at the rattle (in substitution for the horn). The tempo of the dance grew faster, *che-che-che, che-che-che,* as the drama heightened. Khoshi was rolling his shoulders forward now and pumping his hands fiercely so that the ruff rustled and flew out. The climax of the dance marks the moment just before the diviner reveals the agent responsible for the patient's misfortune. Khoshi received a great many tips in praise, even from the drummers.

The male NGANGA NGOMBO is also known among the Eastern Pende. This fact raises the question of whether or not it should be added to the list of seven original mask genres. I never saw an example but the facepiece sounds very close to the Central Pende form, described as having "the face of a woman" *(pala ya mukhetu)* and a coiffure with three braids.

De Sousberghe hypothesized that the Central Pende introduced the female mask to the Eastern Pende during travel to the colonial administration headquarters in Tshikapa before 1930 (1959: 59 n. 1). Evidence exists for a long history for the female mask among the Eastern Pende; however, it is likely that NGANGA NGOMBO spread in this manner. Frobenius and Starr collected no examples of NGANGA NGOMBO among the Eastern Pende, 1905–6. Furthermore, NGANGA NGOMBO is known only in two regions of Eastern Pende country: among the Bakwa Nzumba and Bakwa Nzadi. It is the rarest of village masks today. Its two songs linger in trial contexts and show little regional variation.

In 1989, the male NGANGA NGOMBO was also rare among the Central Pende (except as a facepiece for the foreign trade). The new genre NGANGA is increasingly replacing and transforming the older model.

NGANGA (THE SORCERER)

Around 1954–55, the renowned dancer Mahina of Kinguba attempted to launch a new genre, the sorcerer (NGANGA). He planned to engage in a pantomime with the clown TUNDU of the nefarious nighttime banquets *(panzu)* held by sorcerers in folklore. His audience was stunned.

The mask of the diviner (NGANGA NGOMBO) acted out a positive application of supernatural knowledge. The

genre of the bewitched (MBANGU, chapter 6; GATOMBA, chapter 2) discouraged the pursuit of antisocial sorcery by mocking the dangerous consequences of failure to control its power. However, in a masquerade tradition stressing communality and joy, it was long thought inappropriate to risk alienating individuals through a representation of criminal sorcery.

When Mahina began his performance, the audience revolted. Many older men left, stiff with fury. Others intervened to stop the presentation. As Mahina himself had an unsavory reputation for asocial behavior, popular opinion attributed his death shortly thereafter to punishment for revealing the secrets of his colleagues-in-crime. Mahina's performance is still talked about today, and the brouhaha indicates how inappropriate the subject matter was deemed for a masquerade.

By the mid-1980s, the climate had changed considerably. Chapter 1 discussed how *wanga*, the "power-to-make-things-happen," has been reinterpreted with increasingly negative emphasis since the introduction of Christianity. After Independence, huge audiences watched the Gikalambandji, in a new synthesis of dance and theater, act out a nefarious sorcerers' reunion with the help of costumed actors. The state finally banned it in the 1970s for fear that it would provoke accusations against suspected sorcerers in the crowd. Pendeland was also gripped by a wave of antisorcery revivals, 1980–85, led by Manesa ("He who finishes") of Lozo (Keidel 1988). The very subject censored in Mahina's performance, the sorcerers' nighttime banquet, became a popular subject of urban painting in Kikwit. Although the Pende have had periodic revivals for decades, there is a new acceptance for an entirely negative reinvention of NGANGA NGOMBO in the masquerades.

Around 1983, in a brainstorming session, the sculptors Mashini and Mijiba at Nyoka-Munene invented the mask GIPONJIO. Mashini came up with the song and dance:

> Call: *Giponjio e e e!* Response: *E e e!*
> *Gimuta matulu; giya gembo.*
> *Giponjio!*
>
> Call: Giponjio! Response: E e e!
> He catches grasshoppers;
> he goes to the village [to eat them.]

Giponjio is a large grasshopper, which is believed to survive by devouring smaller grasshoppers (locusts?). The dancer mimicked an old man stalking his insect quarry. GIPONJIO is a metaphor for old men who use their knowledge of sorcery to prey on young people. The drummer Gapata adapted Mashini's song to the drums and the catchy melody has attracted large crowds.

Mashini, Mijiba, and Gilembe at Nyoka launched another new mask, BUANGA MU NGOTO, ca. 1987 as a satire of bitter old men with a penchant for criminal sorcery. Again, Mashini worked out the song and dance:

Buanga e e! Buanga mu ngoto.

Sorcery! Medicines of sorcery [are] in the burlap [sack].

The performer wore an old, raggedy costume with raffia wrapper. The tip-off for the audience of the character's malicious intent was his smoke-darkened burlap sack. It was not the kind of bag that a man would normally carry in the daylight and hinted at long-kept secrets. Since the colonial period, the equitable exchange between the maternal uncle and the individual has been disrupted by the capitalist economy, in which the uncles feel pressured to squeeze and threaten younger family members for cash and labor. Mashini's and Mijiba's conceptions express a strong sense of exploitation by the young.

Also in 1987, an older dancer, Gifembe a Pinda, invented a new mask, Mukandilo, at Kinguba. He pirated a popular dance but changed the words to the song:

Gu mbongo, gu thunda,
Izenu mumone Mukandadilo.

From one end of the village to the other,
Come see Mukandadilo.

Gifembe explained that it was his "gimmick" *(gadilo)* to show a mask connected with magic, with feathers all down the back.

Significantly, all three headpieces were appropriated from foreign forms. In the original brainstorming session for Giponjio, the sculptor Mijiba proposed using one of his "fakes," an Eastern Pende–style Pumbu mask, in order to add freshness and zip to the performance. Encouraged by their success, Mijiba advocated using another "fake" for Buanga Mu Ngoto, this one inspired by illustrations of Songye masks in Frère Cornet's survey of Zaïrian art, *Art de l'Afrique noire au pays du fleuve Zaïre* (1972). Mijiba considers the formal exaggeration of both foreign styles to be frightening to audiences. Mijiba eventually sold his book when he felt that he had mastered its forms—to the sculptor Mungilo. When Mungilo's uncle Gifembe recruited him to make a headpiece for his new invention, Mukandilo, Mungilo also appropriated an exotic form, probably again an Eastern Pende–style Pumbu. So curious was the audience at Kinguba that Gifembe even placed the headpiece in a bamboo enclosure and charged people admission to view it more closely!

By appropriating foreign forms, the sculptors were exercising the same freedom as the dancers to take a shortcut in adding novelty to their creations. The new genre of the sorcerer was attracting crowds through the sense that it was revealing the hitherto concealed. Therefore, it was particularly appropriate that it revealed an astonishing new physiognomy.

After the headpieces were used several times in masquerades at Nyoka-Munene, Mijiba later sold them as "Songye" and "Eastern Pende" masks to middlemen, thereby overturning any definitions of the "authentic" and the "modern." Mijiba also launched a mask Mutumbi wa Ngulu ("the snout of the pig") with Mashini in 1987 that was inspired by an illustration in a book on Chokwe culture. The performer would enter the arena as usual, then fall on his hands and knees to make gestures of rooting in the ground with the headpiece's long snout. Now Pende sculptors and performers draw inspiration from books as well as dances in their quest to reinvent the masquerade.

NOTES

PREFACE

1. Notable exceptions lie in the work of Hans Himmelheber (1960, 1963, [1972]); Eberhard Fischer (1984); Henry John Drewal (1984); Henry John Drewal and Margaret Thompson Drewal (1983). Most recently, Mary Jo Arnoldi has outlined the role of innovation in spawning new puppet characters in the youth masquerades of Bamana in Mali (1988, 1995). Her findings parallel many of the processes described in chapter 2. Frederick Lamp attributes much innovation in Baga masquerades (Guinea) to intense generational rivalry (1996, especially chapters 10–11).

2. I thank Pamela Bruton for bringing the fourth edition to my notice.

3. Obliged to conserve tapes and batteries, I recorded only music, songs, and prayers or orations; exegesis I wrote down by hand. If a field associate said something that I knew I would probably like to quote verbatim, I would use the journalistic method to write down what I could and to ask the person to repeat him- or herself if necessary. I would always read back a prospective quotation to the speaker to check for errors. While small variations may have been introduced this way, this method has the advantage of making sure that the person is willing to be quoted. Occasionally, I did not realize the value of a remark until later and therefore cannot provide the original Kipende, only the translation. I always assured individuals that I would be sure to cite them personally, a gesture vigorously approved by everyone.

4. Henry Goertz asserts: "The clear function of the masks . . . is to pantomime and dramatize typical village types" (n.d., n.p.). See also Jean Vanden Bossche 1950: 5–6; Kochnitzky 1953b: 9; Himmelheber 1960: 345.

5. Later, Rosmarin softens her assertion: "It is not necessary to deny—nor am I doing so—that the poet or novelist knew his genre in order to accept that our narrations of his generic manipulation are nevertheless informed by our present-tense explanatory purpose" (1985: 37).

CHAPTER ONE: "DANCING THE MASKS"

1. Because this is not a kinship study, I will take kinship designations at face value. When they do not correlate exactly with

Western conceptions, I will place them in quotation marks, to avoid confusion.

2. Pende historians identify certain villages as enclaves of families originating in different ethnic groups, who joined them during their migration. For example, the distinctive dialect of Kipende spoken around Kitangua is attributed to distant founders of Holo origins. Other villages are attributed to Shinje, Kwese, Sonde, Aluund (Lunda), or even Imbangala origin.

3. Because of the power of lineage to unite, the linkages between the individual and his or her distant female ancestors may be classed "top secret." Someone who can name another's "grandmothers" can make claims on that person for financial support, for moral support, and for inheritance to the chieftainship. Repatriation of lineages "lost" to the Chokwe in slavery occurs at precisely this level.

4. The director of the excavation was Professor Pierre De Maret. Mashita Mbanza is also sometimes called Mashita Kizungu. I thank Professor De Maret for sending me a copy of the report.

5. Most of Torday's collection is in the Museum of Mankind (British Museum) in London; part of Frobenius's is in the Museum für Völkerkunde in Hamburg; Starr's is in the American Museum of Natural History in New York. For an analysis of Starr's collecting methods, see Schildkrout, in press.

6. The "Kwilu Pende" may one day be called the "Western Pende," but it would be too confusing to do so at this date.

7. There are many excellent analyses of this incident by Pende historians, e.g., Sikitele 1973, 1976, 1986; Yongo 1972–73; Gusimana 1970b.

8. Some histories of Zaïre end the rebellion neatly in April 1964. However, Kwilu and Central Pende associates report that many villages remained in hiding in the forest through 1965 and that state reprisals were fierce during the military occupa-

tion of the countryside. The leader of the rebellion, Pierre Mulele, was captured in 1968.

9. Initiation into the men's fraternity remains very important in the life of the Eastern Pende. Some Central Pende have continued it in a brief, folkloric fashion. West of the Kwilu River, it is defunct.

Terms for men's associations like the *mukanda* are frequently translated as "secret societies." In his talk "The Bamana and the Komo" (delivered at the Thirty-fourth Annual Meeting of the African Studies Association, 23–26 Nov. 1991), Kassim Kone suggested a better translation, "fraternity," which is less exotic and truer to the purpose of such groups.

10. De Sousberghe proposes this date based on a colonial document from 1917 that assigns the age grade to the period before the opening of the first posts of the Compagnie du Kasai, ca. 1903 (1955d: 82 n. 5). De Carolis also assigns the Mingelu to 1903 (1930: 47).

11. De Carolis assigned this age grade to 1917 (1930: 47). De Sousberghe favored 1918–19 (1955d: 82). Territorial Administrator Bomans's estimate of ca. 1920 seems late based on the men's references to World War I (Archives Historiques de la Zone de Gungu, Dossiers Politiques, letter no. 2743/AO/B.9, dated July 1940, p. 1).

There is certainly an unusually large gap between this age grade and its predecessor; however, the date does seem to correlate with the age of the initiates, who died out in the 1960s. Not every village conducts an initiation in the same year and it can take four or five years for the *mukanda* camps to circulate in the region. It may also be that there were longer periods (of perhaps fifteen years) between initiations in the past. De Sousberghe attributes the long gap between this and the preceding generation to the war effort (winding down in 1918–19) and to the collection of rubber in the savanna (1955d: 82).

12. This date is provided by Territorial Administrator

Bomans in a letter to the Kikwit District dated July 1940 (Archives Historiques de la Zone de Gungu, Dossiers Politiques, letter no. 2743/AO/B.9, p. 1). See also Loewen 1972: 74–75.

13. The phrase "power-to-make-things-happen" is adapted from another context in Thompson 1983: 5. Some of the discussion of sorcery is taken from Strother 1996. I have preferred to translate *wanga* as "sorcery" rather than "witchcraft" because the former is less sensationalist. Nonetheless, both terms bear inappropriate links to Satanism and to the principle of "evil." In the Africanist literature, "witch" is also sometimes used to distinguish a person of congenital powers from practitioners who gain their knowledge through study. The Pende know no congenital *wanga*.

14. Because of the consistent and sometimes spectacular response of malaria to Western drugs, it has moved into the class of natural illness. Theoretically, the death of the very old should also be classified as natural, as a "death from God." In reality, there continues to be considerable speculation about who might be responsible, although it lacks the passion of accusations made at the death of a younger person.

15. Quoted by Hillel Italie (1993: E4).

16. This still takes place among the Eastern Pende. Professional dancers today among the Central Pende often seek out personal protections, some quite elaborate. It is hard to tell if there is a growing sense that the dance floor is a dangerous place because a performance there may incite envy. The accusations that swirled around Gifembe in Kinguba are common enough, except for originating in a masquerade. It should also be noted that the residents of Kinguba are Pende-ized Pindji, who began speaking Kipende as their first language a generation ago.

17. Future publications will describe the full ritual context of Eastern Pende masquerades.

18. See "Masques Bapende" 1932; Bomans 1941 in de Sousberghe 1959: 35; de Sousberghe 1960b: 518–19; Nicolaï 1963: 235; Kodi 1976: 258–59. Pende women will throw millet and samples of other staple crops onto the dance floor during masquerades. The Central Pende interpret these offerings as praise gifts (or tips). In contrast, Eastern Pende interpret them as prayers of thanksgiving intended to ensure future harvests.

19. E.g., bad feeling between the new chief of Nyoka-Munene and the Mulamba quarter resulted in a suspension of masquerading from 1987 to 1989.

20. All the Pende refer to village masks as *mbuya* or, less frequently, as *minyangi* (sing. *munyangi*). More rarely, Central and Kwilu Pende also call them *mikanda*, derived from *mukanda* (men's fraternity).

21. In the case of contact with a village mask, treatment might conclude with the carving of a miniature mask, made from wood or from the shell of a nut. Many have confused these amulets with the purely decorative ivory pendants also carved in the shape of certain village masks for both men and women. See Strother 1995a.

22. A diviner might diagnose a man's illness as the result of neglecting an "uncle's" mask. In that case, he would wear a wooden amulet in the shape of one of the oldest village masks (such as MUYOMBO or GIWOYO) until he was able to continue the tradition. It was this custom that confused de Sousberghe into thinking that masks belong to certain lineages and that only one man has the right to dance a given mask (1960b: 512). In fact, village masks know no owner. Anyone may borrow or adapt them. The exception is the unusual twentieth-century subcategory of *mafuzo* masks (discussed in chapter 8).

23. For more on the fieldwork experience, see Strother 1992b and 1996.

24. Although I will follow map conventions, Nyoka-Munene ("the Great") is properly called "Nyoka-Gitamba" and

is in fact smaller than Nyoka-Mulenga, which was misnamed "Nyoka-Kakese" ("the Small") during the early colonial period. For simplicity's sake, I will also sometimes refer to Nyoka-Munene as "Nyoka."

25. Reliable contemporary census material is hard to find because both the people and the government have their own reasons for manipulating the figures. An agricultural census in 1987 listed Nyoka's population at 628 (personal communication, 1989); however, this figure is certainly low. I would estimate 700–800. In 1935–36, a colonial census reported a population of 711 (Sikitele 1986: 45). Since the Pende have known substantial demographic increase, this early figure supports the impression that Nyoka has lost a significant percentage of its population to Kikwit and other urban centers. By Central Pende standards today, Nyoka is judged a medium-large conglomeration.

26. It is hard to know how the political and economic upheaval beginning in 1990 in Zaïre has affected this trade.

27. *"Gusuanguluisa mila yakhadi tshiatshiatshia."*

28. *"Tuejile kwota mutele, ku kalunga kwembo d'etsu."*

CHAPTER TWO: WHO INVENTS MASKS ANYWAY?

1. The *Oxford English Dictionary* (2d ed.) attributes the ultimate origin of the word "patron" to the Latin *pater*, "father." From this source, the Latin *patronus* carried over the sense of "protector and defender." It was also used to describe the former master of a freed slave. The dictionary observes that "patron" in English preserves the nuances of the Latin, and a chief usage is "one who takes under his favour and protection, or lends his influential support to advance the interests of, some person, cause, institution, art or undertaking. . . . (Always

implying something of the superior relation of the wealthy or powerful Roman patron to his client.)"

The "superior relation," based on wealth or social position, that the term conveys may be appropriate in some African contexts, e.g., royal courts. In the masquerading milieu, however, it misrepresents the dynamic relationship between the persons commissioning and sculpting the masks.

2. As chapter 1 explains, the period in question is determined by relating one event to others with documented dates. In this case, Miteleji is sure that he and his friends invented GATOMBA while Nyoka was still located in the *mukulu*, the old village site. The Belgians forced Nyoka to move in 1949, and this date is a handy post-ante-quem in local history. GATOMBA's invention also occurred before anyone in the group had married.

Another dancer, Khoshi Mahumbu, provides independent corroboration. He reports that he began dancing this mask himself in 1947, the year that his father died, following his cousin Miteleji's lead.

3. *"[C]elui qui trouve la vérité dans les palabres"* (de Sousberghe's field notebook "Kipende, 1955–56," p. 14, in his possession in Brussels, Belgium).

4. I thank Père J.-B. Malenge Kalunzu Maka of Lozo-Munene for this reference.

5. Negative M-5416, located in the photo archives of the Institut des Musées Nationaux du Zaïre, Kinshasa, Zaïre.

6. An exception is made by the chief and notables during the long retreat preceding a chief's investiture among the Eastern Pende. Their entire dress during this period must conform to old-fashioned mores.

7. He and Kianza both belong to the age grade Ndende, initiated in 1931. Gatemo remembers that he had a son of good size, aged twelve to fifteen, who helped him drum at the first performance. He also associates it with the time when the Belgians drafted soldiers to fight in World War II.

Ndambi Mun'a Muhega attributes the mask's origin to an unnamed dancer at Ginzungu, who was inspired by the death by lightning of a visiting foreign priest. If this is true, which seems unlikely according to regional testimony, it would be a case of parallel, independent invention (1975: 218).

8. The headdress that he borrowed, typical of a mask like MUYOMBO (plates 2–3), usually belongs to a more mysterious presence, quite unlike the masks mimicking village characters, such as the young man or the old woman.

9. An alternative pronunciation of the mask's name is GAM-BIDI-MUAMBA.

10. The Central and Kwilu Pende tend to call all of their non-Pende eastern neighbors "Luba," whatever their ethnic origin. This makes attributions difficult. In this case, because Gibata learned the dance at Mapungu, in Lele territory, it is safest to assume that he learned it from the Lele.

11. "Lungelo" was the name of a dance in the south in which the dancer holds out his hands in a floating gesture. It is distinct from the dance of the song "Gabidi-Muamba," which focuses on a fast shuffle step, with the hands stretched out in front. Bengo dates this popular dance to 1940–44 (1982: 21). Probably, Gibata saw some similarities in the hand gestures.

12. Ndambi Mun'a Muhega dates its appearance in the village of Kitombe-Samba to 1948 (1975: 84). One wonders if this was the mask "Muluba" documented by Bomans in 1941 (de Sousberghe 1959: 33 n. 1).

13. Again, west of the Loange River this designation probably refers to Lele, or possibly Luluwa, merchants.

14. *Mwenyi* means "stranger" or "traveler" (Gusimana 1972: 121), the two concepts being synonymous in stable, rural populations.

15. See the appendix for an extended discussion of the diviner genre.

16. De Sousberghe published a photograph taken by the Congopresse of "Khaka Kambinga" from Nyoka-Kakese (1959: fig. 52). This image (fig. 7) may or may not be correctly identified. It shows the dancer with the perfect costume for the male version of NGANGA NGOMBO, the Pende diviner. He has the double-headed *musashi* rattle held in the right hand, the long antelope horn held in the left hand, the *manzanga* ruff over the shoulders, the voluminous pleated wrapper, and the long braids popular before sculptors at Nyoka-Munene invented a new hairstyle to better emphasize the mask's distinctive head-shaking (see chapter 3).

Because the diviner in the photo is on his knees, the absolutely diagnostic feature of TATA GAMBINGA's costume, the rattles from ankle to knee, are not visible. Another diagnostic prop, the cane mounted with rattles, is also missing.

17. Hans Himmelheber was ahead of his time in recognizing the desire for personal distinction in many African societies. Extrapolating from his work among the Dan, he wrote: "The artist strives to attain fame. In an African community . . . every man and every woman wants to be important in some way. One man is the best hunter with traps, another one is head of a secret society; this woman is 'mother of the fetishes,' that one is the most hospitable of her quarter. So the artist's ambition is not out of the ordinary" (1963: 92).

CHAPTER THREE: COSTUMING FOR CHANGE

1. This chapter is heavily indebted to the work of Robert Farris Thompson (1968, 1973b, 1974) and Sylvia Boone (1986).

2. The description is Georg Schweinfurth's, cited in Herbert 1984: 277.

3. Sculpted styles were most popular among the Pende west of the Kwilu River.

4. President Mobutu mandated this style for all Zaïrian women in the country as part of his campaign for "authentici-

ty." Recently, he rescinded this law as part of his policy of "liberalization." The future of women's fashion remains uncertain in light of the current economic situation. Western dresses, already worn by young girls, are significantly cheaper than the wrappers. Whatever happens, it will most likely be reflected in the dress of the masks.

5. *"Yene idi nu dibimba gifwa mbuya jiko muto nji hene hamoshi, uvi yanakhala nu dizanga diavula diagu sudiga mushingo. . . . Nganga-Ngombo yana tshiatshelela jisambu go gukina gwenji guagaswe gwanakhala guzanga dia gushingo gula idi mu molu ata tshima idi hashi"* (Muyaga 1974: 62).

6. *"Mbuya ya mambuta, gukena gu'enji gulatulu mu lulendo ula Mazaluzalu."*

7. *"Gestes jiagasue ji'ami jia mbuya mu mukhela. . . . Mudimo wa mukhela gutupula nyanga."*

8. *"Gumba ilema holo dia mishinga yavula, [mbuya] ikhala muza, ginango giavula ha gutala."*

9. I thank Robert Farris Thompson for this reference.

10. *"Gashinga ga gu koko gua mona gamuhagewa mukunda nu gupumuna gitshinyi gia gikata gia koko nu koko. Ha guzondesa. Muya wa mu mbunda mukunda nu gukapumuna kete nu matago, ha ene gukhala akoma."*

11. As noted in chapter 2, Pende west of the Loange River refer to all their non-Pende eastern neighbors as "Luba." Since Gipangu learned the dance in Djoko Punda, it was probably of Lele origin.

CHAPTER FOUR: BIRTH OF AN ATELIER, BIRTH OF A STYLE

1. "Katundu" is a common misspelling. The correct orthography is "Gatundo."

2. *"Aucun Pende, à quelque chefferie qu'il appartienne, ne contestera la maitrise des Katundu en ce domaine"* (1959: 23).

3. *"Cette formule de style est extrêmement ancienne . . . il remonte aux anciens contacts avec les Portugais en Angola"* (1959: 22).

4. *". . . traditions et spécialisations artistiques restent fixées localement dans les villages et les clans"* (1959: 10).

5. *". . . la région de Kilembe et particulièrement de la chefferie Katundu, chefferie la plus importante de la région"* (1959: 22).

6. Major contributors to the biographies that follow were Nguedia Gambembo, Matamu Gabama, Sh'a Kasongo, and Gin'a Khoshi Ndemba.

7. *". . . jouit d'une grande renommée en territoire Bapende"* (1953b: 13).

8. Kochnitzky published the portrait and the photograph of Gabama eating with his article "Un sculpteur d'amulettes au Kwango" (1953b: cover and p. 11). Good prints of Mulders's photographs of Gabama smoking (21.170/2) and Gabama eating with his third wife and children (21.170/3) may be found in the Photothèque of the Voix du Zaïre, Kinshasha.

9. Grandchildren have the right to tease their grandparents (and vice versa). Both sides enjoy the tomfoolery, although it can get out of hand. Nevertheless, no one else in my experience has been successful at containing it. This is quite a testimony to Gabama's force of character and concentrated work habits.

De Sousberghe refers to other family ateliers at Ndongo and Musanga-Lubwe (notebook 22, n.p.).

10. When Gabama's daughter became blind during her father's prolonged absence, Mukubuta a Tumba Ganyi of the Mapumbulu age grade was inspired to compose the following song, still sung today in the village:

> *Gabama a Gingungu wabola guta wenyi yaye e e!*
> *Yala wabola guta wenyi!*
> *Watele wenyi; wetshi guza.*

Mona wa gufua gembo.
Aye, wahuena mu njila.
Ndende wakudila mu njila.
Gabama Sh'a Matamu, Sh'a Khumba, Sh'a Midimba,
Sh'a Ngombe,
You muza mu njila. Yaye e e.

Gabama a Gingungu will do anything to earn money!
He has no scruples on how he earns money!
He went to earn money; he has not returned.
[His] child lies dying at home.
You, you stay silent on the road.
Ndende [i.e., his nephew of the Ndende age grade] is
growing up, on the road.
Gabama, father of Matamu, Khumba, Midimba,
Ngombe,
You are on your way.

The song emphasizes by its sharp criticism how unusual it was
for a sculptor to go on the road.

11. The eastern version of the initiation to the men's frater-
nity *(mukanda)* was structured around several ritual climaxes
and, therefore, adapted much better to the prohibition on cir-
cumcision in the bush. It still enjoys today a prominent role in
village life. The *mukanda* has never died out entirely among the
Central Pende, surviving in the north and in a few villages just
south of the Gatundo. In 1989, the elders of several other villages
were talking about reintroducing it in a reduced, folkloric ver-
sion in order to give their sons and grandsons some connection
to the past.

12. The practice of using the senior artist's name for the
work of the entire atelier accounts for the unlikely attribution
of a bizarre mask to "Kabama sha Mupese" by a source of de
Sousberghe (1959: 51 n. 1; fig. 90). Sh'a Mupesa is the alterna-
tive name of Gitshiola Shimuna, and the headpiece in question
shows some of the inventiveness and fantasy for which he was
famous.

The Institut des Musées Nationaux du Zaïre in Kinshasa
contains a number of masks identified as Gabama's; however,
the attributions are dubious (e.g., 71.1.41, 71.1.42, 71.1.64).
Collected 12 Dec. 1970 by P. Timmermans in the village of
Munzombo, the masks date after the sculptor's death. More
important, they date after the disastrous Mulele Rebellion that
devastated the region for several years. It is more likely that the
men who were selling the masks were using Gabama's name
either to inflate their value or as a reference to the atelier at
Nyoka-Munene.

13. The mask (MCB 32.128) belongs to the Musée Royal de
l'Afrique Centrale (Africa-Museum) in Tervuren, Belgium.
Acquired by Golenvaux in 1930, the mask's provenance is
noted as the village of Bakambushi in the region of Kilembe.
This is not very far from Nyoka. One hopes that further exam-
ples of Gabama's work may yet be identified.

14. "*Mabutu a mbuya jia Gabama, akoma. Khekhesu yahi-
hia.*"

15. "*Meso haleha nu muzulu, azonda.*"

16. "*Muzulu wa gubafumuga.*"

17. For a good summary of standard descriptions of Gatundo
style, see Biebuyck 1985: 232.

CHAPTER FIVE: PENDE THEORIES OF
PHYSIOGNOMY AND GENDER

1. Margaret Drewal and Henry J. Drewal have commented
on "seriate" composition in masquerade, in which the "units of
the whole are discrete and share equal value with the other
units" (1987: 233).

2. Many thanks to Barbara Burtness, M.D., for locating a copy of this image despite the press of her own work.

3. The Pende spectrum might well not have emerged outside an art historical inquiry. When asked how men differ from women, in isolation from physical data, field associates tended to focus on constructs of the average man and the average woman.

Nevertheless, there are many occasions when these distinctions emerge. Young men with peaceable characters are much admired and praised as *doux* (gentle) in contemporary Franco-Kipende slang. Men who have the (perceived) potential for physical action, violence, or social disruption are frequently described as *abala* (dangerous). Despite the dramatic language, this is a fairly common characterization. At the investiture of Eastern Pende chiefs, distinctions of masculinity in the candidates are carefully weighed. However desired, *doux* candidates are rare. Whether the community can make do with an average male or whether the candidate borders on the "dangerous" often becomes the subject for debate.

4. Examples of the usage of *gutuluga*: (1) *Hama haha hatuluga.* (This place is cool [in temperature].) (2) *Tuluga!* (Come down [from the tree]!) (3) *Guma guatuluga!* (It's getting colder.) (4) *Muthu ou watuluga.* (This person is calm/has lots of patience.) The related verb *gutulula* means to lower something. The usage of *gutuluga* provides striking confirmation of the power of coolness as a metaphor in African aesthetics, as outlined by Thompson (1973a).

5. *"Khabu jia akhetu, jiahihia."*

6. *"Yala, nganga; khabu a khabu; wajiya gushiya muthu."*

7. *"Meso bobe a mukhetu ana [gu]lebesa yala. Gima giagasue agutoka, gubindulula, ndo, umuhui. Hene tuana guatamega egi 'Satana,' iyungishi ya mala."*

8. *"Meso a akhetu a gubua, zanze, ha gudijiga gubonga."*

9. *"Meso a mukhetu ala ze [= zanze]; meso a yala alababa."*

10. *"Meso atuluga, ndaga, akhetu ana tangizago gubalega yala. Ginemo giagasue gia gu inzo gidi nu muene [yala]: gusudiga gua mukhetu, gua ana, gunua, gudia, ihemba, savon. . . . Gubanda gua mu pipa, Mumbu gubunuisa, yala udi nu protection."*

11. *"Meso a uhululu, udi mutangiza muavula."*

12. *"Kano gua yala guagutumbamesa; kano gua mukhetu gua gubandesa."*

13. *"Muenya Khabu, muthu wabala."*

14. *"Wajiya gukhala nu mukhetu nu yala hama hamoshi, akhetu aledi mbala kumi, yala mbala jiyadi, nga jitatu, ndaga kano gua yala guana [gu]khala gua gubatega makumi agasue."*

15. *"Mukhetu, giboba gia yala."*

16. *"Muzulu wa yala wa gukanduga, wa gufoboga hadi meso; muzulu wa mukhetu tonono."*

17. *"Muzulu wa mukhetu wa gubulumuga; muzulu wa yala wa gukanduga."*

18. *"Mbuya jia mukhetu, jiahihia. Mbanga jia yala, jialeha; jia mukhetu, jiahihia."*

19. *"Mabutu a yala agusholomoga; a mukhetu, ajimba."*

20. *"Mabutu a akhetu ajimba; a mala aguboboga."*

21. *"Khekhesu ya guvutuga." "Khekhesu ya lueluelue."*

22. *"Izumbu ya meso yabalega gubonga ndaga gafezegeselego muho wa muthu. Ukhadi mufezegesa gifua muho wa muthu, gubonga ndo, ndaga pala jidi jia gudisha. Ukhadi mufezegesa mbuya gifua muthu, gubonga ndo. Ngenyi muthu udi mufezegesa mudimo gifua muthu, gajiyilego gujiya gima. Ha gufezegesa gima, ulondjigo gifua muthu; muthu udi muthu. Ngajiyilego gukhala gugutala, gugusongi ndo. Tuana [gu]zuelago egi mbuya eyi, idi gifua yafuana nanyi. Tuana [gu]bongesago pala ya muthu uvi tuana [gu]bongesa pala ya mutshi udi musonga. Sanga ufezegesa gifua dia muthu, uvi pala gufezegesa ndo."*

23. *"Tushigo mulonda gifua muthu; gima tumufezegesa. Ishigo muthu; idi figua gifuanesa."*

24. To say that MUBOLODI represents a "woodcutter" is misleading because that implies a profession. All men cut wood at one time or another.

25. *"Kano gua yala gudi n'aye ya gukhala gifua muthu udi nu gisugamonyo."*

26. *"Kano gua gubumba gifua gua Pumbu."*

27. *"Givunga gia guthunda giazumbuluga; akhetu nu ivungu ya gubua."*

28. *"Meso a gukangula diago. Meso abala, 'bien-ouvert.'"*

29. *"Kano gu'enji gua gukangula gifua muthu muzuela nu khabu."*

30. *"Mbombo jia mala jila mbalanda gifua telume tua khombo; ya gufunya gifua udi nu khabu."*

31. *"Muzulu wakoma gifua mbinga ya shibidi."*

32. *"Meso akoma."*

33. *"Inzumbu zubulu."*

34. *"Wajiya mbuya."*

35. *"Kano gua yala guana khala gua gukanduga uvi gu'enji guabua ndambo ndaga pala y'enji idi mudijiga gutuluga gifua pala ya mukhetu."*

36. *"Meso a gutala muabonga."*

37. *"Kano gu'enji gua mukhetu diago."*

38. *"Khekhesu yahihia."*

39. *"Mbombo y'enji yabonga (yatela nu mutu)."*

40. *"Meso abala, ishigo mbuya ya mukhetu, ndo."*

41. *"Inzumbu ya gutuluga gifua mudi meso a gutuluga. Zanze!"*

42. Many thanks to Dr. William L. Sanders for these references.

43. Henry Drewal and Margaret Drewal give the most sophisticated analysis of performance criteria (1983: 136 ff.). See also Boston 1960: 57–60; Hersak 1990: 141–42; Borgatti

1979: 55–56; Glaze 1986: 32–36; Blier 1974: 109–11. Blier's "beast" is most likely a male gendered representation in which animal characteristics like horns or fangs are cited as metaphorical allusions to male gendered aggression.

CHAPTER SIX: LEARNING TO READ FACES, LEARNING TO READ MASKS

1. The Pende often use the expression *tsuye tulabe gumutala*," let's go see him [or her] (even though we cannot do anything)," when they visit the sickbed of someone they expect to die. The verb *gulaba* expresses futility.

2. In the 1950s J.-N. Maquet also recorded this version, although he transcribed it incorrectly (de Sousberghe 1959: 43).

3. The Abbé Mudiji has suggested, as many have, that the bow and arrows and other hunting paraphernalia indicate that the mask represents a hunter bewitched because of a sorcerer's envy at his prowess (1981: 265; 1989: 213). This narrative begs the question of why there should be an arrow in MBANGU's humpback and fails to account for the distinctive dance steps.

4. *"Mbangu wabutshiwe muthu wabonga. Lwenyelu Ngauga jiajile jiatshita gutshi, jialowa mbangu [sic]. Mbangu wabuile hajigo diatshiya. . . . Khanda iko inyi yasala yabonga, khanda iko inyi tshiya twamubabele gilema. Na amuhaga ihemba amuhaga ihemba, na puta yaya hene gwasala gulabui"* (Ndambi 1975: 126, 128).

5. I thank Dr. Erna Beumers for bringing this mask to my attention.

6. Similar comedic expressions may be found in the Jesuit collection at Heverlee (one is published by de Sousberghe 1959: fig. 14) and in the Peabody Museum, Harvard University.

7. The condition is formally described as peripheral facial paralysis or unilateral facial palsy. I thank Nancy Huff for the following references to the appropriate neurological texts.

8. It is intriguing to note that the oldest version of the genre, collected by Torday in 1909, shows no distortion of the facial features. It is bisected into black and white neatly down the middle. What is truly unusual about it, however, is that it does not have pierced eyes. Instead, it resembles POTA in being a headpiece intended to be worn slanting off the forehead. It is in the collection of the Museum of Mankind (British Museum) (1910.4-20.470).

9. *"Atteint d'une demi-paralysie faciale, dit-on, il est longtemps resté couché d'un seul côté, entre la maladie et la mort"* (1981: 265; 1989: 214).

10. Incidentally, the rule of eating and offering with the right hand alone was the *only* rule of etiquette on which I as a foreigner was immediately and publicly corrected. Children receive very sharp rebukes if they err.

11. *"Mais une des raisons cachées de l'apparition du mal dans la région du bien, c'est l'envie, un sentiment intérieur et perverti de l'homme, et le* nganga *que nous pouvons être, même à notre insu"* (1981: 266; 1989: 214).

12. This version is also reported in Muyaga 1974: 78; Ndambi 1975: 126 ff.; Mudiji 1981: 265; and Mudiji 1989: 213.

CHAPTER SEVEN: A PRECOLONIAL PENDE ART HISTORY?

1. For a good overview of the historical linguistic method, see Hock 1991. I am grateful to Ruth Herold for guiding me to this source.

2. On the exclusion of NGANGA NGOMBO, see the appendix.

3. Also noted by de Sousberghe (1960b: 506) and Mudiji (1979: 192).

4. GIWOYO parallels the form of the Great Mother mask (IYANLA) in the Yoruba Gelede tradition: "a large head with massive eyes and a long board-like projection below the face" (Drewal and Drewal 1987: 229 and fig. 2). In contrast to the Yoruba mask, however, the head of GIWOYO is usually set at an obtuse angle to the projection extending from the chin, and the projection is much more elaborately incised and decorated. Unlike GIWOYO, Drewal and Drewal report that IYANLA's projection is "identified explicitly as a beard" (1983: 71).

5. For example, Frobenius (1988: 64) and de Sousberghe (1960b: 529) so interpreted the projection. The latter went so far as to speculate that GIWOYO was inspired by the long-bearded Catholic priests who proselytized the Kingdom of Kongo in the sixteenth century. Unfortunately, Fritz Kramer recently adopted de Sousberghe's misinterpretation of the "beard" and its putative European origin to propose that "the types depicted in the masks, being strangers, conveyed an other to the Pende culture" (1993: 164). The Pende most definitely do *not* consider these masks to represent "alien spirits" (Kramer 1993: 151), and everything we know about the function of the masquerades contradicts Kramer's speculation.

6. In affectionate improvisation on GIWOYO's songs, singers will often play with *mutumbi* as a nickname for the mask. They will sing *"Tumbi diaya"* (the projection [snout] is passing) instead of *"Kumbi diaya"* (time is passing) or call the mask *"Giwoyo Tumbidi e e he! E e e he!"* (Giwoyo the Snout). *Tumbidi* here is a deformation of *mutumbi*. Songs focus on the projection because it is what makes the mask distinctive.

No one ever refers to the projection as a beard *(wevu)*. *Without exception,* when I suggested as much to a considerable number of people, every man and woman rejected the idea vociferously. They found the notion bizarre.

7. The presence of the hole is a sure sign in older masks that the object was actually danced. Frobenius's speciman has a

piercing in the chin (fig. 69). In the masterwork held by the National Museum of African Art, there is a visible cord in place halfway down the projection (plate 7).

8. *"Giwoyo egi gidi mudijiga muthu udi ya gufua mu gipona. Mutumbi udi mudijiga muila wa muthu mu gipona. Milele yana mbiwa muthu ya gufua. Mufunda ya gukoka: hana fua muthu, pala yana khala gonze, muila wagasue wa gutshiga."*

9. Mashini offered this explanation to me near the end of my stay. It is not an interpretation generally known today among the Pende. Only the historian Bengo Meya-Lubu gave a similar explanation to account for the form of the mask MUYOMBO. Mashini learned this explanation when his father, the sculptor Gitshiola Shimuna, was counseling the Pende art historian Malutshi-Mudiji-Selenge. Gitshiola presumably learned it from his own teacher, the famous Gabama a Gingungu of chapter 4. Other Pende to whom I mentioned Mashini's interpretation found it as visually compelling as I. Several became excited, responding enthusiastically: "Yes, that's it! That's it!"

10. *"Meso ngegi yana dijiga muthu udi ya gufua."*

11. This information is from field research I conducted in 1989.

12. Olbrechts wrote: "[Pende masks] show with piercing realism the impressive image of a mortuary mask: the lowered eyelid . . . under which the dead eye can be seen . . . ; the fleshless and sunken jaws; the jutting cheekbones; and the pinched nose" ([1946] 1982: 34). Oddly enough, Olbrechts may have been on target in his description of the eyes but otherwise mistakes conventions of physiognomy for naturalistic representation.

13. The gesture of flicking the fly whisks *(gunyigisa minyinga)* is an important one for several key masks. See a possible explanation below in the discussion of the dance of the mask KIPOKO.

14. This fact makes the development of the *mafuzo* masks during the colonial period all the more remarkable. They also were performed on the fringes of the village, as will be discussed in the next chapter.

15. Pende of a practical bent often claim that the downcast eyes of Pende masks represent this propensity of dancers to look down at their feet. The dancers do so for reasons of concentration and good manners and out of fear of stepping on sticks and stones with their bare feet.

16. Correct fitting of the mask is a point of criticism. At a masquerade at Kinguba in 1989, Gifembe a Pinda drew censure for wearing MUYOMBO's headpiece too far back on the head ("like GIWOYO") (fig. 2). Many photos are deceiving in this respect, including the image that Hilton-Simpson took of MUYOMBO and another mask on the Torday expedition of 1909 (fig. 76). Dancers politely pull the headpiece down over their faces so that it may be fully visible in the photograph.

17. De Sousberghe has proposed connecting the etymology of the name MUYOMBO with the Kikongo *nyombo,"* cadavre, cidevant, feu le . . ." (1960b: 506 n. 4). Although the first meaning of *nyombo* in Kikongo is very suggestive given the interpretation noted above, etymology in these languages is very tricky because of the tones. Moreover, as noted in chapter 2, the names of masks often change over time. MUYOMBO may not be the original name of the mask.

Field associates at the two Nyokas insist that the name MUYOMBO replaced an older soubriquet, MUDIAMBA, during the Mapumbulu and Ndende generations. Territorial Administrator Bomans in 1941 and de Sousberghe both recorded the existence of the alternative form (de Sousberghe 1959: 33 n. 1; 45). The name MUDIAMBA has become archaic but may still be found in one of MUYOMBO's invitation songs:

Mudiamba a a Mudiamba,
Mudiamba a Mbelenge,
Za umone Kamiya, Mudiamba a Mbelenge.

Come see Kamiya, Mudiamba a Mbelenge.

One wonders if one or both of the soubriquets was the name of a great dancer in the past (see chapter 2).

18. As noted in chapter 2, successful performers of MU-YOMBO have been in such demand that they began to journey from village to village, accompanied by their drummers, to give solo performances as a means of collecting tips.

19. *"Muyombo wabala guteta akhetu mu gutua. Tundu ha gutua, diana teta akhetu nu guta matengo, nga mu guzua meya."*

20. *"Muyombo, lulendo; Tundu, ilelesa."*

21. Called KIPOKO in the south, the same mask is often named MUKISHI WA MUTSUE in the north. The latter signifies "mask of the head," perhaps referring to the mask's unusual helmet form. In the literature, it is sometimes referred to as "Giphogo," but this is a misspelling and mispronunciation based on *Central* and *Kwilu* Pende orthography and accent.

Small portions of the following discussion have been previously published in Strother 1993.

22. The Eastern Pende refer to this kick as *shapi* (pl. *mashapi*) or as *kipadi* (pl. *ipadi*); the Central Pende, as *pule.*

23. *"Ulumbu wa lukongo udi kuleza khadilo dia ufumu: ungunza, ungambi, uyanga, nu umbundjudi. Lukongo ludi luyadi kuleza luholo lua kukuna, kumuna, kuhika, kwenda kua mukhetsu, nu kutaha kua ngombo. Uvi ulumbu wa Kipoko, udi ulumbu wa fumu."*

24. *"Wenya kulekeza kamba mbuya tuendji kukina jivudise mbuto, bana badie, ha kukudisa kifutshi."*

25. An additional allusion of the long nose will be explored in future publications that deal with KIPOKO's role in the initiation to the men's fraternity *(mukanda)* (fig. 75).

26. The relationship of Pende and Chokwe masks merits further exploration. KIPOKO's mysterious chin projection finds a formal parallel in the chin projection of the Chokwe TSHIKUNGU (or CIKUNGU) (Bastin 1961: 35, 38). In addition, the mask CIHONGO shares several characteristics with MUYOMBO in its use in ritual as well as in the fact that it dances with a hoop and that its dancers would journey to perform in various villages, as did dancers of MUYOMBO (Bastin 1984b: 42 ff.).

27. Most photos are once again deceiving in this respect, as dancers commonly pull the headpieces down to show off the face.

The Luchazi, Luvale, Ndembu, and Chokwe dance a mask, CIZALUKE, that is perched on the forehead in a similar fashion. They use a knitted body-suit to disguise the face of the dancer (Turner 1967: frontispiece, figs. 6–8). The headpiece is not usually carved from wood. I thank Manuel Jordán for this information.

28. The dean of Nyoka-Munene's sculptors, Nguedia, insisted that although the faces of GINJINGA and POTA are almost identical, there is one subtle distinction. POTA's will show the receding hairline of a mature man (rendered in stylized form as two white triangles *[mahala]* on either side of the temples), whereas GINJINGA's will not, because only a young man could possibly execute its dance.

29. In his description of the dance, de Sousberghe seems to have confused GINJINGA with the mask GALUSUMBA, which dances with a bow and arrow and pantomimes hunting birds (1960b: 513, 520).

30. The Eastern Pende call the great blue turaco *kulukulu* in imitation of one of its cries. Specialists should note that flora and fauna names do vary sometimes according to region. De

Sousberghe calls this bird *kolomvu,* although his footnote reveals some confusion (1956: 14 and n. 1).

31. *Munyangi* (pl. *minyangi*) is a general term for "mask," used interchangeably with *mbuya* on both sides of the Loange River. The name MUNYANGI is particularly popular among those Pende living along the Kasai River. Frobenius reports a mask *"Njangi, Maske mit Federschmuck"* (1988: 64); Himmelheber collected a "Kinjinga" *(sic)* among the Bakwa Nzumba (Museum für Völkerkunde, Basel, III.9511, collection notes) (fig. 86).

32. Some of this discussion is drawn from Strother 1995b: 313. There are elusive references to bird imagery for GINJINGA as well. Dancer Bundula Ngoma places white feathers at the temples of his headpiece. Although he is forced to use duck or pigeon feathers, he explained that they substitute for the extinct *pungu. Pungu,* the "leopard of the air," seems to have been an enormous eagle with a wingspan of two meters. Some claim that it was capable of carrying off a grown chicken. Charles Delhaise noted in 1924 at a performance at Kilembe, in the heart of the Central Pende, that GINJINGA *"orné, à l'arrière, de plumes d'épervier (ou à défaut d'autre grand oiseau)."* He described GINJINGA's dance as mimicking *"la chute d'un oiseau blessé à mort"* (Musée Royal de l'Afrique Centrale [Africa-Museum], Section Ethnographique, dossier no. 433, p. 1).

33. *". . . couvert d'herbes pour simuler un arbre très feuillu"* (ibid.).

34. De Sousberghe identified the leaves as manioc, as did Territorial Administrator Bomans in 1941 (de Sousberghe 1960b: 512; Musée Royal de l'Afrique Centrale [Africa-Museum], Section Ethnographique, dossier no. 433, p. 1). However, when Himmelheber photographed POTA in action in 1938–39 (1993: fig. 89), it was dressed in leaves and plentiful cords, but the leaves were not of manioc. Nguedia claimed that often *mis-*

elenge are preferred (the leaves in Himmelheber's photo look like *miselenge*) because they are stiff and do not fall off. Khoshi Mahumbu performed the mask in 1989 with leaves from the *mubo (Burkea africana?)* and scrub *miheta (Hymenocordia acida)* and some *khokha.* He said that he preferred the last because it is a ground vine with lots of leaves that hangs down nicely. At Gungu in 1989 a dancer from Kinzamba availed himself of Chinese bamboo *(mumbungu).* Field associates stressed that what was important was that the mask be covered with leaves; the type was unimportant.

35. See also Muyaga's account (1974: 45).

36. *"Kikhokho kiamukuata."*

37. It is hard to pin down the date at which the first wooden facepieces were introduced, as they appear to have coexisted with hooded forms for some time. A field photo exists in which some entrepreneurs are showing off their wares, including a TUNDU with protruding eyes. The photo was taken by Joyce Doyle or Donald Doyle between 1911 and 1932, possibly 1919–23 (Brett-Smith 1983: fig. 17).

38. There seems to be an example of this type collected by F. Wenner in 1930 (Musée Royal de l'Afrique Centrale [Africa-Museum], MCB 32.534; Section Ethnographique, dossier ethnographique no. 538).

39. Musée Royal de l'Afrique Centrale (Africa-Museum), MCB 53.74.5478.

40. The history of the distribution of PUMBU-like masks has yet to be written, but there are some striking parallels in either dance or headpiece with the Chokwe TSHIKUNGU, the Kota NGIL, the Kwele GON, and the Mbwela MPUMBU.

41. Today many villagers among the Eastern Pende assume that the high chief gives the duty of providing spirits for guardianship to a senior sorcerer. So while there is no literal

assassination, people believe that the lives are provided through sorcery.

42. For exegesis of the resonance of *nduwa* feathers, see Strother 1996. I thank Costa Petridis for helping to identify this bird.

43. The translation from the French is my own. De Sousberghe observes that *somba* is an archaic word signifying "to kill" (1959: 48 n. 1). In fact, among the Eastern Pende, where the word is still current, it refers specifically to the chief's ritual beheading at his investiture of a ram, which substitutes for the stranger. Therefore, a better translation might be "sacrifice him."

44. At a masquerade at Nyoka-Munene in 1989, Masuwa began to perform PUMBU without a blade. Despite the skill of his dance, the criticisms rang out: "Who is going to flee if Pumbu doesn't have a blade?!" *(Pumbu, pogo ndo. Pumbu yana laba gulengewa.)* Finally, someone handed the dancer a machete. Part of the fun of the performance is the scariness.

45. It seems that older masks may have had a more standard helmet shape and that they have become increasingly elongated since the 1930s. I have enjoyed discussing this point with Marc Leo Felix.

46. Ngoma Kandaku Mbuya, an old blacksmith and sculptor of Ndjindji, has claimed that PUMBU was once literally used in battle. This makes sense, considering its present functions and physiognomy, as explained below. Ngoma is usually a good source for information about the chiefdom because of his privileged birth as a son of one of the last great Eastern Pende chiefs to reign before the Belgian occupation.

47. *Mbanda* in Kipende is the word for "co-wife" in polygamous households. The prefix *g/ka* is used as a diminutive. Therefore, the name *Gambanda* could be supposed to refer to a young co-wife; however, no one refers to the mask as a co-wife.

Today, inspired by the mask, "Gambanda" is a popular girl's name.

48. See the appendix for a more extended discussion of the Central Pende variations on the genre.

49. This is an interpretation recorded also by de Sousberghe in his field notebook "Kipende, 1955–56," p. 14.

50. *"Pota, mbuya. Ipota ishigo 'mufuegesesa' gima gimoshi, khuta ulumbu w'enji."*

51. Future publications will elaborate on this important concept in Pende art and theology. The metaphor of "transistors" was suggested by Chief Samba a Kavundji (Ngoyi Kisabu Kavundji).

52. These masks are found in the Museum of Mankind (British Museum), London: female mask (1910.4-20.476) (Mack 1990: pl. 5), PUMBU (1910.4-20.473), MBANGU (1910.4-20.470).

53. Etnografisch Museum, Antwerp (A.E. 551), acquired in 1920. Although the points of the coiffure are blunter than on other examples, the extraordinary vivacity of the features justifies an attribution to the PUMBU genre. The exaggerated cicatrices on either side of the eyes indicate an origin in the Lake Matshi region. An unwise application of pesticide is probably responsible for turning this magnificent sculpture black.

The two transitional PUMBU suggest that the Central Pende headpiece may once have been carved as a forehead mask (on the model of POTA) (figs. 55, 97). One can easily imagine that PUMBU might once have represented chiefly *ngunza* more abstractly (as it does today among the Eastern Pende) before being domesticated into something of a village character with a face mask.

54. *"Kambanda kadi nu meso a mutsu nu pala ya mutsu."*

55. See the appendix for discussion of major mask genres and subgenres not discussed in the text.

CHAPTER EIGHT:
MASKS IN THE COLONIAL PERIOD

1. I wish to thank Professor Jan Vansina for a rigorous reading of this chapter, which substantially improved its historical argumentation. There are a few points at which we differ because I believe local administrators in Pendeland overstepped what may have been strictly legal or customary in the colony as a whole. When pertinent, I have discussed some of these issues in the notes. The historian Sikitele has provided ample documentation for systematic abuses of administration among the Kwilu Pende (1986). What's more, for the purposes of this chapter, Pende *perceptions* of coercion are as relevant as the letter of the law.

2. See the discussion of *ngunza* and their garb in the sections on the mask Pumbu in the Coda to part I and in chapter 7.

3. De Sousberghe photographed a series of *mafuzo* masks (which he calls *"masques redoubtables"*) at Nyoka-Kakese, ca. 1955–57 (Université Libre de Bruxelles, Département d'Histoire d'Art, slide library). Although of considerable documentary importance, these transparencies testify to the decline that the *mbuya jia mafuzo* had suffered by the 1950s. Performers agreed to show Pagasa, Mbungu, Kolombolo, and others all at the same masquerade, in full sunshine for better photography, and were not always careful to keep the crowd at a proper distance (figs. 99–101, 104).

4. Mudiji divides masks into structural categories, as *"anthropomorphe"* or *"zoomorphe,"* *"primordial"* or *"récent"* (1981: 69–71; 1983: 34; 1989: 66–68). He then places the animal maquettes of the *mafuzo* in the "primordial" category. Mudiji cites no supporting evidence, and nothing in my fieldwork supports this supposition. See further discussion of his method in n. 30, below.

5. Some in the literature confuse the Eastern Pende mask Pakasa with the late-developing Central Pende *mafuzo* mask representing the Cape buffalo. The Eastern Pende performer wears a facepiece equipped with eyeholes, so that the dancer can see to pursue his victims with his whip. It is classed as a "mask of the men's fraternity" *(mbuya ya mukanda).*

The Central Pende mask (Pagasa) has no direct link to the men's fraternity; it belongs instead to the exclusive Central Pende category of *mafuzo* masks. Attached to the basketry frame forming the animal's body, these masks are "blind": they have no eyeholes. The dancers rely on verbal instructions from their assistants to move about on the fringe of the village.

De Sousberghe erroneously reversed the functions of these masks (1959: 57). He bases the association of the "Western Pende" Cape buffalo mask with the men's fraternity on a document written by a Belgian administrator in 1917. Although that administrator penned his report in Kilembe, he may well have collected the songs elsewhere. At that date, Kilembe was still in the same administrative unit as the Eastern Pende.

6. Although the Pende did not previously incorporate large maquettes of animals into their village masking, there is evidence for the practice in the wider region. See, for example, Chewa masking (Yoshida 1993).

7. *"[Pagasa] court à quatre pattes et donne des coups de tête à droite et à gauche qui font fuir des spectateurs. Il a, au derrière, un sac de boue qu'il lâche à certains moments pour imiter les excréments de buffle. Les assistants le menacent d'arcs et de fusils. On tire dessus à blanc et il tombe. On se précipite et on lui enlève ses vêtements pour imiter l'enlèvement de la peau. Les femmes poussent des cris de joie"* (Musée Royal de l'Afrique Centrale [Africa-Museum], Section Ethnographique, dossier no. 433, p. 3).

8. Ndambi's account of the masks is particularly useful in

recording audience reaction and in its focus on the masking traditions of one region (Ngudi). Unfortunately, the author does not distinguish between his eyewitness and his sometimes unreliable thirdhand accounts. Readers should use extreme caution with the French translation that accompanies the text. The translator takes great liberties, suppressing details and interpreting difficult concepts in the most random and impressionistic manner. He also sometimes adds his own unmarked commentary.

9. The elephant is the one maquette to have a history among the Pende. The Eastern Pende close the initiation to the men's fraternity *(mukanda)* with a coming-out ceremony that they refer to in fraternity language as the slaughter and feast of the elephant. Over much of the territory, this is marked by chopping down an umbrella tree, drying it, and playing it like a drum. In Nzumba country, however, men once prepared an elephant mask for these ceremonies, which was made in the same fashion as the *mafuzo* masks.

The missionary Frank J. Enns photographed a beautiful example, 1926–30 (see fig. 103) (1930: 9). Few masks could surpass the exquisite delicacy of this work. Many thanks to Katharine Enns, his daughter, for locating this unique documentary transparency.

10. *"Ngiamba idi shitu yabala nu avula khenji gayimona galego ana yivwa muguvwa, ngiamba idi shitu yakoma nu muto wakoma meso azonda"* (Muyaga 1974: 165).

11. *"[N]gana buta khuta mona mungoshi mukunda gula ngabuta ana avula nzala mbayingina mumembo"* (Ndambi 1975: 298).

The missionary Ivan de Pierpont commented many times on the damage that elephants can wreak in agricultural fields (1919c: 223; 1925b: 494; 1926a: 31–34). He wrote in 1923: *"J'ai toujours eu, étant en Europe, la plus grande considération pour l'éléphant. C'est un noble animal.... Lorsqu'on est en Afrique,* *quand on est témoin des ravages, de la destruction, de la ruine que laisse sur son passage une troupe d'éléphants, le point de vue change! ... La présence d'éléphants à proximité d'un village, signifie pour celui-ci la famine"* (in Wilmet 1939: 188). One missionary reported that a troop of elephants can destroy a manioc field extending several hectares in one night (de Pierpont 1926a: 33 n. 1).

Historian Jan Vansina suspects that the reputation of the elephant in this regard was exaggerated in order to get around colonial restrictions on hunting: "The destruction of fields was the colonial excuse to kill an elephant, share the meat and ... get the ivory.... I have seen a field arranged quickly around an elephant already killed to justify its hunting" (letter to author, 14 Sept. 1994).

12. While no one has continued to *dance* the leopard, the sculptor Mungilo at Kinguba carves its face often for the foreign trade. Although no one wears them, these masks garner great admiration from his peer group for their inventiveness.

13. *"Gikwaya gidi shitu yabalega gubala"* (Muyaga 1974: 134).

14. *"Tala, wahuenyi gale, gifua mbungu."*

15. At Ngunda, the GIHUNDUNDU concession is owned by Kangu, a member of the Ndende age grade. Kangu continues the mask from his father, a Mingelu (initiated ca. 1901–3), who introduced it to the village.

16. *"Kolombolo di'ami, nga wayile thunda, nga wayile mbongo, dila tuvue."*

17. This dancer learned from his father, who was tutored by Nyoka-Munene's first sculptor, Maluba, of the Milenga age grade.

18. De Sousberghe published photos from a performance commissioned at Gungu in 1958 of MBAMBI and MBOLOKOTO (1959: 55, 57, figs. 102–3).

Chief Kikunga-Tembo (Kangoro Kanyama) from the East-

ern Pende may be able to throw some light on the complicated history of this pair of masks. In testimony collected by Nzomba Kakema Dugo, the chief reports: *"Nous n'avions pas le masque Mbambi. Quand le chef Keza est mort à 1934* [in the Bandundu administrative region], *on m'a envoyé le message que je puisse envoyé* [sic] *son héritier p.c.q.* [sic] *j'ai aussi doit de donner un candidat pour héritier c'est alors que j'ai envoyé Kayamba Kindjingu à 1935 pour remplacer Keza. Il y a un de mes oncles qui l'avait accompagné. Ce dernier est de la génération Ndeke. C'est lui qui a copié le masque Mbambi qu'il avait vu dans le Bandundu. Arrivé dans le Kasai* [region], *il l'a imité et l'a donné le nom de Kingandanganda. Ce masque ne dancait que la nuit au clair de la lune. Mbolokoto n'intervenait jamais pour divertir l'attention des spectateurs. Donc Mbambi est d'origine de Bandundu. En outre, Mbolokoto n'est pas de notre origine. Je l'avait en de mon père Ngulungu* [on the Kasai River]" (personal communication). Because the Eastern Pende practice positional succession, each successive holder of a title takes the name of the title, which is also the name of the village. Consequently, the chief always speaks in the first person, even when he is referring to one of his predecessors.

What appears to have happened is that when the people of Kikunga-Tembo sent a candidate in 1935 to inherit the position of paramount chief in the Keza clan, one of the visiting Eastern Pende in the entourage saw a performance of MBAMBI and then reintroduced it at home as an entertainment mask, distinct from the village masks danced for ritual purposes. The name KINGANDANGANDA that he gave to it refers to something that has an insignificant form.

In the opposite direction, during the negotiations over the choice of candidate, a visiting Central Pende from the village Ndumbi a Gabunda witnessed a performance of the mask MBOLOKOTO at Kikunga-Tembo. He later appropriated the form of MBOLOKOTO, removing it from its ritual context among the Eastern Pende, to provide an exotic, scary distraction during the construction of MBAMBI. In letters to de Sousberghe, Donatien Tukweso confirms the ties of the village Ndumbi a Gabunda to the Keza and Kisamba clans (17 Sept. and 24 Nov. 1958). The story of MBAMBI and MBOLOKOTO illustrates how masks could move on occasion between the Central and Eastern Pende.

Eastern Pende field associates at Ndjindji clarify another point. In the Samba clan, Kombo-Kiboto is paramount chief, but at one time a subordinate chief on the Kasai River, Ngulungu, gathered great power. (Frobenius met one of the chiefs of Ngulungu.) Technically, the mask PUMBU can only belong to a paramount chief; however, in order to honor him, Kombo granted Ngulungu the form of his mask PUMBU but told him to call it MBOLOKOTO. A son of one of the chiefs Ngulungu eventually inherited at Kikunga-Tembo, and Ngulungu gave him the right to introduce the mask into his chiefdom.

19. Based on interviews at the state festival of 1958, Donatien Tukweso wrote to de Sousberghe that *"Bwando-Gambembo tient l'originalité de Mbambi à Ndumbi."* His maternal nephew Gibau-Kianza had taken charge and was aided by his own nephew, Pulu (letter dated 26 Oct. 1958). Tukweso photographed Gibau and Pulu at Gungu in 1958 (de Sousberghe 1959: fig. 104).

20. Tukweso photographed a MBAMBI with arms in 1958 that was performed under the supervision of Gibau-Kianza and Pulu (de Sousberghe 1959: fig. 102). Tukweso described for de Sousberghe how the top section of MBAMBI was made flexible so that four to six men concealed inside were able to make the top sway back and forth by shaking the base from within (26 October 1958). At Gungu in 1989, I did not observe this more complicated mode of construction.

21. *"Figure importante. Homme à deux tètetes* [sic] *. . . arrive en dansant très lourdement. Est affublé de beaucoup de tissus (indigènes) pour augmenter son volume. S'assied au*

milieu auprès du chef. Porte un couteau au dos; a en main un arc et trois [flèches?]. Doit effrayer les enfants et les femmes quand il arrive; Femmes et enfants fuient; seuls les hommes restent" (Musée Royal de l'Afrique Centrale [Africa-Museum], Section Ethnographique, amended list of Charles Delhaise appended to dossier no. 538 [F. Wenner]). De Sousberghe comments on this list (1959: 33 n. 1).

22. *"Mbuya ya mambuta; gukena gu'enji gulatulu mu lulendo ula Mazaluzalu."*

23. See Van Coppenolle and Pierson 1982: 110. René Pierson made this important collection of stories around Kilembe from 1938 to 1946, when he opened sixty rural schools.

24. *". . . enfants en grand nombre, bien gros, bien gras, tous esclaves . . ."* (Van Coppenolle and Pierson 1982: 112).

25. De Sousberghe, field notebook 22.

26. Colonial officials monitored men's societies very closely. One report from 1938 asserts that the *mungonge* had spread through concessions among the Pende and that its northern frontier at that date was found at Kilembe (Archives Historiques de la Zone de Gungu, Dossiers Politiques, report "Secte du Mungonge," dated 20 Apr. 1938, by Territorial Administrator Van Neer, p. 1). De Sousberghe records that the *mungonge* was introduced into Kilembe, in the heart of the Central Pende, in 1935–36. It reached the northern frontier around Idiofa by 1937. In 1947, it was still popular enough in the north for the state to ban it to prevent men who harvested nuts for the palm oil factories from missing a week of work during initiations (field notebook with reports from the Archives de Tshikapa, p. 105 and facing page). My own fieldwork corroborates a Central Pende introduction of both the male and the female societies in the 1930s. Kodi concurs. One of his sources suggests that Pende on the southern frontier began to appropriate the rite just before the Chokwe invasion (1976: 332).

The secular nature of the society for the Pende is under-scored by contrasting their attitudes with those of the Aluund (Lunda) of Mwaat Kombaan. In 1989, every former practitioner whom I interviewed of the *mungong* and its female counterpart, *tshiwil*, told me that as Christians (particularly Kimbanguists) they would never consider performing the rites precisely because of their religious content. Many were reluctant to speak of them or to trace the drawings because of their performative nature. Ironically, Pende willingness to perform in public has led scholars to overemphasize the place of the societies in their cultural life (de Sousberghe 1956; de Heusch [1972] 1982; Bastin 1984a).

27. De Sousberghe photographed a performance of Nyoga at Ngashi in 1956 (1959: figs. 59–62).

28. There is a vague allusion to this in de Sousberghe 1959: 58. Without specifying his sources, Mudiji asserts that the danced serpents represent pythons, a religious symbol for the *njinda* sect ca. 1939 (1983: 39–40). Closely related sects and antisorcery movements spread like wildfire across the Kasai and Kwilu provinces in the late 1920s and were particularly strong in the early 1930s among the Pende west of the Kwilu River. It is not always easy to distinguish them, as they tended to merge with each other. Nevertheless, it appears that serpent imagery was central to the Lukusa cult (a variant on the widespread Lukoshi), which found followers among the Mbuun and Pende in the early 1930s (Vansina 1973: 64–67; Sikitele 1986: 967). Adherents kept snakes that were supposed to have the faculties of speech and of metamorphosis into men (Sikitele 1986: 967). No one mentions a special dance, but it is quite common for one to exist in such movements. There is good evidence that the Njinda (or Nzinda) cult referred to by Mudiji was operating well before the Pende revolt of 1931 and was centered on a wooden power object rather than snakes (Sikitele 1986: 957 ff.). The historian Sikitele writes that because the Pende fear snakes, they experimented only briefly

with Lukusa, but that its concern with liberating the country from the Belgians was absorbed into the Njinda movement (1986: 970–71).

29. Territorial Administrator Charles Delhaise was the first to describe (in 1924) GANGONGA and PAGASA, masks belonging to the *mafuzo* category (Musée Royal de l'Afrique Centrale [Africa-Museum], Section Ethnographique, dossier no. 433, pp. 2–3). At some later date, he added another from this group, GINZENGI, in an addendum to the list and actually sent examples of the PAGASA and GINZENGI masks to Belgium through his superior, F. Wenner (Musée Royal de l'Afrique Centrale [Africa-Museum], Section Ethnographique, dossier no. 538). The museum owns both the GINZENGI (MCB 32.525) and the PAGASA (MCB 32.532) masks. De Sousberghe pictures the latter (1959: fig. 58).

Territorial Administrator Bomans was the first to record (in 1941) the existence of a subcategory of *"redoubtable"* masks that appear at twilight on the fringe of the village to close the masquerade (de Sousberghe 1959: 38). De Sousberghe wrote that he himself only learned of the category during his second research trip, 1955–57, when one could occasionally hope to see performances by GINZENGI and MBUNGU. He learned of MBAMBI in 1958 (1959: 39). In the category of *"masques redoutables,"* de Sousberghe lists GINZENGI, MBUNGU, PAKASA, and MBAMBI (1959: 56–57). He knew of KOLOMBOLO, GANGONGA, and NYOKA but did not realize that they were also classed in the same group (1959: 35, 47–48, 58).

Muyaga Gangambi was the first to identify the subcategory of village masquerading by its indigenous name *(mbuya jia mafuzo)* and to list a lion's share of the masks included in it (1974). Ndambi Mun'a Muhega describes some of these masks (1975).

30. Since they have become rare, the transformation of the *mafuzo* into a category of ominous apparitions has led to some confusion. As already mentioned, many Pende dismiss them today as "masks of sorcery." Others sometimes extend the sense of "ominous apparition" to masks of very different history and import. For example, the Abbé Mudiji positions Pende masks on a chart by classifying the masks as recent or primordial; as ordinary or frightening *("effrayant" or "mafúzó")* (1989: 66). He then collapses GIWOYO, PUMBU, and FUMU into the same category as GINZENGI and MBUNGU (67) even though there is nothing blown for the first three and they were never promulgated by concessions. Because PUMBU is accompanied by armed helpers, it is not uncommon for nonspecialists today to hesitate about whether or not the mask should be included among the *mafuzo.* Mudiji's inclusion of GIWOYO and, in particular, FUMU (the chief) is more eccentric. The abbé's argument, as he himself foresaw, demonstrates the dangers of doing structural analysis before a thorough history.

31. De Sousberghe assumed that because the *mafuzo* masks were cloaked in greater secrecy and because they were disappearing they were *"de vieux masques traditionnels"* (1959: 39). Without disclosing his criteria for doing so, Mudiji assigns the entire *mafuzo* category to the *"primordial"* (1989: 67–68). As noted above, these assumptions are not supported by associates in the Gatundo and northern regions.

Because the *mafuzo* masks were run in their heyday as concessions and because the masks have since become embroiled in rumors of sorcery, I found that it was critical to interview the remaining men who were actively involved with their manufacture or presentation. In contrast to the other village masks, there is a noticeable gulf between the testimony of the presenters and of the audience. Ndambi Mun'a Muhega's book is an example of a text that draws entirely on audience beliefs (1975).

Men involved in the manufacture or presentation of the masks universally insisted on a sharp correlation of the *mafuzo* category with two age grades: the Mingelu and the Mapumbu-

lu. They certainly did not consider them to belong to the oldest cadre of masks predating immigration from Angola.

32. For example, Sh'a Biele (NJIAMBA) at Ngunda; Kangu (GIHUNDUNDU) at Ngunda; and the last GANGONGA dancers at Nianga-Kikhoso. After a long lapse, the professional dancer Khoshi Mahumbu, a Solomogo initiated in 1946, has reclaimed GINZENGI for performance abroad and at state festivals because its dance is suited to his increasing years. He has also found that it is a big hit with foreigners. Khoshi learned it from the aged Sh'a Nango Ginua, a Pumbulu, who in turn learned it from the man who introduced the mask to Nyoka-Munene: Gitshiola Manango of the Mingelu age grade. PAGASA has likewise been reclaimed by younger dancers for state festivals.

33. Delhaise gives an excellent description of GATUA ULU's dance in 1924 (Musée Royal de l'Afrique Centrale [Africa-Museum], Section Ethnographique, dossier no. 433, p. 2).

34. "Le Blanc a trouvé les Mingelu déjà circoncis, tandis que nous autres les Maphumbulu, nous ne l'étions pas encore. Nous avons été circoncis en présence du Blanc; et c'est nous qui avons circoncis les Ndende" (in Sikitele 1986: 1211).

35. Sikitele dates the Mapumbulu initiation earlier, ca. 1910–12. He writes that circumcision of this age grade was under way when the first colonial administrators appeared with military escort. These soldiers were called mapumbulu, a word that recalls pombeiros, the armed Luso-African traders who traveled in caravans in the interior of Angola during the slave trade (1986: 771, 1204 n. 5). It can take five or more years for initiation camps to circulate within a region and there are always stragglers. Sikitele worked primarily among the Kwilu Pende. My own research largely supports de Sousberghe's estimate of ca. 1918–19 (1955d: 82). I found that the Central Pende from Nianga-Kikhoso north to Lake Matshi uniformly associate the Mapumbulu with World War I. They refer to specific

individuals conscripted out of the camps or drafted after graduation. Some note that the age grade originally called itself "Mbunda" but renamed itself as "soldiers" (pl. mapumbulu) due to the conscriptions. This evidence suggests an adjusted estimate, ca. 1916–19.

36. "Quand j'arrive sur la hauteur qui domine la vallée de la Lutshima, je vois au loin tous les villages qui se vident de leurs habitants emportant tout leur fourbi: poules, chèvres, cochons. Inutile d'aller chez eux: je ne verrais personne. Je modifie mon itinéraire et à l'improviste je me présente dans un hameau de Moansa. Fuite générale et éperdue. . . ."

37. "Un infirmier (ndombi) vociférait dans le village: 'Demain au premier chant du coq, vous laverez avec de l'eau chaude vos coups [sic], vos têtes et tout votre corps. Car Le Blanc ne touche pas la saleté des Noirs.' Les gens couraient vers la rivière pour couper des feuilles appelées en pende 'mienge,' en guise de savon. Vers deux heures du matin, les gens mettaient de l'eau dans des pots en terre cuite et faisaient bouillir de l'eau, en vue d'enlever la graisse du cou et de la tête. Maman m'écorchait pratiquement le cou avec des feuilles plongées dans de l'eau chaude. Si votre cou est sale, vous payez une amende."

38. Archives Historiques de la Zone de Gungu, Dossiers Politiques, letter dated 20 May 1922 to Luebo from Territorial Administrator Frings (approved June 1922).

39. For similar testimonies, see Gusimana 1970b: 63; Sikitele 1986: 1216–17.

40. Raingeard 1932: 23; Sikitele 1986: 542, 557. The investigations following the 1931 rebellion also brought out such excesses as dishonest scales, forced contracts, and regular acts of personal sadism, such as rape, throwing hot pepper in the eyes, and rubbing people with excrement (Raingeard 1932: 35; Sikitele 1986: 563 ff.). Dr. Raingeard, speaking generally for the

Kwango, believed that unrestrained commercial practices were responsible for increased malnutrition and illness by diverting too much labor from agriculture (44).

41. Sikitele has collected an ironic celebration of the completion of a stretch of road to Kikanji:

Mutumba a Ngolo weza gu Kikanji!
Ndombi ya Munganga ize ingutagane. (1986: 1202)

The automobile of Territorial Agent Lombaerde has come to Kikanji!
Now may a nurse [use the road to] come take care of me.

42. Although agricultural quotas were largely intended for men, indigenous labor distribution (plus the stress on men elsewhere) meant that a lion's share of the work fell on women, with the exception of the planting and harvesting of palm groves.

43. Theoretically, officials were supposed to pressure chiefs to provide a certain number of boys. However, resistance to conscription remained strong until the mid-1940s. One territorial agent admitted to his superiors in 1922: *"S'il fallait ici se former au volontariat, il serait impossible de fournir un seul homme"* (in Sikitele 1986: 787). My own fieldwork supports Sikitele, who includes some graphic personal testimony (1986: 1265, 1270).

44. The Huileries du Congo Belge (hereafter HCB) opened in 1911 and began to recruit workers among the Pende in 1921 for its plantations at Lusanga (Leverville), more than 200 kilometers from the Pende frontier. Because the conditions were execrable and the pay was poor, they had little success. In an extraordinary move, the District of the Kwango in 1923 made territorial officials directly responsible for providing workers for HCB in exchange for a premium. One of the measure's sup-

porters argued that this aid was already furnished unofficially and without remuneration: *"Que ce travail actuellement, par un doux euphémisme, est appelé 'aide légal efficace' et que d'autre part il est intimement lié au recensement des populations"* (Sikitele 1986: 593). Thereafter, territorial agents and their soldiers traveled regularly with recruiters (Sikitele 1986: 585, 1237; Kodi 1976: 404–5). By preference, however, they pressured chiefs (with promises of premiums and under threat of flogging and arrest) to do the dirty work for them (Sikitele 1986: 590–91).

In response, a disgusted territorial administrator complained in 1925 that the colonial official had become *"un véritable marchand d'hommes"* (quoted in Orts 1930: 17). Abuses were so flagrant by 1926 that the colonial government ordered territorial agents to abstain from recruitment, but it had to back off due to vociferous complaints from the HCB (Sikitele 1986: 595 ff.). A report of 1930 confirmed that the District of the Kwango was unique in permitting territorial agents to travel with HCB recruiters (596). The Kwilu Pende and those in the south bore the brunt of this activity because they do not have substantial palm groves of their own, unlike the Central Pende. Oppressive HCB recruiting was the single most important factor leading to the Pende rebellion of 1931 in these very regions.

45. The history of colonial attitudes toward circumcision has yet to be written. In a groundbreaking article based on colonial discourse in the 1920s and early 1930s, Nancy Hunt outlines Belgian concern regarding depopulation and the incentives used to encourage African women to give birth in maternity wards, to change their patterns of breast-feeding, etc. (1988). Although I did not investigate the subject at length, my field associates attributed women's use of maternity wards and the circumcision of boys as infants in the 1930s to coercive force and the threat of fines. It may be that their entire memory is

colored by the compulsion used for so many other things. Or it may be that individual missionaries and officials overstepped the law. For example, there are documented cases in the 1920s where missionaries threatened recalcitrant villages with state involvement and arrests if they did not provide boys for school and catechism training (Sikitele 1986: 857 ff.). Kodi records that the state began interfering seriously with the men's fraternity after the Pende revolt of 1931. Missions that wished to do away with the boys' initiation began to insist on circumcising male infants at birth during this period (1976: 329 n. 1).

46. "*Ceux qui ne clôturaient pas leurs maisons, étaient arrêtés, jetés en prison et soumis à une lourde amende. On dirait que tous les Blancs qui venaient dans les villages cherchaient à nous exploiter ou à tirer profit. Ainsi le médecin nous imposa le travail des cabinets. . . . Quand on ne construsait pas son cabinet, on payait une amende; quand on ne faisait pas sa plaine, on payait une amende; quand on ne clôturait pas sa maison, on payait une amende et quand on n'avait pas d'argent pour payer l'amende, on était arrêté et acheminé, corde au cou, au Territoire où on était jeté en prison.*"

47. The era of the imposition of colonial rule tends to be understudied by historians, especially for those peoples living in the savanna belt of Zaïre. I am exceedingly grateful to Professor Jan Vansina for sending me a copy of Sikitele's encyclopedic dissertation (1986) on this subject.

48. I thank historian Joseph Miller for bringing this work to my attention.

49. "*. . . univers redoutable. Lieu potentiel de 'devoration.' . . . il pouvait aussi être converti en espace de protection individuelle, dans des situations dangereuses*" (Mbembe 1991: 102).

50. "*. . . la violence coloniale ne toucha pas seulement l'espace physique au sein duquel évoluait l'autochtone. Elle*

toucha aux fondements mêmes de son imaginaire" (Mbembe 1991: 119).

51. Siegfried Kracauer provides an early model of how populations may use popular entertainment for indirect commentary on repressive regimes in his study of frothy Offenbach operettas (1938).

52. "*. . . à se tenir obstinément à l'écart de tout européen*" (Congo/Zaïre Archives, Northern [Flemish] Belgian Province of the Society of Jesus, box 15/2, folder 2: P.C. Varia N 25, Historia Missionis Congolensis [Vicariatus Apostolicus Kwangensis—EE. DD. Van Hée, S.J.], signed J. Hamerlinck [1931?]).

53. "*. . . son autorité est grande, il se procure ce qu'il veut et quand il veut. Le village de Mukedi est pour lui sa salle de danse et sa brasserie, il a à son service une trentaine de danseurs 'MINGANJI.' On danse exactement t.l.j.—près du lupangu [enclosure] du chef. Les hommes adultes et valides sont ses pourvoyeurs de vin de palme.*

"*La vie à Mukedi se résume par danser et vin de palme, le chef médaillé règle cette vie.*

"*P.S. Je souligne qu'on danse indistructement [sic] t.l.j.*" (Archives Historiques de la Zone de Gungu, Dossiers Politiques, dossier Sefu-Zamba, letter dated 29 Jan. 1945 to the territorial administrator of the Bapende, signed by Territorial Agent Cabiaux).

54. For an overview, see Barber 1987.

CONCLUSION: THE ROLE OF THE AUDIENCE IN INVENTION AND REINVENTION

1. Much of this chapter was published in Strother 1995c.

2. "*Gu malu guamuleluga!*" "*Itshi wahatshi mu sambu?*" "*Wajiya sha!*"

3. Filmmakers have long attempted to use previews to recap-

ture some of the freedom of television producers (or play-wrights like August Wilson) to respond to audience reaction. Lawrence Levine recounts several examples of acclaimed directors who made substantive changes in response to the preview reception of their films (1993: 316–17). In a famous recent example, initial preview disappointment was responsible for a drastic reworking of the ending to the film *Pretty Woman.*

4. Allen F. Roberts analyzes in depth a related witticism, "System D," which also refers to the creativity and necessity of hustling in a chaotic economy (1996). I am grateful to the author for sharing his manuscript.

5. Many commentators confuse mass audience with *proletarian* audience. In fact, although "high" art forms often do not appeal to the masses because they require a specialist education, "popular" art forms are consumed by everyone, although in some cases their generation may be localized to a particular class or segment of society. Consider television, opera in its heyday, or comic books. Does the Beatles' audience know social class?

6. I am not arguing that Central Pende masqueraders "influence" painters, or vice versa, but that both practices emerge from a shared cultural matrix. Susan Vogel has come to a similar conclusion: "Like nineteenth-century traditional art, virtually all strains of twentieth-century African art are client or market driven. . . . Today, the interaction between African artist and patron in general continues the traditional relationship between artist and client, and between the artist and the work" (1991: 20–21).

BIBLIOGRAPHY

A. ARCHIVES

Archives Historiques de la Zone de Gungu, Gungu, Zaïre. Dossiers Politiques.

Congo/Zaïre Archives. Northern (Flemish) Belgian Province of the Society of Jesus (Jesuits), Brussels, Belgium.

de Sousberghe, Léon, S.J. Personal records, field notebooks (including copies of lost archival documents), letters. Brussels, Belgium.

Enns, Frank J. Photographs by Frank J. Enns of the Eastern and Central Pende during his career as a missionary in Zaïre, 1926–69. Katharine Enns collection, Buhler, Kansas, United States.

Institut des Musées Nationaux du Zaïre, Kinshasa, Zaïre. Photo archives.

Jesuit Collection, Heverlee, Belgium. Accession file on statue 2322 ("Nzinda").

Musée Royal de l'Afrique Centrale (Africa-Museum), Tervuren, Belgium. Section Ethnographique. Archives. Dossiers ethnographiques. Fonds ethnographiques. Photo collection.

Royal Anthropological Institute, London, United Kingdom. Photo Archives. Photos taken by H. W. Hilton-Simpson on Emil Torday's expedition, 1907–9. Copy of Hilton-Simpson's expedition journal.

Université Libre de Bruxelles, Belgium. Département d'Histoire d'Art. Slide library: Léon de Sousberghe's field slides from the 1950s (copies are available for study at the Eliot Elisofon Photographic Archives of the National Museum of African Art, Smithsonian Institution, Washington, D.C.).

Voix du Zaïre, Kinshasa, Zaïre. Photothèque. Inherited the photo archives of the colonial Congopresse.

B. WORKS ON THE PENDE OF ZAÏRE

"Arts et sauvagerie." 1930. *L'Illustration Congolaise* (Brussels), no. 104 (1 May): 2974.

"At the Beginning." 1982. *AIMM* [Africa Inter-Mennonite Mission] *Messenger* 49, no. 5 (Dec.).

Bastin, Marie-Louise. 1961. "Un masque en cuivre martelé des Kongo du nord-est de l'Angola." *Africa-Tervuren* 7, no. 2: 29–40.

"Bâtons de Chef Bapende." 1932. *L'Illustration Congolaise* (Brussels), no. 131 (1 Aug.): 4171.

Beckers, J. 1925. "L'ermite de Kilembe fait ses adieux à la solitude." *Missions Belges de la Compagnie de Jésus,* 27ᵉ année: 56–60.

Bengo Meya-Lubu. 1982. "Portrait du groupement Kipindji." Manuscript.

Bertsche, James E. 1965. "Congo Rebellion." *Practical Anthropology* 12, no. 5 (Sept.–Oct.): 210–26.

Biebuyck, Daniel. 1985. *The Arts of Zaire.* Vol. 1, *Southwestern Zaïre.* Berkeley and Los Angeles: University of California Press.

Bittremieux, L. 1938. "De inwijking der Baphende's." *Congo, Revue Générale de la Colonie Belge* (Brussels), 19ᵉ année, tome 1, no. 2 (Feb.): 154–67.

———. 1939. "De Baphende's van Luanda (Opper-Kasai)." *Congo, Revue Générale de la Colonie Belge* (Brussels), 20ᵉ année, tome 1, no. 2 (Feb.): 153–81.

———. 1940. "Een verhaal van de Baphende." *Congo, Revue Générale de la Colonie Belge* (Brussels), 21ᵉ année, tome 1: 150–53.

Bourgeois, Arthur P. 1990. "Helmet-Shaped Masks from the Kwango-Kwilu Region and Beyond." *Iowa Studies in African Art* 3: 121–36.

Brasseur, M. 1954. "La protection de la mère et de l'enfant dans la formation médicale de Kitangua." *L'Aide Médicale aux Missions,* 26ᵉ année, no. 4 (Oct.): 140–47.

Brett-Smith, Sarah. 1983. "The Doyle Collection of African Art." *Record of The Art Museum, Princeton University,* 42, no. 2.

Butaye, Omer. 1929. "Mariages entre barbus et bébés." *Revue Missionnaire des Jésuites Belges* (Louvain) 3 (Oct.–Nov.): 392–94.

Comhaire-Sylvain, Suzanne. 1949. "Proverbes récueillis à Léopoldville." *Zaïre* (Brussels) 3, no. 6 (June): 629–47.

De Carolis. 1930. "Us et coutumes indigènes: La circoncision." *Le Conseiller Congolais,* 3ᵉ année, no. 1 (Feb.): 47–48.

de Heusch, Luc. 1955. "A propos d'une mise en question par le P. de Sousberghe des thèses de M. Cl. Lévi-Strauss." *Zaïre* (Brussels) 9, no. 8 (Oct.): 849–61.

———. 1982 [1972]. *The Drunken King.* Trans. Roy Willis. Bloomington: Indiana University Press.

Delaere, Jacques. 1942–45. "*Nzambi-Maweze:* Quelques notes sur la croyance des Bapende en l'Être suprême." *Anthropos* 37–40: 620–28.

———. 1946. "A propos des cousins croisés." *Bulletin des Juridictions Indigènes et du Droit Coutumier Congolais* (Elisabethville), 14ᵉ année, no. 11 (Sept.–Oct.): 347–66.

de Pierpont, Ivan. 1919a–d. "Mission du Kwango: Journal de voyage du Père Ivan de Pierpont, S.J." *Missions Belges de la Compagnie de Jésus,* 21ᵉ année. a) (June): 82–90; b) (Oct.): 197–200; c) (Nov.): 221–25; d) (Dec.): 247–50.

———. 1919e–f. "Dans la Brousse: Lettre du P. Ivan de Pierpont, S.J." *Missions Belges de la Compagnie de Jésus,* 21ᵉ année. e) (Sept.): 174–75; f) (Oct.): 195–97.

———. 1920a–d. "Journal de voyage du Père Ivan de Pierpont." *Missions Belges de la Compagnie de Jésus,* 22ᵉ année. a) (Jan.): 23–26; b) (Feb.): 49–53; c) (Mar.): 77–78; d) (Apr.): 102–7.

———. 1921a–c. "Journal de voyage du Père Ivan de Pierpont." *Missions Belges de la Compagnie de Jésus,* 23ᵉ année. a) (Aug.): 239–41; b) (Sept.): 265–70; c) (Oct.): 297–304.

———. 1921d. "Quelques Croquis Congolais: Extraits d'une lettre du P. Pierpont." *Missions Belges de la Compagnie de Jésus,* 23ᵉ année (Dec.): 349–53.

———. 1923. "Journal de voyage du P. de Pierpont." *Revue Missionaire des Jésuites Belges* (Louvain), pp. 293–94.

———. 1924. "Note documentaire sur la mission de Kikwit." *Missions Belges de la Compagnie de Jésus,* 26ᵉ année: 438–42.

———. 1925a–b. "Journal du P. I. de Pierpont." *Missions Belges*

de la Compagnie de Jésus, 27ᵉ année [June or later]: a) 445–50; b) 491–95.

———. 1926a–b. "Mission du Kwango: Journal du P. I. de Pierpont." Missions Belges de la Compagnie de Jésus, 28ᵉ année. a) (Jan.): 31–36; b) (Feb.): 63–69.

de Sousberghe, Léon. 1954a. "Cases cheffales sculptées des Ba-Pende." Bulletin de la Société Royale Belge d'Anthropologie et de Préhistoire 65: 75–81, plus eight pages of illustrations.

———. 1954b. "Étuis péniens ou gaines de chasteté chez les Ba-Pende." Africa 24, no. 3 (July): 214–19.

———. 1954c. "Pactes d'union dans la mort ou pactes de sang chez les Bapende et leurs voisins." Zaïre (Brussels) 8, no. 4 (Apr.): 391–400.

———. 1955a. "L'étude du droit coutumier indigène: Méthode et obstacles." Zaïre (Brussels) 9, no. 4 (Apr.): 339–58.

———. 1955b. "Forgerons et fondeurs de fer chez les Ba-Pende et leurs voisins." Zaïre (Brussels) 9, no. 1 (Jan.): 25–31.

———. 1955c. "Les frères de belles-mères dans les sociétés du Kwango et l'interprétation des structures de parenté." Zaïre (Brussels) 9, no. 9 (Nov.): 927–42.

———. 1955d. Review of La tradition historique des Bapende orientaux, by Dr. G. L. Haveaux. Zaïre (Brussels) 9, no. 1 (Jan.): 79–83.

———. 1955e. Structures de parenté et d'alliance d'après les formules pende. Académie Royale des Sciences Morales et Politiques, Mémoires in-8°, n.s., vol. 4, fasc. 1 (Ethnographie). Brussels.

———. 1956. Les danses rituelles mungonge et kela des ba-Pende (Congo belge). Académie Royale des Sciences Coloniales, Classe des Sciences Morales et Politiques, Mémoires in-8°, n.s., vol. 9, fasc. 1 (Ethnographie). Brussels.

———. 1958a. "Découverte de 'tours' construites par les Pende sur le Haut-Kwango." Bulletin de l'Académie Royale des Sciences Coloniales, Classe des Sciences Morales et Politiques, n.s., tome 4, séance 12: 1334–45.

———. 1958b. "Régime foncier ou tenure des terres chez les Pende." Bulletin de l'Académie Royale des Sciences Coloniales, Classe des Sciences Morales et Politiques, n.s., tome 4, séance 12: 1346–52.

———. 1959. L'art pende. Académie Royale de Belgique, Mémoires in-4°, 2d ser., vol. 9, fasc. 2. Brussels.

———. 1960a. "Cases cheffales du Kwango." Congo-Tervuren 6, no. 1: 10–16.

———. 1960b. "De la signification de quelques masques pende: Shave des Shona et Mbuya des Pende." Zaïre (Brussels) 14, nos. 5–6: 505–31.

———. 1960c. "Noms donnés aux Pygmées et souvenirs laissés par eux chez les Pende et Lunda de la Loange." Congo-Tervuren 6, no. 3: 84–86.

———. 1961a. Deux palabres d'esclave chez les Pende (Province de Léopoldville, 1956). Académie Royale des Sciences d'Outre-mer, Classe des Sciences Morales et Politiques, Mémoires in-8°, n.s., vol. 25, fasc. 5 et dernier. Brussels.

———. 1961b. "Un masque Tshokwe de Cucumbi (Haut-Kwango, Angola)." Africa-Tervuren 7, no. 3: 85–87.

———. 1963. Les Pende: Aspects des structures sociales et politiques. Musée Royal de l'Afrique Centrale, Classe des Sciences Humaines, Annales, série in-8°, no. 46. Tervuren.

———. 1967. "Enfance hors-lignage et solidarité clanique dans les sociétés congolaises." Africa-Tervuren 13, no. 1: 10–14.

———. 1986. Don et contre-don de la vie: Structure élémentaire de parenté et union préférentielle. Studia Instituti Anthropos, vol. 40. St. Augustin: Anthropos-Institut.

de Sousberghe, Léon, and Jean Willy Mestach. 1981. "Gitenga: Un masque des Pende." Arts d'Afrique Noire 37: 18–29.

Enns, Frank J. 1930. "Customs of the Bampende in Nyanga Ter-

ritory. IV. Boys Initiated into Manhood." *Congo Missionary Messenger* 2 (Aug.): 8–9, 16.

Flament, E. 1940. "Totémisme." *Bulletin des juridictions indigènes et du droit coutumier congolais* (Elisabethville), 8ᵉ année, no. 7 (Jan.–Feb.): 209–11.

Frobenius, Leo. 1907. *Im Schatten des Kongostaates.* Berlin: Georg Reimer.

———. 1983 [1928]. *Mythes et contes populaires des riverains du Kasaï.* Trans. Claude Murat. Wiesbaden: Franz Steiner Verlag.

———. 1988. *Ethnographische Notizen aus den Jahren 1905 und 1906.* Ed. Hildegard Klein. Vol. 3, *Luluwa, Süd-Kete, Bena Mai, Pende, Cokwe.* Stuttgart: Franz Steiner Verlag.

Gambembo Gawiya-A-Ganzaji. 1980. "Le cadre humain de l'exploitation huilière au Kwilu: Essai d'interprétation dialectique de peuplement humain." *Africa* (Rome) 35: 99–110.

Gardi, Bernhard. 1986. *Zaïre Masken Figuren.* Basel: Museum für Völkerkunde und Schweizerisches Museum für Volkskunde.

Goertz, Henry. n.d. "History of the Acquisition of the Collection." Manuscript in the possession of the Kauffman Museum, North Newton, Kansas.

Gusimana wa Mama [Bartholomé Gusimana]. n.d. "Attributs Cheffaux des Chefs Pende." Collection Afrique, no. 15. Manuscript. Library of Congress, Washington, D.C.

———. n.d. "Dieux et déesses africains." Collection Afrique, no. 31. Manuscript. Library of Congress, Washington, D.C.

———. n.d. "Investiture des Chefs Pende." Collection Afrique, no. 12. Manuscript. Library of Congress, Washington, D.C.

———. n.d. "Les origines et guerres Pende." Collection Afrique, no. 4. Manuscript. Library of Congress, Washington, D.C.

———. 1968. "L'homme selon la philosophie pende." *Cahiers des Religions Africaines* (Jan.): 65–72.

———. 1970a. "Nzambi selon la philosophie pende." *Cahiers des Religions Africaines* (Jan.): 31–40.

———. 1970b. "La révolte des Bapende en 1931 (souvenir d'un témoin)." *Cahiers Congolais de la Recherche et du Développement* (Kinshasa), no. 4 (Oct.–Dec.): 59–69.

———. 1971. "L'homme et l'unité de la race humaine: L'origine cosmogonique de l'homme et l'unité de la race humaine selon la philosophie pende basée sur la légende de Gawiganzanza." *Revue du Clergé Africain* (Mayidi, Democratic Republic of the Congo) 26: 169–80.

———. 1972. *Dictionnaire Pende-Français.* CEEBA (Centre d'Études Ethnologiques), 3d ser., vol. 1. Bandundu, Zaïre: CEEBA.

———1979. "Les Pende: Étapes historiques." Collection Afrique, no. 51. Manuscript. Library of Congress, Washington, D.C.

———1980. "Rapports des Blancs sur la révolte des Baphendes." Collection Afrique, no. 53. Manuscript. Library of Congress, Washington, D.C.

Haaf, E., and J. Zwernemann. 1975. *Geburt-Krankheit-Tod in der afrikanischen Kunst.* Stuttgart: F. K. Schattauer Verlag.

Harris, Moira F. 1976–77. "A Pende *Mbuya* from Zaire." *Minneapolis Institute of Arts Bulletin* 63: 117–23.

Haveaux, G. L. 1954. *La tradition historique des Bapende orientaux.* Institut Royal Colonial Belge, Section des Sciences Morales et Politiques, Mémoires, Coll. in-8°, vol. 37, fasc. 1: 5–55. Brussels.

Herold, Erich. 1969. "Umění Kanžských Bapende." *Nový Orient* (Apr.): 104–5.

Hilton-Simpson, H. W. n.d. Unpublished journal from the expedition of 1907–9 to the Belgian Congo. Royal Anthropological Institute, London.

———. 1911. *Land and Peoples of the Kasai.* London: Constable & Co.

Himmelheber, Hans. 1960. *Negerkunst und Negerkünstler.* Braunschweig: Klinckhardt & Biermann.

———. 1993. *Zaire 1938/39: Photographic Documents on the Arts of the Yaka, Pende, Tshokwe, and Kuba.* Zurich: Museum Rietberg.

Hochegger, Hermann. 1981–83. *Le langage des gestes rituels.* Illustrated by Binia Binalbe and Ngana Mulwa. CEEBA (Centre d'Études Ethnologiques), 2d ser., vol. 66 (1981), vol. 67 (1982), vol. 68 (1983). Bandundu, Zaïre: CEEBA.

Hoet, Paul. 1936a. "Mikotto." *Jezuieten Missies,* no. 2 (May): 134–39.

———. 1936b. "Malafoe." *Jezuieten Missies,* no. 8 (Dec.): 287–89.

———. 1937. "De Vergiftproef." *Jezuieten Missies,* no. 9 (Jan.): 335–36.

Janzen, John M., and Kauenhoven-Janzen, Reinhild. 1975. "Pende Masks in Kauffman Museum." *African Arts* 8, no. 4 (summer): 44–47.

"Jurisprudence: Tribunal de Territoire de Gungu (Kwilu)." 1961. *Bulletin des Tribunaux Coutumiers* (Elisabethville), 29ᵉ année, no. 1 (Jan.–Feb.): 47–56. (On the Pende, see pp. 51–54.)

Keidel, Levi. 1988. "A Diviner Comes to a Zairian Village." *Mennonite Life* (Mar.): 8–12.

Kitele Sh'a Mayele. n.d.. "La sortie des Pende et la façon d'avoir un grand chef Pende." Manuscript in hands of family.

Kjersmeier, Carl. 1937. *Centres de style de la sculpture Nègre africaine.* Vol. 3, *Congo belge.* Paris: Éditions Albert Morancé.

Kochnitzky, Léon. 1952. "D'un carnet de route musical." *Jeune Afrique,* 6ᵉ année, no. 18, 3ᵉ et 4ᵉ trimestres: 26–32.

———. 1953a. "Masques géants, masques en miniature." *La Revue Coloniale Belge* 8, no. 174 (1 Jan.): 53–55.

———. 1953b. "Un sculpteur d'amulettes au Kwango." *Brousse* (Léopoldville), n.s., no. 3: cover and 9–13.

Kodi Muzong Wanda. 1976. "A Pre-colonial History of the Pende People (Republic of Zaire) from 1620 to 1900." Ph.D. diss., Northwestern University.

Kramer, Fritz. 1993. *The Red Fez: Art and Spirit Possession in Africa.* Trans. Malcolm Green. New York: Verso.

Laurenty, J. S. 1959. "Note sur un xylophone pende." *Congo-Tervuren* 5, no. 1: 16–18.

Lebeuf, Annie M. D. 1960. "Le rôle de la femme dans l'organisation politique des sociétés africaines." In *Femmes d'Afrique Noire,* ed. Denise Paulme, 93–119. Paris: Mouton & Co.

Lecomte, Jean-Marie. 1973. "Enquête sur l'agriculture traditionnelle à Kisanzi." In *Agriculture et élévage dans l'entre Kwango-Kasai,* 173–81. CEEBA (Centre d'Études Ethnologiques), 1st ser., vol. 5. Bandundu, Zaïre: CEEBA.

Lema Gwete. 1982. "Art populaire du Bandundu." In *Sura Dji: Visages et racines du Zaïre,* 51–77. Paris: Musée des Arts Décoratifs.

Lengelo Guyigisa. 1980. *Mukanda, l'école traditionnelle Pende.* CEEBA (Centre d'Études Ethnologiques), 2d ser., vol. 59. Bandundu, Zaïre: CEEBA.

Le Paige, G. 1938. "L'art et la statuaire au Kwango." *Revue de l'Aucam,* 3ᵉ année, no. 2 (Feb.): 78–85.

Loewen, Melvin J. 1972. *Three Score: The Story of an Emerging Mennonite Church in Central Africa.* Elkhart, Ind.: Congo Inland Mission.

"Le 'Lukusa' chez les Bapende-Ambunda." 1934. *L'Essor Colonial et Maritime,* 13ᵉ année, no. 16 (22 Apr.): 9.

Luyoyo, Laurent. 1957. "Il faut sauver l'agriculture du Kwango." *La Voix du Congolais* (Léopoldville) (Nov.): 848–49.

Mack, John. 1990. *Emil Torday and the Art of the Congo, 1900–1909.* Seattle: University of Washington Press.

Maes, J. 1934. "Vocabulaire des populations de la région du Kasai-Lulua-Sankuru." *Journal de la Société des Africanistes* (Paris) 4: 209–68.

———. 1935. "Le camp de Mashita Mbansa et les migrations des Bapende (d'après les observations du R. P. De Decker et des Administrateurs territoriaux Weekx et Jochmans)." *Congo, Revue Générale de la Colonie Belge* (Brussels), 16e année, tome 2, no. 5 (Dec.): 713–24.

Maesen, Albert. 1958. "Masques du Congo." *Belgique d'Outremer* (Brussels) 275: 101–4.

———. 1975. "Un masque de type 'Gitenga' des Pende occidentaux du Zaïre." *Africa-Tervuren* 21, no. 3/4: 115–16.

Maquet, Jean-Noel. 1953. "Initiation à la musique congolaise." *Jeunesses Musicales (Journal National des Jeunesses Musicales de Belgique)* 21 (Dec.): 1–3.

———. 1954a–m. "Anthologie folklorique: Initiation à la musique congolaise." *Micro Magazine*, 10e année, a) no. 462 (14 Feb.): 11–12; b) no. 463 (21 Feb.): 9–10, 26; c) no. 464 (28 Feb.): 11; d) no. 465 (7 Mar.): 9; e) no. 466 (14 Mar.): 8–9, 14; f) no. 467 (21 Mar.): 8–9; g) no. 468 (28 Mar.): 8–9; h) no. 469 (4 Apr.): 9; i) no. 470 (11 Apr.): 9–11; j) no. 471 (18 Apr.): 10–11; k) no. 472 (25 Apr.): 9–10; l) no. 473 (2 May): 9; m) no. 474 (9 May): 12, 14–15. These articles contain the texts of a series of broadcasts given on the Belgian National Radio program *Anthologie folkorique: Causeries musicales.* The series began 15 Jan. 1954. Maquet used Pende music to introduce his audience to African instruments and compositions.

———. 1954n. "Initiation à la musique congolaise: Musiciens Bapende." *Bulletin de l'Union des Femmes Coloniales,* 26e année, no. 144 (Jan.): 28–31.

———. 1954o. "La musique chez les Bapende." *Problèmes d'Afrique Centrale* (Brussels), no. 26: 299–315.

Maquet, M. 1937. "L'herminette des chefs dans le District du Kwango." *Les Arts et Métiers Indigènes dans la Province de Léopoldville,* fasc. 3 (Nov.): 1–3 and cover.

Maquet-Tombu, Jeanne. 1953. "Arts et lettres: Le sculpteur Mupende Kabamba." *Bulletin de l'Union des Femmes Coloniales,* 25e année, no. 142 (July): 16–17.

"Masques Bapende (Kasai)." 1932. *L'Illustration Congolaise* (Brussels), no. 130 (1 July): 4086, 4091.

Mathy, Rose-Marie. 1953. "Chez les Bapende, la calebasse: Ses usages et sa décoration." *Bulletin de l'Union des Femmes Coloniales,* 25e année, no. 142 (July): 17–18.

Mbonyinkebe Sebahire, U. 1974. "*Ndoki:* La croyance en la magie et la sorcellerie chez les Pende." Review of Gakodi a Gukalamuga's unpublished mémoire (Kisangani, 1972). *Cultures au Zaïre et en Afrique* (Kinshasa), no. 5: 235–40.

Milou. 1931. "Les coiffures." *L'Illustration Congolaise* (Brussels), no. 120 (1 Sept.): 3686–92.

"La Mission de Mwilambongo (Kwango) . . ." 1933. *L'Illustration Congolaise* (Brussels), no. 141 (1 June): 4524.

Mudiji Malamba Gilombe [Théodore Malamba-Mudiji; Mudiji-Malamba Gilombe]. 1969. "En lisant 'L'homme selon la philosophie pende.'" *Cahiers des Religions Africaines* (Jan.): 132–38.

———. 1979. "Le masque phende *giwoyo* du musée de l'Institut Supérieur d'Archéologie et d'Histoire de l'Art de l'Université Catholique de Louvain." *Revue des Archéologues et Historiens d'Art de Louvain* 12: 169–93.

———. 1981. "Formes et fonctions symboliques des masques *Mbuya* des Phende: Essai d'iconologie et d'herméneutique." Ph.D. diss., Université Catholique de Louvain, Louvain-la-Neuve.

———. 1983. "La forme et la *trans*-forme du masque traditionnel africain." *Revue Philosophique de Kinshasa* 1, no. 1 (Jan.–June): 25–44.

———. 1989. *Le langage des masques africains.* Kinshasa: Facultés Catholiques de Kinshasa.

Mulambu-Mvuluya, Faustin. 1971a. "Contribution à l'étude de la révolte des Bapende (mai–septembre, 1931)." *Les Cahiers*

du CEDAF (Centre d'Étude et de Documentation Africaine, Brussels), no. 1: 1–52.

———. 1971b. "La révolte des Bapende (mai–septembre 1931): Étude d'un mouvement de résistance des populations rurales congolaises à la colonisation." *Congo-Afrique* (Kinshasa) (Mar.): 115–36.

Mupende [pseud.]. 1947. "Bapende-Dansen." *Band: Algemeen Tijdschrift* (Léopoldstad-Kalina), 6^de jaargang, no. 1 (Jan.): 9–12.

Muyaga Gangambi. 1974. *Les masques pende de Gatundo.* Illustrated by Tshiamo a Muhenge. CEEBA (Centre d'Études Ethnologiques), 2d ser., vol. 22. Bandundu, Zaïre: CEEBA.

Ndambi Mun'a Muhega [Ndambi Munamuhega] 1975. *Les masques pende de Ngudi.* Illustrated by Binia Binalbe-Talo. CEEBA (Centre d'Études Ethnologiques), 2d ser., vol. 23. Bandundu, Zaïre: CEEBA.

Needham, Rodney. 1963. "Prescriptive Alliance and the Pende." *Man* (London) 63 (Apr.): 58.

Ngolo Kibango. 1976. *Minganji: Danseurs de masques Pende.* CEEBA (Centre d'Études Ethnologiques), 2d ser., vol. 35. Bandundu, Zaïre: CEEBA.

Nicolaï, Henri. 1963. *Le Kwilu: Étude géographique.* Centre Scientifique et Médical de l'Université Libre de Bruxelles en Afrique Centrale, [Publication] no. 69. Brussels.

Niyonkuru, Lothaire. 1978. "Phonologie et morphologie du Giphende." Mémoire de licence spéciale en linguistique africaine, Université Libre de Bruxelles.

Norden, Hermann. 1924. *Fresh Tracks in the Belgian Congo.* London: H. F. G. Witherby.

Nzamba Mundende. 1974. *Gandanda: Initiation et mythes pende.* CEEBA (Centre d'Études Ethnologiques), 2d ser., vol. 4. Bandundu, Zaïre: CEEBA.

Nziata Mulenge. 1974. *Mythes Pende: Pour la guérir, il faut ton coeur!* CEEBA (Centre d'Études Ethnologiques), 2d ser., vol. 9. Bandundu, Zaïre: CEEBA.

Olbrechts, Frans M. 1982 [1946]. *Congolese Sculpture.* Trans. Daniel Crowley and Pearl Ramcharan-Crowley (from the 1959 French ed.). New Haven, Conn.: Human Relations Area Files.

Palata Fulgence Duval. 1957. "'Mbuya': Le masque Tundu." *Echos de Gungu* 1 (July–Aug.): 11.

Pauwels, Jacques. 1961. "La répartition de la population dans le territoire de Gungu (Congo)." *Bulletin de la Société Royale Belge de Géographie* (Brussels), 85^e année, nos. 1–4: 89–129.

Petridis, Constantijn. 1992a. "*Gipogo* et *Pumbu a Mfumu:* Masques du pouvoir cheffal chez les Pende du Kasaï." *Rev. do Museu de Arqueologia e Etnologia* (São Paulo) 2: 75–89.

———. 1992b. "Wooden Masks of the Kasai Pende." *Working Papers in Ethnic Art* (Ghent) 6.

———. 1993. "Pende Mask Styles." In *Face of the Spirits: Masks from the Zaire Basin,* ed. Frank Herreman and C. Petridis, 62–77. Antwerp: Etnografisch Museum.

Pierot, Fabrice. 1987. "Étude ethnoarchéologique du site de Mashita Mbanza (Zaïre)." Mémoire de licence en histoire de l'art et archéologie, Université Libre de Bruxelles.

Renier, M. 1952. "Pour un essai de paysannat indigène chez les Bapende et les Basuku sur la base de plantations de bambous." *Zaïre* (Brussels) 6, no. 4 (Apr.): 363–78.

Röschenthaler, Ute. 1985. "Die Mbuya-Masken der Pende." Master's thesis, Freien Universität Berlin.

Rubin, William. 1984. "Picasso." In *"Primitivism" in 20th Century Art,* ed. William Rubin, vol. 1, pp. 241–333. New York: Museum of Modern Art.

———. 1987. "Pende Mask." In *Perspectives: Angles on African Art,* 58–60. New York: Center for African Art and Harry Abrams.

Sabakinu Kivilu. 1974. "Les sources de l'Histoire démographique du Zaïre." *Études d'Histoire Africaine* 6: 119–36.

Samaltanos-Stenström, Katia. 1987. "If 'The Wages of Sin Is Death.'" *Critica d'Arte* 52: 63–70.

Samano Joachim. 1957. "Mode de succession au pouvoir chez les Bakwa Mushinga." *Echos de Gungu* (July–Aug.): 14–15.

Schildkrout, Enid. In press. "Personal Styles and Disciplinary Paradigms: Frederick Starr and Herbert Lang in the Congo." In *The Scramble for Art in Central Africa*, ed. Enid Schildkrout and Curtis A. Keim. New York: Cambridge University Press.

Schwetz, J. 1924. "Rapport sur les travaux de la Mission Médicale Antitrypanosomique du Kwango-Kasai, 1920–23." *Société Belge de Médecine Tropicale, Annales*, vol. 3 (subsidiary report).

Scohy, André. 1952. "Savanes du Kwango." In *Étapes au Soleil*, 135–73. Brussels: Aux Éditions du Chat Qui Pêche.

Selenge Pascal Bruno. 1955. "Fable . . . de Mulikalunga (Kwango)." *La Voix du Congolais* (Léopoldville) (May): 440–42.

Sikitele Gize a Sumbula [Sikitele Gize]. 1973. "Les racines de la révolte pende de 1931." *Études d'Histoire Africaine* (Université Nationale du Zaïre at Lubumbashi) 5: 99–153.

———. 1976. "Les causes principales de la révolte pende en 1931." *Zaïre-Afrique* (Kinshasa) 16: 541–55.

———. 1986. "Histoire de la révolte pende de 1931." 3 vols. Ph.D. diss., Université de Lubumbashi.

Sohier, Jean. 1955. "Reflexions d'un juriste sur 'L'étude du droit coutumier' par le R. P. de Sousberghe." *Bulletin des Juridictions Indigènes et du Droit Coutumier Congolais* (Elisabethville) 23 (Sept.–Oct.): 108–22.

Stappers, Leo. 1953. "De toongroepen en hun wijzigingen in de taal van de Aphende." *Kongo-Overzee* (Antwerp) 19, no. 4: 376–79.

Strother, Z. S. 1992a. Caption essays on Pende art for *Kings of Africa*, ed. Erna Beumers and Hans-Joachim Koloss, 316–17. Maastricht: Foundation Kings of Africa.

———. 1992b. "Inventing Masks: Structures of Artistic Innovation among the Central Pende of Zaïre." Ph.D. diss., Yale University.

———. 1993. "Eastern Pende Constructions of Secrecy." In *Secrecy: African Art that Conceals and Reveals*, ed. M. Nooter, 156–78. New York: Center for African Art.

———. 1995a. Caption essays on Pende art for *Africa: The Art of a Continent*, ed. Tom Phillips, 262–63. Munich: Prestel.

———. 1995b. Caption essays on Pende art for *Treasures from the Africa-Museum (Tervuren)*, ed. Gustaaf Verswijver et al., 312–14. Tervuren: Royal Museum for Central Africa.

———. 1995c. "Invention and *Reinvention* in the Traditional Arts." *African Arts* 28 (spring): 24–33, 90.

———. 1996. "Suspected of Sorcery." In *In Pursuit of History: Fieldwork in Africa*, ed. Carolyn Keyes Adenaike and Jan Vansina, 57–74. New York: Heinemann.

Struyf, P. 1931. "Migration des Bapende et des Bambunda." *Congo, Revue Générale de la Colonie Belge* (Brussels), 12e année, tome 1, no. 5 (July): 667–70.

Torday, Emil. 1913. *Camp and Tramp in African Wilds*. London: Seeley, Service, & Co.

Torday, Emil, and Joyce, T. A. 1907. "On the Ethnology of the South-Western Congo Free State." *Journal of the Royal Anthropological Institute* 37: 133–56, plates 17–20.

———. 1922. *Notes ethnographiques sur les populations habitant les bassins du Kasai et du Kwango oriental*. Musée du Congo Belge, Ethnographie, Annales, 3d ser., vol. 2, fasc. 2. Tervuren.

Van Coppenolle, Renée, and Pierson, René. 1982. *Bapende: Contes—Legendes—Fables*. Ottignies: Éditions J. Dieu-Brichart.

Van de Ginste, Fernand. 1946. "Anthropometric Study on the

Bapende and Basuku of the Belgian Congo." *American Journal of Physical Anthropology,* n.s., 4, no. 2 (June): 125–51.

Vanden Bossche, Adrien. 1950. "La sculpture de masques Bapende." *Brousse* (Léopoldville), no. 1: 11–15.

Vanden Bossche, Jean. 1950. "Le film au service de l'ethnographie." *Brousse* (Léopoldville), no. 1: 5–8.

———. 1954. *Sectes et associations indigènes au Congo Belge.* Léopoldville-Kalina: Éditions du Bulletin Militaire Force Publique.

———. 1966 [1951]. "L'art plastique chez les Bapende." In *L'art nègre,* 143–47. Paris: Présence Africaine.

Van Impe, G. 1950. "Een kijkje bij de Bapende." *Band: Algemeen Tijdschrift* (Leopoldstad-Kalina), 9ᵈᵉ jaargang, no. 11 (Nov.): 424–25.

Verhaegen, Benoît. 1966–69. *Rebellions au Congo.* 2 vols. Brussels: Centre de Recherche et d'Information Socio-politiques (CRISP).

Verly, Robert. 1959. "L'art africain et son devenir." *Problèmes d'Afrique centrale,* 13ᵉ année, no. 44: 145–51.

Volprecht, Klaus. 1972. *Sammlung Clausmeyer Afrika.* Cologne: E. J. Brill.

Vunda, Aaron-René. 1953. "Kiyilu, jeune homme stupide: Un conte des Bapende de Kitombe (Kwango)." *La Voix du Congolais* (Léopoldville) (Sept.): 650–51.

Wauters, C. 1949. "L'esotérie des Noirs devoilée." *Revue Coloniale Belge,* 4ᵉ année, no. 87 (15 May): 300–302.

Weaver, William B. 1945. *Thirty-five Years in the Congo.* Chicago: Congo Inland Mission.

Wilmet, Louis. 1939. *Un broussard héroïque: Le R. P. Ivan de Pierpont, S.J. (1879–1937).* Charleroi: J. Dupuis Fils & Cie.

Wissmann, Hermann [von], et al. 1974 [1888]. *Im Innern Afrikas: Die Erforschung des Kassai während der Jahre 1883, 1884, und 1885.* Nendeln: Kraus Reprint.

Yongo Somi a Lumbidi [Yongo a Lumbidi Mon'a Somi].

1972–73. "Réaction Phende contre le système colonial (mai–septembre 1931)." Mémoire présenté pour l'obtention de Diplôme en Théologie, École de Théologie Évangélique de Kinshasa.

C. GENERAL WORKS

Achebe, Chinua. 1984. "Foreword: The Igbo World and Its Art." In *Igbo Arts: Community and Cosmos,* by Herbert M. Cole and Chike C. Aniakor. Los Angeles: Museum of Cultural History, University of California.

Ackerman, Diane. 1990. *A Natural History of the Senses.* New York: Random House.

Arnoldi, Mary Jo. 1988. "Playing the Puppets: Innovation and Rivalry in Bamana Youth Theatre of Mali." *TDR (The Drama Review)* 32, no. 2 (summer): 65–82.

———. 1995. *Playing with Time: Art and Performance in Central Mali.* Bloomington: Indiana University Press.

Bakhtin, M. M. 1981. *The Dialogic Imagination: Four Essays.* Trans. Caryl Emerson and Michael Holquist. Austin: University of Texas Press.

Barber, Karin. 1987. "Popular Arts in Africa." *African Studies Review* 30, no. 3 (Sept.): 1–78.

Barthes, Roland. 1972 [1957]. "The World of Wrestling." *Mythologies,* 15–25. Trans. Annette Lavers. New York: Hill & Wang.

———. 1982 [1962]. "The Imagination of the Sign." In *A Barthes Reader,* ed. Susan Sontag, 211–17. New York: Hill & Wang.

Bass, William M. 1971. *Human Osteology.* Columbia, Mo.: Missouri Archaeological Society.

Bastin, Marie-Louise. 1984a. "Mungonge: Initiation masculine des adultes chez les Tshokwe (Angola)." *Baessler-Archiv,* n.s., 32: 361–403.

———. 1984b. "Ritual Masks of the Tshokwe." *African Arts* 17, no. 4: 40–45, 92–93, 95–96.

Ben-Amos, Paula. 1989. "African Visual Arts from a Social Perspective." *African Studies Review* 32, no. 2: 1–53.

Blier, Suzanne Preston. 1974. "Beauty and the Beast." In *African Art as Philosophy*, ed. Douglas Fraser, 107–13. New York: Interbook.

Bohannan, Paul. 1961. "Artist and Critic in an African Society." In *The Artist in Tribal Society*, ed. Marian W. Smith, 85–94. New York: Free Press of Glencoe.

Boone, Sylvia Ardyn. 1986. *Radiance from the Waters: Ideals of Feminine Beauty in Mende Art*. New Haven: Yale University Press.

Borgatti, Jean. 1979. "Dead Mothers of Okpella." *African Arts* 12, no. 4 (Aug.): 48–57, 91–92.

Borges, Jorge Luis 1981. "Dr. Jekyll and Edward Hyde, Transformed." In *Borges: A Reader*, ed. Emir Rodriguez Monegal and Alastair Reid, 140–43. New York: Dutton.

Boston, J. S. 1960. "Some Northern Ibo Masquerades." *Journal of the Royal Anthropological Institute* 90, pt. 1 (Jan.–June): 54–65.

Bourgeois, Arthur P. 1991. "Mbawa-Pakasa: Buffalo Imagery among the Yaka and Their Neighbors." *Arts d'Afrique Noire* 77 (spring): 19–32.

Brothwell, D. R. 1981. *Digging up Bones*. 3d ed. Ithaca: Cornell University Press.

Chernoff, John Miller. 1979. *African Rhythm and African Sensibility*. Chicago: University of Chicago Press.

Comaroff, Jean. 1985. *Body of Power, Spirit of Resistance*. Chicago: University of Chicago Press.

Comaroff, John, and Jean Comaroff. 1992. *Ethnography and the Historical Imagination*. Boulder: Westview Press.

Coquery-Vidrovitch, Catherine. 1976. "The Political Economy of the African Peasantry and Modes of Production." In *The Political Economy of Contemporary Africa*, ed. P. Gutkind and I. Wallerstein, 90–111. Beverly Hills and London: Sage.

Cornet, Joseph. 1972. *Art de l'Afrique noire au pays du fleuve Zaïre*. Brussels: Arcade.

Cowling, Mary. 1989. *The Artist as Anthropologist: The Representation of Type and Character in Victorian Art*. New York: Cambridge University Press.

Crowley, Daniel J. 1989 [1973]. "Aesthetic Value and Professionalism in African Art: Three Cases from the Katanga Chokwe." In *The Traditional Artist in African Societies*, ed. Warren L. d'Azevedo, 221–49. Bloomington: Indiana University Press.

Darwin, Charles. 1873. The Expression of the Emotions in Man and Animals. New York: D. Appleton & Co.

d'Azevedo, Warren L., ed. 1989 [1973]. *The Traditional Artist in African Societies*. Bloomington: Indiana University Press.

Dejong, Russell. 1979. *The Neurologic Examination*. 4th ed. New York: Harper & Row.

Derrida, Jacques. 1980. "The Law of Genre." Trans. Avital Ronell. *Critical Inquiry* 7, no. 1: 55–81.

Drewal, Henry John. 1984. "Art, History, and the Individual: A New Perspective for the Study of African Visual Traditions." *Iowa Studies in African Art* 1: 87–114.

Drewal, Henry John, and Margaret Thompson Drewal. 1983. *Gelede: Art and Female Power among the Yoruba*. Bloomington: Indiana University Press.

Drewal, Margaret Thompson, and Henry John Drewal. 1987. "Composing Time and Space in Yoruba Art." *Word and Image* 3, no. 3 (July–Sept.): 225–51.

Dyken, Paul R., and Max D. Miller. 1980. *Facial Features of Neurologic Syndromes*. St. Louis: C. V. Mosby Co.

Fabian, Johannes. 1978. "Popular Culture in Africa: Findings and Conjectures." *Africa* 48, no. 4: 315–34.

Fabian, Johannes, and Ilona Szombati-Fabian. 1980. "Folk Art

from an Anthropological Perspective." *Perspectives on American Folk Art,* ed. Ian M. G. Quimby and Scott T. Swank, 247–92. New York: W. W. Norton & Co.

Falkner, Alex. 1842. "Introduction to the Study of Phrenology." *The Phrenological Almanac,* ed. D. G. Goyder, no. 1: 1–16.

Fieldhouse, D. K. 1978. *Unilever Overseas: The Anatomy of a Multinational, 1895–1965.* London: Croom Helm.

Fischer, Eberhard. 1984. "Self-Portraits, Portraits, and Copies among the Dan: The Creative Process of Traditional African Mask Carvers." Trans. Christraud Geary. *Iowa Studies in African Art* 1: 5–28.

Fischer, Eberhard, and Hans Himmelheber. 1984. *The Arts of the Dan in West Africa.* Zurich: Museum Rietberg.

Foucault, Michel. 1970 [1966]. *The Order of Things: An Archaeology of the Human Sciences.* New York: Vintage Books.

Freud, Sigmund. 1950 [1912–13]. *Totem and Taboo: Some Points of Agreement between the Mental Lives of Savages and Neurotics.* Trans. James Strachey. New York: W. W. Norton & Co.

Giblin, James. 1990. "Trypanosomiasis Control in African History: An Evaded Issue?" *Journal of African History* 31: 59–80.

Gilroy, John. 1990. *Basic Neurology.* 2d ed. New York: Pergamon Press.

Glaze, Anita J. 1986. "Dialectics of Gender in Senufo Masquerades." *African Arts* 19, no. 3 (May): 30–39, 82.

Harbage, Alfred, ed. 1969. *William Shakespeare: The Complete Works.* New York: Viking Press.

Herbert, Eugenia. 1984. *Red Gold of Africa: Copper in Precolonial History and Culture.* Madison: University of Wisconsin Press.

Hersak, Dunja. 1990. "Powers and Perceptions of the Bifwebe." *Iowa Studies in African Art* 3: 139–54.

Himmelheber, Hans. 1963. "Personality and Technique of African Sculptors." In *Technique and Personality,* ed. Margaret Mead, 79–110. New York: Museum of Primitive Art.

———. [1972]. "La signification des masques chez quelques tribus de la Côte-d'Ivoire." In *Congrès international des africanistes, 2e session, Dakar, 11–26 déc. 1967.* Paris: Présence Africaine.

Hobsbawm, Eric, and Terence Ranger, eds. 1983. *The Invention of Tradition.* Cambridge: Cambridge University Press.

Hock, Hans Henrich. 1991. *Principles of Historical Linguistics.* 2d ed. New York: Mouton de Gruyter.

hooks, bell. 1992. "Is Paris Burning?" In *Black Looks,* 145–56. Boston: South End Press.

Hunt, Nancy Rose. 1988. "'Le bébé en brousse': European Women, African Birth Spacing and Colonial Intervention in Breast Feeding in the Belgian Congo." *International Journal of African Historical Studies* 21, no. 3: 401–32.

Italie, Hillel. 1993. "Author Blends Humor, 'Cosmic Despair'" [interview with Margaret Atwood]. *Ann Arbor News* (26 Dec.): E4.

Jameson, Fredric. 1981. *The Political Unconscious.* Ithaca: Cornell University Press.

Janson, H. W. 1977. *History of Art.* 2d ed. Englewood Cliffs, N.J.: Prentice Hall; New York: Harry Abrams.

Jauss, Hans Robert. 1982. *Toward an Aesthetic of Reception.* Trans. Timothy Bahti. Minneapolis: University of Minnesota Press.

Jewsiewicki, Bogumil. 1986. "Collective Memory and the Stakes of Power: A Reading of Popular Zairian Historical Discourses." *History in Africa* 13: 195–223.

———. 1991. "Painting in Zaïre: From the Invention of the West to the Representation of Social Self." In *Africa Explores: 20th Century African Art,* ed. Susan Vogel, 130–51. New York: Center for African Art.

Jewsiewicki, Bogumil, Kibla Lema, and Jean-Luc Vellut. 1973.

"Documents pour servir à l'histoire sociale du Zaïre: Grèves dans le Bas-Congo (Bas-Zaïre) en 1945." *Études d'Histoire Africaine* 5: 155–88.

Johnson, Barbara C. 1986. *Four Dan Sculptors: Continuity and Change.* San Francisco: Fine Arts Museums of San Francisco.

Kasfir, Sidney L. 1984. "One Tribe, One Style? Paradigms in the Historiography of African Art." *History in Africa* 11: 163–93.

———. 1987. "Apprentices and Entrepreneurs: The Workshop and Style Uniformity in Subsaharan Africa." *Iowa Studies in African Art* 2: 25–47.

Kopytoff, Igor. 1971. "Ancestors as Elders in Africa." *Africa* 41, no. 2 (Apr.): 129–42.

Kracauer, Siegfried. 1938 [1937]. *Orpheus in Paris: Offenbach and the Paris of His Time.* Trans. Gwenda David and Eric Mosbacher. New York: Alfred A. Knopf.

Krauss, Rosalind. 1985. *The Originality of the Avant-Garde and Other Modernist Myths.* Cambridge: MIT Press.

Kris, Ernst, and Otto Kurz. 1979 [1934]. *Legend, Myth, and Magic in the Image of the Artist.* Trans. Alastair Laing and Lottie M. Newman. New Haven: Yale University Press.

Krogman, Wilton M. 1962. *The Human Skeleton in Forensic Medicine.* Springfield, Ill.: Charles C. Thomas Publisher.

Kuhn, Thomas S. 1970. *The Structure of Scientific Revolutions.* Enl. 2d ed. Chicago: University of Chicago Press.

Kuper, Adam. 1988. *The Invention of Primitive Society.* New York: Routledge.

Lakoff, George, and Mark Johnson. 1980. *Metaphors We Live By.* Chicago: University of Chicago Press.

Lamp, Frederick. 1996. *Art of the Baga.* New York: Museum for African Art.

Lanternari, Vittorio. 1962. *Les mouvements religieux des peuples opprimés.* Trans. Robert Paris. Paris: François Maspero.

Levine, Lawrence W. 1993. *The Unpredictable Past.* New York: Oxford University Press.

Lomax, Alan. 1968. *Folk Song Style and Culture.* American Association for the Advancement of Science, Publication no. 88. Washington, D.C.

Lyons, Maryinez. 1987. "The Colonial Disease: Sleeping Sickness in the Social History of Northern Zaire, 1903–1930." Ph.D. diss., University of California, Los Angeles.

Mbembe, Achille. 1991. "Domaines de la nuit et autorité onirique dans les maquis du Sud-Cameroun (1955–1958)." *Journal of African History* 32, no. 1: 89–121.

McNaughton, Patrick R. 1993. "Theoretical Angst and the Myth of Description." *African Arts* 26, no. 4: 14–23, 82–84, 88.

Memel-Fotê, Harris. 1968. "The Perception of Beauty in Negro-African Culture." In *Colloquium on Negro Art, Dakar, 1966.* Papers from the 1st World Festival of Negro Arts. Paris: Présence Africaine.

Miller, Joseph C. 1973. "Requiem for the 'Jaga.'" *Cahiers d'Études Africaines* 13, no. 1: 121–49.

———. 1976. *Kings and Kinsmen: Early Mbundu States in Angola.* Oxford: Clarendon Press.

Mudimbe, V. Y. 1988. *The Invention of Africa.* Bloomington: University of Indiana Press.

Mulambu Mvuluya [Faustin Mulambu-Mvuluya]. 1974. "Cultures obligatoires et colonisation dans l'ex-Congo belge." *Les Cahiers du CEDAF* (Centre d'Étude et de Documentation Africaines, Brussels), nos. 6–7.

Newcomb, Horace, ed. 1982. *Television: The Critical View.* 3d ed. New York and Oxford: Oxford University Press.

Oppen, Achim von. n.d. *Terms of Trade and Terms of Trust.* Hamburg: Lit Verlag.

Orts, Pierre. 1930. *Le Congo en 1928.* Brussels: Etablissements Généraux d'Imprimerie.

Ottenberg, Simon. 1993. "Where Have We Come From? Where

Are We Heading? Forty Years of African Art Studies." *African Arts* 26, no. 1: 71–73, 91–93, 103–4.

Raingeard, Dr. 1932. "La Main-d'Oeuvre au Kwango." *Revue de Médecine et d'Hygiène Tropicales* 24 (Jan.–Feb.): 21–48.

Ranger, T. O. 1975. *Dance and Society in Eastern Africa, 1890–1970.* Berkeley and Los Angeles: University of California Press.

Richter, Dolores. 1980. *Art, Economics, and Change.* La Jolla, Calif.: Psych/Graphic Publishers.

Roberts, Allen F. 1993. "'Sinister Caricatures,' 'Mimetic Competition': European Cannibalism in the Latter Years of the Belgian Congo." Revised draft for Workshop on Cannibalism, held at Uppsala University, 2–3 June.

———. 1996. "The Ironies of System D." In *Recycled, Re-Seen: Folk Art from the Global Scrap Heap,* ed. C. Cerny and S. Seriff, 82–101, 188–90. New York: Harry Abrams, for the Museum of International Folk Art, Santa Fe.

Rosmarin, Adena. 1985. *The Power of Genre.* Minneapolis: University of Minnesota Press.

Rothstein, Mervyn. 1990. "Round Five for a Theatrical Heavyweight." *New York Times,* sec. 2, pp. 1, 8.

Rubin, Arnold. 1987. "Artists and Workshops in Northeastern Nigeria." *Iowa Studies in African Art* 2: 7–22.

Sacks, Oliver. 1984. *A Leg to Stand On.* New York: Summit Books.

Schapiro, Meyer. 1953. "Style." In *Anthropology Today,* ed. A. L. Kroeber, 287–311. Chicago: University of Chicago Press.

Shipman, Pat, Alan Walker, and David Bichell. 1985. *The Human Skeleton.* Cambridge: Harvard University Press.

Silver, Harry R. 1979. "Beauty and the 'I' of the Beholder: Identity, Aesthetics, and Social Change among the Ashanti." *Journal of Anthropological Research* 35, no. 2 (summer): 191–207.

———. 1981. "Calculating Risks: The Socioeconomic Foundations of Aesthetic Innovation in an Ashanti Carving Community." *Ethnology* 20, no. 2 (Apr.): 101–14.

Simmel, Georg. 1950. "The Stranger." In *The Sociology of Georg Simmel,* ed. and trans. Kurt H. Wolff, 402–8. New York: Free Press.

Szombati-Fabian, Ilona, and Johannes Fabian. 1976. "Art, History, and Society: Popular Painting in Shaba, Zaire." *Studies in the Anthropology of Visual Communication* 3, no. 1: 1–21.

Thompson, Robert Farris. 1966. "An Aesthetic of the Cool: West African Dance." *African Forum* 2, no. 2 (fall): 85–102.

———. 1968. "Esthetics in Traditional Africa." *Art News* 66, no. 9 (Jan.): 44–45, 63–66.

———. 1969. "Àbátàn: A Master Potter of the Ègbádó Yorùbá." In *Tradition and Creativity in Tribal Art,* ed. Daniel P. Biebuyck, 120–82, pls. 80–95. Berkeley and Los Angeles: University of California Press.

———. 1973a. "An Aesthetic of the Cool." *African Arts* 7, no. 1 (autumn): 40–43, 64–67, 89–91.

———. 1973b. "Yoruba Artistic Criticism." In *The Traditional Artist in African Societies,* ed. Warren L. d'Azevedo, 19–60. Bloomington: Indiana University Press.

———. 1974. *African Art in Motion.* Los Angeles: University of California Press.

———. 1981. "Kongo Civilization and Kongo Art." In *Four Moments of the Sun: Kongo Art in Two Worlds,* by R. F. Thompson and Joseph Cornet, 34–140. Washington, D.C.: National Gallery of Art.

———. 1983. *Flash of the Spirit.* New York: Random House.

Todorov, Tzvetan. 1990 [1978]. *Genres in Discourse.* Trans. Catherine Porter. New York: Cambridge University Press.

Tshibangu Kabet Musas. 1974. "La situation sociale dans le ressort administratif de Likasi (ex-Territoire de Jadotville) pendant la Guerre 1940–45." *Études d'Histoire Africaine* 6: 275–311.

Turner, Victor. 1967. *The Forest of Symbols.* Ithaca: Cornell University Press.

Vail, Leroy, ed. 1989. *The Creation of Tribalism in Southern Africa.* Berkeley and Los Angeles: University of California Press.

Vansina, Jan. 1962. "La fondation du royaume de Kasanje." *Aequatoria* 25, no. 2: 45–62.

———. 1970. "Cultures through Time." In *Handbook of Method in Cultural Anthropology,* ed. Raoul Naroll and Ronald Cohen, 165–79. Garden City, N.Y.: Natural History Press.

———. 1973. "Lukoshi/Lupambula: Histoire d'un culte religieux dans les régions du Kasai et du Kwango (1920–1970)." *Études d'Histoire Africaine* 5: 51–97.

Vogel, Susan. 1984. "'The Sheep Wears His Spots Where He Pleases,' or The Question of Regional Styles in Baule Sculpture." *Iowa Studies in African Art* 1: 29–44.

———. 1991. Foreword and introduction to *Africa Explores: 20th Century African Art,* ed. Susan Vogel, 8–31. New York: Center for African Art.

Wagner, Roy. 1981. *The Invention of Culture.* Rev. and exp. ed. Chicago: University of Chicago Press.

Wechsler, Judith. 1982. *A Human Comedy: Physiognomy and Caricature in Nineteenth Century Paris.* Chicago: University of Chicago Press.

Weil, Peter M. 1988. "Fighting Fire with Fire." In *West African Masks and Cultural Systems,* ed. Sidney L. Kasfir, 153–85. Musée Royal de l'Afrique Centrale, Classe des Sciences Humaines, Annales, no. 126. Tervuren.

White, Luise. 1993. "Cars out of Place." *Representations* (summer): 27–50.

Wölfflin, Heinrich. 1950 [1915]. *Principles of Art History.* Trans. M. D. Hottinger. New York: Dover Publications.

Yoshida, Kenji. 1993. "Masks and Secrecy among the Chewa." *African Arts* 26, no. 2 (Apr.): 34–45, 92–94.

INDEX

Pende names are alphabetized by the first name. Mask names are capitalized.

aesthetics: beauty, Pende terms for, 184,
186–88, 192; connoisseurship, Pende terms
for, 92, 99, 103–35, 137, 311n.16; link to
ontology, 118; "masks of beauty," 145,
192–93, 221, 223, 250, fig. 8; of fear, 217,
223, 227, 314n.44. *See also* anti-aesthetic;
body: aesthetics of; costume: aesthetics of;
hairstyles: aesthetics of
Aluund (Lunda), 6, 8, 302n.2; *mungong,* 180,
245–46, 318n.26; *tshiwil,* 180, 293,
318n.26; fig. 1
amulets, 303nn. 21–22. *See also* pendants
ancestors. *See* dead, the
animals, 244, 312n.30; hippo, 84, 86; *kholoma*
(leopard), 159, 204, 211, 234, 238–39, 241,
249; *khoshi* (lion), 159, 211, 234, 238–39;
monkey, 166, 193; *mudiji* (two-spotted
palm civet, *Nandinia binotata*), 60, 295;
mukenge (mongoose), 60; *njiamba*

(elephant), 84, 234, 236–38, 239; gazelle,
295; *njinji* (Central Pende) or *ndjindji*
(Eastern Pende) (serval or civet?), 60, 204;
nvudi (sitatunga), 295; *pagasa* (Cape buf-
falo), 159, 234–37, 239, 248, 260; *shimba*
(genet), 60, 295; *thengu* (roan antelope),
295; *tshima* (small gray monkey), 60; wild
boar, 239. *See also* birds; crocodiles; snakes
animals and reptiles (masks of), 164–66,
234–39, 246–48, 281, 315nn. 4–6. *See also*
Gikwaya; Kholoma; Khoshi; Mutumbi
wa Ngulu; Njiamba; Nyoga; Pagasa
anti-aesthetic, 127–30, 144, 208–11, 217
antisorcery movements, 13, 247, 297, 318n.28
"Article 15," 107–8, 277, 281, 323
audience, 30, 196, 222–23, 315n.8, 319n.31;
praise gifts, 79, 196, 215, 221, 285, 296,
303n.18; reception of comedic masks, 35,
49, 62, 114, 151, 192, 209–10, 284, 286; of

"masks of beauty," 49, 69–70, 181–82,
187–88, 192, 273, 284; of ominous masks,
215–16, 223, 233, 236–38, 241, 296–97;
plate 3, fig. 10. *See also* invention: role of
audience; dance: criticism

Baga, 301n.1
Bamana, 301n.1
Bandundu Pende. *See* Western Pende
Belgian Congo, xxvii, 253–63
Bembete, 294. *See also* Mbuya ya Mukhetu
Bengo Meya-Lubu, 184, 305n.11, 311n.9
bewitched, masked genre of, xvii, 297. *See also*
Gatomba; Mbangu
birds, 193; coucal, 143; *galanda,* 245–46; great
blue turaco *(Corythaeola cristata),* 143,
202–3, 312n.30, figs. 86–87; guinea fowl,
143; *matala* (weaverbirds), 47, 66–67, 69;
nduwa (Lady Ross's violet turaco,